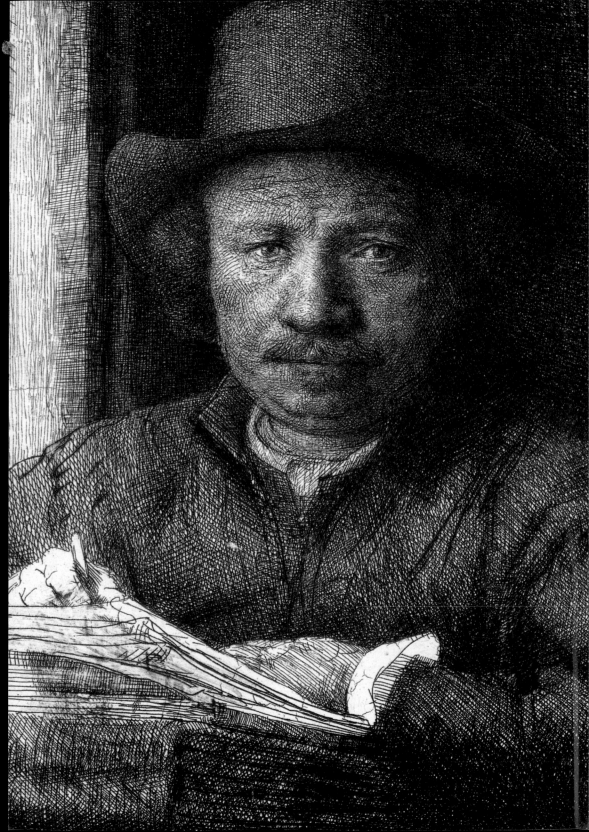

Rembrandt

Opposite
Self-Portrait Drawing at a Window (detail of 134), 1648.
Etching, drypoint and engraving, second state; 16 × 13 cm, 6³⁄₈ × 5¹⁄₈ in

Few faces from the pre-photographic age are as familiar as Rembrandt's (1–3). Round, grey-blue eyes, now clear, now watery, set in a steady gaze; upturned nose, occasionally elegant, more often bulbous; thin moist lips, parted in speech or emphatically shut; abundant curls, unruly and inspired even when groomed. This face and its expressions were already famous in the eighteenth century, when many artists, not least Sir Joshua Reynolds (1723–92), borrowed them for their self-portraits (4).

Rembrandt painted, drew and etched himself with unprecedented frequency: some eighty self-portraits survive, and his different guises are almost as numerous, ranging from soldier to artist, beggar to gentleman (5, 6). In this bewildering array his face is the constant, even as its changes track the passage of time. Rembrandt's self-portraits invite us to study his face. His earliest, made around 1630, show little more than his head, shaded or brightly lit, placid or extroverted (7). Even in his most elaborate roles Rembrandt favoured his face with the brightest and most carefully modulated light, with the finest brushwork.

Early in his career Rembrandt developed a meticulous technique for facial description. Although his brushwork later became increasingly broad, its unique tricks for faces were remarkably consistent. He used a small, stiff brush and viscous paint to render the look of porous, slightly oily skin. He guided the brush to follow the undulations of the face. A fanning white highlight on the forehead or cheek and a sharper, brighter one on the nose strengthen the three-dimensionality of the face. Red touches on the cheeks and nose suggest living tissue under the off-white skin. Lips appear moistened with single touches of pink or white. Dark irises and a little white paint along the lower eyelid yield shiny eyes, enlivened further by the half-shaded sockets.

The compositional skill and colouristic precision with which Rembrandt fashioned his self-portraits made them uncannily direct

1
Self-Portrait with Steel Gorget, c.1629. Oil on panel; 38 × 30·9 cm, 15 × 12¼ in. Germanisches Nationalmuseum, Nuremberg

2
Self-Portrait at the Age of 23, 1629. Oil on panel; 15·5 × 12·7 cm, 6⅛ × 5 in. Alte Pinakothek, Munich

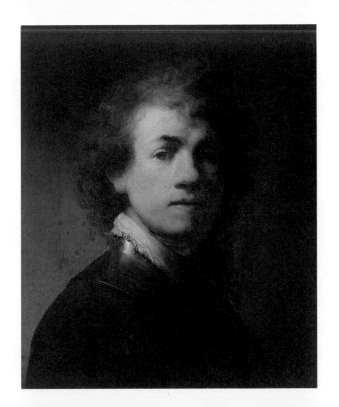

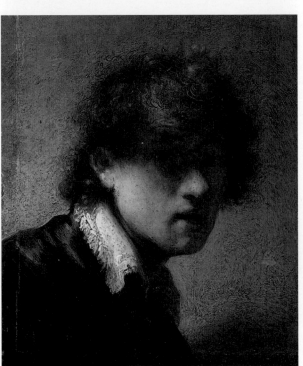

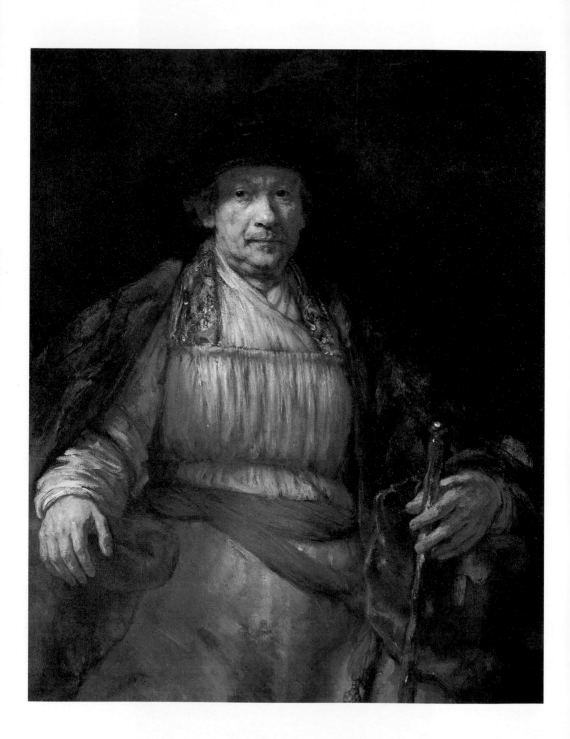

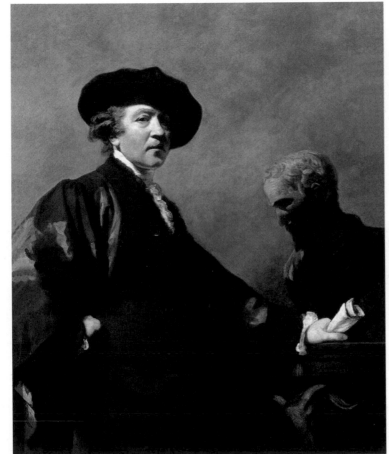

3
*Self-Portrait at
the Age of 52*,
1658.
Oil on canvas;
133·7 × 103·8 cm,
52⅝ × 40⅞ in.
Frick
Collection,
New York

4
**Sir Joshua
Reynolds**,
*Self-Portrait as
Doctor of Civil
Law*,
1773.
Oil on panel;
127 × 101 cm,
50 × 39¾ in.
Royal
Academy of
Arts, London

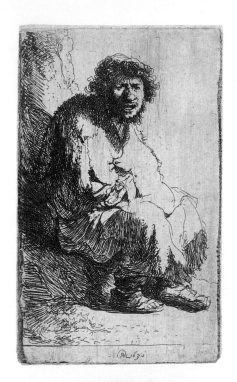

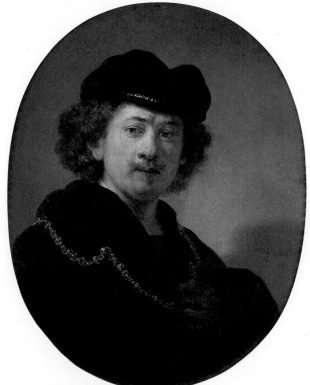

encounters between painter and viewer. Rembrandt's face and dark eyes – 'windows of the soul', contemporaries called them – give the sense that we are looking into the interior of a deeply thoughtful man. Face to face with Rembrandt, the three and a half centuries between him and us can seem irrelevant. This apparent accessibility – the result of a powerful imagination and the technical means to match – is a compelling reason for his appeal, then as now. Rembrandt's contemporaries praised portraits by him and his peers as lacking only speech, and they must have admired this quality in his self-portraits, many of which are found in seventeenth-century collections. But self-portraiture fascinated Rembrandt and his contemporaries for other reasons too.

5
Self-Portrait as Beggar, 1630. Etching; 11·6 × 7 cm, 4½ × 2¾ in

6
Self-Portrait as Gentleman, 1633. Oil on panel; 70·4 × 54 cm, 27¾ × 21¼ in. Musée du Louvre, Paris

7
Self-Portrait, Surprised, 1630. Etching; 5·1 × 4·6 cm, 2 × 1⅞ in

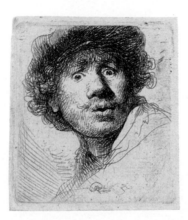

In the seventeenth century portraiture, and especially portraiture of people outside the governing élite, was still novel, having gained wide currency only in the sixteenth century. As most northern European artists occupied middling social ranks, self-portraiture had even less of a tradition. Most artists who painted themselves before Rembrandt had proper social credentials for self-portraiture. Jan van Eyck (*c*.1390–1441) was court artist to Philip the Good of Burgundy; Albrecht Dürer (1471–1528) belonged to the intellectual élite of Nuremberg; and Peter Paul Rubens (1577–1640) was a courtier and diplomat, who painted himself primarily at the request of friends and patrons such as Charles I of England (8). Rembrandt was keenly interested in Dürer and Rubens, but neither artist left a record of his changing face as comprehensive as Rembrandt's. By its sheer extent, his self-portrait production inaugurated a type of pictorial autobiography.

Throughout seventeenth-century Europe, autobiographical statements were produced in unprecedented variety, including diaries, memoirs and philosophical self-investigations. Although such writing had distinguished Western antecedents, reaching back to the *Confessions* of St Augustine, it did not become common practice until the fifteenth century. At the literary end of the spectrum stand the *Essays* of Michel de Montaigne and, in Holland, the Latin memoir of Constantijn

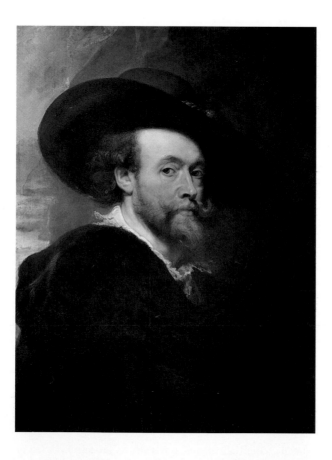

8
Peter Paul Rubens,
Self-Portrait,
*c.*1622–3.
Oil on panel;
86 × 62·5 cm,
33⅞ × 24⅝ in.
Royal
Collection,
Windsor
Castle

Huygens, secretary to the Prince of Orange. But all sorts of other people recorded their lives, from the well-travelled, gossipy Samuel Pepys and his Dutch counterpart, Constantijn Huygens Jr, to the schoolteacher David Beck, who in 1624 recorded his every move, and the midwife Catharina Schrader, who jotted down the joyful and harrowing facts of her career. The growth in such personal testimonies coincided with the rise of portraiture and self-portraiture. Both forms of expression helped shape the notion that the individual is worthy of

interest and record for his or her own sake, rather than as one of countless human souls under God. This fundamentally modern confidence is rooted in complex social, religious and philosophical developments, some of which will be introduced here because of their forceful presence in Rembrandt's culture.

The new valuation of the individual was underpinned by the Protestant Reformation, launched in 1517 by the German theologian Martin Luther as a protest against the abuses of priestly influence. Although Luther aimed to change the Catholic Church from within, the Reformation soon became a religious movement all its own, with a particularly powerful following in northern Europe. By the mid-sixteenth century it was evident that the religious differences between traditional Catholics and Reformers were too fundamental to allow reconciliation within the Church. Numerous Reformed denomina-tions, collectively termed Protestant, organized themselves in central and northern Europe. Reformers such as Luther and John Calvin charged that Catholic priests promoted external means of salvation, including confession and the rote repetition of penitential prayers, at the expense of inner faith. Especially contentious was the Church-sponsored sale of indulgences, licences that released worshippers from years in purgatory. The Reformers also condemned the ornamentation of churches with works of art, for they feared that believers might mistake the images of holy figures for their essences.

For all the differences among them, leading Reformers agreed that the salvation of human souls depends entirely on God's grace, which can be attained only through direct faith in God's sacrifice of his son for the redemption of human sin. This faith cannot be taught by priests or generated by liturgical ritual. At best, ministers can demonstrate the truth of Christ's message by careful explication of the Word of God, as recorded in the Bible, and by guiding the congregation in prayer. Such exegesis should aim to teach Christians to read and study the Word of God on their own, and for that purpose the Bible must be made accessible in reliable vernacular translations. This proposal was revolutionary, as the Latin Bible had traditionally been brought to worshippers through the mediation of priests. The Protestant interest

in the believer's direct relationship to God and the Bible, and the spread of literacy it encouraged, stimulated new emphasis on individuals and their thoughts, developed in private prayer and reading.

Protestant agitation against the centralized Catholic Church, controlled by the Pope in Rome, fell on willing ears in the Netherlands. For old dynastic reasons, this loose grouping of states, provinces and cities was governed by the Habsburg kings of Spain. The Calvinist protest in the Netherlands was so inflammatory that in 1566 a tidal wave of iconoclasm – the destruction of religious art – heaved from town to town, ridding churches of stained glass, sculpture and paintings. In the Catholic attempt to stem the Protestant surge in northern Europe, the Spanish kings sided with the Vatican. Eager to be free of Spanish government for political as well as religious reasons, Netherlandish noblemen and Reformers revolted against King Philip II of Spain in 1568.

In the Eighty Years' War that lasted until the Peace of Münster in 1648, the seven rebellious Dutch provinces succeeded in forging a republic that comprised most of the present-day Netherlands. Unlike the Habsburg Empire or the Catholic Church, the Dutch Republic had a decentralized political and economic structure, governed by the States General, who represented the provinces. Depending on the political and military situation, this body of delegates appointed a military *stadhouder* ('keeper of cities') or *raadspensionaris* ('legal counsel') to conduct foreign and military policy. Although the *stadhouder*'s office was not hereditary, in practice it was invariably filled by one of the princes descended from William I of Orange, the revered leader of the revolt. The Spanish government and Catholic Church retained control of the Southern Netherlands, roughly equivalent to modern Belgium.

The Dutch Republic prescribed no state religion, but its debt to the Reformed leaders who had driven popular support for the war meant that the country was nominally Calvinist. Catholics, Jews and Lutherans constituted about half of the population of two million, but political office, religious worship, education and public morality codes had a Calvinist stamp in all provinces except Utrecht, which remained a bishopric, and Brabant, which the Republic incorporated by military victory.

An emphasis on individual responsibility was stimulated in the Republic by Protestant tenets and by a sense of stake in the country's new independence; it was also furthered by experimental science and empirical philosophy. Dutch scientists participated constructively in the rapid exploration of microscopic and telescopic worlds. Motivated by respectful wonder at God's creation as well as economic interests, their observations incidentally confirmed the privileged place of the human species in creation. Among the Dutch pioneers of the scientific revolution, Simon Stevin, Christiaan Huygens, Anthony van Leeuwenhoeck and Jan Swammerdam gained international reputations in mathematics, physics, biology and entomology.

In the seventeenth century science was inseparable from empirical philosophy, which attempted to define in verifiable terms the relation-ship of human beings to the world and its creator. The most articulate exponent of this branch of philosophy was René Descartes, who spent much of his writing life in Holland. His famous condensation of the nature of the human self to his 'I think, therefore I am' was published in Leiden in 1637, and his controversial views were debated in the scholarly communities of Amsterdam, Utrecht and Haarlem. Around 1650, Frans Hals (1582/83–1666) painted his portrait, which was circu-lated in an engraving (9). An anonymous poem below praises the philosopher as 'the *Child of Nature*: her one son who opened an entry for the mind into her womb'.

Rembrandt's incessant representation of his face and body suggests a Cartesian belief in the actuality and relevance of the self, a faith constantly tested in the analysis of one's mental state, but a faith nonetheless. An eighteenth-century record of a drawing by Rembrandt of Descartes, unfortunately lost, hints that the artist may have met the philosopher. More probably, he encountered the startlingly modern thinker Baruch Spinoza, his younger contemporary and fellow towns-man in Amsterdam, who sought to understand God's relationship to individuals in rational terms, without recourse to mystical notions.

Although Rembrandt's interest in the outer manifestation of his person aligns his self-portraits with contemporary philosophy, his self-portraits are clearly no philosophical tracts. Whether made as

private, introspective documents or as art for public consumption, we know that he sold or gave away many, for none appears in the 1656 inventory of his possessions, drawn up when he was forced to declare insolvency. Collectors who knew Rembrandt or his art may have liked having his portrait as a celebrity item. An English courtier gave Charles I one of Rembrandt's early self-portraits, and a late self-portrait entered the gallery of Cardinal Leopoldo de' Medici in Florence, which comprised dozens of paintings of famous men,

NATVS HAGÆ. TVRONVM PRIDIE CAL. APR. 1596. DENATVS HOLMIÆ. CAL. FEB. 1650

RENATUS DESCARTES. NOBILIS GALLUS. PERRONI DOMINUS. SUMMUS MATHEMATICUS & PHILOSOPHUS.
Talis erat vultu NATVRA FILIVS: *unus*
Qui Menti in Mateis viscera pandit iter.
Arcanisq. suis quavis miracula cursis,
Miraclum reliquum solus in orbe fuit.

F. Hals *pinxit* I. *Suyderhoeff* sculpsit

9
Jonas
Suyderhoef
after Frans
Hals,
René Descartes,
1650.
Engraving;
31·6 × 23 cm,
12½ × 9 in

10
*Self-Portrait
in Oriental
Costume with
Poodle*,
c.1631.
Oil on panel;
66·5 × 52 cm,
26⅛ × 20½ in.
Musée du Petit
Palais, Paris

including numerous self-portraits. Others may have admired his self-portraits for their fanciful costumes and inventive poses (10) or for their apt rendering of human emotions or 'passions'.

Rembrandt's artistic interest in facial expression is evident in his series of self-portrait etchings from around 1630, in which he tried out a wide range of sentiments, as if putting on different masks (11). These small studies may reflect contemporary drawing practice, as their origins in

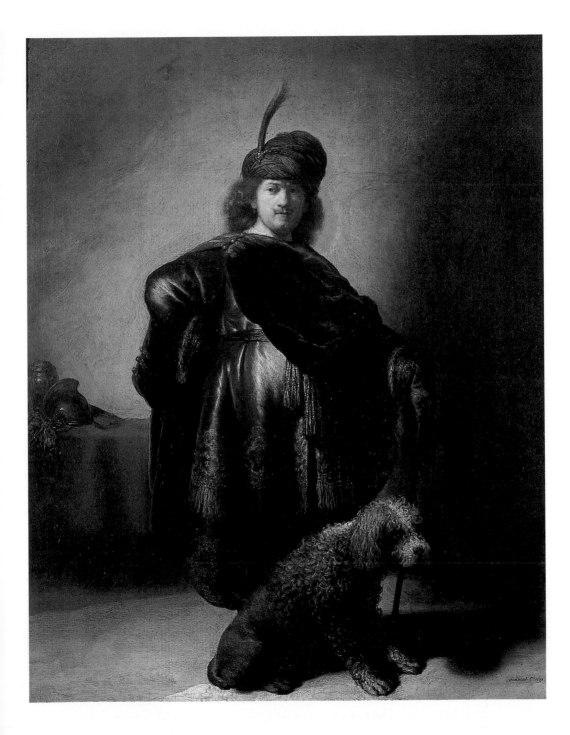

Rembrandt's self-portrait drawings suggest (12). Half a century after their production, Rembrandt's pupil Samuel van Hoogstraeten (1627–78) discussed the exercise of self-expression in his *Introduction to the High School of Painting* (*Inleyding tot de Hooge Schoole der Schilderkonst*), a treatise published in 1678. Quite possibly transmitting his master's lesson, he recommended that artists learn to render the passions by trying out emotions in the mirror and fixing their reflections in drawings. Rembrandt's decision to apply this practice in reproducible etchings suggests that they must have been made for circulation beyond the studio. Early in Rembrandt's career, they could advertise his capacity for capturing human expression and spread knowledge of the face he would turn into fascinating art for the remainder of his life. They may even have encouraged a collecting habit in his first customers: just as modern collectors seek perfect series of certain stamps, watches or toys, owners of Rembrandt's self-portrait prints may have aimed to own all of his faces.

Rembrandt's focus on the expressive face, honed over years of studying his own, is characteristic of all his human subjects: in portraits and genre scenes, in biblical and classical stories. Often combined with powerful poses and gestures, it produced memorable individuals. Even in quick, informal works, Rembrandt concentrated on individual responses registered in faces and gestures. In a sequence of rapid pen sketches he recorded the antics of a toddler who succeeds in pulling a cap off an old man's head (13). A cross-fire of lines economically suggests the child's intense concentration and the elderly man's awkward defence. Virtually all of Rembrandt's work is marked by the personal, familiar vision that animates these sketches.

Rembrandt's interest in the specificity of human life, with all its virtues and foibles, thrived in a predominantly Protestant milieu. Though conscious of classical antiquity, Dutch society was neither constrained nor exceptionally stimulated by this lofty heritage, and the Republic's decentralized organization gave its people a proto-democratic stake in the ordinary. Rembrandt's most fascinating works live the dual existence of all striking art, as rich visual experiences regardless of their historical context and as masterly products

11
Self-Portrait, Frowning, 1630.
Etching;
7.5 × 7.5 cm,
3 × 3 in

12
Self-Portrait with Mouth Open, *c*.1628–9.
Pen and brown ink with grey wash;
12.7 × 9.5 cm,
5 × 3¾ in.
British Museum, London

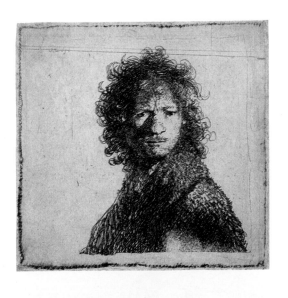

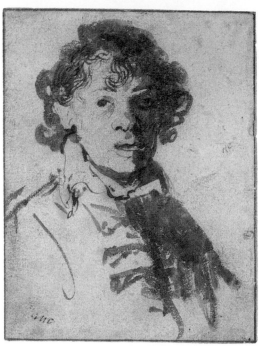

of particular circumstances. This book attempts to situate Rembrandt in his original artistic, economic and social environment, in the belief that such knowledge can enhance our pleasure in his art and our understanding of his continuing relevance.

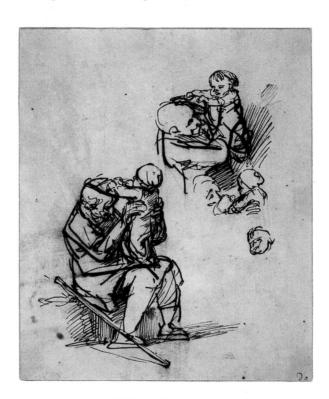

13
*Studies of
an Old Man
with a Child
on his Lap,*
*c.*1639–40.
Pen and brown
ink with
brown wash;
18.9 × 15.7 cm,
$7\frac{1}{2} \times 6\frac{1}{8}$ in.
British
Museum,
London

1

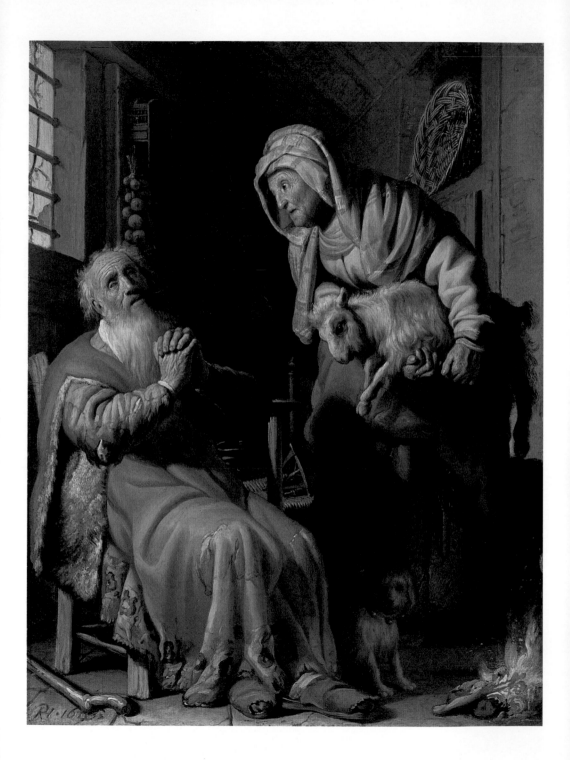

Nothing about the lineage of Rembrandt Harmensz van Rijn points to his later choice of profession. He was born on 15 July 1606 in Leiden, the ninth child of Harmen Gerritsz van Rijn (15) and Neeltgen Willemsdr van Zuytbrouck. Rembrandt's father was of middle-class stock, having inherited the family malt mill 'De Rijn' which stood by the city walls overlooking the Oude Rijn, or Old Rhine river (16). His mother was a baker's daughter but she was related to an old ruling or 'regent' family of Leiden. The large family supported itself without difficulty, and both Rembrandt's parents left respectable estates on their deaths. They seem to have belonged to the Reformed Church, the city's official denomination from 1566, but Neeltgen's relatives had remained Catholic. Although Catholicism would have excluded them from public office, Rembrandt's relationship to them may have facilitated his eventual access to regent circles in Amsterdam.

Rembrandt left no statement as to why he became an artist – few painters did before the nineteenth century – and his written remarks about his art and life are scanty. Any historical reconstruction of Rembrandt must use a multitude of sources: from the paintings, drawings and prints made by him, his pupils and followers, to a diverse range of manuscripts and published documents, including municipal and church registers, legal papers, account books, household inventories and the few early biographies and assessments of Rembrandt. The first contemporary appreciation of Rembrandt appeared in 1628, when he was only twenty-two, but most of the early writings about him postdate his death by at least six years. The most extensive, by Arnold Houbraken (1660–1719), was published in 1718 as part of his *Great Theatre of Netherlandish Artists* (*De groote schouburgh der Nederlantsche konstschilders en schilderessen*); it is the last record by someone who had known Rembrandt's associates. Rembrandt's own contributions to the written record are modest. They comprise seven letters to one patron and a message to another, signatures on legal

14
*Tobit and Anna
with the Kid
Goat,*
1626.
Oil on panel;
39.5 × 30 cm,
15½ × 11⅞ in.
Rijksmuseum,
Amsterdam

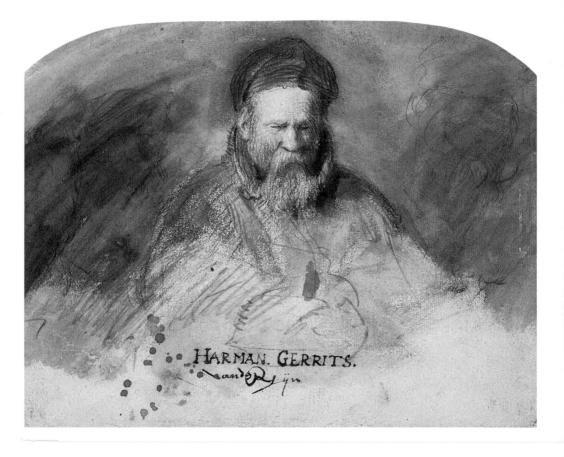

HARMAN. GERRITS.

15
*Harmen
Gerritsz van
Rijn,*
*c.*1630.
Charcoal,
red chalk and
watercolour;
18·9 × 24 cm,
7½ × 9½ in.
Ashmolean
Museum,
Oxford

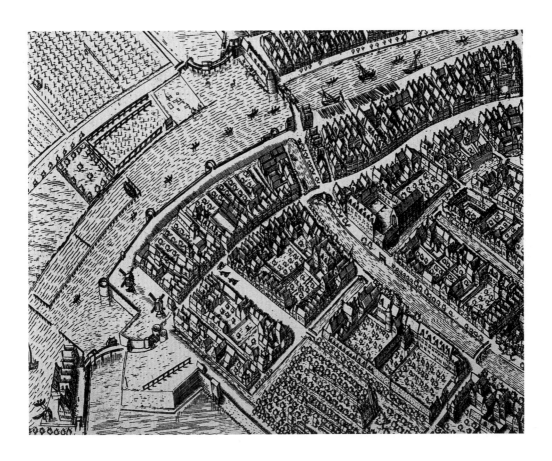

16
Pieter Bast,
Detail from
map of Leiden
with the
location of
the house
and mill of
Rembrandt's
parents,
1600

documents and a few dozen notations on works of art. Rembrandt's inscriptions of this sort usually concern the works at hand; occasionally they offer brief comments on his art and business.

None of these documents is as effective as Rembrandt's art in bringing him to life, but they are crucial to understanding his career. The first biography of Rembrandt was included by Jan Jansz Orlers, the burgomaster of Leiden, in his *Description of the City of Leiden* (1641). He claimed that Rembrandt's parents sent him to the city's Latin School in hopes of preparing him for a university education, but that Rembrandt

had no desire or inclination whatsoever in this direction because by nature he was moved toward the art of painting and drawing. Therefore his parents were compelled to take him out of school, and according to his wish they brought and apprenticed him to a painter from whom he would learn the basic and principal rules of art.

Rembrandt's deviation from his parents' plans is a familiar motif of the biographies of Italian Renaissance artists published in 1550 by Giorgio Vasari (1511–74) as the *Lives of the Most Excellent Painters, Sculptors, and Architects*. The Dutch painter and writer Karel van Mander (1548–1606) told the same anecdote of Netherlandish artists in his *Book of Painting* (*Het Schilder-Boeck*) of 1604, which reproduced many of Vasari's biographies and included new ones for Northern painters. Despite its familiar plot, Orlers' account rings true. Leiden's university register of 1620 confirms that Rembrandt was enrolled as a literature student at the age of fourteen. To enter, he must have attended Latin School successfully, and in keeping with Orlers' story about his early departure from the university, Rembrandt's name never recurs on the register.

Rembrandt's change of plan would have given his parents little reason to worry. Painting was a respectable trade in the Dutch Republic, easily on a par with his older brothers' occupations of milling, baking and shoemaking. As the youngest son, Rembrandt would not inherit the mill, and his parents may have sent him to Latin School because of exceptional promise. Whatever the case, his education is a mark of his family's prosperity, for it was a costly proposition in a period when most children – and especially ninth children – received no formal

education. At school he would have studied elementary mathematics, Latin grammar, the Bible, some Reformed theology and school versions of the Greek and Roman classics.

For a gifted boy in Leiden, painting must have been a reasonable, though hardly glorious, prospect. After Amsterdam, Leiden was the second largest and most prosperous town in Holland, which was the leading province of the Republic. As the only Dutch university city, it was home to intellectuals who might foster art collecting. Despite these favourable conditions, Leiden's artistic culture around 1620 was modest. The guild of St Luke, patron saint of painters, had been abolished in 1572, and there were no contemporary painters of the calibre of Lucas van Leyden (*c*.1494–1533), the city's most famous earlier artist, whose prints Rembrandt would later collect and emulate. Orlers wrote that Rembrandt was apprenticed to the local painter Jacob Isaacsz van Swanenburgh (1571–1638) for three years, and immediately impressed certain 'art-lovers' with his promise. Later biographers who knew Rembrandt or his pupils confirm this story.

Rembrandt's mother may have known Van Swanenburgh because he belonged to a prominent Catholic family. Only a few paintings can be attributed to him, and most represent infernal scenes such as *The Sibyl Showing Aeneas the Underworld* (17), a scene from Virgil's *Aeneid*. Vaguely reminiscent of the ever-popular hell scenes in the manner of Hieronymus Bosch (*c*.1450–1516), the painting has countless tiny figures swirling through a fiery, panoramic landscape anchored at lower right by the gaping mouth of Cerberus, watchdog to the underworld. Such pictures were old-fashioned for Dutch painting of the early seventeenth century, although they continued to sell well in the southern Netherlands.

It is not surprising that Van Swanenburgh's paintings left no perceptible mark on Rembrandt's works, for the primary purpose of his apprenticeship was to acquire the fundamental skills of painting, and Rembrandt would not have been allowed to sign and sell works under his own name. Much is now known about the apprenticeships, tools, materials and working processes of seventeenth-century painters, thanks in part to the technical investigations of the Rembrandt

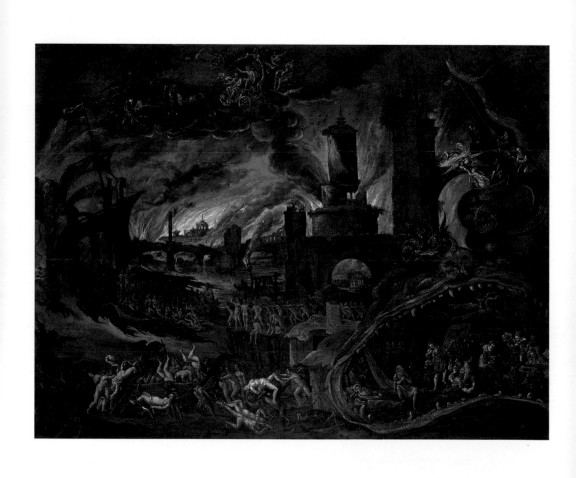

Research Project. In 1969, this team of Dutch scholars began to examine every one of the implausibly many paintings that were then attributed to Rembrandt, in an effort to determine what he had actually painted. The goal has proved elusive, and not only because of the sheer number of paintings involved. Rembrandt had dozens of associates, students, assistants and followers throughout his career, and, like Van Swanenburgh before him, he could have sold the works of his pupils under his 'trademark'. On occasion, Rembrandt must have let them collaborate on his paintings. Moreover, deciding just what is within the bounds of Rembrandt's normal standards of quality, and what falls short of them, ultimately remains a subjective enterprise. But if the Rembrandt Research Project has not delivered the definitive catalogue of Rembrandt's works it intended to produce, it has published more detailed technical data and keen observations than are available for any other Dutch painter, and it has thereby clarified Rembrandt's working procedures and those of seventeenth-century painters in general.

In Van Swanenburgh's studio, Rembrandt would first have learnt to select and prepare painting materials. Some tools and materials were supplied commercially, but many had to be made or finished in the workshop. Easel painting in the seventeenth century was done on wood panels or canvas, and Rembrandt would have studied the standard sizes and constructions of panels, and techniques of stretching canvases into frames. He would also have learnt how to mix the ground, which, applied directly to the entire panel or canvas, provided a smooth surface for painting. When painters left some of the ground bare in places, as Rembrandt often did in the shaded areas of his portraits (see 1, 2 and 6), the ground colour contributed to the overall tonality and atmospheric quality of the painting.

Technical research has clarified that Rembrandt's grounds are fairly typical of seventeenth-century artistic practice, and may often have been applied by the panel or canvas suppliers. In his panel paintings they usually consist of chalk bound in animal glue, occasionally covered with a thin layer or *primuersel* ('priming') of umber pigments bound in oil. His canvas grounds have more complicated structures, as we will see in Chapter 2.

17
Jacob
Isaacsz van
Swanenburgh,
*The Sibyl
Showing
Aeneas the
Underworld*,
1620s.
Oil on panel;
93.5 × 124 cm,
36¼ × 48¾ in.
Stedelijk
Museum de
Lakenhal,
Leiden

Van Swanenburgh would also have taught Rembrandt to prepare paints by grinding pigments and mixing the particles with a binding medium such as linseed oil. Another essential skill was the arrangement of the paints on a palette. Ernst van de Wetering has shown that the palette of Rembrandt's time was small by modern standards, about 30 cm (12 in) long, and usually carried only the few colours needed to complete a particular passage in a painting. For other areas, the painter would prepare new palettes. Van Swanenburgh must have shown Rembrandt how to obtain different effects with the various brushes and palette knives. Rembrandt would have learned how to steady his hand while painting, supporting it on a maulstick: a cane propped against the frame of the painting.

As an apprentice, Rembrandt would have observed the stages of inventing and producing a finished painting, and begun to draw in chalk or pen and ink, from objects, prints, drawings and plaster casts of body parts. Students often drew only parts of the human body, such as eyes, arms and legs, in preparation for drawing the complete form. Rembrandt would have learnt to draw live models and compositional sketches after he had mastered these basic techniques. Later still, he would have begun to paint in oil, copying pictures or helping to finish paintings in the master's manner. He would have watched Van Swanenburgh paint the composition's outlines and areas of light and shade, probably in brown, grey and black paint. After this stage, known as dead-colouring, the master elaborated the painting in colourful detail, working in small passages, mostly from the background towards the foreground, and finally applying a protective varnish.

Because Rembrandt would not have been permitted to sign his own works or to paint independently, there are no known paintings from his apprentice years. Although Leiden had no painters' guild, its workshops probably observed the sorts of guild regulations enforced in other cities, which required apprentices to paint in the style of the master. Guilds were concerned to maintain control over the quality and price levels of art, and thus painters could not sell works in their own name unless they had established themselves as independent masters who paid guild dues.

In addition to teaching Rembrandt the secrets of his art, Van Swanenburgh must have stimulated his artistic interests. The master had lived in Italy

for twenty-five years and specialized in painting mythological subjects, which at that time ranked with scenes from Roman history and the Bible as the most prestigious themes. He may also have brought back drawings of classical and Renaissance art. Rembrandt's next move was possibly inspired by the exposure to his teacher's Italian experience. Orlers mentions that, after the standard apprenticeship time of three years, thus around 1624, Rembrandt's father agreed to apprentice him to Pieter Lastman (1583–1633) of Amsterdam, 'for further and better instruction'. According to Orlers Rembrandt 'stayed with him about six months, but then decided to practise the art of painting entirely on his own'. Lastman had also lived in Italy and, although a Catholic artist in Protestant Amsterdam, he was one of the most highly regarded painters of his generation, responsible for seminal innovations in Dutch history painting. Proud of his Italian credentials, he frequently signed his works 'Pietro Lastman' even after his return from Rome.

Around 1600, Dutch history painters had favoured the representation of male and female nudes in varied, difficult poses that demonstrated an understanding of anatomy and an ability to use it to express emotion. Patrons and painters were especially drawn to stories of the loves of the Greek gods, told vividly in Ovid's *Metamorphoses*. To help painters represent these titillating tales, Van Mander included a lengthy explanation of the *Metamorphoses* in his *Book of Painting*. Narrative clarity was not central to this type of painting. In *The Wedding of Peleus and Thetis* (18), Abraham Bloemaert (1564–1651), the leading painter of Utrecht, focused on the revelry of the divine guests at the expense of Eris, the goddess of Discord, who on this occasion sowed the seeds of the Trojan War. Lastman preferred serious themes, selecting morally poignant, often obscure tales from ancient history or the Old Testament and presenting them in a direct manner that had been developed by Italian artists around the turn of the century.

Lastman's colourful panel of *Orestes and Pylades Disputing at the Altar*, painted in 1614 (19), showcases these accomplishments. It depicts the Greek hero Orestes arguing with his best friend Pylades as to who must be sacrificed for their joint theft of a temple statue: each wanted to die so his friend could live. Orestes won the dispute, then recognized the temple

18
**Abraham
Bloemaert**,
*The Wedding
of Peleus
and Thetis*,
c.1596.
Oil on canvas;
101 × 146·5 cm,
39¾ × 57⅝ in.
Alte
Pinakothek,
Munich

19
Pieter
Lastman,
Orestes and
Pylades
Disputing at
the Altar,
1614.
Oil on panel;
83 × 126 cm,
32⅝ × 49⅝ in.
Rijksmuseum,
Amsterdam

priestess as his sister Iphigenia and managed to escape with her and Pylades. Rather than depicting the dramatic moment of deliverance, Lastman opted for the noble quarrel, with Iphigenia looking on. Unlike Bloemaert, he distributed his brightly lit protagonists across the front plane, in the manner of Roman relief sculpture, against a backdrop of Mediterranean scenery and classical architecture. In 1657 the poet Joachim Oudaen praised Lastman for his 'art of composition' in this very painting.

After his six months with Lastman, Rembrandt moved back to Leiden to become an independent painter. There, he could live at home and avoid guild dues. Although Rembrandt spent only a brief time in Lastman's studio, his absorption of his master's lessons was thorough, for his earliest known paintings introduced Lastman's innovative subjects and style to Leiden. In 1625 he signed and dated *The Stoning of St Stephen* (20), painted on a large panel of the horizontal format favoured by Lastman. The theme seems odd for a painter from a Protestant family, for the Reformation forcefully rejected the Catholic cult of saints as mediators of salvation. But St Stephen was a particularly bona fide saint. Recorded in the Bible (Acts 6:5–7:60) as deacon of the early Christian Church in Jerusalem, St Stephen was revered as the Church's first martyr, stoned to death for his belief. Seventeenth-century viewers readily drew analogies between past and present events, and Stephen's fate would have recalled the courage of the early Reformers, many of whom suffered for their faith. Appropriately, Rembrandt's Stephen has the sweaty look of a deacon in distress, rather than the pathos of a Catholic martyr. The first owner of this painting may well have seen it in these terms, for he was probably Petrus Scriverius, a historian with a firm commitment to Protestantism. Identified with the more tolerant yet politically weaker side of the Dutch Reformed Church, he eventually had his books confiscated. Scriverius lived near Van Swanenburgh and owned two large paintings by Rembrandt, of which this may have been one. He would not have used Rembrandt's painting in worship, but would have admired it for its narrative exposition.

To structure Stephen's martyrdom, Rembrandt drew on the compositional tactics and antique flavour of Lastman's pictures. He surely knew Lastman's lost *Stoning of St Stephen*, of which a copy survives, but his work is more directly indebted to a painting by Adam Elsheimer (1578–1610; 21).

20
The Stoning of St Stephen,
1625.
Oil on panel;
89·5 × 123·6 cm,
35¼ × 48⅝ in.
Musée des Beaux-Arts, Lyon

21
Adam Elsheimer,
The Stoning of St Stephen,
c.1602–5.
Oil on tinned copper;
34·7 × 28·6 cm,
13⅝ × 11¼ in.
National Gallery of Scotland, Edinburgh

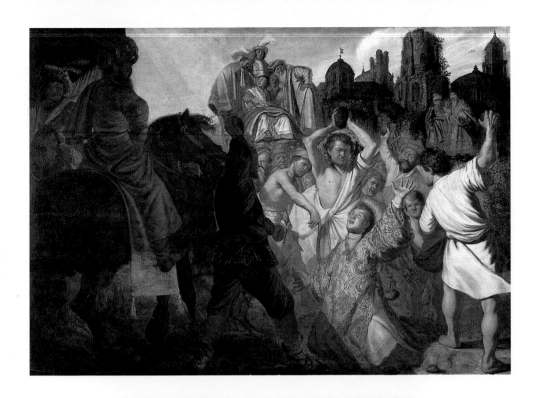

This German painter was living in Rome at the same time as Lastman, and his influence on Lastman's bright palette and richly painted fabrics is evident. From Lastman, Rembrandt borrowed architecture to evoke Jerusalem and the prominent Pharisee in 'oriental' dress, who approved Stephen's murder. In Elsheimer, Rembrandt admired the bright shafts of sunlight illuminating the kneeling saint from above. He also borrowed Elsheimer's muscular executioners, Stephen's scintillating vestments and the Roman soldier on horseback. Rembrandt's soldier looms in the dark foreground shadow of a tall building on the left, which creates depth in the tight space. Such a space-creating device, termed a *repoussoir*, was also used by Elsheimer, who may have adopted it from Caravaggio (1571–1610) and other early seventeenth-century Roman artists. Perhaps to announce his youthful accomplishment, or to present himself as an eye-witness, Rembrandt gave a bystander behind Stephen his own features.

The subject of a history painting Rembrandt signed in 1626 (22), of virtually the same size as *The Stoning of St Stephen*, is disputed. As a painting, the work demonstrates Rembrandt's rapid strides in the representation of space and the imitation of different textures. Instead of the conspicuous *repoussoir* of *The Stoning of St Stephen*, Rembrandt painted an impressive pile of arms and armour, which creates depth while displaying a growing mastery of texture and historical flavour. Once again, Rembrandt included his own face at the back of the painting, gazing out from behind the raised sceptre of the most commanding figure.

The proposal of the art historian M L Wurfbain that this painting depicts *Palamedes before Agamemnon* is reasonably convincing. The Greek soldier Palamedes was instrumental in forcing Odysseus to fight in the Trojan War, but Odysseus retaliated by framing Palamedes for treason. Agamemnon, commander of the Greek army, condemned Palamedes to death by stoning. If Rembrandt painted this obscure episode, the dashing figure in gold brocade would be Odysseus, and the kneeling soldier with the shield would represent Palamedes protesting his innocence. In 1625 Joost van den Vondel, Amsterdam's most distinguished poet, had published a play that was ostensibly about Palamedes but in reality a transparent replay of the politically

motivated execution in 1619 of Johan van Oldenbarnevelt, the chief
policy advisor to the States General and advocate of peace with Spain.
Cast as Palamedes, Van Oldenbarnevelt had been at odds with religious
hardliners and the Princes of Orange, who favoured continuing
warfare. Scriverius, who probably owned this painting as well as
The Stoning of St Stephen, was associated with Van Oldenbarnevelt's
faction. Given that Palamedes and St Stephen were both innocents
stoned to death, it is tempting to see these two paintings of similar
size as pendants or counterparts to each other, commissioned by
Scriverius. The Palamedes identification remains uncertain, however,
for there are two pleading figures rather than one.

As he was completing these ambitious, difficult works, Rembrandt
began to paint the intimate renderings of biblical stories that were
to become his distinctive contribution to religious painting. His earli-
est effort in this genre is the small painting *Tobit and Anna with the
Kid Goat*, dated 1626 (see 14). Its convincing handling of space, light
and texture constitutes a further leap in technical confidence, and its
palette, while still bright in Lastman's vein, is more harmonious. This
modified style matches the tenor of the story of the pious, blind Tobit,
once rich but now poor, who has just accused his wife Anna of stealing
the goat she holds at her hip. As Anna, wide-eyed at her husband's
charge, claims her innocence, Tobit recognizes that his visual disability
has blinded his heart. In despair and remorse, he clasps his hands to
pray for forgiveness. Rembrandt told this story of faith lost and
regained according to the Book of Tobit (2:21–3:6), which Protestant
theologians considered apocryphal – that is, didactically useful but
not part of the canonical Old Testament. His interpretation of the tale
as a domestic dispute in a humble interior was motivated by an earlier
print of the story, which had introduced Anna's hunched pose and the
homely furnishings. Using oil paints in a colourful palette, Rembrandt
transcended his source to create a tangibly 'real' version of this home.
Ever since oil had been introduced as a binding medium in the
fifteenth century, Netherlandish painters had capitalized on its
translucency and viscosity to imitate textures and atmospheric effects
with startling veracity. In 1626, Rembrandt rapidly developed his
handling of oil paint for this purpose. In this painting he dextrously

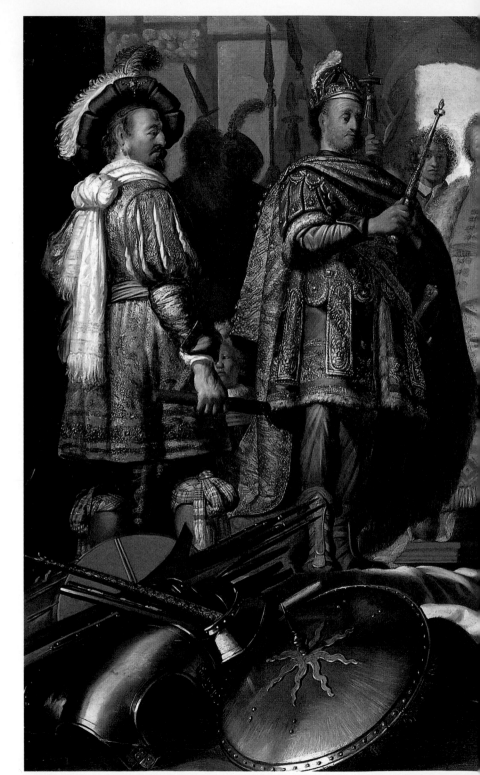

22
History
Painting
(Palamedes
before
Agamemnon?),
1626.
Oil on panel;
90·1 × 121·3 cm,
35$\frac{1}{2}$ × 47$\frac{3}{4}$ in.
Rijksdienst
Beeldende
Kunst, The
Hague, on loan
to the Stedelijk
Museum de
Lakenhal,
Leiden

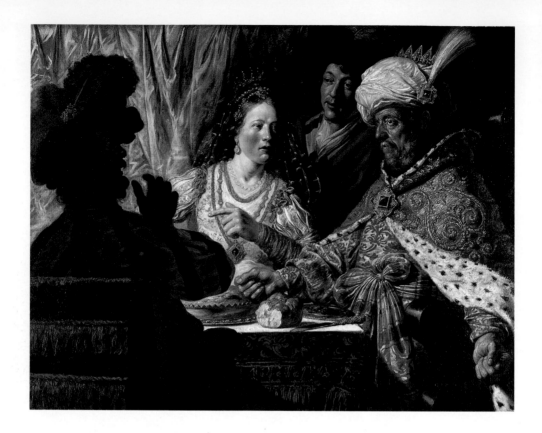

rendered wrinkled skin, a wicker basket, the fur of Tobit's robe, the coats of kid and terrier. The fire is a *tour de force*, with its leaping flames and crackling embers, imparting a mellow glow to Anna's robes. Yet these fine details are carefully subordinated to the clear narrative.

A penchant for bright colour schemes, dark *repoussoirs*, conspicuous textures and dramatic narratives also animates the earliest works of Rembrandt's contemporary and fellow townsman Jan Lievens (1607–74), who worked closely with him at this time. Lievens' daring, almost garish art is exemplified by his large *Banquet of Esther and Ahasuerus* (23). A child prodigy, Lievens had preceded Rembrandt in an apprenticeship with Lastman from about 1617 to 1619, and this painting's palette, theatrical gestures and roughly textured surface owe much to the master's work. The half-length figures that fill the picture, however, originated in paintings by followers of Caravaggio. Around 1600, this Roman artist had introduced bold, sharply lit paintings of half-length figures (24), and this formula soon travelled north with

23
Jan Lievens,
The Banquet of Esther and Ahasuerus,
c.1625–6.
Oil on canvas;
134·6 × 165·1 cm,
53 × 65 in.
North Carolina Museum of Art, Raleigh

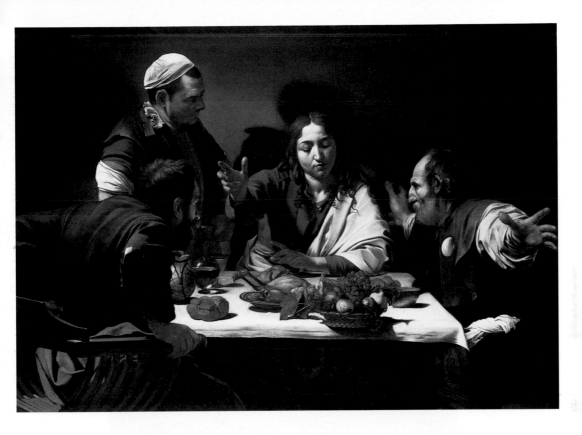

French and Netherlandish painters. Several of the Dutch 'Caravaggists' worked in Utrecht, a Catholic city some 85 km (50 miles) from Leiden. Lievens' dramatic presentation of the story from the Book of Esther (7:1–6) establishes his youthful awareness of their recent innovations. Esther, the Jewish wife of the Persian King Ahasuerus, has just revealed to her husband that his adviser Haman has plotted the destruction of Jews in his kingdom. As Esther points to Haman, Ahasuerus clenches his fists and tightens his mouth in rage. Lievens put Haman in a *repoussoir* position that effectively casts him in darkness and silhouettes his fear.

The Banquet of Esther and Ahasuerus is one of two dozen paintings, drawings and prints that document the close working relationship between Rembrandt and Lievens from about 1626 to 1632. On at least five occasions, the young painters represented the same subjects in similar styles; in other instances they rendered different subjects in shared compositions. They painted and drew each other, and the same old man and woman frequently recur in their works from this period

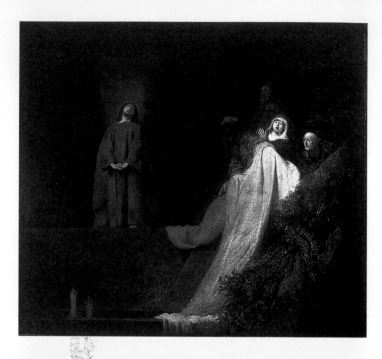

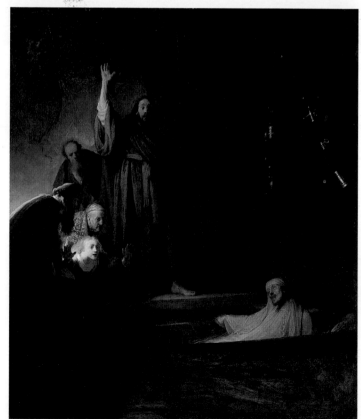

(see 34, 35). The give-and-take between Rembrandt and Lievens in these years has fuelled speculation that they had a joint studio. It was unusual, and forbidden according to other cities' guild regulations, for independent painters to keep a common workspace. Presumably, the guilds wanted to prevent artists gaining unfair economic advantage from sharing overhead costs, but in Leiden the absence of a guild would have allowed the young painters to do just this. The joint efforts of Rembrandt and Lievens spurred remarkable creativity, in the best tradition of artistic rivalry. They may have seen themselves in terms of the famous competitions between ancient Greek artists, which Van Mander and others loved to recount. Zeuxis and Parrhasios outdid each other in making paintings that deceived the eye; Protogenes and Apelles contested each other's talents for the finest line drawing.

25
Jan Lievens,
*The Raising
of Lazarus*,
1631.
Oil on canvas;
103 × 112 cm,
40½ × 44 in.
Brighton
Museum
and Art
Gallery

26
*The Raising
of Lazarus*,
c.1630–1.
Oil on panel;
93.5 × 81 cm,
36⅞ × 31⅞ in.
Los Angeles
County
Museum
of Art

A series of pictures by Rembrandt and Lievens of *The Raising of Lazarus* trumps these classical rivalries in creativity. The miracle of Christ's first triumph over death lent itself to high drama, and they made the most of it – Lievens in a painting and an etching; Rembrandt in a drawing, etching and painting. The deliberate differences between their two paintings are as striking as the similarities (25, 26). Both painters created a dark space, in keeping with John's description of the tomb as a cave, and both represented the dead man's resurrection in response to Christ's command (John 11:38–44). They enriched the biblical account by imagining the astonishment of Mary and Martha, Lazarus' sisters, and their mourning companions. Rembrandt stayed closer to John's text, showing Christ's mouth open and arm raised at the moment when he 'raised his voice in a great cry: "Lazarus, come forth."' Lievens conflated an earlier moment, when Jesus lifts his eyes heavenward to thank his Father, with the raising, indicated by the ghostly emergence of Lazarus' hands from the grave. Whereas Lievens opted for broad areas of light and dark, juxtaposing the white shroud and face of Mary against a darkness from which only Christ's face and hands stand out, Rembrandt created a subtler effect of light penetrating the cave from outside. The brightest illumination is reserved for Mary, who leans forward with both hands raised. Secondary light picks out Christ's face, glimmers on the reviving Lazarus, and reflects off the sword, bow, quiver and turban above. These details relieve the

monotony of the dark cave and, by their 'oriental' appearance, suggest the distant location of Christ's miracle.

The chronological order of these paintings and the works on paper associated with them is uncertain, and their complex interrelationship shows how closely the artists collaborated. Rembrandt drew a copy of an etching by Lievens, and seems to have used the sheet in preparing his painting. In his undated print, Lievens reproduced his own painting in reverse, which suggests that Rembrandt based his painting on that of Lievens. Yet Rembrandt's drawing is dated 1630 and Lievens' painting 1631. Rembrandt's painting is substantially different from his drawing after Lievens, and has no date; nor does his etching, which is even further removed from Lievens' composition. One possibility is that Lievens worked on the painting and the etching during 1630 and completed them in 1631, when he dated the print. Rembrandt could have copied the etching in progress the previous year, and perhaps added the date to record the year of the composition's invention. It has occasionally been suggested that Rembrandt gave his drawing an earlier date to claim the composition as his, but if that was his intention it would have been more effective to back-date his painting or print rather than his working sketch.

This sheet reveals Rembrandt's tireless rethinking of his work (27). In the painting he retained only the vertical format and general composition. He deepened the space by angling Christ and the tomb away from Lievens' frontal conception, creating the energetic sense of drama that would soon characterize his history painting. The sheet also points to Rembrandt's lifelong use of drawings as preliminary explorations, rather than complete preparatory designs. Not long after he copied Lievens' etching, he reworked the drawing, covering several figures with white body-colour and adding a group of figures to the left who strain to lower a corpse into the tomb. He thus changed the theme into Christ's own entombment, watched by the original bystanders and by newly added figures. This creative reinterpretation of compositions on related themes is typical of Rembrandt's play with his own and others' inventions.

By the time Rembrandt and Lievens were making their Lazarus pictures, they had already gained the admiration of Constantijn Huygens, a

27
The Entombment of Christ, reworked over *The Raising of Lazarus*, 1630. Red chalk on paper, with corrections in white body-colour; 28·2 × 20·4 cm, 11⅛ × 8 in. British Museum, London

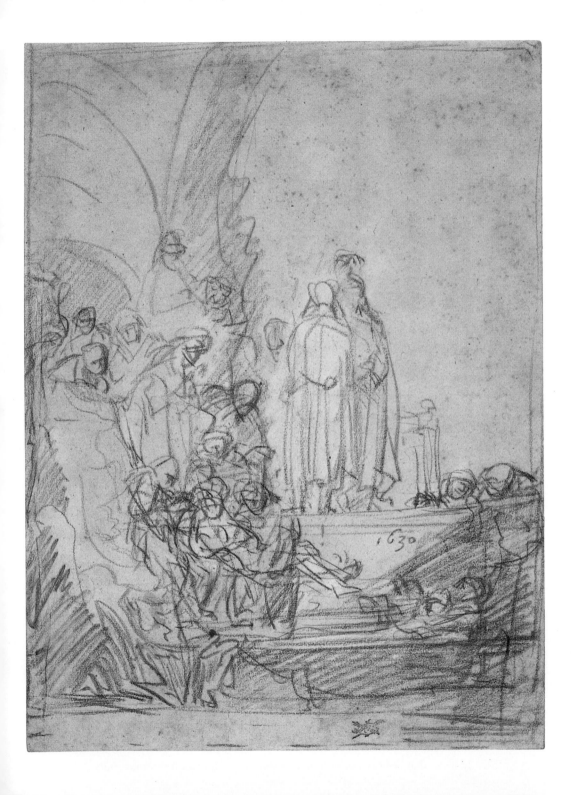

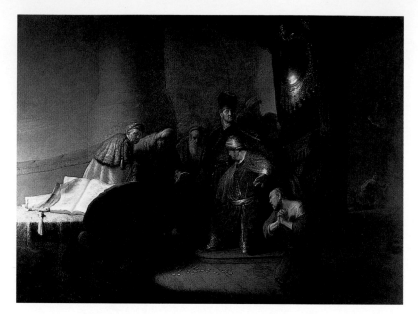

28
The Penitent Judas Returning the Thirty Pieces of Silver, 1629. Oil on panel; 79 × 102·3 cm, 31⅛ × 40¼ in. Private collection

connoisseur of painting and a powerful figure in the Republic. As secretary to *Stadhouder* Frederik Hendrik, Huygens lived in The Hague, near Leiden. In a memoir of *c*.1630 he recalled visiting 'a pair of young and noble painters of Leiden', whom he considered 'marvels of talent and skill' – the only Dutch painters equal to the classical and modern Italian painters. His discussion of their works perceptively identifies their relative strengths in the late 1620s. Rembrandt 'is superior to Lievens in his sure touch and liveliness of emotions', but,

Lievens is the greater in inventiveness and in audacious themes and forms … Rather than depicting his subject in its true size, he chooses a larger scale. Rembrandt, by contrast, devotes all his loving concentration to a small painting, achieving on that modest scale a result that one would seek in vain in the largest pieces of others.

To exemplify Rembrandt's strengths, Huygens singled out *The Penitent Judas Returning the Thirty Pieces of Silver* of 1629, which Rembrandt must have completed shortly before his visit (28):

Compare this with all Italy, indeed, with all the wondrous beauties that have survived from the most ancient times. The gesture of that one despairing Judas … that one maddened Judas, screaming, begging for forgiveness, but

devoid of all hope, all traces of hope erased from his face; his gaze wild, his
hair torn out by the roots, his garments rent, his arms contorted, his hands
clenched until they bleed; a blind impulse has brought him to his knees,
his whole body is writhing in pitiful hideousness. All this I compare with
all the beauty that has been produced throughout the ages … I maintain
that it did not occur to Protogenes, Apelles or Parrhasios … that a youth,
a Dutchman, a beardless miller, could put so much into one human figure.

**Huygens' misstatements about Rembrandt's painting (Judas is plainly
not screaming) can be explained only in part as lapses of memory. An
accomplished Latinist, Huygens was familiar with the classical tradition
of writing descriptions of paintings that would evoke the emotional
experience of seeing the work itself, and his energetic rhetoric may have
been such an attempt to bring *The Penitent Judas* before the mind's eye.**

**Although the Judas figure may seem a straightforward development
of the despairing Tobit (see 14), Rembrandt appears to have been
proud of it – in 1634 he engaged the printmaker Jan Gillisz van Vliet
(*c.*1600/10–68) to make an etching after the figure's top part (29). Judas'
emotional eloquence is also characteristic of the half dozen Pharisees,
whose responses of interest, surprise, disgust and rejection Rembrandt
differentiated carefully. Within its restrained palette, the picture's**

tonal variety is rich, ranging from bright white in the still life of books to dark purple, green and gold in the costumes and ritual objects.

Huygens concluded by chastising both painters for their self-confidence, which made them claim that they did not need to visit Italy. They explained that they could see plenty of Italian art in the Netherlands and wished to profit from their youth by painting, rather than waste time on travel. Both reasons make sense: Italian art was avidly collected on the Dutch art market, and Italy's great monuments were well known through prints. Both painters did enjoy ample opportunities for work, to which Huygens was to add several commissions.

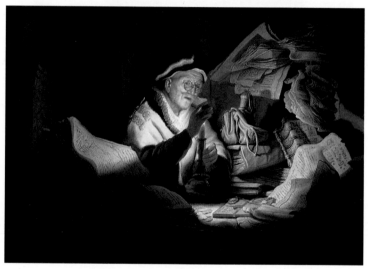

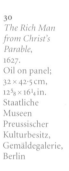

30
The Rich Man from Christ's Parable,
1627.
Oil on panel;
32 × 42·5 cm,
12⅝ × 16¼ in.
Staatliche Museen Preussischer Kulturbesitz, Gemäldegalerie, Berlin

The unified colour scheme and subtle light/dark contrast or *chiaroscuro* of Rembrandt's *Judas* and *Raising of Lazarus* departed from his bright, wide-ranging palette of 1625–6. He had arrived at this subdued style during 1627, partly through awareness of novel experiments in colour by Lievens and other Dutch artists. It is especially effective in Rembrandt's small pictures of one or two figures, in the narrative manner of his *Tobit and Anna* of 1626 (see 14). Comparison of that painting with *The Rich Man from Christ's Parable* of 1627 (30) demonstrates the suddenness of the change.

Once again Rembrandt staged a biblical theme in an intimate setting, using a cramped office for Christ's parable of the rich man who 'stores up treasure for himself, and is not rich toward God' (Luke 12:13–21).

An old man sits at a desk cluttered with books, ledgers and a fat purse. The biblical nature of the scene is indicated only by scrambled Hebrew lettering on the documents and by the man's clothes. Although these garments are not antique, their mismatched combination of beret, mill-stone collar and tabard would have struck contemporaries as archaic. Through his spectacles the man examines a coin held in his right hand, which shields from view the candle that illuminates the room. The nocturnal moment emphasizes the man's obsessive concern for his wealth, and hints at God's challenge: 'You fool, this night your soul shall be required of you: then whose shall those things be, which you have

31
Hendrick ter Brugghen,
Old Man Writing by Candlelight,
c.1625.
Oil on canvas;
65·8 × 52·7 cm,
25⅞ × 20¾ in.
Smith College Museum of Art, Northampton, Massachusetts

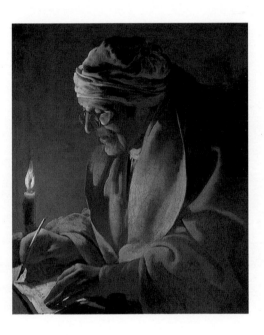

provided?' Rembrandt explored the effects produced by the single light source. The man's right arm produces strong foreground shadows, while his glasses throw delicate lines onto his face; the quirky shadows of the purse strings call attention to the soft leather binding of the book on which it rests. Pinpoint reflections highlight the tasselled clasps of the man's tabard, the wire rims of his glasses, the tip of his nose.

Rembrandt derived both the theme of this picture – a meditation on avarice – and the candle from followers of Caravaggio in Utrecht, including Hendrick ter Brugghen (1588–1629; 31). The old man, the carefully observed refraction of light through the glasses, the strong

chiaroscuro and rather monochrome colouring have their origin
in these sources. Yet Rembrandt's end result is markedly different
in scale and effect from their large canvases, as it draws equally on
contemporary innovations in Dutch still life. The picture's small size,
cool colouring and striking pile of books, documents and coins align
it with the still-life arrangements of the Leiden artist Jan Davidsz
de Heem (1606–83/84; 32). After De Heem had introduced the genre
around 1626, Lievens painted several such pictures. Rembrandt, too,
lingered over curling paper, resistant leather and lumpy wax; in the
most prominent book, he heightened the illusion of separate pages

32
Jan Davidsz
de Heem,
*Still Life with
Books, Violin
and Inkwell,*
1628.
Oil on panel;
36·1 × 48·5 cm,
14¼ × 19⅛ in.
Mauritshuis,
The Hague

33
*Two Old Men
Disputing (The
Apostles Peter
and Paul?),*
1628.
Oil on panel;
72·3 × 59·5 cm,
28½ × 23½ in.
National
Gallery of
Victoria,
Melbourne

by scratching thin lines through the paint, exposing the ground.
His choice of the still-life formula was appropriate because it often
reflected on the futility of earthly goods. The rich old man ignores the
vanity of the worldly still life of which he is the centre. No mere instru-
ment of avarice, the scales also symbolize God's ultimate reckoning.

The Rich Man is especially appealing for Rembrandt's new ability
to settle a figure into its surroundings by using rhythmic yet varied
outlines, none of which overlaps more than is necessary to create a
cosy clutter. Similarly effective contours, enhanced by strong contrasts
in lighting, structure his picture of *Two Old Men Disputing* (33).

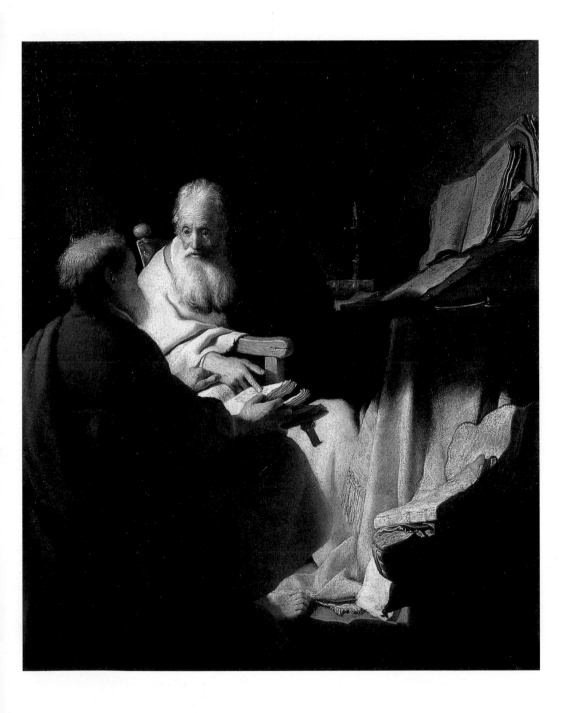

Although this is a daylight scene, it has the same restrained colour range. The robes and beards of the two men indicate that they are not modern scholars but probably religious figures, identified by Christian Tümpel as the apostles Peter and Paul. The man with the balding head and rounded beard fits the traditional type of St Peter, and the travel pouch beneath the books on the floor seems to confirm the suggestion that the scene represents Paul's visit to Peter, recorded in Galatians 1:18.

More significant than the precise narrative is Rembrandt's transformation of it into a compelling debate between two scholars. Paul, the most influential Christian exegete, leans forward, his mouth open in speech, his index finger resting on the page. Listening quietly, Peter prepares to respond by marking two places in the book. The juxtaposition of the hands and the book near the bright centre of the painting underscores the importance of God's Word. In their seriousness, Rembrandt's saints are ideal practitioners of the biblical study promoted by Calvinism; they also represent model scholars in a town that prided itself on its Protestant university and honored Peter as its patron saint. Jacques de Gheyn III (1596–1641), an artist and religious official who bought the picture, may well have seen them as such scholars. His inventory describes the picture as one in which 'two old men sit and dispute, one with a book on his lap, while sunlight is coming in'.

Almost half of Rembrandt's works of the 1620s present images of old age: an old miser, the ageing Tobit and Anna, prophets and apostles getting on in years. This disproportionate interest in older people, which Lievens shared, was new in Dutch art. Rembrandt's anonymous old men and women are often supposed to represent his father (34) and mother (35), even though there is no known portrait of his mother and none of the men resembles Rembrandt's drawing of his father (see 15). Rembrandt may well have asked his mother, a free model, to sit for him – in 1679, ten years after his death, an inventory already identified a print as 'Rembrandt's mother' – but if he did, this fact was not recorded by the first owners of these pictures. In the early 1630s, an envoy of Charles I acquired for his art-collector king a painting of Rembrandt's old woman (35), presumably for its pictorial interest rather than the identity of its subject. An inventory of the Royal

Collection taken in 1639 accurately describes the picture as 'an old woeman with a greate Scarfe uppon her heade with a peaked falling band'. Two years later a copy of the painting in the collection of Jacques de Gheyn III was described as 'a painting of an old little *tronie*'. The word *tronie* was a generic term for 'face', but in seventeenth-century artistic terminology it referred to bust-length paintings of single figures, displaying interesting facial features, inspired emotional expressions and fanciful costumes. The *tronie* thus became an ideal vehicle for the study of human expression, the play of light and the display of inventiveness. Rembrandt's self-portrait busts from around 1630 are *tronies*, too, showing the painter in varied emotional states (see 2, 7, 11 and 12). In his *Self-Portrait with Steel Gorget* (see 1), he wears the metal collar and lovelock that were the prerogatives of military officers and courtiers – attributes he could not have sported in life, but that were appropriate to the genre of the *tronie*.

Tronies were painted from live models and copied from paintings; their sitters were usually anonymous, although prints after them, often made years later, frequently identified them as historical figures. Thus Van Vliet's etching after Rembrandt's *Judas* (see 29), which turned Judas into a nameless *tronie*, was copied in an etching by the Bohemian printmaker Wenceslaus Hollar (1607–77), who identified him as the Greek philosopher Heraclitus. The large number of surviving *tronies* by Rembrandt and Lievens, and the many print series dedicated entirely to *tronies*, indicate how firmly they established the imaginative genre.

The physical effects of old age offered rewarding opportunities for *tronies*, and Rembrandt relished this challenge in history paintings and *tronies* alike. In *Tobit and Anna with the Kid Goat* (see 14), he carefully differentiated the skins of his protagonists. Tobit's brow is furrowed in grief and the blue veins in his hands are set off against thin rolls of pale pink skin; Anna's facial skin is taut, though grooves radiate from her eyes and her brownish hands are roughened by work. Rembrandt's old *tronies* have loosely painted, mottled skin that suggests burst veins, uneven pigmentation or rough stubble.

Seventeenth-century writings on art suggest that such virtuoso renderings of old faces and hands were admired because the subject was

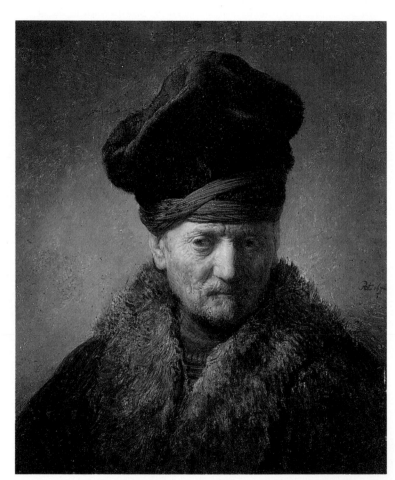

34
*Old Man in
a Fur Cap*,
1630.
Oil on panel;
22·2 × 17·7 cm,
8¾ × 7 in.
Tiroler
Landesmuseum
Ferdinandeum,
Innsbruck

35
Old Woman,
c.1629.
Oil on panel;
60 × 45·5 cm,
23⅝ × 17⅞ in.
Royal
Collection,
Windsor Castle

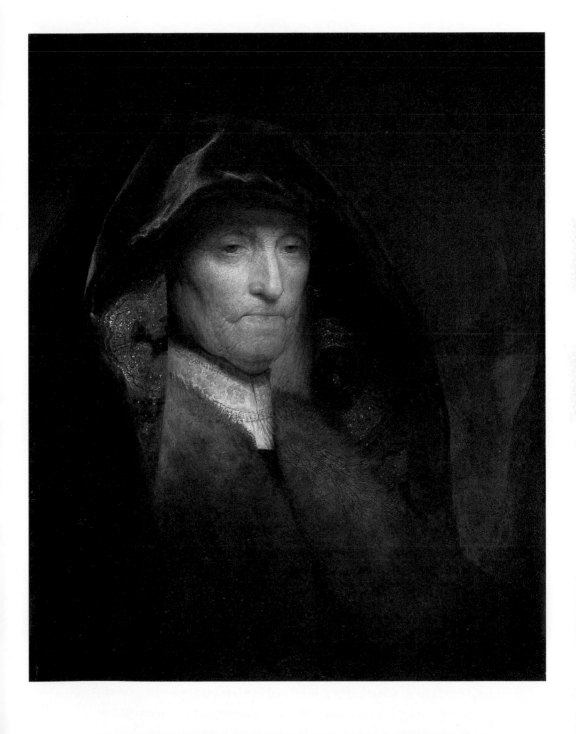

36
The Pegleg,
c.1630.
Etching;
11·4 × 6·6 cm,
4½ × 2⅝ in

schilderachtig ('worthy of painting' or 'picturesque'). In the 1620s many Dutch painters sought such humble themes: country hovels, beggars and peasants, simple meals of herring and bread. They may have been stimulated by the accomplishments of the ancient Greek painter Peiraikos, who had gained the highest praise and largest rewards for his pictures of lowly themes. Yet despite this classical precedent, these subjects required no knowledge of literature to be appreciated and were well suited to the rapidly expanding Dutch art market. Eschewing obvious religious imagery, they were also acceptable themes in the Protestant culture of the Northern Netherlands. Only after the middle of the seventeenth century, when Dutch painters and collectors argued increasingly that art should aspire to the classical standards of Italy and France, did the vogue for low themes decline. The artist Jan de Bisschop (1628–71) must have been thinking of Rembrandt and Lievens when he lamented the penchant of Dutch painters for 'misshapen, old, wrinkled persons'.

Around 1630 Rembrandt also etched beggars, another theme that reaped De Bisschop's scorn. His *Pegleg* (36) is a dissembling beggar who has bound his functional left leg onto a wooden stump. Rembrandt's rapid manipulation of the etching needle makes the print resemble a sketch and suggests the scruffiness of the character. Nevertheless, Rembrandt's prints of beggars do not echo the general middle-class condemnation of such mendicants. They never have the negative inscriptions found on earlier images, and his animated self-portrait as a scowling beggar argues against

a censorious interpretation (see 5). Like his contemporaneous self-portrait *tronies*, these prints were exercises in rendering extreme human expressions and studies in the *schilderachtig* mode. Rembrandt's self-portrait as beggar advertised his accomplishment in both challenges, but his beggars and elderly biblical figures also offered a humanized, down-to-earth vision that made them exemplars of Reformed faith, for Protestant theologians emphasized the miracle of God's grace for all human beings. In this light, Rembrandt's destitute beggars, and especially his mendicant self-portrait, embody the moral imperfection in all human beings.

Even when Rembrandt's interest in the old and the flawed is seen in its artistic, social and religious context, his penchant for 'real' people appears more markedly personal than that of his contemporaries. His desire to humanize historical characters is equally evident in his earliest mythological paintings, most of which have little to do with Protestant concerns. His *Andromeda* (37) presents a young woman in a believable state of panic. The mythical Andromeda was sacrificed to a sea monster because of her mother's boastfulness, but was rescued by Perseus on the winged horse Pegasus. In her awkwardness, Rembrandt's figure deviated from artistic tradition, which took the story as an opportunity to paint a voluptuous nude woman, chained to a rock. Rembrandt's Andromeda has a well-rounded belly, flabby upper arms and prematurely stretched skin. She glances up anxiously towards the right, perhaps glimpsing her saviour Perseus in flight. Earlier Netherlandish paintings of the theme include both the monster and the hero who later became Andromeda's husband. By isolating Andromeda and sketching a cursory setting, Rembrandt focused attention on her body and feelings of anxious anticipation. This unconventional rendering may acknowledge contemporary interpretations of Andromeda as an innocent maiden who trusted in her salvation – a pagan counterpart to the Christian believer. But Rembrandt's decision to deny Andromeda her canonical beauty more clearly signals a search for artistic novelty, in keeping with the innovations of his earliest religious paintings.

More unconventional still, Rembrandt's *Seated Nude* (38) is a shocking twist on the grand nudes of the classical legacy that had been revived

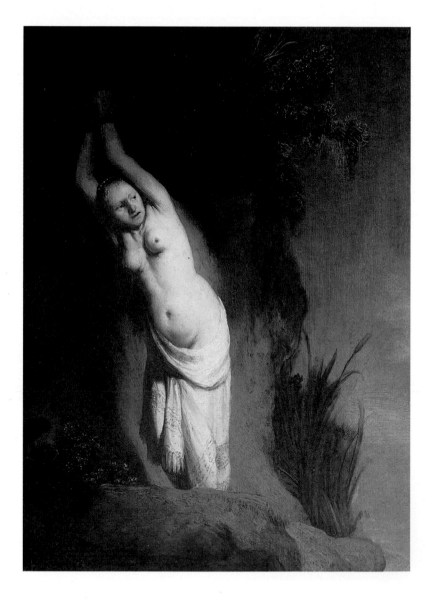

37
Andromeda,
*c.*1630–1.
Oil on panel;
34·1 × 24·5 cm,
13$\frac{1}{2}$ × 9$\frac{5}{8}$ in.
Mauritshuis,
The Hague

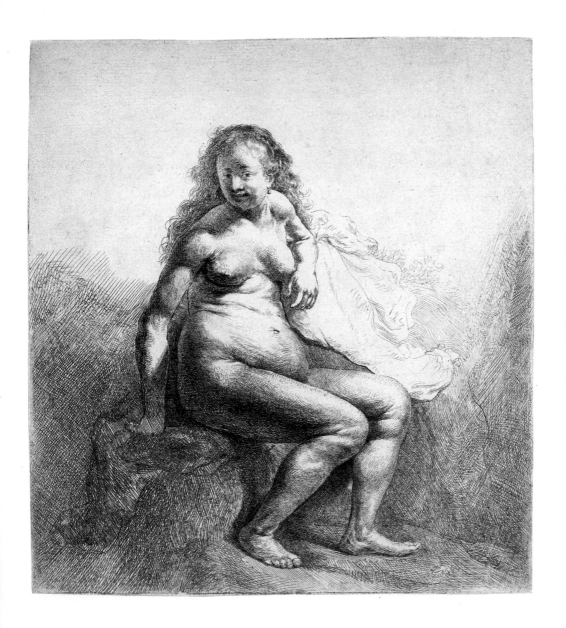

38
Seated Nude,
*c.*1631.
Etching;
17·7 × 16 cm,
7 × 6³⁄₈ in

in the Italian Renaissance and more recently by Rubens, the most famous Netherlandish painter of the time. In its technical range, from bare outlines to deep shadows, this etching demonstrates Rembrandt's facility with the print medium, but it is his uncompromising rendering of rolls of fat, double chin, sagging breasts, awkward extremities and crude stocking marks that rivets our attention. The woman's direct stare heightens the effect: she is unashamed of her ungainly nudity. She lacks attributes that might identify her as a historical figure, and she is no model in a studio, for the mound on which she sits and the shrubbery to her right suggest an outdoor setting. She appears to be another of Rembrandt's celebrations of the excessively earthy. De Bisschop derided such nudes for their 'fat and swollen belly, hanging breasts, pinch marks of garters in the legs, and lots more of such monstrosity'. While Rubens also favoured a voluptuous female body, he did so to suggest fertility or seductiveness, and usually ignored its everyday imperfections. Rembrandt, possibly in conscious contrast, exaggerated the marks of living so much that the woman's extravagant body became the print's theme. Before the mid-seventeenth century, Rembrandt's grotesque inventions were much admired. The reproducible medium suggests that he expected his work to find ready buyers, and Wenceslaus Hollar honoured it with an etched copy of 1635.

39
The Painter in his Studio, c.1629. Oil on panel; 25 × 32 cm, $9\frac{7}{8}$ × $12\frac{5}{8}$ in. Museum of Fine Arts, Boston

Within five years of completing his apprenticeships, Rembrandt had become a productive artist of considerable ambition. He had made contacts with prominent artists and connoisseurs that would prove beneficial to his future career. His early work was versatile in subject and technique, encompassing a novel brand of religious painting, a speciality in *tronies* and other picturesque figures, eloquent emotional expression and stylistic innovations in painting and etching. Although his techniques were in many ways traditional, his new themes and painstaking efforts at representing light and texture demonstrate his commitment to building a reputation.

Rembrandt registered his reflectiveness about art in his early self-portraits and in a mesmerizing picture, *The Painter in his Studio*, from about 1629 (39). As a painting of an artist at work it was unprecedented. Studio pictures typically had the painter sitting or standing

immediately behind his easel, but here the looming easel enlarges the distance between the diminutive artist and his work. The *konstkamer* ('art room'), as the studio was called, is picturesquely shabby, bare but for the essentials: a table with some bottles for oil and varnish, a grinding stone for pigments, two clean palettes suspended from a nail in the wall. Light suffusing the room from the left catches the edge of the panel. The painter, dressed in a fanciful version of studio clothes, stands back with a brush in his right hand and a palette, more brushes

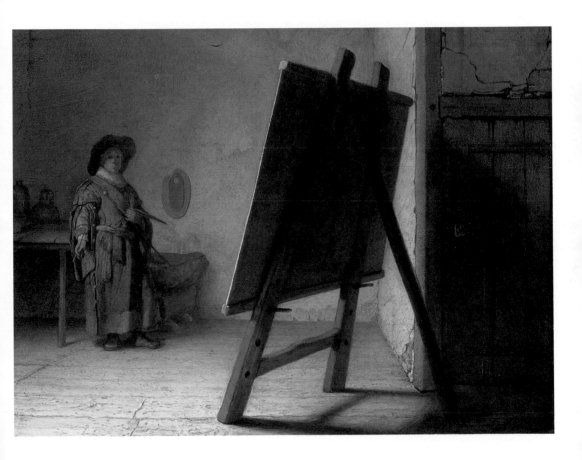

and a maulstick in the other. His features are not sufficiently distinct to allow his identification, surely because Rembrandt intended him as an image of the painter in general. It has been argued that Rembrandt depicted here a particular mode of making paintings: the artist first stands back to form a mental image of his composition and colour scheme, then works '*uyt den gheest*' ('from the mind'), as the most inventive artists ought to, according to such painter–theorists as Van

Mander. This conception of art underscores the imaginative effort Rembrandt expended, even when painting the unassuming outer appearance of people and things. To be persuasive, his deceptively simple imitation of nature required planning and experimentation.

As the testimonies of Huygens and Orlers make clear, and as numerous imitations of his early works attest, the young Rembrandt was a revelation to the Dutch art world. His rapidly growing reputation soon brought pupils, of whom Gerard Dou (1613–75) became one of the most distinguished. His earliest works are clever compilations of Rembrandt's motifs

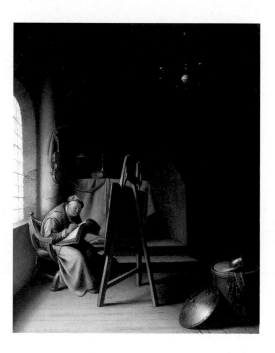

40
Gerard Dou,
*Old Painter
Writing behind
his Easel*,
c.1631–2.
Oil on panel;
31·5 × 25 cm,
12³⁄₈ × 9⁷⁄₈ in.
Private
collection

and tricks, with a penchant for elderly men and women and the ways in which light reveals texture. In the *Old Painter Writing behind his Easel* of the early 1630s (40), Dou positioned an artist behind an easel like Rembrandt's, but he is writing rather than painting. His studio is cluttered with meticulously described objects, including a gleaming shield like that in Rembrandt's early history painting (see 22) and a side table borrowed from *Two Old Men Disputing* (see 33). Later Dou made uncanny textural veracity his lifelong speciality, and effectively established a school of Leiden painters with it. Well before then, Rembrandt had left his native city for the wider prospects and deeper pockets of Amsterdam.

Although Rembrandt had attracted patronage, critical approval and pupils in Leiden, and in the process stimulated the city's cultural flowering, he was undoubtedly aware of the richer possibilities elsewhere in the Republic. Huygens was not the only connoisseur from out of town to take note of the young Rembrandt: in 1628 Arnout Buchelius, a lawyer from Utrecht, claimed that 'the son of a Leiden miller is highly, if prematurely, esteemed'. A year later, 'a small *tronie* by Rembrandt' was recorded in the inventory of the painter Barent Teunisz Drent (1577–1629), who lived in Amsterdam. By 1631, Rembrandt had apparently established enough contacts in Amsterdam to warrant a move to the leading city of the Republic. Orlers indeed noted that he was receiving commissions from its citizens while he was still living in Leiden.

41
The Anatomy Lesson of Doctor Nicolaes Tulp (detail of 52)

In the early seventeenth century, Amsterdam had become a flourishing artistic centre. After Spain recaptured the Southern Netherlands in the 1580s, as many as 100,000 Protestant refugees fled to the Republic, and by 1600 Amsterdam's population had grown to 90,000, while Catholic Antwerp, once northern Europe's leading commercial centre, saw its population of 84,000 halved. Throughout the Dutch revolt, the Republican fleet blockaded the Flemish coast and the River Scheldt, which gave access to the harbour of Antwerp. While Antwerp's maritime trade declined, Amsterdam became the hub of a Dutch commercial empire built on bulk shipping (particularly of wood and grain) and luxury goods. In the early seventeenth century, the States General approved the foundation of the United East Indies Company, which was given a monopoly on Dutch trade with Africa, the Indian subcontinent, the Indonesian archipelago and Japan. With its Amsterdam base, this huge trading company soon became the pre-eminent force in Asian trade. The city's vigorous economy encouraged the specialization of financial industries, concentrated in the Amsterdam Exchange (built in 1608). To accommodate its rapidly growing population, Amsterdam steadily expanded on an orderly plan of concentric canals (42).

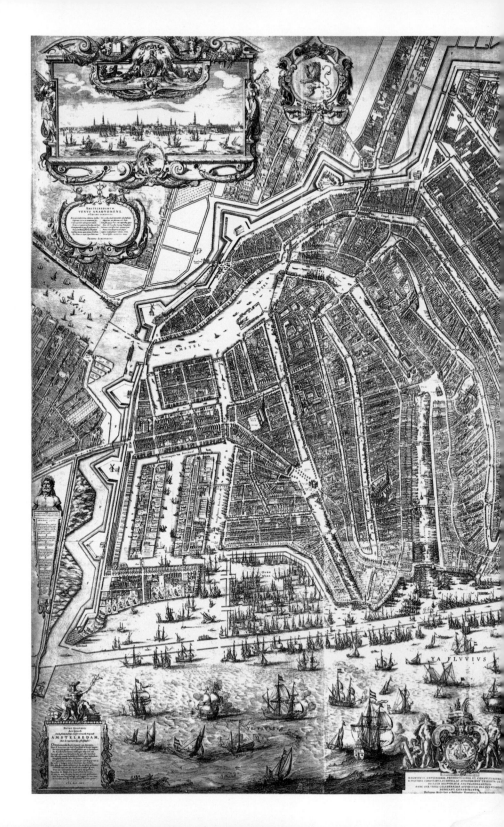

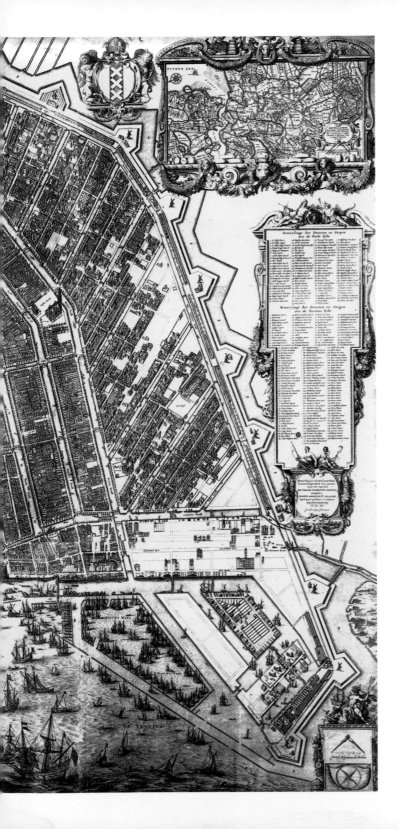

**42
Balthasar
Florisz,**
*Map of
Amsterdam,*
1625.
University
Library,
Amsterdam

Amsterdam's premier commercial position attracted merchants and skilled workers from all over Europe and the Mediterranean world, and even from Asia, Africa and the Americas. Although Catholics, Jews, Lutherans and Muslims found niches within the city's economic fabric – despite its Calvinist foundation – this apparent openness was driven primarily by commercial interest, and had inflexible limits: public office, guild membership and open worship were problematic or forbidden for non-Protestants. Pragmatic tolerance also had cultural benefits, for Amsterdam became home to intellectuals and artists of varied traditions, especially from the Protestant and Jewish communities. On account of his unorthodox Jewish views, the philosopher Spinoza was expelled from Amsterdam's Portuguese synagogue, but the city offered a congenial environment for his ecumenical explorations of Jewish and Christian faith. Contemporaries recognized the direct relationship between commercial success and intellectual ambition: in 1632 Caspar Barlaeus, a scholar recruited from Leiden to teach at Amsterdam's new institution of higher learning, the Illustrious Athenaeum, celebrated its founding with an oration on the relationship between knowledge and trade. The printing industry, in which Rembrandt became actively involved, graphically demonstrated how learning generates business. The city had developed a modest print trade in the sixteenth century, but in the seventeenth it usurped Antwerp's leading position as a polyglot publishing centre for all manner of texts, from Latin classics to pulp fiction, Dutch Reformed doctrine to Hebrew heterodoxy. The industry fostered and benefited from high literacy in the cities of the Netherlands, which outdid reading levels throughout Europe.

Rembrandt probably moved to Amsterdam around the end of 1631. He bought a garden plot just outside Leiden in March of that year, and in November was still receiving tuition fees for Isack Jouderville (1612–45/48), his second pupil in Leiden. A life insurance document of July 1632 verifies that he was 'lodging' in Amsterdam in the house of Hendrick Uylenburgh, perhaps permanently. Uylenburgh was a prominent art dealer who offered studio and living space to young painters. The first known transaction between the two men indicates Rembrandt's standing: while still in Leiden in 1631, he lent the dealer

a thousand guilders, about five times the annual income of a day labourer. Their relationship was mutually beneficial, however, since Uylenburgh specialized in matching portrait sitters and painters, and probably brokered Rembrandt's first such commissions from Amsterdam's wealthy citizens.

By the end of 1631, Rembrandt had begun to paint a remarkable series of portraits of Amsterdam residents, including businessmen, regents and clerics. Although Rembrandt had received no formal portrait commissions before, at least three dozen portraits by him survive from the first half of the 1630s. His early self-portrait etchings, his *tronies* and his talent for capturing facial expressions may have helped Uylenburgh to promote him as a portraitist. For his part, Rembrandt must have realized that portraiture offered the best entrée into Amsterdam's competitive art market, where local portraitists such as Thomas de Keyser (1596/97–1667) and Nicolaes Eliasz, also known as Pickenoy (1590/91–1654/56; 43), enjoyed steady orders. Nevertheless, with such competition success was not guaranteed. Even Frans Hals, the great portraitist of nearby Haarlem, had almost no patrons in Amsterdam. Hals' rapid-fire brushwork enlivened the faces of his sitters in an unprecedented manner (44), but it may have appeared unfinished to an audience accustomed to the meticulous polish and stately poses of the conservative Amsterdam tradition (see 43). Rembrandt's first portraits strike a balance between liveliness and elegance, and this novel combination brought him instant business.

Around the time of his move, Rembrandt painted a life-size portrait of Nicolaes Ruts (45), a Calvinist merchant who traded with Russia. Since the painting hung in the house of his daughter Susanna well before his death in 1638, she may have commissioned the work or received it as a gift. Her desire to have such an impressive portrait of her father is a reminder that, like wallet photographs today, portraits were intended to make absent people present, in life and in death. Huygens states this purpose explicitly:

painters who occupy themselves with the human face perhaps do not earn so much admiration, because they concentrate all their powers on but one end of the human body. Yet they have a noble profession that is

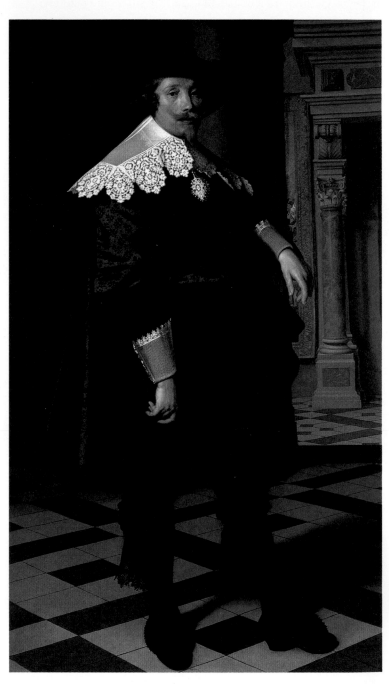

43
Nicolaes Eliasz (called Pickenoy), *Cornelis de Graeff,* c.1633.
Oil on canvas; 184 × 104 cm, 72½ × 41 in.
Staatliche Museen Preussischer Kulturbesitz, Gemäldegalerie, Berlin

44
Frans Hals, *Banquet of the Officers of the Guild of Harquebusiers,* 1627.
Oil on canvas; 183 × 266·5 cm, 72 × 104¾ in.
Frans Halsmuseum, Haarlem

essential to all humanity. Thanks to them we do not die, in a sense, and we descendants maintain contact with our ancestors. I am much attached to this pleasure.

Rembrandt's portrait of Ruts serves this commemorative function well, for he drew on the experience of his early history paintings and *tronies* to give Ruts palpable presence. The chair back on which he rests his right hand distances him slightly, but his direct gaze and the letter he proffers establish close contact. The light coming from the upper

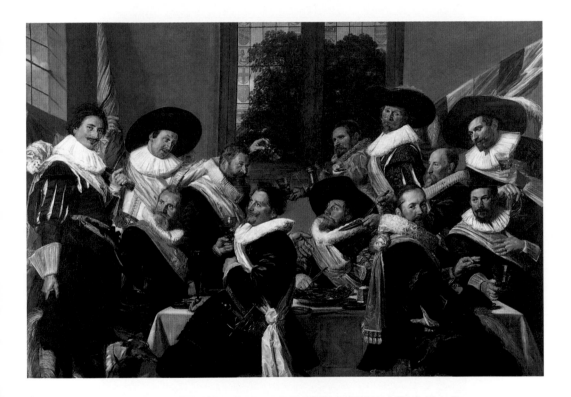

left focuses attention on Ruts' face and hands; fine brushwork describes the fur on his hat and coat, perhaps in reference to the Baltic fur trade in which he probably participated. His active stance gives him a substantial but agile appearance, vividly silhouetted against the indistinct background. This compositional device indicates Rembrandt's awareness of the powerful yet elegant portraiture of the Flemish painter Anthony van Dyck (1599–1641), who worked at the court in The Hague around the time Rembrandt was painting Ruts. Confident and precise brushwork in finely nuanced tones

quickens the merchant's earnest face; it is further energized by the flowing lace collar and calligraphic scratch-marks that suggest highlights on his moustache.

These artistic ploys – the striking illusion of contact between sitter and viewer, dynamic silhouette, convincing texture, spotlighting of face and hands – explain why, within a year of his move, Rembrandt had become one of Amsterdam's leading portraitists. His animated poses and handling of paint evoked personal presence beyond that of the more static portraits of his peers. His emphasis on the face and avoidance of heightened emotional expression suggested the presence of measured, sincere individuals, even if comparisons of his portraits make clear that Rembrandt's remarkably 'natural' style conferred a certain sameness on his sitters. Rembrandt's portrait style perfectly accords with Huygens' remark that, for a portrait to become 'a unique revelation of someone's soul', it should eschew such artificial effects as wildly expressive eyes, an abrupt turn of the neck, a falsely charming mouth.

45
Nicolaes Ruts,
1631.
Oil on panel;
116 × 87 cm,
45⅝ × 34¼ in.
Frick
Collection,
New York

Rembrandt's life-size companion paintings of Marten Soolmans (46) and Oopjen Coppit (47), painted in 1634, demonstrate well his ability to absorb and enliven conventional portrait formulas. Standing, full-length portraiture had traditionally been the prerogative of kings, queens and courtiers, and when Rembrandt painted this couple it was still rare for middle-class citizens. The couple's wealth and prominence – Oopjen came from a distinguished Amsterdam family – and the occasion of their marriage in 1633 must have justified the spectacular formula and elaborate attire. Rembrandt's brilliant brushwork captured the varied textures of the clothing, especially the intricate lace collars. He first painted a scalloped white area, then superimposed black lines to convince us that we are looking through gaps in the lace to the dark doublet underneath. The rosettes on Marten's shoes, painted in grey and white dashes, shimmer like silvery silk. His conspicuously held glove may denote his recent marriage, for at weddings the bride's father customarily handed the groom a glove, to symbolize the transfer of responsibility for his daughter. Similarly, the ring suspended from Oopjen's pearl choker may be a wedding ring. Although husband and wife each address the viewer in conventional

46
*Marten
Soolmans*,
1634.
Oil on canvas;
207 × 132·5 cm,
81$\frac{1}{2}$ × 52$\frac{1}{8}$ in.
Private
collection

47
Oopjen Coppit,
1634.
Oil on canvas;
207 × 132 cm,
81$\frac{1}{2}$ × 52 in.
Private
collection

fashion, Rembrandt linked them through the man's gesture towards the woman, who seems to move gently in his direction. The dark curtain behind Oopjen extends into Marten's space, but the differently angled floor tiles in each painting make clear that Rembrandt aimed only for an impression of spatial continuity. The disjunction probably had a practical reason, for companion paintings often hung on either side of fireplaces or doorways.

A traditional aspect of these spectacular pendants is the placement of husband and wife. The man in pair portraits usually appeared on the viewer's left and the woman on the right. This arrangement originated in the Christian pictorial tradition of the Last Judgment, in which the blessed and most favoured saints were placed on Christ's right hand (the viewer's left). Most of Rembrandt's portraits of married couples put men in this privileged position, in a formula that was perfectly suited to Reformed views of matrimony. The moralist Jacob Cats wrote best-selling conduct books describing marriage as a partnership of social equals, in which the man nevertheless assumed ultimate responsibility for, and authority over, his wife and children. Portraits of husband and wife such as Rembrandt's register the husband's leading role by placing him in the privileged right-hand position and by giving him the more active or thoughtful appearance.

In 1633 the prominent Calvinist preacher Johannes Wtenbogaert travelled to Amsterdam to be painted by Rembrandt (48). Wtenbogaert had been a tutor of the young Prince Frederik Hendrik, and he had become a household name in 1610 with his *Remonstrantie*, a tract that set forth the positions of the 'Remonstrant' faction of the Reformed Church. Unlike their opponents within the Reformed Church, the Remonstrants did not believe in the doctrine of predestination, which holds that God has predetermined the fate of every soul and that one's conduct on Earth is not subject to free will. Predestination became a divisive political issue in the 1610s, when the *stadhouder* Maurits (Frederik Hendrik's brother and predecessor) sided with its proponents, who also favoured continuing the war against Catholic Spain. The more tolerant Remonstrants advocated reconciliation within

the Reformed Church and a live-and-let-live peace with Spain. In 1618 Maurits' support for the hardliners led to the dismissal of all Remonstrant preachers and the execution of the conciliatory policy-maker Johan van Oldenbarnevelt, which Rembrandt may have allegorized in his early history painting (see 22). Wtenbogaert fled to Catholic Antwerp, where he secretly reorganized the Remonstrant faction. When Frederik Hendrik became *stadhouder* after Maurits' death in 1625, Wtenbogaert returned to The Hague, where he regained his position as scholar and statesman of the Reformed Church.

Wtenbogaert noted in his diary that he sat for Rembrandt at the request of Abraham Anthonisz Recht, an Amsterdam Remonstrant who presumably wanted a portrait of his spiritual leader. Rembrandt portrayed Wtenbogaert as a Protestant minister who takes the word of God as his ultimate authority. His left hand is placed on his heart in a rhetorical gesture of honest declaration; the open book behind him suggests the source of his statement. Two years after the portrait was finished, Wtenbogaert or one of his supporters asked Rembrandt to portray him in an etching (49), his first commissioned portrait print. Rembrandt created an intimate image of the preacher as biblical scholar, a modern emulator of the studious apostles of his early history paintings (see 33). Scribbled below is a Latin ode to Wtenbogaert by the legal scholar Hugo Grotius. Known today for his tracts on international law, Grotius was equally famous in his time for championing the Remonstrant cause. He was sentenced to life imprisonment in 1618 but managed to escape to France, where he remained for the rest of his life. His poem chides Wtenbogaert's opponents and celebrates the preacher's return to The Hague.

Rembrandt portrayed people of many different religions. In 1633 he painted a Catholic couple, whose religion had not prevented them attaining wealth and status (50). Jan Rijcksen was a shipbuilder for, and shareholder in, the United East Indies Company, and his wife, Griet Jans, was the daughter of another shipbuilder. Most seventeenth-century portraits of couples paired single paintings of husband and wife, but Rembrandt portrayed this mature couple on one canvas, engaged in an everyday exchange.

48
Johannes Wtenbogaert, 1633.
Oil on canvas; 130 × 103 cm, 51⅛ × 40½ in.
Rijksmuseum, Amsterdam

49
Johannes Wtenbogaert, 1635.
Etching and engraving, fourth state; 25 × 18·7 cm, 9⅞ × 7⅜ in

50
The Shipbuilder Jan Rijcksen and his Wife Griet Jans, 1633.
Oil on canvas; 111 × 166 cm, 43¾ × 65⅜ in.
Royal Collection

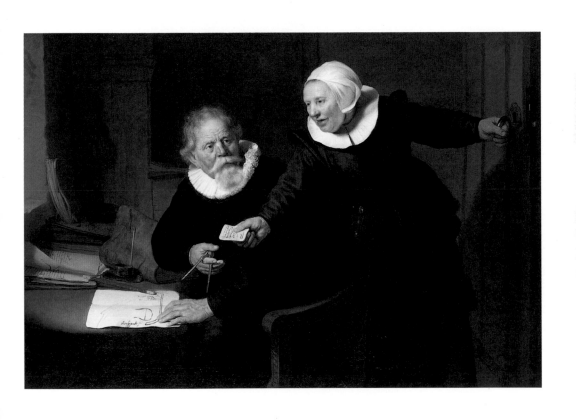

While the averted gazes of the sitters suggest momentary activity rather than a posed situation, the husband still appears to the viewer's left, as leading partner in the marriage. Rijcksen has been interrupted at his work by his wife, who hands him a letter. As he turns from his desk to receive it, he holds his compasses open above a design for a ship. The letter and the drawing are the brightest, most prominent objects in the room, and they identify the primary sitter, his business and his portraitist – the letter bears Rijcksen's name and is 'signed' by

Rembrandt. Griet Jans' reaching posture lends depth to the space; her open mouth suggests speech. The difference in complexion between husband and wife – his ruddy, hers lighter with touches of blush – was an artistic convention. Female paleness hinted at the common ideal that women ought to stay at home, even if they actually ventured out on all manner of errands; the male weathered look intimated a life of strenuous business, even if much of it was conducted indoors.

Rijcksen's decision to be portrayed with such clear allusions to his business was unusual and indicates the importance of shipbuilding in

the Republic. The rapid expansion of the Dutch fleet during the early seventeenth century had fuelled innovations in shipbuilding. The bulging Dutch *fluit* ('flute'), introduced around 1600 to carry bulk loads economically, was particularly renowned. Entrepreneurs, tradesmen and a new breed of 'ship lovers' provided an audience for guides to maritime trade and shipbuilding. In the same year that Rembrandt painted the double portrait, he etched an illustration for *Der Zee-Vaert Lof*, one such book 'In Praise of Seafaring'.

Like Catholics, Dutch Jews were denied opportunities for public office and excluded from the guilds, but they were prominent in other intellectual and economic realms. Rembrandt developed close contacts with several Amsterdam Jews. In 1636 he made an unassuming portrait etching of Samuel Menasseh ben Israel, one of the most respected Jews in the Republic (51). The loosely etched portrait gives Menasseh a modest, quietly confident air – an impression that is consonant with his life. His family had fled from Portugal to Amsterdam in 1605, where they formed part of a rapidly growing community of Sephardic refugees. A precocious scholar of comparative religion as well as classical languages, Menasseh was appointed rabbi in Amsterdam's second Sephardic synagogue when he was eighteen. With the backing of Jewish professionals and businessmen, he set up a successful Hebrew press in 1627. Menasseh's motto 'equipped as a pilgrim' is a perfect metaphor for his searching mind, which led him to correspond with Calvinist theologians about convergences between Judaism and Christianity. His *Conciliador* (1632) sought to resolve divergent passages in the Jewish Bible. It was admired by scholars such as Grotius but denounced by stricter Christian and Jewish thinkers alike. Rembrandt may have met Menasseh because the rabbi was a neighbour of Uylenburgh's; however the contact was made, the portrait commission from this prominent intellectual is a mark of Rembrandt's established reputation.

Rembrandt's overnight rise to the status of leading portraitist had been catalysed by his *Anatomy Lesson of Doctor Nicolaes Tulp* of 1632 (52). As chief lecturer of the Surgeons' Guild, Tulp occasionally gave public dissections of executed criminals in the guild's anatomical amphitheatre. Such demonstrations were rare events – executions were not

common – and painters were usually asked to commemorate them in group portraits destined for the guild's boardroom. Such depictions had traditionally emphasized straightforward portraits of the participants and merely indicated the lesson, sometimes using a skeleton instead of a corpse (53). In *The Anatomy Lesson of Doctor Nicolaes Tulp* the faces of the eight men involved in the demonstration are rendered in clearly illuminated detail. But Rembrandt's *Anatomy Lesson* is also a record of an absorbing event to which all the sitters respond.

Rembrandt relinquished the symmetry of earlier anatomy lesson portraits to separate Tulp from the other surgeons. While two look out, as though inviting the viewer to share in the lecture, most concentrate on the lesson, and one or two even check what they see against an opened textbook. Their intense concentration makes for a vivid record of the scene, yet it was clearly not painted on the spot. Seventeenth-century paintings were prepared and executed over several days or even months, and x-ray photographs reveal that Rembrandt repeatedly changed the composition as he worked. The man in profile at the far left was added at a very late stage, and the man at the top originally wore a hat like Tulp's. Rembrandt differentiated the colours, lighting and finesse of his brushwork to create convincing spatial recession from the foreground to the back wall, and to focus attention on the central action. Ordering all individuals around one significant event and subordinating secondary characters to the principal figure were among the traditional strategies of history painting that Rembrandt had learnt from Lastman. Here he applied these principles to a portrait intended to commemorate a historic event.

It would be wrong, however, to describe the *Anatomy Lesson* as a pretext for a history painting. Rembrandt's or the surgeons' decision to leave out the anatomical theatre and its audience was a concession to the function of the painting as a decorous portrait. Moreover, Rembrandt deviated from the customary order of dissection, in which the surgeon first opened the abdominal cavity and removed the intestines, then proceeded to the dissection of the limbs and brain. To begin with the forearm would have been poor surgical practice. Rembrandt may have painted such an unconventional dissection in

52
The Anatomy Lesson of · Doctor Nicolaes Tulp, 1632.
Oil on canvas; 169·5 × 216·5 cm, 66³⁄₄ × 85¹⁄₄ in.
Mauritshuis, The Hague

53
Thomas de Keyser, *The Anatomy Lesson of Doctor Sebastiaen Egbertsz de Vrij*, 1619.
Oil on canvas; 135 × 186 cm, 53¹⁄₈ × 73¹⁄₄ in.
Amsterdams Historisch Museum

80 Rembrandt

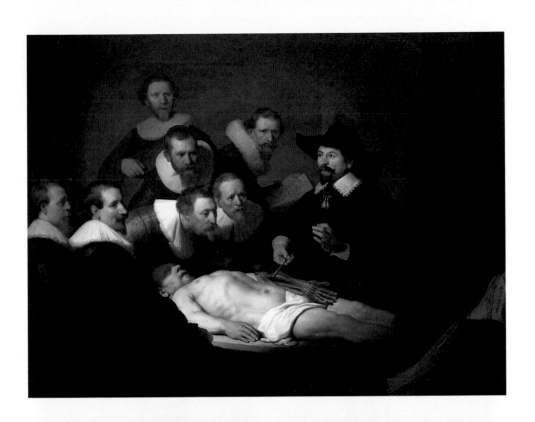

part at the surgeon's request, to convey a particular message. Tulp has opened the corpse's forearm and uses forceps to lift the muscles and tendons that bring together the thumb and index finger, while demonstrating this very movement with his own left hand (see 41). The action invokes the great Netherlandish Renaissance physician Andreas Vesalius, whose large compendium of anatomy was illustrated with a portrait of the author holding a dissected forearm and showing the tendons that move the digits (54). The book held by the surgeon to Tulp's right

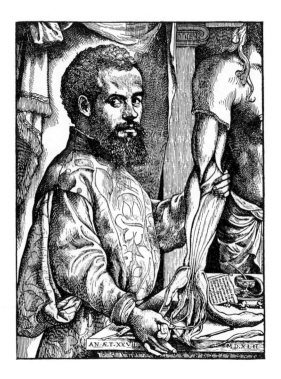

originally showed an arm; it was painted over around 1700 with the names of the sitters. The choice of lesson, surely Tulp's, was probably motivated by the belief that the human hand with its opposing thumb fundamentally distinguishes people from animals. According to one of Tulp's students, in his teaching the doctor demonstrated these very muscles as evidence of such divine human privilege.

Of the painted portraits surveyed in this chapter, all except that of Ruts (see 45) are on canvas rather than panel. While Rembrandt continued to use oak panels for smaller, delicate works, he increasingly favoured canvas painting in the course of his career. This choice was determined

partly by the large sizes of paintings required for the grand houses built on Amsterdam's spacious new canals. The preparation and advantages of canvas support for paintings have been analysed in technical studies of Rembrandt's canvases conducted by the Rembrandt Research Project and the National Gallery in London. Large wood panels were expensive and difficult to move. In his treatise on painting of 1678, Samuel van Hoogstraeten, Rembrandt's former pupil, noted that canvas was 'best suited to large paintings, and, when well primed, easiest to transport' because it could be rolled up. Linen canvas was sold in bolts of standard widths measured in the unit of the ell (about 69 cm or 27 in). To make up wider or taller canvases, strips of canvas were sewn together. The numerous seventeenth-century canvas paintings that have the width or height of an ell or its multiple were probably supplied directly by weavers or primers. Canvases of irregular size were specially sewn in the studio or by the supplier.

54
Anonymous,
*Andreas
Vesalius,*
woodcut
from Vesalius,
*De humani
corporis fabrica
libri septem,*
1543

The grounds of Rembrandt's canvases include customary pastes, possibly applied by commercial primers, and unusual combinations of substances that may have been of Rembrandt's own making. Many of his early canvases have double, oil-based grounds, in which a weave-filling layer of reddish earth pigment is topped by a second layer containing lead white and black pigments that establish a grey tone and smooth texture for the ground. From the 1640s onwards Rembrandt often used single-layer grounds containing coarsely ground quartz bound in oil, coloured with yellowish pigments. He may have favoured this substance for its coarser structure, which in his late paintings supports rougher paint effects; or he may have preferred its lesser cost, for ochre and quartz were cheaper than lead white and the application of a single layer required less labour.

In the studio the canvas was stretched for priming or painting. It was laced into a temporary wooden frame or 'strainer'; once the painting was finished, it was removed from the strainer and tacked over a permanent stretcher. Alternatively, it might be attached straight away to a stretcher, either by wrapping the edges of the canvas around it and nailing them to its sides or by tacking the canvas to the front of the stretcher. A self-portrait by Rembrandt's pupil Aert de Gelder

(1645–1727) shows both preliminary and final stretching methods (55): the artist is painting on a canvas laced into a strainer, while an unfinished canvas with edges tacked into the stretcher stands behind his easel. All stretching methods could cause scalloped distortions of the weave along the edges of the freshly primed canvas because of the greater tension at the tacking or straining points. Occasionally, these 'cusping' patterns can reveal that a painting was cut down in size after completion. The double portrait of Jan Rijcksen and Griet Jans (see 50), for example, has cusping along three sides but none along the top, proving that is was originally larger (an early print after the painting indeed gives the sitters more headroom).

Besides the impressive series of portraits Rembrandt made in his first years in Amsterdam, there is much evidence of his social and artistic success. In 1634 he became a member of the city's Guild of St Luke, after fulfilling the residency requirement for Amsterdam citizenship that was the prerequisite for guild membership. As an art dealer in the guild, Uylenburgh had served as Rembrandt's agent until that time, and their relationship must have gained strength from Rembrandt's engagement in 1633 to Saskia Uylenburgh, Hendrick's niece. Their marriage a year later was consecrated in the Reformed Church. Saskia was the daughter of the burgomaster of Leeuwarden, the most important city in the province of Friesland. Six years Rembrandt's junior, she must have been an attractive partner for a painter who was just entering Amsterdam society, but with his artistic and financial promise Rembrandt was also a bit of a catch. The couple initially lodged with Uylenburgh, until in 1635 they were able to rent a comfortable house on the River Amstel in the heart of Amsterdam. There they had distinguished neighbours, including their landlord Willem Boreel, a lawyer for the United East Indies Company.

Three days after the betrothal Rembrandt drew an intimate portrait of Saskia wearing a straw hat, recording the occasion in an inscription below (56). He made the drawing with silverpoint (a refined precursor of the lead pencil) on vellum prepared with a white ground. This technique had traditionally been used for the illumination of precious manuscripts, and Rembrandt may have used it because it turned the

55
Aert de Gelder, *The Artist as Zeuxis,* 1685. Oil on canvas; 142 × 169 cm, 55⅞ × 66½ in. Städelsches Kunstinstitut, Frankfurt

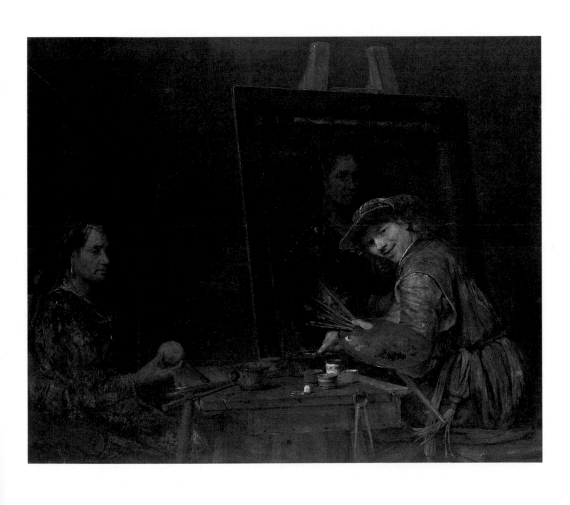

drawing into a luxury record of a treasured occasion, although it has also been shown that silverpoint and prepared parchment were used for humbler sketchbooks because they allowed lines to be erased with saliva or a moist sponge. Even if made as a sketch or in preparation for a painting, however, the drawing's precise inscription and the rounding of the parchment suggest that Rembrandt meant this memento to stand. The discrepancy between Saskia's finely detailed face and quickly drawn costume recalls Rembrandt's variation of finish in his painted portraits, in which the face always received meticulous attention, and it evokes the masterly portrait drawings of Hans Holbein the Younger. The drawing remains a remarkably tender personal record, close in spirit to Rubens' joyous portraits of his young wife Helena Fourment. The flowers on Saskia's hat and in her hand playfully underscore her youthful beauty.

56
Saskia Uylenburgh Three Days after her Betrothal to Rembrandt, 1633. Silverpoint on parchment; 18·5 × 10·7 cm, 7¼ × 4¼ in. Staatliche Museen Preussischer Kulturbesitz, Gemäldegalerie, Berlin

Rembrandt showered Saskia with flowers in two paintings that appear to portray her as Flora, the Roman goddess of spring and fertility. In the version of 1635, Saskia is dressed in billowing linens, silks and brocades (57). Her three-quarter-length pose is standard for portraits, as is the dark background, with suggestions of a garden. The staff coiled with flowers is reminiscent of a shepherd's crook, and Rembrandt may have meant to paint his wife as an idyllic Arcadian figure, in keeping with a Dutch vogue for pastoral literature and dress that was promoted by the *stadhouder*'s court. Flora's décolletage fits the erotic stereotype of the shepherdess. Around 1630, Dutch noblemen, ladies and regents had begun to have themselves portrayed in shepherd costumes, and Saskia's social standing would have justified the conceit. The lavish bouquet and floral accessories, however, indicate that her primary identification is with Flora. It is also apt given the couple's hope for children.

For whom did Rembrandt intend his paintings of Flora with features resembling Saskia's? Such a refined, life-size picture would have been an expensive keepsake, and the couple would not have needed two. Since no paintings of Saskia as Flora are listed in the inventory of Rembrandt's effects taken in 1656, he must have sold them or given them away. While her family in distant Leeuwarden may have wished to have her portrait,

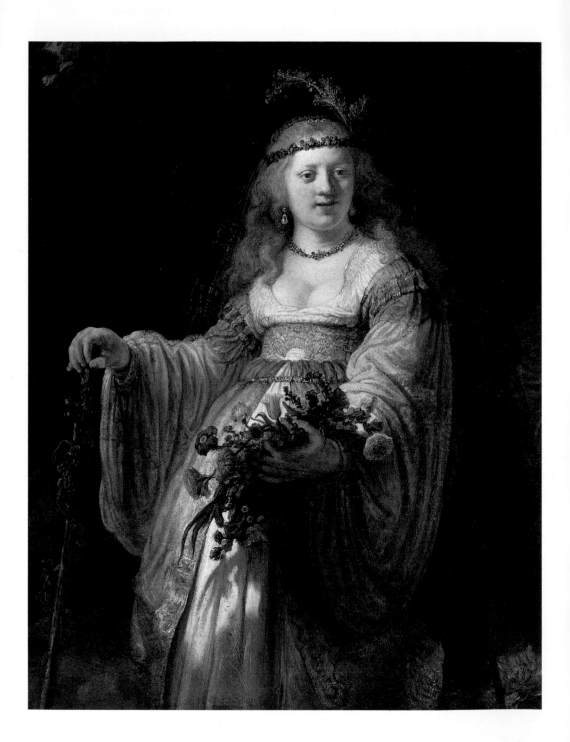

it is known that generic images of Flora (rather than of individuals dressed as Flora) had broad market appeal in the seventeenth century. They appear on paintings and plates, in homes and gardens, and Rembrandt was keenly aware of their currency. On the back of a drawing he made in the 1630s he recorded his sale of paintings by pupils, including three 'Floorae', presumably inspired by Rembrandt's own pictures of Flora. If Rembrandt sold his paintings of Saskia as Flora for their subject rather than as portraits, they would have been unusually earthy renditions of the classical figure. In the course of the 1630s, Rembrandt was to make a speciality of history paintings with a similarly human aspect.

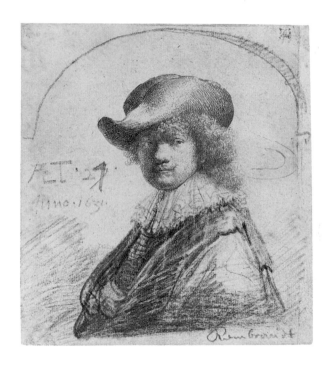

57
(Saskia Uylenburgh as?) Flora, 1635.
Oil on canvas; 123·5 × 97·5 cm, 48⅝ × 38⅜ in.
National Gallery, London

58
Self-Portrait in a Soft Hat, c.1631–4.
Etching, second state, completed in black chalk with touches of pen and brown ink; 13·3 × 12 cm, 5¼ × 4¾ in

Rembrandt also portrayed himself frequently at this time. Several of his self-portraits align him closely with the upright Amsterdam citizens who were his customers, and he worked hard at the refinement of this image. From 1631 to 1634 he intermittently redrew an etching in which he wears the simple but well-cut costume of a prosperous burgher (58). The elegantly angled hat and keen expression are indebted to a dashing self-portrait by Rubens (see 8), which he may have known from an engraving. After completing the etching of his head in 1631 (the year inscribed on it), he continued to experiment with

the angle of his body and the setting: in three surviving versions of the
etching, he sketched these aspects in black chalk. In the version illus-
trated, Rembrandt added an arch and placed his first name at lower
right. The first-name signature was new for him in 1633, when he
worked up this sheet. Before then he had signed his works with the
monogram *RHL*, for Rembrandt Harmensz Leydensis (of Leiden), or
RHL van Ryn. His decision to sign simply 'Rembrandt', the signature
he maintained henceforth, signals his interest in emulating his great
Italian predecessors. Before Rembrandt, only Leonardo, Michelangelo,
Raphael and Titian had become known by their first names.

Other self-portraits from this period confirm Rembrandt's awareness
of the courtly status of renowned Renaissance artists and Flemish
contemporaries such as Rubens and Van Dyck, who painted for the
courts of Italy, the Southern Netherlands, England and Spain. In an
elegant oval panel of 1633 (see 6) Rembrandt wears an old-fashioned
beret of a shape seen in sixteenth-century portraits of eminent noble-
men and artists. Rembrandt's gold chain was a prized mark of
distinction for Renaissance courtiers, including artists, bestowed on
them by princes as both a reward and a reminder of their obligations.
Although the princely chain could not be had in the Dutch Republic,
and Rembrandt's adoption of it was pictorial role play, it was no mere
affectation: in 1632 he had begun to paint for the *stadhouder* Frederik
Hendrik and his wife Amalia van Solms, undoubtedly at Huygens'
recommendation.

The first of these commissions involved the awkward task of painting
a portrait of Amalia to serve as pendant to an existing portrait of
her husband (59, 60), painted in 1631 by the court portraitist Gerard
van Honthorst (1590–1656). The need to match Van Honthorst's
painting explains the anomalous features of Amalia's portrait within
Rembrandt's production. The court painter had represented the
stadhouder in bust-length profile and placed him in an illusionistic
oval frame; he had also used canvas, which Rembrandt did not favour
at the time for works of this size. The profile format may have been
specified for its association with Roman imperial portraits on coins
and medals, and artists relished its particularly recognizable aspect.

As Willem Goeree put it in 1682, in a treatise on the correct representation of the human figure:

the greatest variability of the faces exists but in four remarkable parts or aspects that make up the face: namely in the forehead, the nose, the mouth with the chin: which parts, when seen from the side, deliver the most remarkable and characteristic traits.

The profile's revealing character had the disadvantage of showing up Amalia's less than classically proportioned features, which Rembrandt appears to have made little effort to idealize. Contrary to custom, the two paintings were not hung opposite each other in 1632, when the inventory of the *stadhouder*'s residence in The Hague listed Frederik Hendrik's portrait as being in Amalia's 'small garderobe' and her own in her 'Cabinet', a small room for the display of art. Perhaps the paintings were felt to be poorly matched, for Van Honthorst was later commissioned to paint another portrait of Amalia to serve as a pendant to her husband's. In telling contrast to Rembrandt's portrait, Van Honthorst turned Amalia's face a little towards the viewer and thereby reduced the imperfections of her profile. If the Republic's first couple felt uneasy about Rembrandt's portrait, however, it did not affect their interest in his work, for they commissioned several history paintings from him in the following years.

As Rembrandt's career flourished he attracted many assistants and pupils. Some came for regular apprenticeships, as Dou and Jouderville had in Leiden. The receipts for Jouderville's apprenticeship show that pupils paid Rembrandt a hundred guilders per year, a considerable fee that was confirmed by Joachim Sandrart (1606–75). This German painter knew Rembrandt when he worked in Amsterdam in the 1640s, and published a short biography of him in his *German Academy* (*Teutsche Academie*) of 1675. Other assistants were trained artists who entered Rembrandt's workshop as journeymen, possibly to learn further skills. A decade earlier, Rembrandt had gone to Lastman for the same reason. The first of these ambitious and accomplished painters were Govaert Flinck (1615–60), Jacob Backer (1608–51) and Ferdinand Bol (1616–80). They stayed for several years as assistants who may have been required by guild rules to work in the master's manner, and whose

59 Overleaf
Gerard van
Honthorst,
*Frederik
Hendrik*,
1631.
Oil on canvas;
73.4 × 60 cm
28⅞ × 23⅝ in.
Huis ten
Bosch,
The Hague

60
*Amalia van
Solms*,
1632.
Oil on canvas;
69.5 × 54.5 cm,
27⅜ × 21½ in.
Musée
Jacquemart-
André, Paris

work Rembrandt would have been allowed to sell. Bol produced one of the paintings of Flora that Rembrandt sold, for example, and he and other assistants apparently painted subsidiary parts of portraits, as has been argued convincingly for the hands in the portrait of Johannes Wtenbogaert (see 48).

In the 1640s Flinck and Bol became famous painters in their own right, pursuing other styles once they had left their teacher's workshop. Flinck's talent is evident in his *Shepherdess* (61) painted in 1636 towards the end of his stay with Rembrandt. Flinck derived the concept of his *Shepherdess* from Rembrandt's *(Saskia Uylenburgh as?) Flora* (see 57), and the painting demonstrates his absorption of the master's techniques. To Rembrandt's innovative portraits, Flinck's *Shepherdess* owes her lively silhouette, the shadow against an atmospheric background, the differentiated textures of her face and costume, her rich but restrained colouring, the eyes seen through translucent shadow and even the highlight on her nose.

61
Govaert
Flinck,
Shepherdess,
1636.
Oil on canvas;
74·5 × 63·5 cm,
29⅜ × 25 in.
Herzog Anton
Ulrich-
Museum,
Braunschweig

The Danish painter Bernhardt Keil (1624–87) recounted that, after studying with Rembrandt for two years around 1640, he went to work in Uylenburgh's 'famous academy'. Flinck, too, worked for Uylenburgh after he left Rembrandt's studio. The precise arrangement between Uylenburgh and Rembrandt is not documented, but Rembrandt's thousand guilder loan to the dealer suggests that they were partners in the business. Rembrandt probably asked Uylenburgh to sell work produced in his studio, while providing Uylenburgh with trained artists who could copy popular compositions or portray sitters in a Rembrandtesque manner. This scenario may violate modern taste for originality, but it is confirmed by the many works painted in Rembrandt's innovative style that cannot be attributed to him and must be products of Uylenburgh's 'academy'.

Keil's term should be taken rather loosely. In the seventeenth century 'academy' implied instruction, perhaps provided by Rembrandt to artists in Uylenburgh's employ, and it suggested ambitions for the intellectual status of art. It had earlier been applied to groups of prominent artists in Haarlem and Utrecht, who valued drawing from human models in preparation for history painting. Keil's use of the

word indicates that Uylenburgh or Rembrandt may have provided such opportunities for life drawing. Rembrandt's commitment to such studies is substantiated by many drawings and etchings of nudes, mostly made in the 1640s and 1650s, when life drawing had become established in Amsterdam (see Chapter 6).

By 1636, Rembrandt had captured a huge share of Amsterdam's market for portraiture, received commissions from the court in The Hague, set up an active workshop, married a burgomaster's daughter and moved to a prestigious address. Given this record, his large *Self-Portrait with Saskia in the Guise of the Prodigal Son*, completed around 1635, comes as a shock (62). Unlike Rembrandt's respectable sitters, the artist and his wife appear to flaunt a proto-Bohemian lifestyle, displaying their love affair and their conspicuous consumption. The picture's size (it is his largest self-portrait) is especially puzzling because documentary evidence suggests that Rembrandt made it for himself. As to the meaning of the couple's raffish, self-incriminating appearance, there are several lines of thought.

62
Self-Portrait with Saskia in the Guise of the Prodigal Son, 1635.
Oil on canvas; 161 × 131 cm, 63³⁄₈ × 51¹⁄₂ in. Staatliche Kunst-sammlungen, Gemäldegalerie Alte Meister, Dresden

A seventeenth-century viewer would have identified a woman on a drunken man's lap as a whore pleasing the Prodigal Son of Christ's parable (Luke 16:13). The blackboard on the wall, used to chalk up drinks, and the peacock pie alluding to costly pride were traditional elements in pictures of the Prodigal Son squandering his inheritance. X-ray photographs indicate that Rembrandt initially placed a brothel madam between Saskia and himself. His swaggering attitude and fanciful costume are indebted to sixteenth-century paintings of the Prodigal Son and to more recent Caravaggesque images of rakes and gamblers, and they underscore the scene's fictional character.

Yet why would Rembrandt cast himself and Saskia as the Prodigal Son and his whore? Romantically inclined viewers have seen Rembrandt as showing off his wealth and youthful bride in a defiant snub of middle-class morality. More subtly, the picture has been interpreted as Rembrandt's admission that he shares the original sin of all human beings, a sin that heightens the miracle of God's forgiveness. Rembrandt's pictorial performance may therefore mirror the meaning of Christ's parable, which shows how a dissolute son can be redeemed by penitence

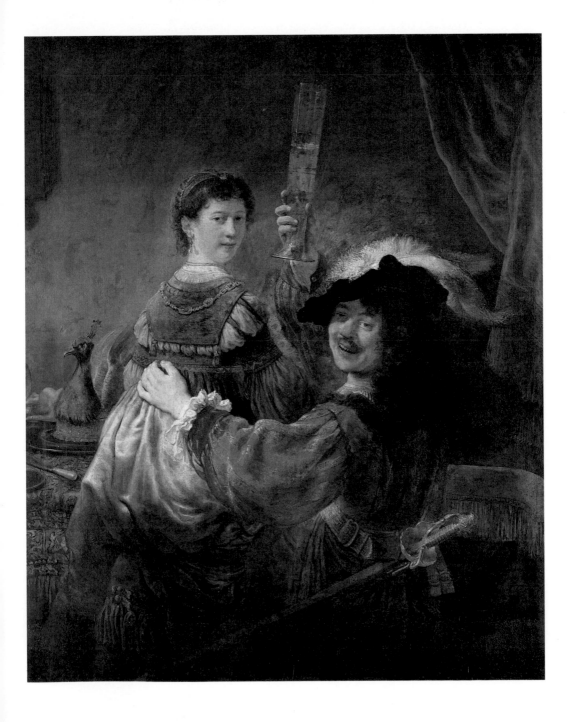

and forgiveness. Nevertheless, Rembrandt's frank smile proclaims that the painting is no pious statement of penitential sentiment.

More plausibly, it has been suggested that the picture expresses Rembrandt's ambivalence about his religion and its relationship to his meteoric rise in artistic and social status, which may sometimes have set him at odds with both his humbler origins and his grander new circles. In 1636 he successfully sued Saskia's relatives for denying her part of her father's estate. Two years later, he sued them for libel because they had claimed that Saskia 'had wasted her parental inheritance with ostentation and vain display', while Rembrandt protested that they still enjoyed 'a superabundance of goods'. In this light, his *Self-Portrait with Saskia* may represent a bit of fun at his in-laws' expense. Whatever its precise meaning, the painting is characteristic of Rembrandt's tendency to infuse historical or legendary figures with personal significance. Although to our modern sensibility such reflection seems a self-evident task of art, Rembrandt did much to make it that.

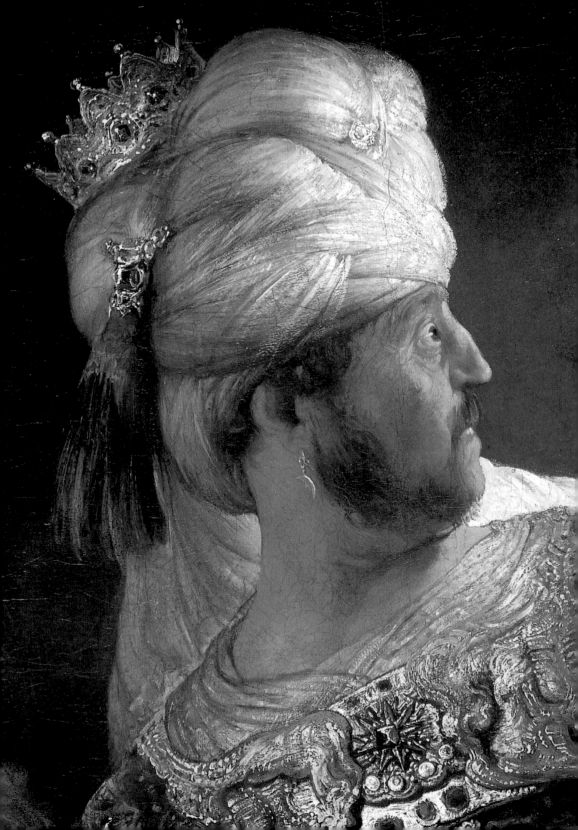

Although Rembrandt gained entry into Amsterdam through portrai-
ture, he did not relinquish his intention of becoming a history painter.
He initially continued to paint the small biblical panels that had
brought him renown in Leiden, but by 1635 he had developed new
specialities in mythological subjects and large, dramatic biblical
scenes. Rembrandt's new departures in history painting must have
contributed mightily to his financial and social success.

The first major biblical work Rembrandt painted in Amsterdam was
in fact destined for Frederik Hendrik in The Hague. In 1632 Huygens'
admiration for the *Penitent Judas* (see 28) led to a commission for
a series of paintings on the Passion of Christ. The five arch-shaped
pictures chronicle the period from the raising of the cross to Christ's
ascension to heaven. In 1631, Rembrandt and Lievens had each painted
impressive arch-shaped canvases depicting Christ on the Cross, based
on an engraving after an altarpiece by Rubens. Rembrandt's picture
may have given Huygens the idea for the series, or alternatively
Rembrandt and Lievens may have produced their pictures as com-
petitive trial pieces for the commission.

The likelihood that Rembrandt and Lievens made their paintings
of Christ on the Cross as trial works, in implicit rivalry with Rubens,
is borne out by the decision to begin the series out of narrative
sequence, with *The Descent from the Cross* and *The Raising of the Cross*
(64, 65). Like Christ on the Cross, both subjects were known in famous
versions by Rubens, who was admired by Frederik Hendrik and
Huygens. The *stadhouder* and his wife were especially taken with his
paintings of female beauty, which they could collect more easily than
his splendid but undeniably Catholic devotional pictures. Huygens
hailed Rubens as 'one of the seven wonders of the world, the Apelles
among painters', evoking the legendary court painter of Alexander the
Great. He praised Rubens' ability to tackle any kind of painting, and his

63
*Belshazzar's
Feast*
(detail of 77)

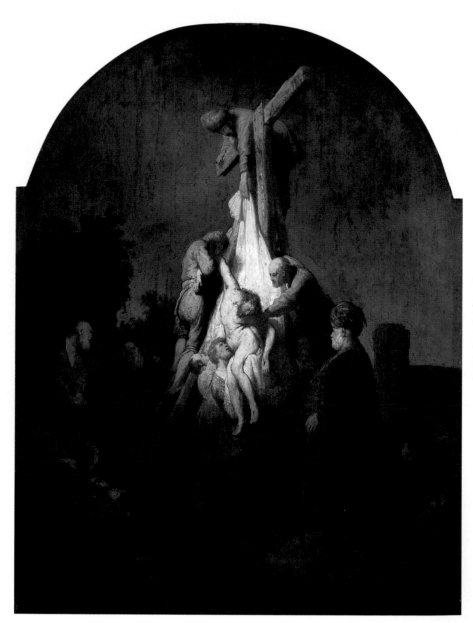

64
*The Descent
from the Cross,*
*c.*1632–3.
Oil on panel;
89·6 × 65 cm,
35¼ × 25⅝ in.
Alte
Pinakothek,
Munich

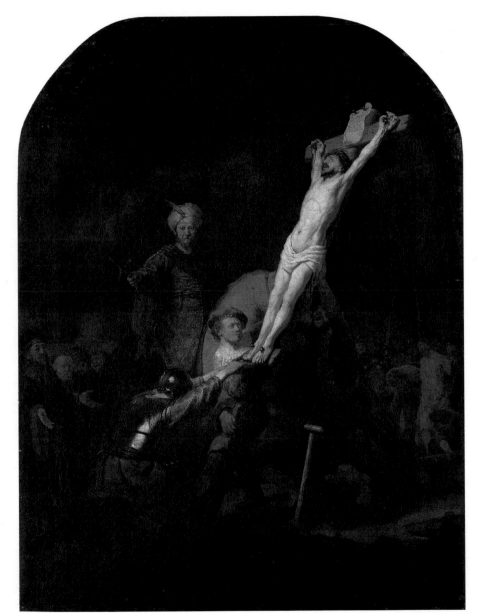

65
*The Raising
of the Cross,*
c.1633.
Oil on canvas;
95·7 × 72·2 cm,
37⅝ × 28½ in.
Alte
Pinakothek,
Munich

moving, naturalistic, oddly beautiful representations of horrifying themes – the very quality he had singled out in Rembrandt's *Penitent Judas*.

Rembrandt's *Descent from the Cross* acknowledged Rubens' composition, which had been engraved in reverse by Lucas Vorsterman (1595–1675; 66), but transformed its classical pathos into a new kind of approachable drama. Four men strain to lower Christ's body into the shroud held by a man hanging over the cross. Christ's sagging, wrinkled physique is an unceremonious interpretation of Rubens' heroic figure, whose curving pose derived from the *Laocoön*, the famous Hellenistic statue that was the embodiment of mortal suffering (67). While Rubens used Laocoön's pose to confer divine dignity on Christ, Rembrandt appropriated it for an all-too-human dead weight. Caught up in a sweeping movement of linked and contrasted bodies and limbs, Rubens' mourners share in Christ's heroism. The altarpiece asks the viewer to contemplate the body of Christ, presented on the shroud as the host is offered on the altar. Rembrandt's painting tells more of a story, dispersing its characters in a deeper space around the cross, and specifying the setting as outside Jerusalem. Rembrandt individualized the attendants' responses: at lower left, Mary swoons with three other women in diverse states of grief; an elderly man in the attitude of the penitent Judas (see 28) and another resembling an astonished figure from *The Raising of Lazarus* (see 26) express sorrow. Both groups of mourners are balanced by the figure of Joseph of Arimathea, provider of Christ's tomb.

66
Lucas
Vorsterman
after Peter
Paul Rubens,
*The Descent
from the Cross*,
1620.
Engraving;
58 × 43 cm,
22⅞ × 16⅞ in

67
Laocoön,
copy of a
Greek original
of *c.*150 BC.
Marble;
h.184 cm,
72½ in.
Vatican
Museums,
Rome

Rembrandt's painting presents Christ's death as a human sacrifice. It details his physical suffering and displays the emotional pain of his mother and followers. It also offers hope: if Christ's wounded, ungainly body can be resurrected, does it not offer proof that faith in God's grace will redeem all humans, tainted with the original sin of Adam and Eve? The blemished, awkward physique of Rembrandt's Christ offers an apt visual translation of this traditional doctrine, which had gained new force in Reformed theology.

The Passion series was a major breakthrough for Rembrandt. It did for his prospects as a history painter what *The Anatomy Lesson of Doctor Nicolaes Tulp* had done for his career as a portraitist, and Rembrandt

was eager to publicize his achievement. Inspired by the example of
Rubens, who routinely had prints made after his paintings, Rembrandt
worked again with Jan Gillisz van Vliet to produce an etching after *The
Descent from the Cross* (68). The inscription at the bottom, *cum pryvl*
('with privilege'), shows that he even copied Rubens' habit of seeking
'privileges', an early form of copyright, for prints of his invention.

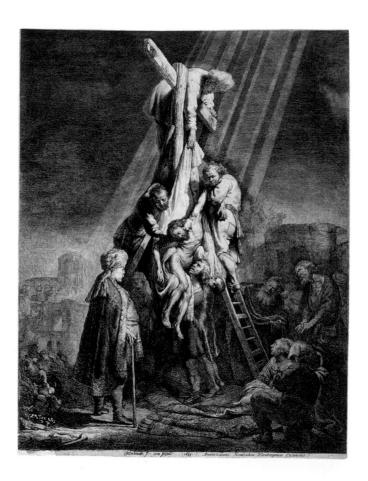

68
Rembrandt
with Jan
Gillisz
van Vliet,
The Descent
from the Cross,
1633.
Etching and
engraving;
51·2 × 40·2 cm,
20⅛ × 15⅞ in

Granted for a limited period and geographic area, the privilege gave
Rembrandt protection from printmakers who might otherwise be
free to issue their own prints of his painting. The etching underscores
Rembrandt's authorship by changing the face of the man on the ladder
into a portrait of the artist, which also turns him into an apparent witness
of the scene. European artists from Sandro Botticelli (1444/5–1510) to
Albrecht Dürer had used such facial signatures to underscore both the
veracity of their religious pictures and their contemporary relevance.

Rembrandt painted a more prominent self-portrait, wearing his familiar beret, at the bright centre of *The Raising of the Cross* (see 65). His role as Christ's executioner is startling: unlike the Roman soldier pulling the cross upright, he cannot claim simply to be following orders. His self-accusatory stance is akin to a technique of Protestant poets, who examined their relationship to Christ and professed their guilt for his continued suffering. A sonnet published in 1630 by the preacher Jacobus Revius has been persuasively compared to Rembrandt's self-portrait:

'Tis not the Jews who crucified,
Nor who betrayed you in the judgment place,
Nor who, Lord Jesus, spat into your face,
Nor who with buffets struck you as you died.

'Tis not the soldiers who with brutal fists
Raised the hammer and raised the nail
Or the cursed wood on Calvary's hill,
Or drew lots, tossed the dice to win your cloak.

I am the one, oh Lord, who brought you there,
I am the heavy tree, too stout to bear,
I am the rope that reined you in.

The scourge that flayed you, nail and spear,
The blood-soaked crown they made you wear,
'Twas all for me, alas, 'twas for my sin.

Rembrandt's painting, too, describes the self-righteous and eager men who raised the cross, only to shift responsibility to the author himself. His weary expression is the visual counterpart to Revius' resigned admission of the sins for which Christ died. The splendid horseman behind Rembrandt addresses us with a similar attitude, inviting us to examine our own role in the Christian drama. If he is the Roman centurion who converted immediately upon Christ's death (as recorded in the Gospels), he is a model of the direct, unmediated faith required of Protestants.

In his biography of Rembrandt, Houbraken marvelled that 'his art was esteemed so much that one had to (as the proverb says) *beg him and give him extra money*. For many years in a row he was so busy painting that people had to wait a long time for their pictures, notwithstanding his assiduousness.' Frederik Hendrik may have been an early victim of Rembrandt's success, for the other three paintings in the Passion series were not delivered until 1636 and 1639. Their completion is partially documented in a correspondence between Huygens and Rembrandt, of which only Rembrandt's seven letters survive. In his first, Rembrandt claimed that he had finished *The Entombment of Christ* and was 'more than half-done' with a *Resurrection* and *Ascension*. The *Entombment* might have been commissioned only at this time to complement the *Raising* and the *Descent*, but Rembrandt's temporizing over the two 'more than half-done' paintings, which were not finished until 1639, suggests that he was simply too busy with commissions from local patrons. They were better placed to put him under pressure to deliver and, for all the prestige of the *stadhouder*'s court, ultimately more instrumental to his success.

69
Christ in the Storm on the Sea of Galilee, 1633. Oil on canvas; 160 × 128 cm, 63 × 50⅜ in. Isabella Stewart Gardner Museum, Boston (stolen in 1990)

Rembrandt's second letter to Huygens points to the likely purpose of the Passion paintings. Although their arched shape was traditional for altarpieces, this function would have been anathema to a Protestant prince. Rembrandt advised that his *Ascension* 'would be displayed to best advantage in the gallery of His Excellency because there is strong light there'. According to the inventory of Amalia van Solms taken in 1668, the series was indeed placed in the gallery of the palace, a long room that allowed exercise in bad weather and offered ample space for hanging paintings. Rembrandt's recommendation that these dark pictures be hung in strong light would allow full appreciation of their dual function as ambitious history paintings and aids to Christian contemplation. In their narrative transformation of the altarpiece format, the Passion paintings constitute a devotional art on Protestant terms.

Rembrandt's *Christ in the Storm on the Sea of Galilee* (69) revisits the theme of unconditional faith central to *The Raising of the Cross*. The painting vividly illustrates the Gospel accounts of Christ calming the waves:

One day he got into a boat with his disciples and said to them, 'Let us cross over to the other side of the lake.' So they put out; and as they sailed

along he went to sleep. Then a heavy squall struck the lake; they began to ship water and were in grave danger. They went to him, and roused him, crying, 'Master, Master, we are sinking!' He awoke, and rebuked the wind and the turbulent waters. The storm subsided and all was calm. 'Where is your faith?' he asked.

(Luke 8:22–5)

Rembrandt painted a view of a fishing vessel in distress, pitched on a towering wave. The terrified crewmen in the bows hold on to anything they can, while two disciples in the stern implore Christ, another prays, and a fourth is too seasick to care. Most of the tempest paintings produced by Rembrandt's contemporaries employed a wider, panoramic format to present an elemental conflict between nature and the human spirit, rarely concentrating on a biblical theme or differentiating the emotions of the crew. Rembrandt's convincing tempest is very much a history painting; a disciple holding on to his hat invites us to empathize with the vessel's plight and consider Christ's imminent response. Rembrandt found a model for his close-up composition in a sixteenth-century print; while this shows Christ sleeping, Rembrandt painted him awake, as if to announce his climactic challenge to his disciples. Borrowing a trick from Dutch tempest painting, he hinted at Christ's restoration of calm by letting shafts of sunlight pierce the clouds.

Houbraken admired Rembrandt's *Christ in the Storm on the Sea of Galilee* 'because the figures and facial features are expressed as naturally in accordance with the event as one could imagine, and they are also more elaborately painted than one usually sees from him'. This assessment was echoed in descriptions and high sale prices throughout the eighteenth century, and modern technical investigations confirm the work's unusually fine finish for Rembrandt's paintings of this scale. Mast, lines, sails and water are rendered with the meticulousness of Gerard Dou (see 40), yet in a surprisingly limited colour range. Rembrandt achieved spatial depth by silhouetting the man in brown on the bows against light sky, and the gold-toned disciple seen from behind against the dark interior of the cabin. His exquisite care over the painting may have been geared to its likely buyer, Jacques Specx, whose inventory of 1653 included five pictures by Rembrandt. Before

settling in the Republic in 1632, Specx had had an adventurous career working for the United East Indies Company, even serving as Governor General of the Dutch East Indies for three years. In Amsterdam, he amassed a distinguished collection of paintings.

The biblical paintings of Rembrandt's first decade in Amsterdam feature the down-to-earth characters he had developed in Leiden, with awkward or ageing bodies, balding pates or matted hair, wrinkled or blemished skin. In their deliberate naturalism, these ordinary, even coarse figures are akin to *The Pegleg* (see 36) and the picturesque *tronies*, but in a biblical context they are also humble Christian figures. Rembrandt's earthy characterization of religious protagonists honours the diligent Bible reading advocated by Reformed preachers: he sketched Christ's disciples as plain fishermen and dressed notables such as Joseph of Arimathea in fanciful oriental-style garb. In several religious narratives, however, Rembrandt inserted motifs of a crudeness that oversteps the bounds of Protestant decorum and that cannot be explained as an attempt to render these Bible stories more accessible.

The most notorious such instance is Rembrandt's *John the Baptist Preaching*, a modest canvas painted around 1634 (70). Its muted tonality of brown, ochre, grey and off-white suggests that Rembrandt may initially have intended it as a model for an etching, although no such print is known. All the Gospels speak of the Baptist preaching the coming of Christ and baptizing repentant sinners in the River Jordan:

John the Baptist appeared as a preacher in the Judaean wilderness; his theme was: 'Repent; for the kingdom of Heaven is upon you.' It is of him that the prophet Isaiah spoke when he said 'A voice crying aloud in the wilderness, "Prepare a way for the Lord; clear a straight path for him".' John's clothing was a rough coat of camel's hair, with a leather belt round his waist, and his food was all locusts and wild honey. They flocked to him from Jerusalem, from all Judaea, and the whole Jordan valley, and were baptized by him in the River Jordan, confessing their sins. When he saw many of the Pharisees and Sadducees coming for baptism he said to them: 'You vipers' brood! Who warned you to escape from the coming retribution? Then prove your repentance by the fruit it bears…' (Matthew 3:1–8)

70
*John the Baptist
Preaching,*
*c.*1634.
Canvas laid
down on panel;
62·7 × 81 cm,
24³⁄₄ × 31⁷⁄₈ in.
Staatliche
Museen
Preussischer
Kulturbesitz,
Gemäldegalerie,
Berlin

To evoke the crowds that flocked to John, Rembrandt invented an eclectic group. He conveyed the universality of John's message by including people of widely different ethnic origins (not mentioned by the Evangelists), ranging from African and Asian to Turkish and Native American. Each member of the audience is sharply characterized according to age, sex, status and attentiveness to John's words: men and women, rich and poor, young and old, good and bad listeners mingle in astonishing diversity. The prominently illuminated people just below John listen intently; a figure resembling the artist looks out to invite the viewer to do the same. One woman quiets her crying toddler, while a turbaned man chides two children fighting over grapes. Three robed men in the central foreground turn away demonstratively; the Hebrew shawl worn by one indicates that they are the Pharisees and Sadducees.

Several artists before Rembrandt, including Pieter Bruegel the Elder (c.1525–69), had represented the Baptist's audience as a diverse crowd, but Rembrandt's painting is especially complex. His variety of gestures to render states of listening is unique: heads cocked, ears turned to John, hands raised to pensive faces. The truly novel motifs of his painting, however, appear in the dark foreground shadows. On the right a mother helps her child defecate in a stream; on the left, two dogs fight and two others copulate. A fifth dog squats to relieve himself in the shadow of the group of Pharisees. These rough intrusions on the Baptist's message recall the grotesque exaggerations of the *Seated Nude* (see 38). Although contemporaries cherished such lowly details in farces, they often questioned such base humour in historical scenes.

Rembrandt's pupil Van Hoogstraeten found them inappropriate, as he recalled in his treatise of 1678:

in a certain nicely composed piece by Rembrandt, representing a Preaching of John, I saw marvellous attention in the listeners of all stripes: this deserved the highest praise, but one also saw in it a dog, who mounted a bitch in unedifying fashion. You may say that this happens and is natural, I say that it is a reprehensible indecency in this story; and that, from this addition, one would sooner say, that this piece showed the Preaching of the Cynic Diogenes, than of Saint John. Such representations reveal the master's silly mind …

Most of these vignettes are painted on a strip of canvas that Rembrandt added after he had painted the central scene. He expanded the painting's height by 20 cm ($7\frac{7}{8}$ in) and its width by 30 cm ($11\frac{3}{4}$ in), and pasted the composite canvas onto a panel. While the work's unconventional elements evoke John's self-imposed roughness and illustrate humanity's earthy condition, they also appear aimed to shock a polite audience, in the manner of Rembrandt's *Self-Portrait with Saskia* (see 62). Perhaps Van Hoogstraeten, who was much concerned about the reputation of painting, objected to this provocative tone. Yet Rembrandt's rigorous naturalism served artistic ends, too, for it allowed him to vary John's flock to its limits. The picture's appealing diversity was appreciated by both Van Hoogstraeten and Houbraken, who had no patience with violations of artistic decorum but chose to ignore the dogs, praising Rembrandt's 'natural representations of the audience's facial features, and the ever-changing costumes'.

Erudite viewers could well have described the qualities Van Hoogstraeten and Houbraken admired with the Latin terms *copia* ('fullness') and *varietas* ('diversity'). Derived from the classical theory of rhetoric, *copia* and *varietas* were highly valued in speechmaking and storytelling, and the painting's myriad motifs can be seen as elements of John's own oration, which chastised the sins of the world that Christ would take away: thus the defecating dog is placed next to the priests rebuked by John. Probably in the 1650s, the painting was acquired by the dilettante scholar Jan Six, who would have savoured Rembrandt's narrative *copia* and incisive *varietas*. The posthumous catalogue of his collection considered the work 'rare and uncommonly artful'.

Like Rembrandt's beggars, nudes and *tronies*, his *grisaille* ('grey painting') also features lowly elements for artistic purpose (see 34–6 and 38). In his mythological paintings of the 1630s, such as *Andromeda* (see 37), he played similarly with the conventions of history painting. Some, most notably *Diana Bathing* (71), were meant to be downright funny. Diana, a pasty-faced woman identifiable only by the sliver of moon on her head, has been spied at her bath by the hunter Actaeon. In punishment, Diana is transforming him into a deer (note the sprouting antlers), soon to be devoured by his hounds. Most of the nymphs are

blissfully unaware of the tragedy, wading daintily and splashing about like eighteenth-century nudes. On the bank a fight has broken out as Callisto scratches and claws to keep the others from discovering her pregnancy, brought about by Jupiter. One nymph holds Callisto down, another pushes back her robe, a third howls in derision.

Rembrandt's retelling of the story still amuses, but seventeenth-century viewers may have found it poignant as well, for they would have read it as a tale of forbidden lusts, represented by Callisto and Actaeon (Callisto almost met Actaeon's fate when Diana turned her into a bear and set dogs upon her; she was saved only by Jupiter). To connoisseurs, Rembrandt's picture may also have seemed artistically subversive. Not only were Ovid's stories of Callisto and Actaeon traditionally represented apart, rather than conflated in a rumbustious scene without narrative focus, but – more seriously – Diana's bath was usually an occasion for representing nude immortals according to classical ideals of female beauty. Rembrandt's homely divinities challenge those preferences.

The artistic interest that unites such incompatible subjects as St John and Diana is evident in Rembrandt's precise characterizations and his use of similar models in both pictures (even the dogs in the left foreground of the *John the Baptist Preaching* appear to the left of Actaeon). Collectors may have valued Rembrandt's earthy religious and mythological paintings for their shared picturesque merits. Jacques Specx, who owned *Christ in the Storm on the Sea of Galilee* (see 69), also bought Rembrandt's *Rape of Europa* (72) and a picture by him of *Saint Paul*, presumably one of Rembrandt's wizened sages.

The Rape of Europa features a familiar cast of pale, flabby young women dressed in brocades and fluttering silks, but its narrative is faithful to Ovid's story (*Metamorphoses*, Book II, 833–75). Desiring Europa, a princess of Tyre, Jupiter disguised himself as a bull on the beach where she was playing with companions. Enchanted by the bull's gentleness the girl eventually mounted him, only to be carried off to Mount Olympus: 'The girl was sorely frightened, and looked back at the sands behind her … Her right hand grasped the bull's horn, the other rested on his back, and her fluttering garments floated in the

71
Diana Bathing, with the Stories of Actaeon and Callisto,
1634.
Oil on canvas;
73.5 × 93.5 cm,
29 × 36⅞ in.
Museum Wasserburg Anholt, Isselburg

breeze.' Rembrandt took pains to depict Europa's fright and her friends' fear and concern. To specify the exotic Middle Eastern coast, he added an improbably shaped coach with an African driver. The busy port of Tyre is characterized by several masts and an eminently European crane.

Rembrandt was probably the first Dutch artist to paint the story, which was frequently illustrated in printed editions of Ovid. His choice of subject may have been motivated by Specx's trading career in the East, as Gary Schwartz has proposed: like Jupiter, Specx enriched the continent that bears Europa's name with exotic bounty. Ovid's account also provided an artistic incentive: the bull's horns were 'so beautifully made that you would swear they were the work of an artist, more polished and shining than any jewel'. Elsewhere in the *Metamorphoses* (Book VI, 103–7), an artist tried to rival this scene's natural beauty, as Greek painters so often did. When Arachne, a young woman famous for her spinning, challenged the goddess Minerva to a contest, she wove a tapestry depicting the metamorphoses of the gods. Of the scene of Europa's abduction, Ovid wrote that 'you would have thought that the bull was a live one, and that the waves were real waves'. Although Minerva punished Arachne for her success by aptly transforming her into a spider, the weaver's legendary naturalism may well have prompted an ambitious young artist to try her theme.

Apart from offering compelling stories, *The Rape of Europa*, *Diana Bathing* and *John the Baptist Preaching* contain carefully painted land-scapes. In *Europa* the idyllic shore and the finely drawn reflections in the sea compete for our attention with the women's terror. Rembrandt's interest in natural settings may have been stimulated by a new awareness of fashionable historical landscape paintings. This genre had originated in the Southern Netherlands and become popular in Amsterdam, where such artists as David Vinckboons (1576–1632?) had imported it shortly after 1600 and the younger Bartholomeus Breenbergh (1598–1657) had begun to update it. Breenbergh's *John the Baptist Preaching* (73), painted while Rembrandt was working on his version, displays a rich but decorous variety of figures, set in a sun-drenched landscape of the kind developed by Breenbergh during a decade spent in Rome.

72
*The Rape
of Europa*,
1632.
Oil on panel;
62·2 × 77 cm,
24½ × 30⅜ in.
J Paul Getty
Museum,
Los Angeles

By 1635 Rembrandt enjoyed sufficiently secure patronage to produce large, dramatic history paintings. Some were probably commissioned, but he may also have made several such time-consuming works without a firm buyer. As each of these pictures is unconventional, their production indicates Rembrandt's confidence in his customer base. Most perplexing of all is *The Abduction of Ganymede* (74), another subject from Ovid. Struck by the beauty of the young Trojan shepherd Ganymede, Jupiter transformed himself into an eagle and snatched him away. Rembrandt transformed the handsome Trojan youth into a bawling infant, who displays a fat bottom and pees in fright. This image represents a clever version of a favourite comic motif in

Renaissance art: the *putto pisciatore* ('urinating cherub') found in fountain sculpture and narrative paintings. Rembrandt's use of the figure may have been inspired by Van Mander's explanation of Ovid's tale. Echoing Platonic philosophy, Van Mander claimed that Ganymede represents the pure soul striving towards God; to immortalize him, Jupiter changed him into the constellation Aquarius, the Water Bearer, who pours rain upon the earth. Although Rembrandt's Ganymede waters the earth, it is difficult to see him as the pure soul seeking God. The cherries held by the child are ambiguous, too: while they are traditional symbols of purity as well as lust, here they are surely remnants of an interrupted

snack. The picture seems an elaborate joke for insiders, requiring knowl-
edge of mythology and artistic tradition to be appreciated fully.

Rembrandt's *Danaë*, his last Ovidian work of the 1630s, is equally
complex (75). She is one of his rare nudes in the grand Renaissance
tradition of Titian and other painters. The princess Danaë was locked
into a bronze chamber by her father, because an oracle had foretold
that she would give birth to his future killer. Inflamed with lust for
her, Jupiter changed himself into a shower of gold and entered her

73
**Bartholomeus
Breenbergh,**
*John the Baptist
Preaching,*
1634.
Oil on panel;
54·5 × 75 cm,
21¹₂ × 29¹₂ in.
Metropolitan
Museum of
Art, New York

74
*The Abduction
of Ganymede,*
1635.
Oil on canvas;
177 × 129 cm,
69³₄ × 50³₄ in.
Gemäldegalerie
Alte Meister,
Dresden

room through the window. Almost all artists presented Jupiter in the
form of gold coins, a fitting bribe for Danaë's elderly female guard or
the maiden herself. Rembrandt's rare decision to picture the god as
sunlight is more plausible, for light passes through glass. It also
corresponded to a convention he had learned from Lastman or the
followers of Caravaggio, who habitually represented divine presence
as bright light (see 24). Danaë's reclining pose, round belly and small
breasts are indebted to Titian's paintings of Venus and Danaë (76),

which Rembrandt may have known from the many versions by Titian's followers. Although artists had often interpreted Danaë as a model of chastity, her Venetian Venus pose and the small Cupid suspended above her head emphasize Danaë's delight at the unexpected turn of events. Soon, when Jupiter and Danaë will consummate their love, Venus' son may shed his manacles and cease his weeping. The gilded Cupid and the bed, ornamented in the fashionable 'auricular' style, turn Danaë's bronze prison into a sumptuous venue for a tryst.

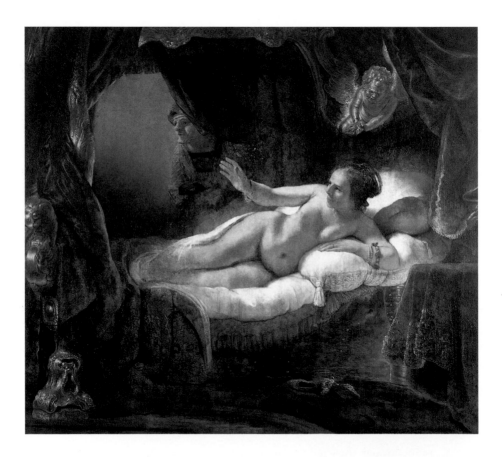

Rembrandt's magnificent nude was attacked in 1985 with sulphuric acid, which corroded much of Danaë's legs, arms and head beyond repair. The assault was the latest episode in the painting's eventful history: x-ray photographs show that Rembrandt altered it even after varnishing, and that by the mid-eighteenth century the canvas had been considerably reduced in size. In revising it Rembrandt widened the opening of the curtain and changed the gesture of Danaë's right

hand. While she initially pushed aside the curtain, she now raises her opened hand to welcome the light, emphasizing her pleasure at the appearance of the god. Although the persistent suggestion that Danaë has Saskia's features is unfounded, it confirms that even Rembrandt's most idealized nude looks more earthbound than the Italian temptresses who served as her model.

Compared with his biblical protagonists, the Ovidian heroines look glamorous. In *Belshazzar's Feast* (77), the tale told in the Book of Daniel justifies Belshazzar's stupefied expression and ridiculously grand posture. Belshazzar, king of Babylon, gave a magnificent

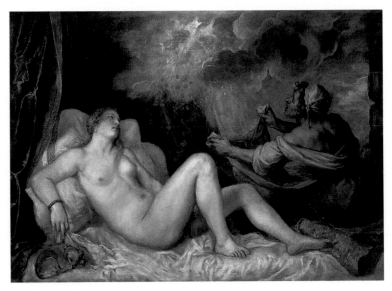

75
Danaë,
*c.*1636
(possibly
reworked
in the early
1640s).
Oil on canvas;
185 × 203 cm,
72⅞ × 79⅞ in.
The Hermitage,
St Petersburg
(before
damage)

76
Titian,
Danaë,
1554.
Oil on canvas;
129 × 180 cm,
50¾ × 70⅞ in.
Museo del
Prado, Madrid

banquet for his noblemen and courtesans, served on the gold and silver vessels that his father, Nebuchadnezzar, had looted from the temple in Jerusalem. Using the sacred utensils, the revellers,

drank wine and praised the gods of gold and silver, of bronze and iron, and of wood and stone. Suddenly there appeared the fingers of a human hand writing on the plaster of the palace wall opposite the lamp, and the king could see the back of the hand as it wrote. At this the king's mind was filled with dismay and he turned pale, he became limp in every limb and his knees knocked.
(Daniel 5:4–6)

Daniel was summoned to interpret the mysterious Hebrew inscription *mene mene tekel upharsin*. Chastising Belshazzar for his lack of humility, Daniel explained that God had numbered the days of Belshazzar's kingdom. That night Belshazzar was killed, and his kingdom taken by the king of the Medes.

The story challenged Rembrandt to represent a supernatural event in convincing terms and to capture the extreme state of agitation it occasioned. As in his mythological paintings, he depicted the moment on which the protagonist's fortunes turn. Belshazzar looks over his shoulder to see the hand completing its writing. A golden white glow marks its divine agency. The king has risen so abruptly that his jewelled chain has swung forward, casting a shadow on his paunch; wine gushes from a pitcher overturned by his sudden motion. His tilting body and outstretched arms – a device borrowed from the portrait of Griet Jans (see 50) – form the spokes of a composition that generates turmoil with great economy: just a few contrasting and complementary figures create a banquet in uproar. Observed by the composed courtesan on the left, a nobleman and two women react with alarm. As in *Danaë*, a restricted palette of yellows, whites and greens, enriched with touches of purple and red, conveys great luxury, as do the king's encrusted brocade, turban and crown (see 63). The illusion of arrested motion, the spatial complexity and the careful observation of reflections and shadows demonstrate Rembrandt's absorption of history painting by Caravaggio, Rubens and their followers.

77
Belshazzar's Feast,
c.1635.
Oil on canvas;
167·6 × 209·2 cm,
66 × 82⅜ in.
National
Gallery, London

Despite this international sophistication the painting has local relevance. Belshazzar's invocation of false deities had offended God, and it may be this aspect of the story that prompted Rembrandt to paint it. Reformed theologians had laid renewed stress on the First and Second Commandments, which forbid the worshipping of other gods and the making of graven images 'of anything in the heavens above, or on the earth below'. Rather than applying the Second Commandment to all pictures, as Orthodox Jewish tradition did, Protestants interpreted it as a proscription of the Catholic use of images in worship. Reformed preachers branded Catholic practices as idolatrous and compared them to biblical examples such as Belshazzar's.

Rembrandt's Hebrew inscription is more directly indebted to the scholarly culture of Amsterdam, however. Although the text is correctly written from right to left, the arrangement of the words in vertical columns is unconventional. In 1639 Rembrandt's acquaintance Menasseh ben Israel (see 51) was to publish the inscription in this same form. Following ancient rabbinical interpretation, Menasseh suggested that God wrote his text in this way to make it incomprehensible to Belshazzar

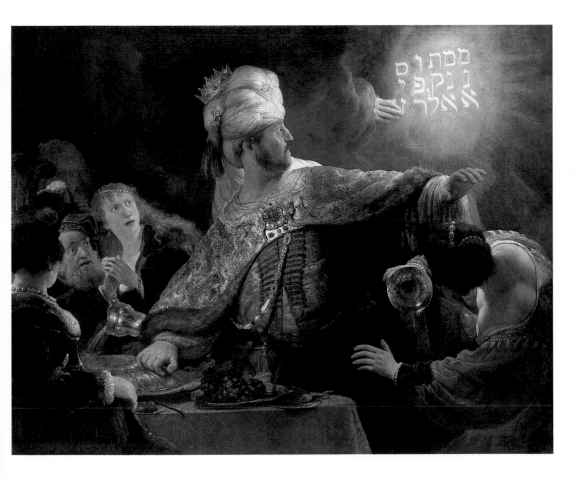

but legible to Daniel. Rembrandt's inclusion of such lore bespeaks contemporary interest in Hebrew tradition. In Amsterdam, Christian scholars scoured Judaic sources to clarify biblical passages, and Jewish thinkers consulted Christian writings. The States Bible of 1637, commissioned by the States General, was a painstaking Dutch translation based on Hebrew, Greek and Latin accounts. In this diverse culture, *Belshazzar's Feast* would have appealed to Jewish and Christian collectors alike.

The humble obedience of the patriarch Abraham formed a perfect counterpart to Belshazzar's pride. The Genesis account of Abraham's covenant with God was one of the richest sources of narrative for history painters such as Lastman, who mined the Old Testament for exemplary tales of faith. Steadfast in his belief in God's promise 'I will make you into a great people', Abraham endured harrowing trials, which struck a chord in the young Republic, eager to legitimize its claim to political, religious and economic autonomy. Dutch leaders identified their struggle for political survival with the ancient history of the Israelites.

The most wrenching of Abraham's trials was God's demand that he sacrifice his son Isaac, the only child of his wife Sarah, born to her in old age. Genesis recounts that Abraham took Isaac to the appointed hill, explained that 'God will provide himself a young beast for a sacrifice', and then bound his son to a pile of wood.

Then he stretched out his hand and took the knife to kill his son; but the angel of the Lord called to him from heaven, 'Abraham, Abraham.' He answered, 'Here I am.' The angel of the Lord said, 'Do not raise your hand against the boy; do not touch him. Now I know that you are a God-fearing man. You have not withheld from me your son, your only son.' Abraham looked up, and there he saw a ram caught by its horns in a thicket. So he went and took the ram and offered it as a sacrifice instead of his son.
(Genesis 22:10–13)

78
The Sacrifice of Abraham, 1635.
Oil on canvas; 193·5 × 132·8 cm, 76⅛ × 52¼ in.
The Hermitage, St Petersburg

In his monumental *Sacrifice of Abraham* (78), Rembrandt followed a long tradition of depicting the climactic moment of deliverance. Adapting the compositional scheme of a small painting by Lastman, he dramatized the event immeasurably through the animated play of hands, glances and diagonally disposed bodies. With his weathered left hand, the white-haired father bends back Isaac's head, covering the boy's eyes and baring his neck. A strong light from above exposes his prepubescent body in all its vulnerability, while the angel delivers God's message and grasps Abraham's wrist so that he drops the knife. Abraham's weary expression and tear-filled eyes register his inner struggle (which the Bible does not mention) as well as his recognition

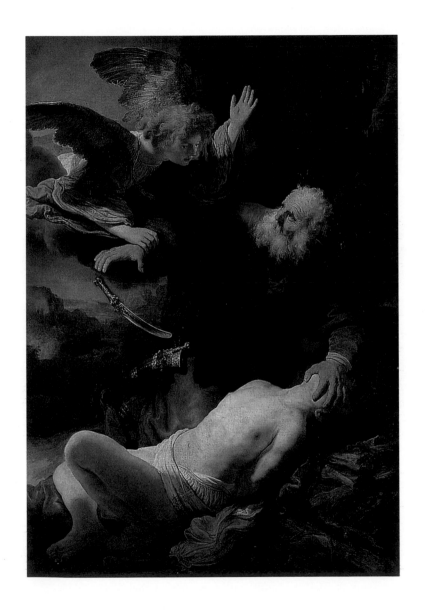

that the angel is God's messenger. Rembrandt expressed the angel's divine status by letting him sail in with the light, which is reflected on to the angel's face from his own left arm and Abraham's head. By leaving out the customary references to the rest of the story, including the substitute ram, Rembrandt rendered *The Sacrifice of Abraham* as a gripping emotional narrative.

If Rembrandt's Belshazzar is the image of the idolatrous heathen and his Abraham the picture of living faith, his Samson is the quintessential flawed hero. There is no crueller painting of the blinding of Samson than Rembrandt's (79). Samson was the last of the Judges, as Israel's leaders were called after the death of Joshua. They were invoked by Dutch historians as models and parallels for the Republic's *stadhouders* and other functionaries. Samson had been pledged to God at birth, at a time when the Philistines oppressed his people, and his consecration gave him phenomenal strength as long as he did not cut his hair. Eventually the Philistines hired the prostitute Delilah to coax from Samson the secret of his strength. She lulled him to sleep and called the Philistines to cut off his hair. Having shaved the weakened hero, the Philistines gouged out his eyes and took him prisoner (Judges 16:20–21). Rembrandt's version of the story is horrifically literal: in a cavernous setting, four Philistine soldiers barely control the writhing Samson, who clenches his teeth and fists as one man pins him down, another shackles him and a third stabs his right eye. Curled in pain, his right leg and toes point to Delilah, who displays the scissors and her trophy of ample locks as she rushes out of the room. Her fine costume, the golden wine jug and luxurious bedclothes imply the sensual cause of Samson's downfall.

Rembrandt's Samson is not the classically muscular giant painted by Rubens and many Italian artists, but a debased Laocoön (see 67). His coarse features and bloated belly mark a sinful body, making it all the more wondrous, Rembrandt appears to suggest, that he should be forgiven to work God's will. For as soon as Samson was imprisoned his hair grew back; he prayed to have his strength returned and pulled down the temple of the Philistines onto himself, killing more of Israel's enemies by his death than he had slain in life.

Whatever Rembrandt's reasons for painting such a violently debased Samson, the result was too challenging for immediate sale. In a letter to Huygens about the Passion series, written in 1639, Rembrandt apparently promised the picture as a gift, three years after it was completed. Although he did not identify the painting by subject, its dimensions were identical to those of *The Blinding of Samson*. Huygens apparently refused the offer, but two weeks later Rembrandt sent the painting, advising him to 'hang this piece in a strong light and in such a way that one can stand far back from it, then it will sparkle well'. The recommendation is appropriate to the gruesome drama and to the strong chiaroscuro, both of which are easier to take from a distance. There is no evidence of Huygens' further response, but the diplomacy of Rembrandt's offer may be questioned. Even if Samson was habitually likened to the *stadhouder*, he was admired for his leadership and strength rather than his fateful tryst. For his part, Rembrandt probably saw the gift as a challenging painting for a connoisseur who had admired his ability to express extreme torment by strong gestures. He could also have expected Huygens to recognize his visual quotation of Samson's body from the *Laocoön* and from a huge painting by Rubens of Prometheus, the hero who stole Jupiter's fire and in punishment had his liver perpetually eaten by an eagle (80). Huygens lavished praise on a picture by Rubens of a similarly appalling theme: the decapitated head of Medusa. To Huygens it was the combination of ghastly lifelikeness and artistic beauty that turned *Medusa* into incomparable art. Rembrandt may have known Huygens' tastes well enough to offer him such a worthy exercise in Rubensian horror.

The dramatic narrative moments, passionate emotion, dynamic action and sumptuous costuming of Rembrandt's *Danaë*, *Belshazzar*, *Abraham* and *Samson* have generated speculation about his knowledge of contemporary theatre. He produced these works just when Amsterdam's theatrical culture was beginning to flourish. The great tragic poet Vondel, and Gerbrand Adriaensz Bredero, his comic counterpart, were among the first career poets to write largely for the theatre. In 1637 the first professional Dutch theatre opened in Amsterdam in a splendid building designed by the architect Jacob van Campen (1595–1657). Almost a thousand spectators attended the frequent performances, usually consisting of a tragedy followed by a comedy or farce.

79
*The Blinding
of Samson*,
1636.
Oil on canvas;
206 × 276 cm,
81⅛ × 108⅝ in.
Städelsches
Kunstinstitut,
Frankfurt

Rembrandt appears to have been fascinated by the new theatre. In 1638 he made several drawings of actors in Vondel's *Gijsbreght van Aemstel*, a tragedy about a medieval Dutch hero written to inaugurate the stage. A sketch of the actor playing the bishop (81) appears to show him in a dressing room reading the script, with his costume hanging beside him. Other drawings by Rembrandt from the same decade represent stock comic characters. In the epic theatre, which concentrated on historical

80
Peter Paul
Rubens and
Frans Snyders,
*Prometheus
Bound*,
c.1611–12.
Oil on canvas;
243 × 210 cm,
95⅝ × 82⅝ in.
Philadelphia
Museum
of Art

themes, he must have relished the imaginative costumes and props evoking the distant past or the Orient. His own use of such references, however, owes more to pictorial tradition, as does his frequent practice of infusing classical narrative with touches of humour, or of representing biblical heroes with pedestrian faces. Both customs are evident in the tragicomedies of Abraham de Koningh on such subjects as Samson or

King Henry IV, but they also flavoured the history paintings of Lastman, Moyses van Uyttenbroeck (1595/1600–1647) and other contemporaries.

Rembrandt's experience of epic theatre was perhaps most relevant to his storytelling. Vondel and De Koningh structured their tragedies around a sudden change, usually for the worse, in the fortunes of Gijsbreght, Oedipus, Samson, David and similar heroes. They borrowed this concept from the Greek notion of *peripeteia*, the sudden reversal that was a central device in Aristotle's dramatic theory. The *peripeteia* was intended to purify the viewer's emotions by evoking both *misericordia* ('pity') for the hero and *horror* ('revulsion') at his fate. The hero's *agnitio*

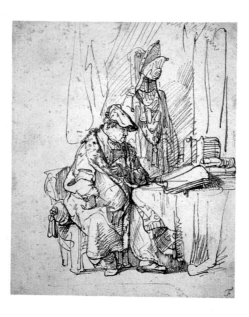

81
The Actor Who Played the Role of Bishop Gosewijn, 1638.
Pen and brown ink; 18·3 × 15 cm, 7¼ × 5⅞ in. Devonshire Collection, Chatsworth

or recognition of the weaknesses that caused his misfortune made him a moral exemplar. Rembrandt's choice of dramatic turning points and representation of the passions they precipitate work to similar effect.

Rembrandt painted the story of Samson on several other occasions in the 1630s, perhaps to form a thematic series for himself rather than for any patron. His *Wedding of Samson* (82), finished in 1638, details the personal roots of Samson's hatred of the Philistines. Against custom, Samson chose to marry a Philistine woman. During the wedding feast he bet that the thirty young guards assigned to watch him would be incapable of solving a certain riddle. Afraid of the guests' wrath,

Samson's wife slyly made him reveal the answer and passed it along. When they answered the riddle, Samson's fury led him to kill thirty other men and desert his treacherous wife. He later returned with a peace offering, but his father-in-law had already given away his daughter and offered him her younger sister instead. Incensed, Samson vowed to unleash his wrath upon the Philistines. The Book of Judges makes it clear that Samson's actions were driven by the Lord's design to give the Israelites a leader in their struggle. For Rembrandt, this religious message was undoubtedly secondary to the story's dramatic pageantry and high-keyed emotion.

The Wedding of Samson is a sumptuous affair, an airier parallel to Belshazzar's fateful feast. Radiant in white and gold, the bride is the silent pivot in a crowd of young lovers and curious guests. Samson has turned from his wife to pose his riddle to a motley gathering of young men, underscoring the terms of the challenge with urgent gestures. His bride's knowing glance suggests her misgivings. Three years after its completion the painting drew high praise from Philips Angel (1617/18–64), a Leiden painter who delivered an address 'In Praise of the Art of Painting' to the local artistic community. For him, Rembrandt's *Wedding of Samson* exemplified the artist's necessary familiarity with the narrative sources and customs of the periods represented. Thus Rembrandt had his guests lie at the table on couches, rather than sit 'the way we do now'. He also distinguished this wedding from others by showing Samson with his long, never-cut hair. While many guests carry on 'as in our contemporary feasts', Rembrandt added enough details to distinguish the biblical wedding from a modern occasion.

For his painting Rembrandt drew on the *Antiquities of the Jews* written by Flavius Josephus, a Jewish storyteller who had sided with the ancient Romans in their war against the Israelites. Reformed writers often consulted this text because it gave additional and psychologically detailed information about events in the Old Testament. Rembrandt is known to have owned a fine High German translation of the book, illustrated with woodcuts. From Josephus' text, he took the division of the party into a group of revellers and a circle of guards attending to

the riddle. The composition's convincing flow, however, results from Rembrandt's seamless blending of various pictorial sources, from prints of rollicking peasant weddings to Leonardo's *Last Supper*, which he had earlier copied from a print after the famous fresco (83). Rembrandt's free rendering of his model, confidently drawn in red chalk, significantly changed Leonardo's work, relaxing the symmetry of the composition, setting the group in a shallow room, and adding an off-centre canopy behind Christ. In *The Wedding of Samson*, a similar canopy marks the bride's seat, from which Samson leans as emphatically as the dark-haired disciple to the right of Christ. The animated conversations between wedding guests adapt the heated exchanges between Christ's followers. Rembrandt's melding of sources to represent a highly unusual theme caused the picture's subject to be misidentified in the eighteenth century as the more familiar *Banquet of Esther and Ahasuerus* (see 23).

In their unparalleled subject matter, the Samson paintings offer an extreme example of Rembrandt's ambitious approach to history painting during the 1630s. Before Rembrandt, Lastman and his pupils had developed a similarly impressive stock of novel themes and unfamiliar representations of traditional ones. Lastman must have encouraged his pupils to find such stories; several, including some of Rembrandt's, are difficult to identify. Seventeenth-century literary theory suggests a rationale for such choices. The first task of an orator or writer was 'invention', a term that referred to the judicious selection and appropriate handling of a striking theme. Novelty of subject could be central to a successful invention, but so could the clever phrasing of a traditional narrative. Later in the century the literary society Nil Volentibus Arduum ('Nothing is difficult to those who strive') prescribed 'Unusualness of Story' as a requirement of all good theatre. 'Unusualness' could be achieved by choosing a unique or rarely represented theme, or by adding unconventional emphasis to a familiar story. Rembrandt's *Wedding of Samson*, *Rape of Europa* and *John the Baptist Preaching* meet these respective demands. The enormous variation in subject matter and emphasis of historical plays and paintings produced in the Republic confirms that Dutch audiences relished narrative novelty.

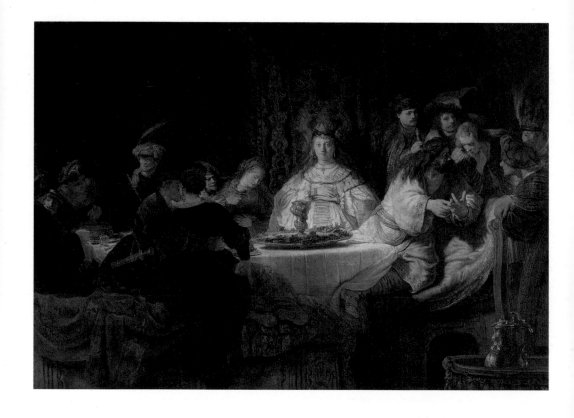

82
*The Wedding
of Samson,*
1638.
Oil on canvas;
125·6 × 174·7 cm,
49$^1$⁄$_2$ × 68$^3$⁄$_4$ in.
Gemäldegalerie
Alte Meister,
Dresden

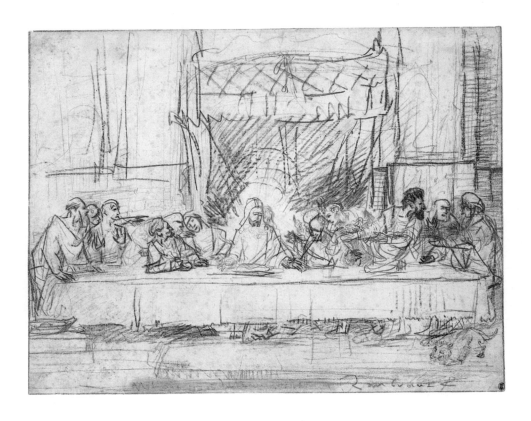

83
**Rembrandt
after an
engraving by
Giovanni
Pietro da Birago
after Leonardo**,
*The Last
Supper*,
c.1633–5.
Red chalk;
36·2 × 47·5 cm,
14¼ × 18¾ in.
Metropolitan
Museum of Art,
New York

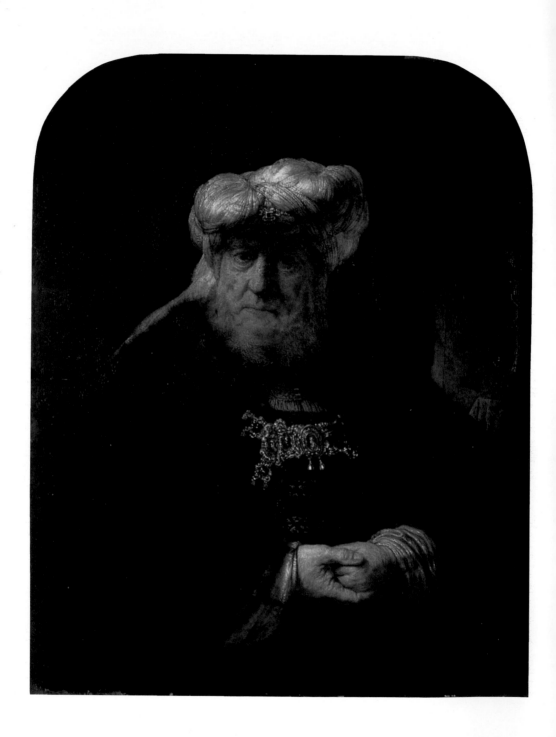

Rembrandt occasionally rendered unconventional stories even less familiar by reducing them to their psychological essentials, to the point where they become virtually unrecognizable. A striking example is his half-length, portrait-like painting of a turbaned old man clasping his hands (84). Only his exotic costume and the temple setting, indicated by a snake coiled round a column, suggest an Old Testament figure. He may be King Uzziah of Judah, who in his pride attempted to usurp priestly power by burning incense in the Temple's holiest sanctuary (2 Chronicles 26:16–20). In punishment, the Lord instantly struck him with leprosy, a disease that would account for the grey blotches on the man's skin. According to Flavius Josephus, the illness

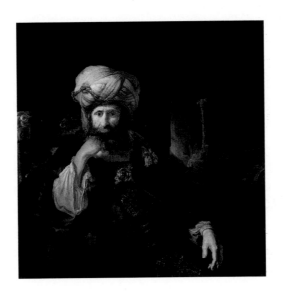

84
King Uzziah Stricken with Leprosy (?), *c.*1639.
Oil on panel;
102·8 × 78·8 cm,
40½ × 31 in.
Devonshire
Collection,
Chatsworth

85
Ferdinand Bol,
King Uzziah Ejected from the Temple (?), *c.*1640.
Oil on canvas;
115·5 × 111 cm,
45½ × 43¾ in.
Private
collection

was conveyed by sunlight entering through a crack in the temple roof, a narrative embellishment that Rembrandt may have translated into the scintillating illumination from above. The subject would have struck a chord in the Republic, where the dividing line between religious and secular authority was subject to contentious debate, and several seventeenth-century copies indicate that the composition indeed found a market. While in Rembrandt's workshop Ferdinand Bol painted a version in which the man leans on his hand in pensive, melancholy fashion (85). Bol faithfully copied the temple attributes, but added two globes. If the man is Uzziah, these terrestrial and celestial spheres might indicate the encroachment of his worldly authority

on sacred ground, and they might even connote his fame 'far and wide', in the biblical words. Together with the books on the shelves above, however, the globes also make the room resemble a scholar's study. Bol's figure, and perhaps even Rembrandt's own, might thus be a philosopher of antiquity, possibly a medical doctor. A snake twisted round a staff was the emblem of Asclepius, the Greek god of medicine, and the column may reconfigure this symbol. The specific features of Bol's figure distinguish him from Rembrandt's older man, and raise the possibility that Bol portrayed a contemporary in a historical guise that was appropriate to his profession.

Rembrandt's single-figure history paintings, of which (*Saskia Uylenburgh as?*) *Flora* (see 57) is also one, resemble his pictures of men in exotic costumes. While their spectacular attire and spirited execution recall the many *tronies* produced in Rembrandt's studio, their individu-alized features and larger formats make them look like portraits of sitters dressed up for a costume ball. Huygens described one such picture by Lievens as 'a painting of some Turkish potentate, done from a Dutchman's head'. Some of these works are indeed portraits, includ-ing the *Self-Portrait in Oriental Costume* of *c.*1631 (see 10), but others are less readily identifiable. One of the boldest is the *Man in Polish Costume*, painted in 1637 on an unusually large oak panel (86). The figure's commanding pose and meticulous modelling have led scholars to propose that he was a Polish envoy to Holland. The costume appears to be outmoded for that date, however, and the man's furrowed brow and dashing moustache indicate that the painting is a study in facial expression, refined lighting and exotic costuming – in other words, an unusually large *tronie*. These types of pictures by Rembrandt and his followers, recorded frequently in inventories, must have been valued for the artist's power to invent a compelling yet imaginary person.

All the same, members of the Dutch élite had themselves portrayed in costumes that placed them in historical roles or idyllic settings, from the biblical to the Arcadian. In a richly modulated etching by Rembrandt, Joannes Wtenbogaert, a nephew of the preacher (see 48), wears archaic sixteenth-century dress (87). The setting and pose recall sixteenth-century pictures of bankers weighing money and gold. These

86
Man in Polish Costume,
1637.
Oil on panel;
96·8 × 66 cm,
38⅛ × 26 in.
National Gallery of Art, Washington, DC

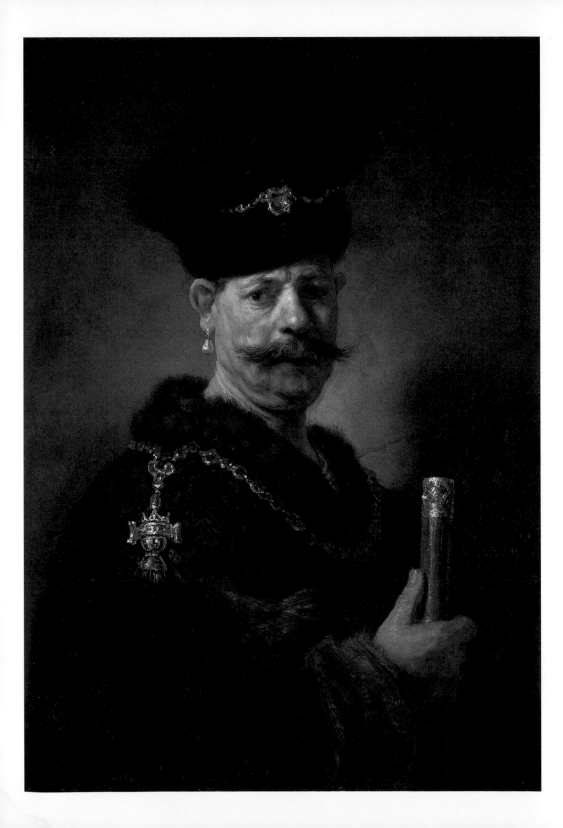

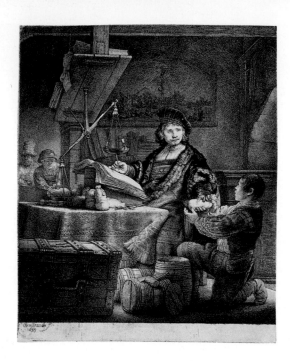

references are appropriate both to Wtenbogaert's profession of tax
collector and to his avid interest in earlier Netherlandish art – he was
a discerning collector of the prints of Lucas van Leyden. In 1639, the
year inscribed on the etching, Wtenbogaert helped Rembrandt secure
outstanding payments from the *stadhouder* for the last two Passion
paintings. In return, Rembrandt gave him the etching and the copper
plate, which he normally would have retained. Rembrandt's urgent
need for payment is explained by a contract of 3 January 1639 for the
purchase of a house at the princely sum of 13,000 guilders. A quarter of
the amount was to be paid within a year and a day of the transfer of the
house on 1 May 1639, with the remainder to be settled 'within five or
six years as he pleases' at five per cent interest. While Rembrandt was
possibly unwise to take on such a huge debt, his position in 1639 as
Amsterdam's leading painter of portraits and histories must have
warranted the risk, to the sellers and to himself.

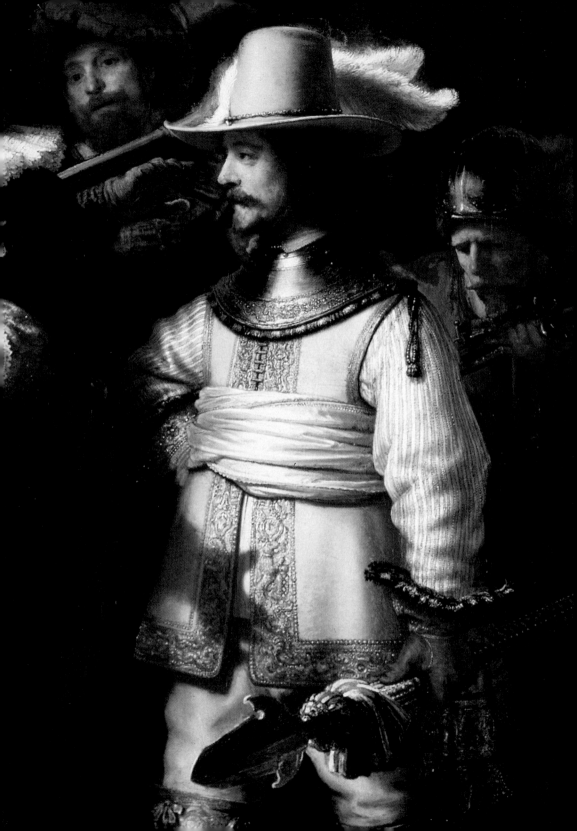

88
*The
Nightwatch*
(detail of 103)

Rembrandt's purchase of an expensive house in 1639 is a measure of his prosperity, his artistic and social standing and his anticipation of a growing family. The house was located on the Sint Antonisbreestraat (89), next to the property once rented by Uylenburgh, where Rembrandt and Saskia had lodged. It had been built in 1606 on a landfill in the heart of Amsterdam, during an early stage of the city's expansion. A construction ordinance had zoned the area for substantial residences rather than the smaller homes of artisans. The neighbourhood soon became a quarter inhabited by successful artists, professionals and merchants, many of them Jewish. Recent research has located several prominent artists on the Sint Antonisbreestraat, including Thomas de Keyser (see 53), Lastman (see 19), David Vinckboons and his architect sons. To one side of Rembrandt's house lived a Portuguese Jewish businessman; his neighbour on the other side was the portrait painter Nicolaes Eliasz (see 43). Across the street lived Menasseh ben Israel (see 51), rabbi in the Portuguese synagogue behind Rembrandt's house.

The house, now a museum dedicated to his life and work, is a harmoniously proportioned, three-storey structure with a large attic that Rembrandt used as studio space for his pupils. Jacob van Campen, the architect of the Amsterdam Theatre, had renovated it around 1633, adding two dormer windows and a classical pediment. The inventory of Rembrandt's possessions taken in 1656 gives a sense of the layout of the house, as it lists the contents room by room. The ground floor had four major rooms, including a *sael*. In many seventeenth-century homes the *sael* was the finest reception room, but Rembrandt's was traditional in that it was also used for sleeping. The four upstairs rooms were given over to Rembrandt's activities as artist and collector. His studio, divided into a 'small room for painting' and 'large room for painting', benefited from four large windows at the front of the house. Behind, much of Rembrandt's art collection was kept in an 'art room', although other works were displayed throughout the house (for the collection, see Chapter 6).

In 1639 Rembrandt probably expected that he and Saskia would have a substantial family to occupy their spacious home, even though they had not been fortunate in childbirth. In 1636 and 1638 they had lost two young infants, a third baby died in 1640. Their son Titus lived to adulthood, but when Saskia died in 1642 he was only nine months old. Much later, in 1654, Rembrandt had one daughter with Hendrickje Stoffels, his housekeeper and common-law wife. Spirited drawings of the 1630s record his observations of domestic life with Saskia and of numerous children, perhaps those of Hendrick Uylenburgh. In an amusing pen-and-ink sketch, Rembrandt captured one of the small tragedies in a

89
Photograph
of Rembrandt's
house,
Amsterdam

toddler's life (90). The boy's resistance to the young woman restraining him shows perfect understanding of bodily movement. The emotional intensity of the moment is equally recognizable, in the child's kicking fury, his caretaker's determination, the scolding pique of the older woman and the sly interest of the siblings.

While most of Rembrandt's drawings of children are rumbustious, those of Saskia in bed anticipate the intimacy of Johannes Vermeer (1632–75). With hindsight these drawings appear elegiac, even premonitory, but their tender sense of a loved, weakened wife perhaps rather registers Rembrandt's response to her pregnancies. In one (91), made

around 1640, Saskia can be seen through the curtains of her elegant four-poster bed, sitting up but looking wan. Beside the bed lies a long wicker basket with a pillow in it for the wetnurse, who would sit there to feed the baby while protecting it from draughts. The pen strokes are confident and varied, from the bold outlines of the furnishings to the delicate scribbles that denote Saskia and her bedclothes. The limpid strokes of wash, applied with a dry brush, recall the translucent shadows in Rembrandt's oil paintings. Alternating with areas of off-white paper, they suggest the light of a drowsy afternoon. Rembrandt's drawings look more haphazard and scratchier than those of his predecessors, and they convey a powerful sense that Rembrandt captured life as he saw it.

However spontaneous these drawings may seem, many had artistic sources and purposes beyond Rembrandt's straightforward delight in recording those around him. Their casual form and subjects placed them in an evolving tradition of drawings of unassuming events that are apparently taken from life but that frequently refer to artistic prototypes. Two innovative draughtsmen in this vein were the Dutch artists Roelant Saverij (1576–1639), who inscribed such studies *naer het leven* ('from the life') even when they were not, and Jacques de Gheyn II (1565–1629), a friend of the Huygens family. Rembrandt surely knew their work. Saverij lived on the Sint Antonisbreestraat until he died (in the year Rembrandt moved there), and Jacques de Gheyn II was the father of Jacques de Gheyn III, who had bought the *Two Old Men Disputing* (see 33) and two other paintings by Rembrandt. The drawing of Saskia in bed is one of Rembrandt's sheets *naer het leven* that may allude to artistic precedent. Its touching view of the exhausted mother behind the opened curtains of a grand bed recalls a famous woodcut by Albrecht Dürer of *The Birth of the Virgin* (c.1503), which Rembrandt apparently owned.

Besides filtering real-life observations through familiar compositions, Rembrandt often turned such sketches into more finished works of art, from etchings to history paintings. In the case of *The Pancake Woman* of 1635 (92), Rembrandt based the etching on several life drawings, including one of children gathered around a pancake baker and another of a crying

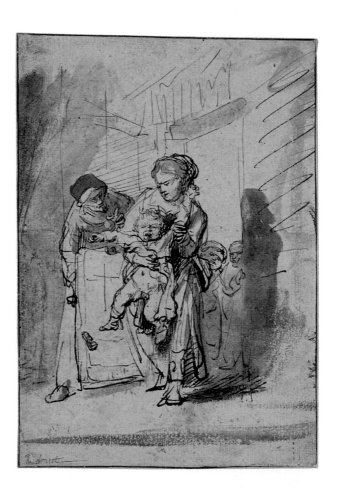

90
Crying Boy,
*c.*1635.
Pen and
brown ink,
wash, white
body-colour;
20·6 × 14·3 cm,
8$\frac{1}{8}$ × 5$\frac{5}{8}$ in.
Staatliche
Museen
Preussischer
Kulturbesitz,
Gemäldegalerie,
Berlin

91
*Saskia in her
Lying-In Room*,
*c.*1640.
Pen and brown
ink, brush
and brown
wash, white
body-colour;
17·7 × 24·1 cm,
7 × 9$\frac{1}{2}$ in.
Rijksprenten-
kabinet,
Amsterdam

boy (see 90), desperate to save his pancake. This child also made his way into *Ganymede* (see 74). The composition was based on pictures by two other artists of a pancake baker seen in profile; indeed, Rembrandt may well have owned the scruffy *Pancake Baker* (93) by Adriaen Brouwer (1606–38), a painter of rough peasant themes. Yet Rembrandt's integration of these sources into *The Pancake Woman* nevertheless impresses us as a scene etched directly from life. For this reason, Rembrandt's studies of women and children have always appealed greatly to collectors. In 1680, the inventory of Jan van de Cappelle (1626–79), a discerning connoisseur and amateur painter, mentioned 135 of Rembrandt's 'drawings of the life of women with children'.

The unpretentious character of Rembrandt's domestic drawings from about 1635 to 1642 departs from the insistent, grotesque realism of his early beggars, *tronies* and nudes. The incisive observation that marks these private drawings is shared by his striking public portraits of this period. He portrayed several distinguished citizens in full-length poses befitting their status, yet with sensitive facial features. Others appear in an intimate half-length format as if at a window. Rembrandt first experimented with this illusionist format in two ambitious self-portraits, an etching of 1639 and a painting of the following year.

In the etching, Rembrandt turns his head to confront the viewer from behind a stone ledge, on which he rests his arm (94). He is well turned out in an embroidered, fur-trimmed cloak and a shirt with striped sleeves and lace cuffs. The cloak's upturned collar and the dashingly cocked beret frame his well-lit face. An expanse of white paper behind Rembrandt focuses attention on his peering eyes and furrowed brow, signs of a confident seriousness. Despite his fine attire, however, the print is no mere record of status. The costume is of sixteenth-century rather than contemporary make, and the composition draws on two powerful Italian Renaissance portraits. Rembrandt took the voluminous material draped over the sill and the lively turn of the head from Titian's *Portrait of a Man* (95). The painting was in Amsterdam at the time, in the superb collection of Alfonso Lopez, who around this date bought at least one painting from Rembrandt. The changes Rembrandt made to Titian's composition originated in Raphael's portrait of the

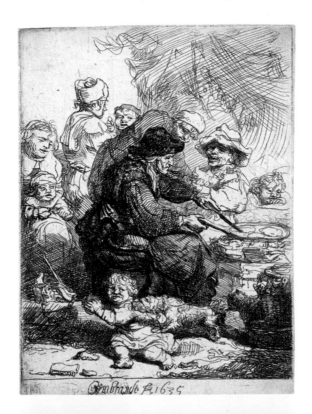

92
*The Pancake
Woman*,
1635.
Etching;
10·9 × 7·7 cm,
4¼ × 3 in

93
**Adriaen
Brouwer**,
Pancake Baker,
mid-1620s.
Oil on panel;
33·7 × 28·3 cm,
13¼ × 11⅛ in.
Philadelphia
Museum of
Art

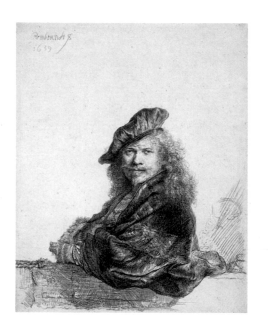

Italian courtier Baldassare Castiglione (96). Rembrandt integrated Castiglione's frontal gaze, beret, upturned collar, fur-trimmed sleeves and folded hands into his self-portrait. He based his design on a thumbnail copy (97) that he had made of the painting in 1639, when it was sold at auction in Amsterdam to Lopez. In his sketch Rembrandt altered the slant of the beret, an impulse he followed in his etching.

Rembrandt's fascination with the two Italian portraits is confirmed by a painted self-portrait (98). Both his costume and beret, arranged more modestly, and the picture's muted tonality acknowledge Raphael's Castiglione. Rembrandt's imposing sleeve, gentler turn of the head and introspective gaze, however, align his painting more closely with Titian's model. He adopted Titian's triple use of the ledge, as support for the arm, backdrop for the sleeve and surface for a signature.

To Amsterdam connoisseurs, Rembrandt's references to the Italian portraits would have made his self-portraits works of emulation, deliberate efforts to evoke and surpass the great artistic achievements of the past. The idea of emulation was central to artistic education, ultimately derived from the theory of rhetoric on which all seventeenth-century teaching was founded. In literature, *aemulatio* was the final stage in the student's attempt to surpass teachers and famous predecessors. In the first phase, *translatio*, students learned to translate the classical writers into contemporary Dutch. They then proceeded to *imitatio*: writing poetry or prose in language as elegant and effective as that of the classical models. Finally, writers strove to outdo these exemplars through *aemulatio*. A favoured technique of imitation and emulation was *contaminatio*, the seamless melding of the motifs and formal characteristics of several examples. Huygens practised all these rhetorical exercises in poems based on the epigrams of the Roman poet Martial and his Renaissance counterpart Erasmus. Playwrights such as Pieter Cornelisz Hooft, Bredero and Vondel enacted *translatio*, *imitatio* and *contaminatio* in updated translations of classical drama. Hooft's *Achilles and Polyxena* (c.1614), for example, fuses classical accounts of the Trojan War in a tragedy that is spiced with nimbly integrated translations and imitations from Ovid and the first-century playwright Seneca. His comedy *Schijnheiligh* transposes

94
Self-Portrait Leaning on a Stone Sill, 1639. Etching and drypoint, second state; 20·5 × 16·4 cm, 8 × 6$\frac{1}{2}$ in

95
Titian, *Portrait of a Man*, c.1512. Oil on canvas; 81·2 × 66·3 cm, 32 × 26$\frac{1}{8}$ in. National Gallery, London

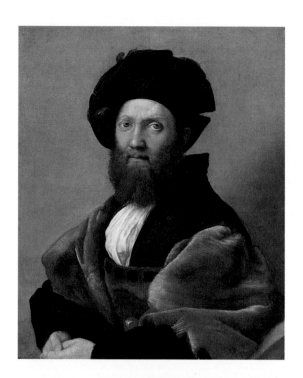

96
Raphael,
*Portrait of
Baldassare
Castiglione*,
c.1514–15.
Oil on canvas;
82 × 66 cm,
32¼ × 26 in.
Musée du
Louvre, Paris

97
**Rembrandt
after Raphael**,
*Portrait of
Baldassare
Castiglione*,
1639.
Pen and
brown ink,
brush and
brown
wash, white
body-colour;
16·3 × 20·7 cm,
6½ × 8⅛ in.
Graphische
Sammlung
Albertina,
Vienna

98
Self-Portrait,
1640.
Oil on canvas;
93 × 80 cm,
36⅝ × 31½ in.
National
Gallery,
London

The Hypocrite by the Italian Renaissance poet Pietro Aretino into a
Dutch setting, and was itself emulated in verse by Bredero. Vondel
emulated classical models by giving their pagan themes a Christian
twist. His successful *Joseph in Egypt* (1640) was a Christian version
of Seneca's *Hippolytus*, which Vondel had once translated in order
to steep himself in the Latin author's emotional expressiveness.

The creative potential of emulation was a commonplace in the
seventeenth-century visual arts as well; Rembrandt may have been
explicit about it in his teaching. His pupil Van Hoogstraeten empha-
sized it in his 1678 treatise, advising painters to pursue 'rivalry in order
to surpass the foremost'. Rembrandt's self-portraits may emulate not
only Raphael and Titian but also the accomplishments of their sitters,
in whose roles Rembrandt painted himself. He inscribed his drawing
of Raphael's portrait with the name of the sitter, and may well have
been aware of Castiglione's contributions to Italian courtly culture.
The quintessential Renaissance courtier, Castiglione was famous for
his *Book of the Courtier* (1528), a prescriptive evocation of life at the
ducal court in Urbino. Although no Dutch painter could aspire to
Castiglione's status in the Republic, Rembrandt had ascended to its
urban equivalent. Documents indicate that, like many members of
the citizen élite, Rembrandt became a serious collector at this time,
acquiring rare prints by Lucas van Leyden and an expensive painting
by Rubens, the most sophisticated contemporary painter–courtier.

Titian's sitter was believed in the seventeenth century to be the
Renaissance poet Ludovico Ariosto, and it is possible that Rembrandt,
by assuming the guise of 'Ariosto', was making claims for the equality
of the intellectual art of poetry and the manually intensive art of
painting. The rivalry between poetry and painting had deep roots in
the Renaissance and was replayed in contemporary treatises on art,
including the published speech of Philips Angel, who had praised
Rembrandt for the literary qualities of his *Wedding of Samson* (see 82).

Rembrandt's self-portraits of 1639 and 1640 certainly announce his
social alignment with the prominent citizens he was commissioned to
portray. His breathtaking portraits of the married couple Nicolaes van
Bambeeck (99) and Agatha Bas (100), painted in 1641, are illusionistic

extensions of his emulation of Titian. Both sitters appear to lean out of arch-shaped surrounds that represent ebony picture frames. So true-to-life are these portraits, the illusion seems to say, that they might step out of their frames. Although both canvases have lost parts of their painted frames and differences in cleaning have separated them in tone, their illusion remains startlingly fresh. Van Bambeeck rests his right arm and left hand on the frame; his sleeve and glove hang in front of it. His quiet pose and expression recall Rembrandt's painted self-portrait (see 98), but the frame, protruding nose and projecting fingers bring him closer to the viewer. His wife's presence is even more tangible. With her left hand holding the side of the frame, she has unfolded her painted fan into our space.

Her pose is unusually forthright for a seventeenth-century portrait of a woman: rather than turning towards her husband, she stands frontally. The light from top left (consistent in both portraits) creates soft shadows on the left side of her face, giving her features more pronounced relief than in more conventional portraits, where the woman's face is turned into the light and thus illuminated more evenly (see 47 and 50). The painterly refinement of her attire is equally arresting. Rembrandt tipped and curled the edges of her lace collar and cuffs, and layered her costume with judicious use of shadow and by contrasts of colour and textural illusion. Her white shirt-sleeves, delineated in dry, undulating strokes, appear puffy underneath the slit black sleeves of her outer garment, and the elegant tip of her bodice casts a shadow onto the brocaded dress below. Intricate knots, rosettes and jewellery are delicately sculpted in paint. The shadows of the bracelets are unexpectedly red, creating an impression of live flesh below lustrous pearls. Her luxurious dress may acknowledge her husband's successful cloth business, and it is fitting for a daughter of the prominent Bas family. The portraits would originally have been set in real ebony frames that further reduced the barrier between image and three-dimensional reality.

For all their presence, the couple's portraits possess the quiet decorum considered proper to the urban élite. In a sense, the incisive but restrained observation of Rembrandt's works after the mid-1630s provides a pictorial equivalent to this social ideal, a deliberate

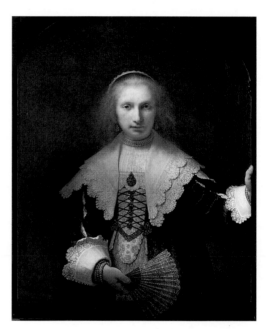

departure from the realist swagger of his earlier works. Extroversion was a quality praised in few, and only ever in men: preachers, guardsmen, actors. In several important commissions, Rembrandt portrayed forceful, demonstrative men of this sort, as in a monumental double portrait from 1641, which shows the preacher Cornelis Claesz Anslo leaning away from his desk to make a point (101). The low viewpoint, unusual in Rembrandt's portraits, may have been determined by an intended high location, perhaps over a mantel, but it also enhances the power of Anslo's speech by evoking his customary position in a pulpit. His indeterminate gaze does not directly address the viewer or his wife, Aeltje Gerritsdr Schouten, but reaches a wider congregation beyond the beholder.

Anslo was a prosperous cloth merchant who also served as a teacher and leader of a Mennonite congregation to which Hendrick Uylenburgh belonged. Named after their founder Menno Simons, the Mennonites were Protestants who advocated a modest, sober life based on Christ's precepts. Fundamentally anti-hierarchical, they rejected government office and chose to be guided by gifted members of their congregation rather than by ordained ministers. Anslo's legendary oratorical skills were dedicated to expounding the Word of God. To signal the source of Anslo's message, Rembrandt placed him before a bookcase and let him indicate the opened Bible and other books on his table. A model member of his audience, his wife looks at these texts while she keeps her right ear turned towards him. Paradoxically, Rembrandt's visually arresting picture proclaims the primacy to Mennonites of the Word – of speech and of hearing God's message.

This position is more explicitly stated in a portrait etching of Anslo, also dated 1641 (102), in which he appears alone in his study. His pen, inkwell and pen case suggest that he has paused in writing a sermon. His mouth is slightly open, and his declamatory gesture is subservient to the book it indicates. A painting stands facing the wall; the nail visible above it hints that it has been taken down. These motifs, not present in the preparatory drawing for the etching, may express the Protestant argument against the use of religious images. Despite the print's scholarly stillness, Anslo's confidence in the Word rings out

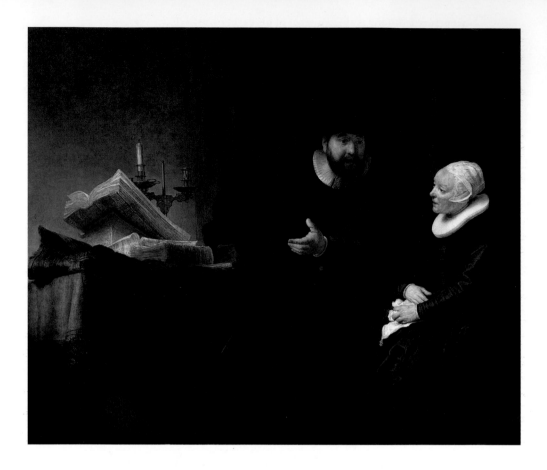

against the mute painting, an idea captured in lines by Vondel
inscribed on the back of the preparatory drawing:

Aye Rembrandt, paint *Cornelis'* voice.
His visible part is the least choice:
Th'invisible one is known but through the ear.
Whoever would see Anslo, must hear.

A Mennonite at the time, Vondel published the poem in 1644 but prob-
ably intended it to be printed below the portrait. It rephrases the
Mennonite doctrine that verbal perception is more truthful than sight,
a notion Rembrandt skilfully worked into Anslo's portraits. The pres-
ence of the poem on the back of the preparatory drawing for the
etching suggests that Rembrandt took up its challenge in his finished
portraits of the preacher. In the painted double portrait, Anslo's voice
seems to be projected by his active body and parted lips.

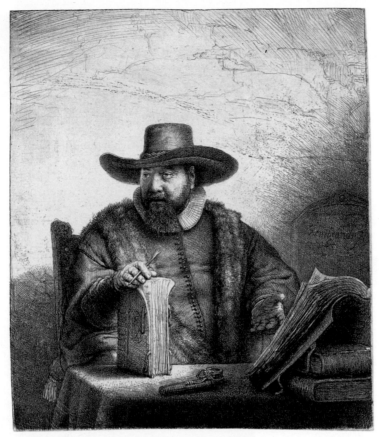

101
Double Portrait of Cornelis Claesz Anslo and Aeltje Gerritsdr Schouten,
1641.
Oil on canvas;
173·7 × 207·6 cm,
68³⁄₈ × 81³⁄₄ in.
Staatliche Museen Preussischer Kulturbesitz, Gemäldegalerie, Berlin

102
Portrait of Cornelis Claesz Anslo,
1641.
Etching and drypoint;
18·8 × 15·8 cm,
7³⁄₈ × 6¹⁄₄ in

While Rembrandt was portraying Anslo, he was already at work on the prestigious task of painting the militia company of Captain Frans Banning Cocq and Lieutenant Wilhem van Ruytenburgh. The resulting work, *The Nightwatch* (103), is his most legendary painting. Although the commission is poorly documented, its facts are fairly clear. Between 1638 and the end of 1640 Rembrandt received an order to paint the militia portrait for the great hall of the Kloveniersdoelen, an elegant new meeting place of the *kloveniers* or harquebusiers, a civic guard allowed to bear muskets. Banning Cocq's company was one of six subdivisions of the guild of harquebusiers, and between 1639 and 1645 the other companies commissioned portraits for the same room from other leading portraitists of Amsterdam, including Nicolaes Eliasz (104), Govaert Flinck and Bartholomeus van der Helst (1613–70). The decoration of the hall was the most prestigious commission of the decade. Just how Banning Cocq and his men were referred to

103
The
Nightwatch,
1642.
Oil on canvas;
363 × 438 cm,
$142\frac{7}{8} \times 172\frac{1}{2}$ in.
Rijksmuseum,
Amsterdam

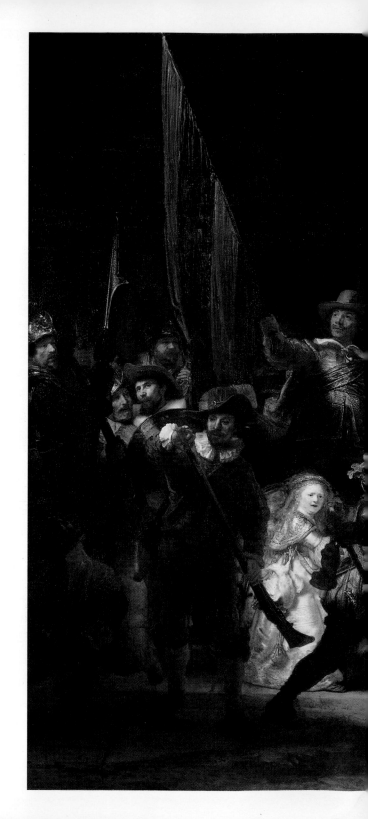

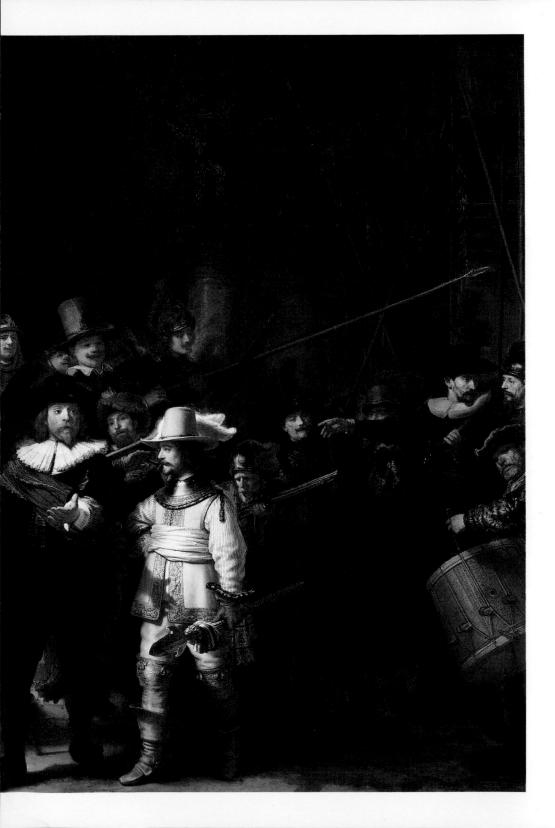

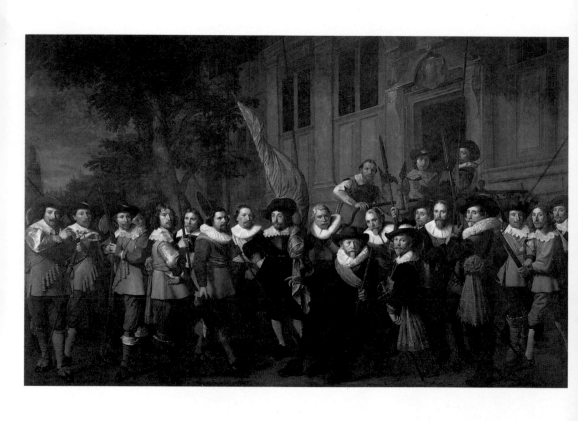

Rembrandt is not known, but since most of the guardsmen were wealthy cloth merchants, it is possible that the introduction was arranged by fellow merchants such as Anslo or Van Bambeeck.

Rembrandt was paid 1,600 guilders for his portrait of Banning Cocq, Van Ruytenburgh and sixteen of their men. According to the testimonies of two sitters, the guardsmen paid about one hundred guilders a head, 'the one a little more and the other a little less, according to their place [in the painting]'. This implies that the sitters knew how they were to be placed in the painting before Rembrandt completed it. He probably presented a sketch of the composition for approval before painting the canvas, and he also must have made preliminary drawings of the setting, the sitters and additional figures. Only two loosely related drawings of militia men survive, but x-ray photographs of *The Nightwatch* confirm that Rembrandt thoroughly prepared its complex composition, for he made few alterations in the course of painting. He surely painted the huge work outside the hall, perhaps in a wooden gallery that he constructed around this time in the courtyard behind his house. After he signed the work in 1642, it was hung in its intended position in the Kloveniersdoelen, opposite windows that overlooked the River Amstel. Around 1715 *The Nightwatch* was moved to Amsterdam's Town Hall, and a century later to the new Royal Museum, the precursor of the Rijksmuseum. It is now the focus of the Rijksmuseum's Gallery of Honour, flanked by the other militia portraits painted for the Kloveniersdoelen, and admired as a national treasure.

If it is difficult to cherish *The Nightwatch* in the same way as Rembrandt's more intimate works, it is impossible not to marvel at its monumental scale, animated pageantry and lustrous light. For much of the nineteenth and twentieth centuries it was seen as the problematic masterpiece of Rembrandt's career, its personal stamp held responsible for precipitating his presumed decline into poverty and ostracism. Although there is no evidence that the men portrayed were dissatisfied with their overlapping or shaded portraits – Rembrandt was paid a respectable sum and the picture was placed where it belonged – admiration for the painting was qualified virtually from the beginning. The earliest known responses suggest how contemporaries saw

104
Nicolaes
Eliasz,
*The Company
of Captain Jan
van Vlooswijck*,
1642.
Oil on canvas;
340 × 527 cm,
133⅞ × 207½ in.
Rijksmuseum,
Amsterdam

this painting that mixes portraiture and action, contemporary costume and timeless attire, theatrical posturing and frantic disorganization.

The first records of the painting's reception are primarily pictorial. By 1649 Captain Banning Cocq, presumably proud of his company and content with its portrait, commissioned a painted copy of *The Nightwatch*, which was then copied on paper for his album of memorabilia (105). Both copies show that the painting was cut down seriously along the left and the top. On the left, two men and a child were removed and the space for the boy rushing forward became cramped. This damage was done around 1715, when the painting was made to fit between two doors in the town hall. Although destructive by modern standards, this measure, intended to accommodate the painting in the town hall, meant no disrespect. The drawing in Banning Cocq's album is described in a seventeenth-century hand: 'Sketch of the painting in the large hall of the Kloveniersdoelen, in which the Lord of Purmerland [Banning Cocq], as captain, summons his lieutenant, Lord of Vlaardingen [Van Ruytenburgh], to order his company of citizens to march out.'

Banning Cocq's description of *The Nightwatch* as an action scene rather than a portrait agrees with comments by Van Hoogstraeten, who worked in Rembrandt's studio in the early 1640s. In 1678, he praised the picture in a passage on proper composition:

It doesn't suffice for a painter to place his figures next to one another in rows, the way one sees here in Holland all too often in the militia halls. The true masters ensure that their entire work is unified … Rembrandt observed this very well, according to many rather too well, in his militia painting in Amsterdam, making more work of the large image of his choice than of the individual portraits that had been commissioned from him. Nevertheless, in my opinion that same work, however flawed, will outlast all of its competitors because it is so painterly in thought, so dashing in the effortless placement of the figures, and so forceful that, according to some, in comparison all the other militia pieces there [in the Kloveniersdoelen] look like playing cards.

Clearly, van Hoogstraeten admired Rembrandt's artful yet seemingly uncontrived composition, even if it compromised individual likenesses.

105
Jacob Colijns (?) after Rembrandt, *The Nightwatch*, c.1649–55. Black chalk and watercolour; 18·2 × 23·3 cm, 7⅛ × 9⅛ in. Rijksmuseum, Amsterdam on loan from a private collection

Bernhardt Keil, another pupil of Rembrandt in the 1640s, was less sanguine about the composition. His comments on *The Nightwatch* were relayed in 1686 by the Italian writer Filippo Baldinucci, who discussed Rembrandt in a treatise on great printmakers. Baldinucci expressed surprise that such a successful artist should have produced a painting that was so 'jumbled and confused that the figures were barely distinguished from each other, although they were made with great study from nature'. Despite these reservations, he recognized that the

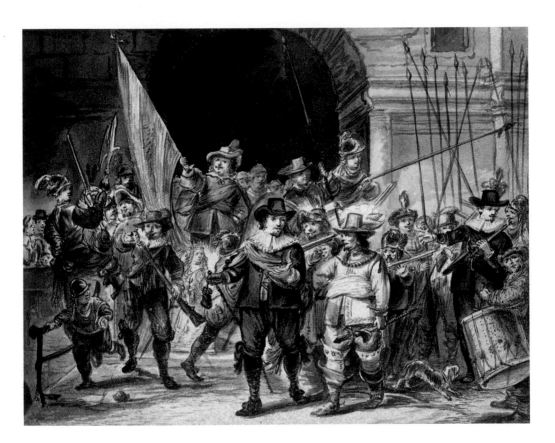

painting brought Rembrandt extraordinary renown, primarily because the captain was painted 'with his foot raised in the act of marching' and 'with a halberd in his hand that is so well drawn in perspective, that, even though on the canvas it looks no longer than half an arm, it appears to all as if it is in full length'.

Although Baldinucci garbled Keil's report by conflating the captain's marked step with his lieutenant's protruding partisan, Keil's admiration

for Rembrandt's illusionism is evident. Splendidly attired in black and gold, Banning Cocq is identified as a captain by his red sash, baton and dangling glove. He steps towards the viewer and extends his left hand with the rhetorical gesture of Anslo (see 101). Strongly foreshortened, his back-lit hand is an illusionist masterpiece; it gives forward thrust to his movement and marks the addressee of his summons by casting a precise shadow onto the lieutenant's gold jacket. Van Ruytenburgh has turned his head in profile to attend to the order as he steps in time with his captain (see 88). The apparent protrusion of his partisan in front of the picture surface, linked visually to Banning Cocq's projecting gesture, is the most spectacular of many such passages in the painting. Further back a musket, a lance, a banner and a pike come forward less insistently; this gradual loss of projection as objects recede in space mimics optical experience. Rembrandt achieved these effects by differentiating the paint texture, building up the pigments in foreground objects and flattening them for figures in the middle and background. Applying traditional atmospheric perspective, he used strong contrasts of colour and brightness to make the captain, lieutenant and man in red come forward. In the background, Rembrandt created more muted contrasts in a palette of grey, ochre, brown and green.

Van Hoogstraeten and Keil spoke as artists. To Banning Cocq's company and to those who visited the Kloveniersdoelen, *The Nightwatch* must have been an innovative collective portrait of the militia's role, history and ambitions. Rembrandt sacrificed the clarity of some individual faces to this aim, as comparison with Eliasz' *Company of Captain Jan van Vlooswijck* (see 104) makes clear. Several of the militia men are in half shadow, and a few heads are obscured to such an extent that their status as portraits is dubious. In the central background, the single eye staring out below a telltale beret may belong to Rembrandt, but the identification of this man, too, remains uncertain. Rembrandt further heightened the confusion about the identities of the guardsmen by inserting over a dozen extraneous figures. The overwhelming prominence of Banning Cocq and Van Ruytenburgh stems partly from their high social and military status: as titled regents, they are distinguished pictorially from the merchants

who served under them. Nevertheless, the militia company may have been troubled by the relative obscurity of some portraits, for soon after the painting's completion an unknown artist added the heraldic shield on the arch that bears the names of the eighteen men portrayed.

The three civic militia guilds of Amsterdam boasted an illustrious history originating in the fourteenth century. The officers who commanded the companies of each guild belonged to the city's ruling patriciate, and lesser members, too, had to be sufficiently well-off to afford the dues. The militias traditionally guarded the city gates and kept order, but by the seventeenth century their functions had become largely ceremonial. In summer the companies conducted weekly Sunday marches through the city. When Marie de' Medici, the exiled former regent of France, visited Amsterdam in 1638, the militia guilds marched to enliven her festive entry. The civic guard could still expect to be mobilized, however, as they had been in 1622 when Prince Maurits asked Amsterdam to assist in the defence of Zwolle. Although the expected Spanish attack never materialized, the poet Jan Jansz Starter praised the valiant guards of Amsterdam in the refrain, 'When the Land is in peril, every citizen is a soldier'. The militia companies thus preserved their military rights, which also served the symbolic purpose of proclaiming Amsterdam's independence against the claims of the States General or *stadhouder*. The privileges of the harque-busiers included the right to bear muskets, conduct target practice and fire arms during marches.

Militia portraits traditionally represented the civic guard in company attire at their annual banquets or arranged in formation. Those by Frans Hals, in particular, convey a lively sense of guardsmen celebrat-ing in this way (see 44). Rembrandt was the first painter to organize his militia portrait around the central action of the captain summon-ing his lieutenant, and to subordinate the other militiamen to this theme. Rather than being lined up, the company is beginning to gather in front of a wall pierced by a dark arch, which symbolically refers to the city walls and gates traditionally defended by the militia. The drummer at the right strikes a rousing rhythm, while near him

a man in black civilian dress alerts others to the captain's movement. The ostentatiously dressed ensign has just unfurled the company banner; behind him to the left, several men strain to follow the proceedings.

Not all figures are falling into line. The boy with the powder horn runs off, perhaps because he has been frightened by the commotion behind the captain, where a youth in old-fashioned military costume strides against the general movement, disappearing behind Banning Cocq. A musket has emitted white puffs of smoke around Van Ruytenburgh's hat, making it clear that the diminutive soldier has just fired, to the alarm of the man who wards off the gun with his hand. What to make of this misguided shooting? Possibly, it serves to emphasize the

company's right to bear arms, which is elaborated by two other men handling muskets. Together, the three figures demonstrate the art of musketry in a sequence from left to right. The man in red is ramming the gunpowder, the youth has fired, and the helmeted figure to the lieutenant's right is blowing the pan. Each of these actions was pictured in similar fashion in a well-known manual, *The Exercise of Armes* (1607), illustrated by Jacques de Gheyn II (106). But while the men who open and close the sequence handle their guns in a pacific manner, the ill-timed firing suggests abuse of the musket privilege. The concerned reaction of one militia member recalls the company's habitual observance of the laws and etiquette of gunfire.

By partially hiding the firing youth, Rembrandt limited the distraction from the central theme. By contrast, the ravishing girl in gold and blue is designed to call attention to herself (107). As bright as Van Ruytenburgh, she is framed by the man in red, the striding youth and the captain's glove. Like the shooting youth, the girl and her less prominent companion move against the company's forward direction, surely because they, too, serve a symbolic role. Her gold and blue are the heraldic colours long associated with the *kloveniers*, and she holds aloft a silver-rimmed drinking horn of the type used during company banquets. Even the white fowl suspended from her belt owes its presence to the company's traditions: its prominent claws represent the militia's emblem, displayed on all guild paraphernalia.

The brilliant illusionism, active portraits and cleverly integrated heraldry do not by themselves account for the fascination of *The Nightwatch*. The painting as a whole has a pronounced theatrical character, effected by the lively action, varied costumes and stage-like space, which distributes the actors on different levels in front of a structure that resembles a theatre set. The drummer and the two emblematic girls evoke the actors who traditionally accompanied the pageants of amateur theatre groups and perhaps of the militia guilds themselves. Banning Cocq's dramatic step and gesture make him the central actor in this *tableau vivant*.

Beyond its theatrical character, the painting owes its power, as Van Hoogstraeten claimed, to its pictorial unity. By wishing that Rembrandt 'would have kindled more lights in it', however, he censured the selective distribution of glowing lights that was Rembrandt's signature unifying technique. Van Hoogstraeten's remark about the painting's darkness contains the germ of the painting's popular name. It is often noted that this civic guard had no nocturnal duties and that the picture was named *The Nightwatch* only around 1800, when the remaining civic militia did patrol at night and the painting had become obscured by thick yellow varnish. Van Hoogstraeten's comment underlines the unusual darkness of this militia portrait, even without discoloured varnish. Although its darkest pigments have become darker with time, the painting's light was never that of a sunny day.

106
Robert de
Baudous after
Jacques de
Gheyn II,
*Ramming the
Powder, Firing
and Blowing
the Pan*, from
*The Exercise
of Armes*,
1607

108
The Triumph
of Mordecai,
c.1640–2.
Etching and
drypoint;
17·4 × 21·5 cm,
$6^7_8 × 8^1_2$ in

It is a light Rembrandt had developed in his history paintings, in his
Sacrifice of Abraham or *Blinding of Samson* (see 78, 79). This light is
dazzling when it picks out significant faces and events, muted when it
leaves lesser details in translucent shade. It throws strong foreground
shadows to suggest depth. In *The Nightwatch* it harmonizes an astonish-
ingly disparate array of figures and gives them a sense of shared purpose.

The company's choreography is equally indebted to Rembrandt's
historical compositions in which bystanders surround central charac-
ters in undulating movement. Particularly close to *The Nightwatch* in
many respects is *The Triumph of Mordecai* (108), etched by Rembrandt
around this time. When the Jews lived in exile in Persia, Mordecai
uncovered a plot against King Ahasuerus, who was married to
Mordecai's foster-child Esther. Ahasuerus asked his adviser Haman,
the adversary of the Jews, how to thank the saviour of a king. Expecting
the tribute to befall himself, Haman proposed giving such a man a
royal procession on horseback. Ahasuerus then ordered Haman to
honour Mordecai in this fashion, making him shout 'See what is done
for the man whom the king wishes to honour' (Esther 6:6–11). In the
etching Haman strides forward in the manner of Banning Cocq,

watched by Ahasuerus and Esther from a balcony at upper right. Mordecai and Haman are followed through the gate by boisterous spectators, some grateful and deferential, others sneering and angry. After this episode, Esther and Mordecai were to save the Jews from the destruction Haman plotted for them (see 23). To some contemporaries, Mordecai's role as saviour of God's chosen people made him an exemplar for men such as Banning Cocq, sworn to uphold the independence of the citizenry.

In its fusion of portrait, allegory and history, *The Nightwatch* is unparalleled in the history of the militia portrait. It had no heir in the genre, in part because of its unconventional character and in part because the civic guards were quickly losing their *raison d'être*. The militia guilds of Amsterdam fell into decline before the end of the seventeenth century, even though in 1650 they were still prepared to defend the city against the threat of a siege by the *stadhouder* Willem II (r.1626–50), whose powers Amsterdam sought to curb. In the painting that is their finest memorial, Rembrandt pushed the synthesis of portrait and narrative, first explored in *The Anatomy Lesson of Doctor Nicolaes Tulp* (see 52), as far as a group portrait could bear. Only a hierarchical institution as steeped in history and pageantry as a civic guard could have given him the opportunity to do so, and it therefore comes as no surprise that Rembrandt's work after *The Nightwatch* lacks its exuberance.

Until the 1960s, the year 1642 was seen as the fateful summit of
Rembrandt's life. The death of Saskia and the presumed critical failure
of *The Nightwatch* were believed to have precipitated a dramatic
change of fortune. Biographies routinely sketched the decade after *The
Nightwatch* as one of domestic upheaval, a steep decline in commis-
sions, rejection by in-laws and patrons and imminent financial ruin.
But, most writers agreed, disaster had its artistic benefits. Most of
Rembrandt's works from the 1640s are smaller and more tranquil than
the spectacular set pieces of the preceding decade. Their introspective,
sometimes melancholy tone encouraged biographers to locate the
genesis of this new art in Rembrandt's troubled mind. In 1948 the art
historian Jakob Rosenberg phrased the change in memorable terms:

109
Jan Six,
1647.
Etching,
drypoint and
engraving;
24·5 × 19·1 cm,
9⅝ × 7½ in

Such a piling up of misfortunes must have made these years bitter ones
for Rembrandt. But disillusionment and suffering seem to have had only
a purifying effect upon his human outlook. He began to regard man
and nature with an even more penetrating eye, no longer distracted by
outward splendour or theatrical display … An altered sense of values is
revealed in his art of this middle period. He was able to approach his
immediate surroundings and his fellow men with a heightened sensitive-
ness to true human values and to interpret the Bible with deeper sincerity.

Rosenberg discerned direct connections between Rembrandt's personal
difficulties in the 1640s, his financial problems of the 1650s and the
quietly observant character of his work throughout this period. It is
a gripping story, but Rosenberg's thesis should be qualified by the
evidence. Although Rembrandt's domestic life after Saskia's death
was disorderly, the heightened intimacy and introspection of his art
preceded his private ordeals. His patronage did not so much decline as
change in character, from a clientele of wealthy merchants, profession-
als and preachers to a circle of intellectuals and artists. And his financial
ruin was a complex affair of the 1650s with few links to his earlier

personal troubles (see Chapter 7). Even so, Rosenberg succinctly identi-
fied the special fascination of Rembrandt's art and life in the 1640s.

Rembrandt's 'heightened sensitiveness' to people and their environ-
ment was already evident in his *Christ Appearing to Mary Magdalene*
– a theme of tremendous dramatic potential – which he painted in
subdued fashion in 1638 (110). Instead of having Mary attempt to touch
Christ, as was customary, he showed her at the point of realizing that
the gardener is the resurrected Christ. Her attitude of surprise, much

110
Christ
Appearing
to Mary
Magdalene,
1638.
Oil on panel;
61 × 49·5 cm,
24 × 19½ in.
Royal
Collection

gentler than the vehement responses in *The Raising of Lazarus* (see 26),
registers her dawning recognition. The setting outside Jerusalem has
a delicacy rarely matched in Rembrandt's painted landscapes. Even
when his works of the 1640s retain an interest in theatrical splendour,
their expressive realism is subdued compared with the histrionics of
the penitent Judas or the writhing Samson. For all its colouristic spec-
tacle, *Christ and the Woman Taken in Adultery*, painted in 1644 (111),
envisions the shame of the adulteress and the wrath of her persecutors
as intimate emotions.

Rembrandt's personal life after Saskia's death was certainly unconventional, and it caused difficulties despite his comfortable finances: his assets at Saskia's death were valued at 40,750 guilders. Unlike most well-off young widowers of his time, he did not remarry. Saskia's will stipulated that Rembrandt should transfer half of their joint property to Titus upon remarriage, and although Rembrandt would have been able to give his son the money, he may have balked at the expense. Titus was an infant when his mother died, and Rembrandt employed

111
Christ and the Woman Taken in Adultery, 1644.
Oil on panel; 83·8 × 65·4 cm, 33 × 25¾ in.
National Gallery, London

Geertge Dircks to care for him. She soon became Rembrandt's mistress – a situation that became complicated when, in 1647, he engaged the much younger Hendrickje Stoffels as a live-in housekeeper. Hendrickje soon replaced Geertge in Rembrandt's affections, and he apparently attempted to buy Geertge off with a small alimony. Geertge denounced Rembrandt to a court of arbitration, claiming that he had broken a promise of marriage; the charge was not substantiated, but Geertge was awarded an increase in compensation. When she was found to

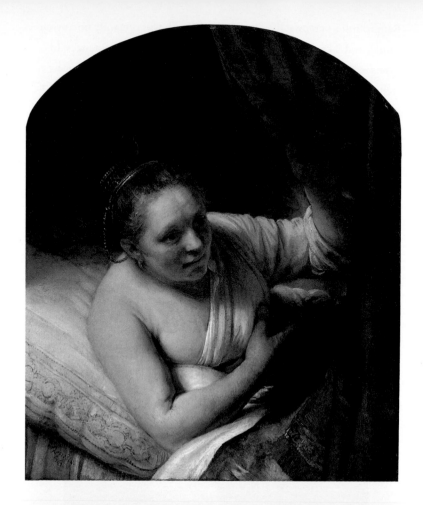

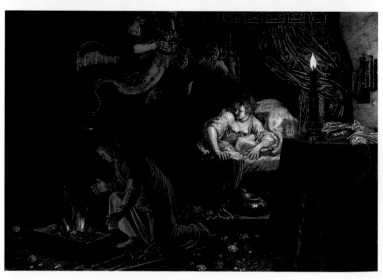

have pawned some of Saskia's jewellery, which she had been given, Rembrandt paid to have her detained in a house of correction. Whether or not these domestic disturbances made Rembrandt's art turn inward, he certainly encouraged this view by the unprecedented extent to which he turned his life and family into artistic subjects. He had already done so in his self-portraits, in paintings of Saskia as Flora and in drawings of women and children, and he continued the practice after 1642, thus helping shape the modern view of the artist, whose work is valued for the insight it affords into his life and soul.

It is possible that some of Rembrandt's biblical works from the 1640s comment on his relationship with Geertge, even though they are also ambitious history paintings. The subject of *Christ and the Woman Taken in Adultery* offered the comforting thought that Christ invited those without sin to cast the first stone (John 8:8). Admittedly, this meticulous painting cannot be reduced to such a personal purpose, but the parallel between the adulteress and Geertge may well have occurred to Rembrandt. Although Geertge cannot certainly be identified, she may have been the model for the intensely private *Woman in Bed* (112). Here a mature, well-rounded woman pushes aside a rich crimson bed curtain, leaning forward as though to address or to observe someone. Her features are startlingly specific. Before the nineteenth century, painters rarely painted nude or semi-nude women in bed unless they were representing seductresses such as Venus or Danaë. Rembrandt's model is certainly no divine love object, but her frown suggests she may be intended as Sarah, from the apocryphal Book of Tobit. Sarah had been married seven times, only to see each husband killed on the wedding night by an evil spirit. The guardian angel of Tobias, her eighth husband, taught him how to exorcise the spirit by burning the entrails of a fish (Tobit 8:1–3). Lastman's rare painting of this tale (113), which shows her leaning anxiously out of bed, may have stimulated Rembrandt to paint Sarah's observation of the exorcism.

The complexities of Rembrandt's private life did not have marked repercussions for his patronage or his social and financial standing. Rembrandt enjoyed prestigious commissions throughout the 1640s and apparently prospered. In 1646 Frederik Hendrik asked him to

112
Woman in Bed,
*c.*1645.
Oil on canvas;
81·1 × 67·8 cm,
31⅞ × 26¾ in.
National
Gallery of
Scotland,
Edinburgh

113
Pieter
Lastman,
The Wedding
Night of Tobias
and Sarah,
1611.
Oil on panel;
42 × 57 cm,
16½ × 22½ in.
Museum of
Fine Arts,
Boston

paint two scenes from the infancy of Christ to complement the Passion series. Rembrandt received 2,400 guilders for the pair, twice his fee for the last two Passion paintings. In these years Rembrandt became more closely associated with Amsterdam's intellectual élite, which constituted a new source of commissions.

If anyone was concerned about Rembrandt's extramarital relations it would have been Hendrick Uylenburgh, who was Saskia's uncle and a man of sober Mennonite faith. Uylenburgh's distaste may have caused a dearth of portrait commissions between 1642 and 1652, although Rembrandt made five portrait etchings of prominent sitters in this period and began to paint portraits again in 1652. It is possible that a cooled relationship with Uylenburgh temporarily weakened his position on the portrait market, where he was encountering serious competition from Govaert Flinck and Bartholomeus van der Helst. This younger generation of portraitists flattered sitters with grand poses, silken brushwork and a more variegated palette.

Flinck's portrait of Margaretha Tulp (114), Nicolaes' daughter, demonstrates the appeal of this style. Margaretha addresses the viewer from a garden terrace, in a pose that lets her silk dress flow to best advantage. Painted in 1655, the year of her marriage to the regent Jan Six, the portrait integrates allusions to pure love and to Margaretha's name into an image of effortless elegance. The tulip in the classical urn behind her was both a prized flower (some specimens fetched vast sums, especially during the 'Tulip mania' of the 1630s) and a reference to the name Tulp (Dutch for tulip). Slightly opened, it also refers playfully to her still virginal state, for the single tulip in an urn was an emblem of premarital virginity. The spray of flowers she holds in a fountain dedicated to Amor denotes the purity of her love. Moreover, Margaretha's first name means 'pearl' in Latin, a coincidence that prompted the prominent jewellery in the portrait and led Vondel to compare her natural beauty to that of an unadorned pearl. In a poem on Flinck's portrait, he credited its naturalism with arousing her fiancé's desire for his 'tulip'.

While Flinck's portrait may not look particularly natural to us, to Vondel and Six its easy elegance embodied an ideal of natural bearing.

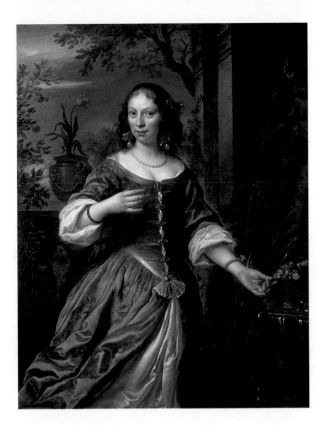

This bright, prestigious portrait mode derived from Van Dyck's court portraiture, and it became the manner of choice for Amsterdam's élite. Following Van Mander's terminology, art critics contrasted its smooth (*glad*), neat (*net*) brushwork with the rough (*rouw*) style. *Rouw* brushwork and restricted colour schemes rapidly lost favour in the 1650s, as changes in all Dutch genres of painting attest. Rembrandt's style had never been smooth, but in this period it became insistently rough. This predilection may have affected his portrait commissions, although many patrons, including Six, were sympathetic to it.

Rembrandt's decreasing activity as a portraitist allowed him, possibly by choice, to dedicate his efforts to history painting. Remarkably, all of his narrative paintings after *Danaë*, with a few late exceptions, have religious rather than mythological themes. His loss of interest in classical themes may have been due less to his personal inclinations (in the 1650s he made several mythological etchings) than to a general trend in the demand for history paintings. Mythological paintings

rarely accounted for more than four per cent of works in Amsterdam collections, and the average percentage declined over the century to the benefit of landscape, still life, portraiture and scenes of domestic and social life.

A few biblical paintings by Rembrandt from this decade are conspicuously delicate and diminutive in scale, replacing the dynamism of the grand religious works of the 1630s with images of domestic intimacy. Rembrandt's *Holy Family with a Curtain* of 1646 (115) shows a young

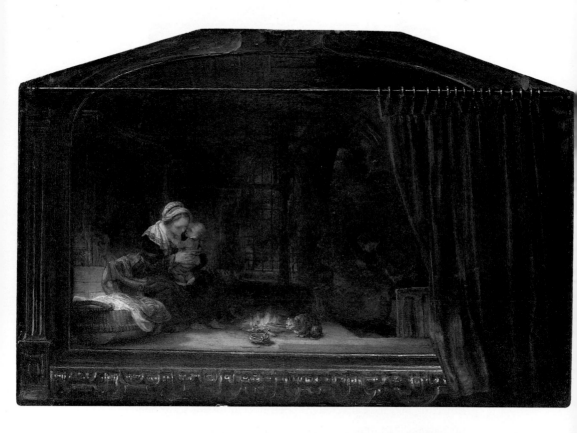

mother in a deep blue dress, her head and shoulders covered with white shawls, drawing to her a little boy in red. A cat sits by a fire, and in the darker recesses a man chops wood. Christianity's first family here recalls the newly popular domestic paintings of peasant and urban life. Mary's tender embrace of the boy, reminiscent of Rembrandt's drawings of mothers and children, follows a Netherlandish convention for emphasizing the earthly relationship between the Virgin and Christ.

The make-believe curtain in front of the illusionistically painted frame further indicates the scene's sacred nature. In traditional Christian ritual and art, curtains were often used to stage the revelation of holy figures – of Christ crucified, the consecrated Host or the Virgin Mary. Rembrandt's use of the curtain, however, is exceptional in that it 'reveals' the humble character of his religious truth, devoid of angels, haloes or references to Christ's sacrifice. In Protestant culture this painting may have been a particularly acceptable representation of the Virgin Mary, for she is seen not as saint but as model parent of Christ. In that sense, *The Holy Family with a Curtain* revives a saint who had been central to Christian belief and iconography in the Netherlands before the Reformation.

More mundanely, the curtain also represents the standard contemporary practice of covering paintings with a cloth to protect them from dust. It signalled a painting's treasured status and enabled owners to surprise guests by revealing it. Rembrandt's illusionistic version of the curtain calls attention to the painting's artistry. An invisible hand seems just to have drawn it back, for it is swinging towards the right and has yet to return to a vertical position. To an erudite viewer, the implied presence of someone pulling back the curtain would have recalled a famous ancient legend concerning artistic achievement, recounted by Pliny the Elder:

115
The Holy Family with a Curtain, 1646.
Oil on panel; 46·5 × 68·5 cm, 18¼ × 27 in.
Staatliche Museen, Kassel

In a contest between Zeuxis and Parrhasios, Zeuxis produced so successful a representation of grapes that birds flew up to the stage-building where it was hung. Then Parrhasios produced such a successful eye-deceiving picture of a curtain that Zeuxis, puffed up with pride at the judgment of the birds, asked that the curtain be drawn aside and the picture revealed. When he realized his mistake, he conceded the prize with an unaffected modesty, saying that whereas he had deceived birds, Parrhasios had fooled him, an artist.
(*Natural History*, XXV, 65)

Rembrandt was perhaps the first Dutch painter to translate Pliny's tale into an illusionistic depiction of a contemporary frame with a curtain. After he introduced the motif, many Dutch painters experimented with it. From about 1650 they painted curtains in front of church interiors, kitchen scenes, reading women and fine bouquets. Rembrandt's

pupil Nicolaes Maes (1634–93) drew two copies of *The Holy Family with a Curtain* and applied the motif to his own paintings of domestic interiors. Such illusionist curtains were painted primarily in front of secular scenes, suggesting that Rembrandt's trickery was more important for its artistic challenge than its religious connotations. Although Maes' copies from the 1650s imply that Rembrandt kept the work for a while, it may be one of Rembrandt's two paintings of Mary and Joseph listed in the 1657 inventory of the art dealer Johannes de Renialme, who supplied the city's choosiest collectors.

Several of Rembrandt's paintings of the 1640s are arch-shaped. Their rounded tops were probably tailored to their placement in private homes, where they competed with other paintings, closely hung on the walls. The focus guaranteed by the arched format, refined colour accents and stunning illusionism all helped a painting to stand out, and Rembrandt's moderately sized paintings of this period display such features in abundance. One of the most fetching is his much-emulated *Girl at a Window* of 1645 (116). Dressed in a white shirt, she leans on a stone windowsill as if caught in a moment of repose. Rembrandt brought her forward, out of the picture plane, by unobtrusive means: the sharp shadows of her arm and necklaces, deep contrasts between her bright body and the dark background, and well-placed touches of white on her forehead, nose and lips. The painter and critic Roger de Piles (1635–1709), who acquired the work in the 1690s, placed it in his 'cabinet', a study filled with books and smallish works of art, including forty prints by Rembrandt.

De Piles championed the vigorous brushwork and sensuous, lifelike colour of Rubens and Rembrandt against the preferences of the Royal Academy in Paris for the cooler and smoother manner of painting perfected by Nicolas Poussin (1594–1665). His anecdote about the illusionist appeal of Rembrandt's *Girl at a Window* supported his position:

Rembrandt was well aware that in painting one may, without too much difficulty, deceive the eye in representing immobile and inanimate objects; and not content with this fairly common artifice, he strove after the means whereby to trick the eyes with living bodies. He tested this on others with the portrait of his servant girl, which he placed in his

window so that the whole aperture was filled with the canvas. All those who saw it were deceived, until, when the painting had been there for several days and the girl's posture always remained the same, everyone began to realize that they had been tricked.

Although no one can really have been fooled, the anecdote emphasizes Rembrandt's delight in illusionist experimentation. Elsewhere De Piles noted that Rembrandt's illusion depended on his clever composition and colouring. The fact that he hung the painting in his study confirms its

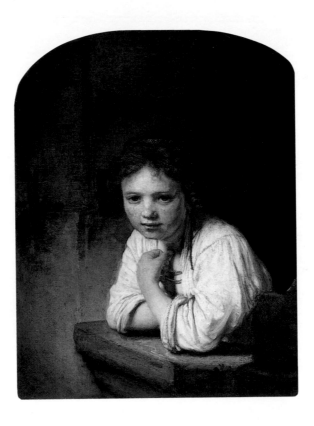

116
Girl at a Window,
1645.
Oil on canvas;
82·6 × 66 cm,
32¹⁄₂ × 26 in.
Dulwich
Picture
Gallery,
London

status as a 'cabinet piece' (*kabinetstuk*), defined by Van Hoogstraeten as a medium grade of art, below the highest rank of history painting but charming in its wide range of subjects and pleasing effects, including attractive landscapes, fires, night scenes, well-rounded milkmaids, surprising jests, powerful expressions and so on. Although he found such themes humble, he considered them 'challenging enough to make the boldest spirits sweat before they will climb the stage of honour where one finds these amusements'.

117
Rest on the Flight into Egypt, 1647. Oil on panel; 34 × 48 cm, 13³⁄₈ × 18⁷⁄₈ in. National Gallery of Ireland, Dublin

Van Hoogstraeten's cabinet pieces included fires and night scenes, and it is indeed likely that Rembrandt's small works of the 1640s were admired for their complex lighting. *The Holy Family with a Curtain* is illuminated from top left outside the painting and by glowing embers within, and its light fluctuates from bright white to impenetrable darkness. His *Rest on the Flight into Egypt* (117), painted in 1647, is a study in multiple light sources. Joseph and Mary, with the child on her lap, are sitting by a fire tended by a shepherd boy. An older shepherd brings cattle and sheep to feed, while another man approaches with more animals, his lantern casting a faint light on the road. The fire's warm glow, rendered in thick, dry yellow pigment, produces reflections of the Holy Family, shepherds and animals in the nearby stream. The craggy, inhospitable slope above the campfire is illuminated by cold moonlight, refracted by sweeping clouds. Tiny sparks of light mark windows in a gloomy castle.

Where *The Holy Family with a Curtain* resembles a scene of ordinary life, *The Rest on the Flight into Egypt* is primarily a landscape. As the Gospels give no details of the Holy Family's flight after they were warned by an angel of Herod's plans, the subject offered Rembrandt plenty of scope. By reducing the main characters to diminutive accents in a dramatically illuminated landscape, he developed an existing interpretation of the theme by Adam Elsheimer, whose painting on

118
**Adam
Elsheimer**,
*The Flight
into Egypt*,
1609.
Oil on copper;
31 × 40 cm,
12¼ × 15¾ in.
Alte
Pinakothek,
Munich

copper sets the escape in a nocturnal landscape lit by a fire, a lantern, the rising full moon and its reflection in the water (118). The Milky Way and several stars scintillate on the copper's smooth surface. Rembrandt knew this picture through an engraved copy by Hendrick Goudt (1585–1648), which bears an inscription explaining the luminary spectacle: 'The Light of the World flees into darkness'. The tensions within Rembrandt's landscape are apt metaphors for the Christ child's contradictory position in the world, precarious yet secure.

Because landscape painting was ostensibly without a traditional 'subject', and often purported to give an unvarnished view of nature, it paradoxically offered artists a congenial medium for the display of eye-catching effects. Apelles, the court painter to Alexander the Great, had been celebrated for his ability to paint such ephemeral phenomena as lightning and stormy clouds. In his *Schilder-Boeck* of 1604, Van Mander advised young artists to follow Apelles' example and go out into nature to capture its wondrous phenomena. Further encouraged by an increasingly vigorous market for secular pictures, landscape had become one of the most innovative and popular genres of painting in the Republic. Rembrandt had taken it up in the later 1630s, initially in paintings that emulate the dramatic effects of Apelles rather than the modest local scenes that were a mainstay of Dutch landscape painting.

Rembrandt's *Stormy Landscape* (119) depicts a hillside town under dark, windswept clouds pierced by eerie sunlight. The billowing trees are a vivid pale green, and a curved bridge over a stream, lit from behind, separates the glowing, perhaps biblical, town from the humbler foreground. As Van Mander had recommended, Rembrandt filtered his observations *naer het leven* ('from life'), through an idealized vision born *uyt den gheest* ('from the imagination'). He merged the potentially disparate results by restricting his palette to the near-monochrome range favoured by Jan van Goyen (1596–1656) and other landscape painters.

119
Previous page
Stormy Landscape,
c.1637–9.
Oil on panel;
52 × 72 cm,
20$\frac{1}{2}$ × 28$\frac{3}{8}$ in.
Herzog Anton Ulrich-Museum, Braunschweig

120
View of Amsterdam,
c.1640.
Etching;
11·2 × 15·3 cm,
4$\frac{3}{8}$ × 6 in

In the 1640s, Rembrandt continued to paint exotic landscape settings and sensational atmospherics, but spent more time sketching the lowlands outside Amsterdam. One of his first landscape prints, a *View of Amsterdam* (120), combines direct observation and judicious composition to create a panorama of the city. Although the buildings are placed in the order Rembrandt would have seen from a dyke near his house, the print is less a topographic record than a rhythmic evocation of the city's profile against a towering sky. Rembrandt did not correct the inevitable reversal of the observed scene in the printing process, and he adjusted the heights of buildings to create an impressive skyline. His decision to reserve three-quarters of the paper for the sky was inspired by recent innovations in panoramic landscape painting by Van Goyen (121) and others, but his agile manipulation of the

121
**Jan van
Goyen**,
*A Windmill
by a River*,
1642.
Oil on panel;
29·4 × 36·3 cm,
11⅝ × 14¼ in.
National
Gallery,
London

etching needle energized the formula. The scribbles and vertical lines denoting grasses and reeds create convincing recession from the foreground to the river. On its bank, a few sketchy, diminutive figures generate a monumental sense of space in the small etching. Although the free handling indicates that Rembrandt may have begun to prepare the copper plate on the spot, his emendations make it clear that he finished it in the studio. The haystack at left, for example, was drawn over a barge that may have distracted from the city's profile.

Rembrandt prepared his landscape prints in drawings that he made on his walks, but he never copied these directly. The careful execution of these drawings confirms that he considered them completed works of art. He must have kept many as models for his pupils (copies are known) and for sale. The 1656 inventory of his assets includes two albums 'full of landscapes, drawn from life by Rembrandt'. Twenty-seven of these were eventually owned by Nicolaes Flinck, who may have inherited them from his father Govaert. One of the finest, identifiable by the 'F' in the lower left corner, is a pen-and-wash drawing of a *Farmhouse among Trees with a Man Rowing* (122). The location was a quiet tributary of the Amstel, 16 km (10 miles) outside the city. With bold strokes of a reed pen, Rembrandt indicated rushes on the left bank and a man rowing. As in reality, the viewer perceives these foreground forms in their generality and looks past them to see the

122
Farmhouse among Trees with a Man Rowing, c.1648–50. Pen and brown ink and wash, corrections in white body-colour; 13·2 × 19·8 cm, 5¼ × 7¾ in. Devonshire Collection, Chatsworth

123
Rembrandt after Titian, *Mountainous Landscape with a Riderless Horse*, c.1650–2. Pen and brown ink and wash, corrections in white body-colour; 18·8 × 30·3 cm, 7⅜ × 11⅞ in. Staatliche Museen Preussischer Kulturbesitz, Gemäldegalerie, Berlin

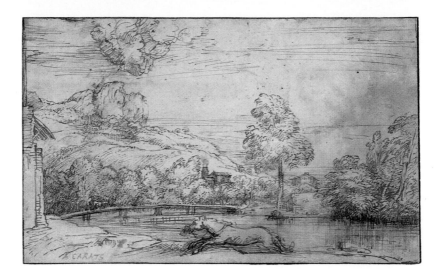

farmhouse between the trees, drawn in sharper focus with a fine quill. More distant farmsteads and the church tower of Ouderkerk dissolve in an atmospheric blend of delicate pen lines and wash.

Rembrandt's free touch delineating foliage, structures, reflections and figures looks the epitome of spontaneity. No Dutch artist had drawn in this manner before, and he must have taught himself the technique. Sixteenth-century Venetian drawing provided a potent model. Domenico Campagnola (c.1482–after 1515) and Titian had developed a fresh mode of landscape drawing that Rembrandt knew well: he retouched a drawing by a follower of Campagnola, and made two copies after drawings by Titian (123). In his copy Rembrandt faithfully imitated Titian's feathery trees and shimmering reflections, but he used fewer lines to attain these effects.

Rembrandt's cabinet paintings and landscape drawings of the 1640s depart strikingly from the portraits and history paintings of his first decade in Amsterdam. Their interest in 'real' people, whether biblical or contemporary, and in unassuming local landscape suggest a newly introspective and attentive vision. Rembrandt's walks in the country-side and absorption in experimental cabinet pieces may have offered consolation for the loss of Saskia and a reprieve from tensions in his household, but whatever the genesis of Rembrandt's newly under-stated art, its pictorial novelty presumes a sophisticated public. The

portrait etchings he made between 1646 and 1658 depict a community of collectors, artists and dealers that appreciated and encouraged his more experimental art.

In their directness, these prints recall the portrait of Menasseh ben Israel (see 51), although they are more elaborate in composition and technique. Their textural finesse resulted from Rembrandt's finely tuned working of the copper plates (see Chapter 8). In one, the painter Jan Asselijn (*c.*1615–52), who had recently returned from Rome, cuts a dashing, confident figure in front of one of his Italianate landscape paintings (124). In another print Ephraim Bueno, a Jewish physician of similarly cultivated appearance, has halted at the bottom of a staircase, as if preparing to go out (125). His earnest gaze suggests his erudition: his intellectual interests included writing and translating Spanish poems, and he had been an investor in Menasseh ben Israel's press. Rembrandt probably knew the publisher and art dealer Clement de Jonghe more directly (126). De Jonghe issued prints by established artists such as Lievens and Roeland Roghman (1627–92), a landscape painter whom Houbraken described as Rembrandt's friend. In 1679 the inventory of De Jonghe's business included seventy-four plates for Rembrandt's etchings. De Jonghe confronts the viewer in a casual yet monumental pose, his face cast in the evocative shadow Rembrandt favoured for self-portraits.

Rembrandt left other documents of his familiarity with leading Amsterdam professionals and intellectuals. On three occasions, he contributed drawings to *alba amicorum* or 'friends' albums'. From the sixteenth century on, members of the Dutch élite compiled such collections of sayings and pictures, solicited from relatives, friends and eminent acquaintances – Banning Cocq's album is one such book (see 105). Rembrandt made two drawings for the album assembled by the learned regent Jan Six. As the scion of an aristocratic family of cloth merchants, Six was free to devote most of his time to his poetry, his library and his collection of art and antiquities. His marriage to Margaretha Tulp in 1655 strengthened his position in the city's oligarchy, in which he held many posts including that of burgomaster. Rembrandt probably met him as early as 1641, when he painted a portrait of Six's

124
Jan Asselijn,
*c.*1647.
Etching,
drypoint and
engraving,
first state;
21·6 × 17 cm,
8½ × 6⅝ in

125
Ephraim
Bueno,
1647.
Etching,
drypoint and
engraving;
24·1 × 17·7 cm,
9½ × 7 in

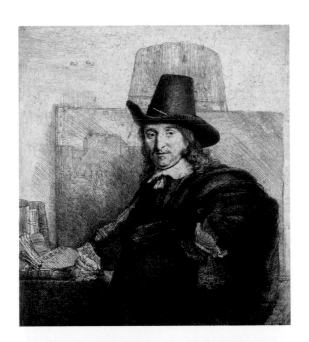

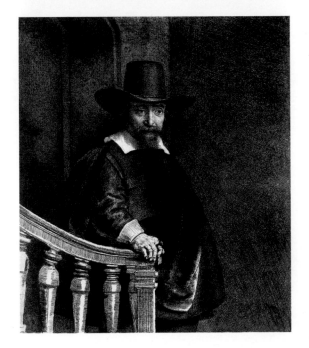

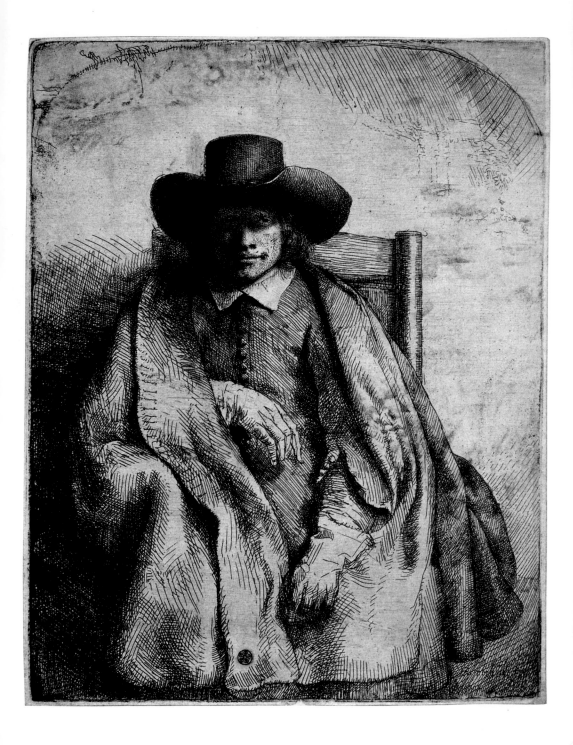

mother; several other works document their close contact until about 1654. The first is Rembrandt's beautifully modulated portrait etching of Six reading by a window (see 109). As the print was prepared in at least three drawings – an unusually high number for Rembrandt – Six was probably much involved in the design. The result, traced directly from the final drawing, presents the quintessential gentleman-scholar, turned away from the world yet illuminated by its knowledge, implied by the bright light reflecting off Six's book onto his face.

126
Clement de Jonghe, 1651. Etching, drypoint and engraving, fourth state; 20·7 × 16·1 cm, 8⅛ × 6⅜ in

127
Medea, or The Marriage of Jason and Creusa, 1648. Etching and drypoint; 24 × 17·6 cm, 9½ × 6⅞ in

Six must have liked the portrait, for he retained the etching plate for future impressions. Almost immediately, he engaged Rembrandt to make a title etching for the publication in 1648 of his tragedy *Medea*, which had been performed the year before (127). Six's novel interpretation of the harrowing myth emphasized the human plight of Medea, who was deserted by her husband Jason for his lover Creusa. In mad despair, she murdered Creusa and her own two sons. Rembrandt's ominous illustration of Jason's wedding to Creusa sets the marriage ceremony in a church-like interior, which is separated from the lower

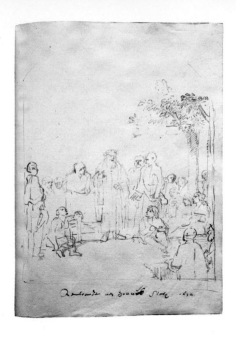

foreground by two curtains. This two-level space separated by trans-
verse drapes recalls the stage of the Amsterdam Theatre, but it is not
likely that the print represents an actual production of Six's play. The
actors are dressed in a mixture of classical and oriental costumes, an
anachronistic combination typical both of Rembrandt's history paint-
ings and of contemporary theatre. In the deep shadows at the right
lurks Medea, bearing the instruments of doom: the poisoned robe is
her wedding gift to Creusa, the dagger will kill her sons. The etching
exudes the mournful air of Six's moral: 'Alas, Unfaithfulness, how dear
thy cost'.

Rembrandt's drawings for Six's *album amicorum* honoured Six's clas-
sical and literary avocations. One depicts an elderly woman reading,
possibly Six's mother, surrounded by a bust and attributes of Minerva,
goddess of wisdom. The second depicts Homer reciting his poetry to a
rapt audience (128). The disposition of figures on a hillside is clearly
derived from Raphael's fresco *Parnassus*, which represents the moun-
tain of Apollo, god of poetry, and his Muses of art and science. Six had
travelled to Italy and may have seen the painting at the Vatican, and
Rembrandt undoubtedly knew the engraving after it by Marcantonio
Raimondi (1487–1534; 129). In the foreground, where the fresco was
interrupted by a door, Rembrandt left blank space. He adopted

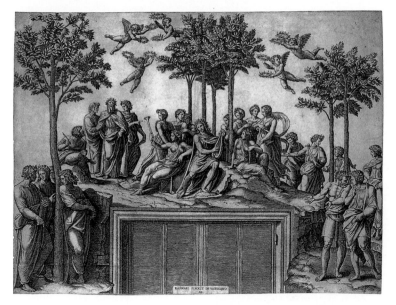

128
*Homer Reciting
his Verses*,
1652.
Pen and
brown ink;
25·5 × 18 cm,
10 × 7 in.
Six Collection,
Amsterdam

129
**Marcantonio
Raimondi
after Raphael**,
Parnassus,
c.1515.
Engraving;
18·7 × 34·6 cm,
7³⁄₈ × 13⅝ in

Raphael's Homer and several of the listeners, including a Muse peeping around a tree, while the young man writing down the blind poet's words is modelled on Homer's scribe in the print.

For all its debts to Raphael, *Homer Reciting his Verses* is executed in a rough, blocky manner that is the antithesis of Raimondi's smooth curves and detailed surfaces. Rembrandt's style, attained with a dry quill pen, defines by suggestion rather than description, drawing attention to his physical manipulation of the pen. Rembrandt's drawings of the 1650s frequently look as if he were experimenting with the minimum means necessary to render the essence of a situation or character. The rough appearance of such drawings has been compared to a humble mode of classical rhetoric, an unpolished oratory considered appropriate for the communication of plain truths. It had gained favour with prominent scholars in Amsterdam, particularly among erudite Reformed preachers, for whom a plain style of speech represented the honest transmission of God's Word.

Six may have admired Rembrandt's minimalist draughtsmanship for its rhetorical honesty, and he apparently enjoyed its aesthetic qualities. He bought Rembrandt's rough grisaille of *John the Baptist Preaching* (see 70), and Rembrandt drew a design for its frame (again arched) in a

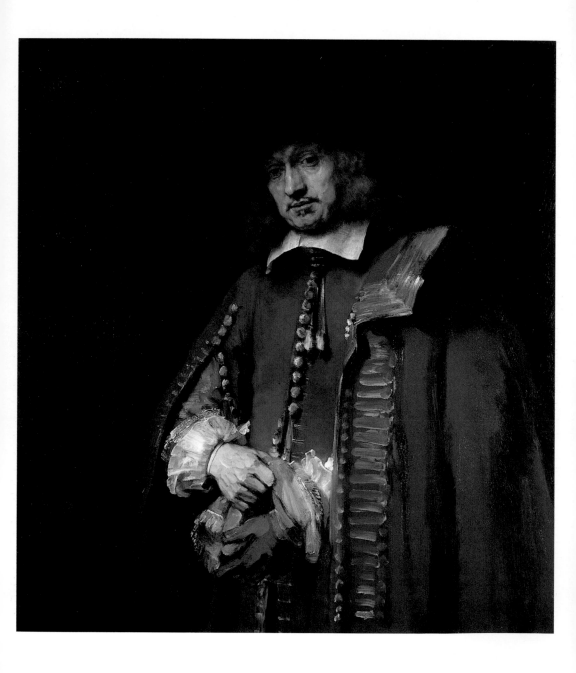

skeletal manner. More tellingly, in 1654 he portrayed Six in a style that is the painterly equivalent of his rough-edged draughtsmanship (130) and an alternative to the elegant manner in which Flinck portrayed Six's bride (see 114). Like Ephraim Bueno, whose contemplative expression he shares, Six is preparing to step out. But there is no banister in front of him; the red cloak and the fringed leather glove he is pulling on seem close enough to touch. Rembrandt painted no other portrait with such dashing, broad strokes, which serve as a forceful reminder that the heavy folds of red wool, the shimmering brass buttons and the scalloped white cuffs are not real but remade in paint. It has been quite plausibly suggested that Rembrandt's ravishing brushwork, rapid yet calibrated, is a deliberate metaphor for an ideal of courtly demeanour

130
Jan Six,
1654.
Oil on canvas;
112 × 102 cm,
44 × 40⅛ in.
Six Collection,
Amsterdam

131
Six's Bridge,
1645.
Etching;
12·9 × 22·4 cm,
5 × 8⅞ in

that Six held dear. Baldassare Castiglione, the subject of Raphael's portrait emulated by Rembrandt (see 96, 97), had coined the term *sprezzatura* to evoke the indefinable spark of the true courtier, a grace that appears effortless even though it is meticulously cultivated. Six owned several copies of Castiglione's *Book of the Courtier*, and in 1662 the first Dutch translation was dedicated to him.

The confluence of Rembrandt's and Six's artistic interests has long been recognized. It was evoked delightfully by Edmé-François Gersaint, who in 1751 published the first catalogue of Rembrandt's prints. Explaining the identification of a landscape etching by Rembrandt known as *Six's Bridge* (131), Gersaint claimed that the print resulted from a bet between the artist and his patron. During a meal at

Six's country estate, a servant was sent to town to buy mustard. To pass the time, Six challenged Rembrandt to etch the view from the window before the servant's return – and Rembrandt delivered. The story is as untrustworthy as De Piles' tale about the *Girl at a Window*, and it is as critically astute. *Six's Bridge* is Rembrandt's most economical landscape etching. The boldly delineated shapes of the bridge, trees and boat are set against diminutive forms scribbled along the horizon to create a vast pictorial space. The rigging and foliage dissolve against a white expanse of sky. Gersaint's assertion that Rembrandt always carried prepared etching plates with him has a ring of truth in this case. The location cannot be identified as Six's bridge, but the apocryphal title does justice to his patronage of Rembrandt's shorthand style.

In a *Satire on Art Criticism* drawn in 1644, Rembrandt commented on the judgment of collectors – presumably excluding the connoisseurs at whom he aimed his newly experimental works (132). The drawing's inscriptions are difficult to decipher, but its general tenor is clear. On the left, a man is judging a portrait lying on the ground before him. His position on an empty barrel and the ass's ears poking through his hat signal that he is pontificating vapidly; as a popular proverb had it, 'hollow barrels [empty heads] sound loudest'. Although numerous

132
Satire on Art Criticism,
1644.
Pen and brown ink;
15·6 × 20 cm,
$6\frac{1}{8} × 7\frac{7}{8}$ in.
Metropolitan Museum of Art, New York

133
Rembrandt after Andrea Mantegna,
The Calumny of Apelles,
c.1652–4.
Pen and brown ink with brown wash;
26·3 × 43·2 cm,
$10\frac{3}{8} × 17$ in.
British Museum, London

bystanders hang on his words, the one man addressing the viewer wipes his behind in eloquent evaluation of the art lover's expertise.

Rembrandt fused several classical stories into his comic scene. The ass's ears evoke King Midas, who judged a musical contest between Apollo on the lyre and Pan on the shepherd's flute. When Midas awarded the prize to Pan, Apollo gave him a pair of donkey's ears. The same ears disfigure an equally ignorant judge in a drawing of *The Calumny of Apelles* by Andrea Mantegna (*c.*1431–1506). Rembrandt, who owned and copied Mantegna's drawing (133), used its composition as the starting point for the *Satire on Art Criticism*. Mantegna's drawing represents Apelles' allegory of false accusations brought against him by an invidious painter, a favourite tale of Renaissance art literature. Rembrandt must also have known Apelles' reputation for chastising amateur judges of art. A cobbler once pointed out that Apelles had made a mistake in painting a shoe, and went on to comment on a defect in a painted limb. Apelles thanked the shoemaker for his correction of the shoe, but told him to 'stick to his last' when it came to artistic matters. And when Alexander the Great spoke about Apelles' paintings in his studio, the painter advised his patron to cease because even the apprentices were laughing at his incompetent commentary.

Virtually no self-portraits survive for the decade following Rembrandt's role play as Renaissance gentleman in the portraits of 1639 and 1640 (see 94, 98). When he returned to self-portraiture in 1648 he had rethought the purpose of these works, now apparently favouring direct observation over imaginary construction. In his *Self-Portrait Drawing at a Window* (134), Rembrandt shares the serious purpose of his recent sitters, but unlike them he is at work in modest studio attire, peering out as if trying to fix his features from a mirror. The print gives a palpable sense that it is the record of the work session it depicts. Its dark, heavily manipulated character attests to his concentrated activity, to the physical work his art demanded. The chameleon portraits of the artist as gentleman, beggar, prodigal and virtuoso represent a past stage: Rembrandt here asks to be considered purely as an artist, now identified with a subtler but direct naturalism.

If, as this self-portrait intimates, Rembrandt placed a high value on his artistic autonomy, he was acutely aware of his economic dependence on connoisseurs. He never lost sight of his art as business, but it was perhaps inevitable that his increasingly experimental art would come into conflict with his commercial enterprise.

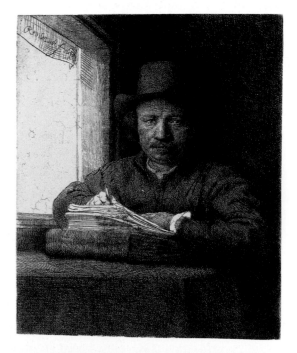

134
Self-Portrait Drawing at a Window,
1648.
Etching, drypoint and engraving, second state;
16 × 13 cm,
$6\frac{3}{8} \times 5\frac{1}{8}$ in

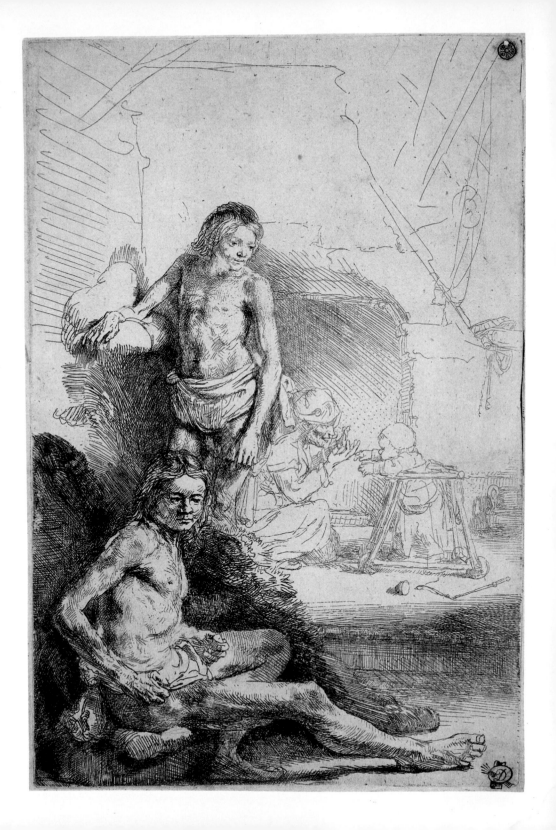

Documents of 1634 and 1642 identify Rembrandt as a *coopman*, or merchant, rather than as a painter. All independent artists were merchants in the sense that they manufactured luxury products for sale. Most masters received fees to train pupils and hired assistants to increase their output, and many also dealt in works of art. Rembrandt engaged in all of these activities, and he managed the publication of his own prints (see Chapter 8). For the first two decades of his career, Rembrandt's business flourished, enabling him to buy his substantial home and to acquire a distinguished collection of art and curiosities. The house and the collection played central roles in his art business, and hence in its failure in 1656, when Rembrandt transferred his assets to a receiver. His legal justification for this arrangement cited 'losses suffered in the trade as well as damages and losses at sea'. Rembrandt's mounting financial problems of the 1650s have presented a bonanza to his biographers. The documents about his bankruptcy convey invaluable information about his house and assets, his creditors and friends.

Rembrandt's business was highly diversified. At one point he even rented out his basement for tobacco storage, but most of his trade involved art. He must have received an excellent education in the management of an art business from Uylenburgh, who apparently managed his protégés in several ways, lending or renting out studio and living space, arranging training with masters who would supply him with workshop pictures, brokering portrait commissions and acting as dealer. Rembrandt is twice documented as a creditor of Uylenburgh's business and must have been one of his partners. Other financiers included the Mennonite congregation, Pieter Beltens (who sold his house to Rembrandt), Nicolaes van Bambeeck (see 99) and several painters. Lambert Jacobsz (1598–1636), an artist and close friend of Uylenburgh, ran a branch of the firm in Leeuwarden, Saskia's home town.

135
The Walker,
c.1646.
Etching;
19·4 × 12·8 cm,
$7^5_8 \times 5$ in

During his first decade in Amsterdam, Rembrandt probably sold many works by himself and his students through the Uylenburgh consortium. Jacobsz' posthumous inventory includes one painting by Rembrandt and six pictures identified as copies after him. They all represent the picturesque subjects Rembrandt had begun to develop in Leiden, including a 'hermit studying in a cave' and several *tronies*. The inventory carefully distinguishes the different types of *tronies*: 'a head of an old man with a long full beard', 'an old woman in a black bonnet', 'a handsome young Turkish prince', 'a soldier with black hair wearing neck armor' and 'a small head of a woman wearing an oriental headdress', specified as a portrait of Uylenburgh's wife. These single-figure paintings were good exercises for Rembrandt's students, who sometimes gave them to relatives, as inventories of 1638 and 1639 show. These modest works also provided popular, affordable merchandise for the open market. Peter Mundy, an English traveller who visited Holland in 1640, singled out 'Rimbrantt' as representative of the many Dutch painters supplying the huge art market, which comprised the wealthiest collectors of 'costly peeces' as well as butchers, bakers and blacksmiths. The number of copies after Rembrandt described in contemporary inventories supports Mundy's bullish view of the art market and Rembrandt's role in it.

Other sources confirm Rembrandt's active interventions in the art market. In 1637 the painter Jan Jansz den Uyl (1595/6–1640) paid him a small fee for sitting with him during an auction of his paintings. Den Uyl may have asked Rembrandt to bid on his paintings, thus raising their prices. Rembrandt's involvement in such practices was recorded with disbelief by Filippo Baldinucci, the Italian print critic who relied on information supplied by Bernhardt Keil. In his account of 1686, Baldinucci claimed that Rembrandt habitually outbid others for art by great masters, paying extravagant sums to gain credit for his profession. He further maintained that Rembrandt elevated prices for his own etchings by buying them up from all over Europe, thus creating artificial scarcity. Like many early statements about Rembrandt, these charges have elements of truth, as we will see in the discussion of his printmaking career (Chapter 8).

Although Uylenburgh and Jacobsz offered Rembrandt an efficient commercial outlet, he also sold his studio output himself. Besides commissioning religious pictures and a portrait, the *stadhouder* may have bought a self-portrait and the *Old Woman* (see 35) straight from Rembrandt's studio. In 1629 he apparently gave them to an English ambassador, who presented them to King Charles I. Claude Vignon (1593–1640), a French painter and dealer, sought to buy work from Rembrandt – any work – in 1641. Vignon was just then evaluating a

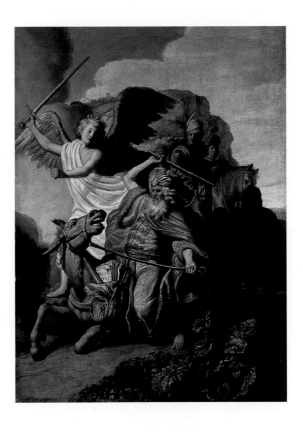

136
Balaam and the Ass,
1626.
Oil on panel;
63·2 × 46·5 cm,
24⅞ × 18¼ in.
Musée Cognacq-Jay, Paris

group of paintings that Alfonso Lopez wished to sell in Paris, including Titian's *Portrait of a Man* (see 95) and Rembrandt's painting of the prophet Balaam (136), which the artist had sold to Lopez. It is one of his first paintings, based directly on a composition by Lastman, and he must have kept it in his stock since 1626. Rembrandt was paid directly for his portraits, too, even when others may have arranged the commissions.

By 1640 Rembrandt could command high prices. In 1639 the last pair of Passion paintings fetched 1,200 guilders, and seven years later he

received double that amount for two paintings of Christ's infancy. At 1,600 guilders *The Nightwatch* (which took at least a year to paint) was remunerated handsomely. In the same period Andries de Graeff, an Amsterdam burgomaster, was charged 500 guilders for 'a painting or portrait' by Rembrandt. It may be the *Man Standing in a Doorway* (137), which is inscribed 1639 and, with its grand setting and pose,

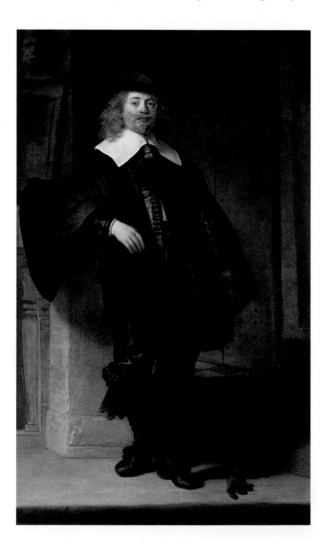

befits De Graeff's status. Although a deposition by Uylenburgh shows that De Graeff refused to pay for his painting, Uylenburgh and other expert arbiters agreed that he owed Rembrandt the full price. In 1642 Rembrandt received another 500 guilders for a double portrait of Abraham van Wilmerdonx, a director of the West Indies Company,

and his wife. Ten years later Antonio Ruffo, a nobleman of Messina, paid the same amount for Rembrandt's magnificent *Aristotle* (see 159).

Copies or independent paintings by Rembrandt's students fetched small fractions of the prices paid for his autograph works, and inventories frequently specified whether a painting was a *principael* (original) or a copy after his invention. In 1618, when Rubens wished to exchange several of his paintings for a collection of antiquities, his offer included notes on the extent of his involvement in each picture (including the *Prometheus* he painted with Frans Snyders; see 80). Rembrandt may have had so many assistants that, even if their individual works were valued at only a few guilders, they still contributed substantially to his income. Documents show that his studio assistants were valuable in other ways, serving as witnesses to Rembrandt's depositions or buying art on his behalf. More significantly, apprentices brought in fees. In his treatise of 1675, Joachim Sandrart claimed that 'Fortune had filled Rembrandt's house in Amsterdam with virtually innumerable prominent children', who paid a hundred guilders a year for instruction. He estimated that Rembrandt earned another 2,000 to 2,500 guilders a year from works made by his pupils. Sandrart is probably a reliable source: he lived in Amsterdam from 1637 to 1645 and painted one of the militia portraits for the Kloveniersdoelen. The standard fee of a hundred guilders per year is confirmed by the recorded charges for Isack Jouderville, Rembrandt's pupil in Leiden. Sandrart's comments on Rembrandt as teacher focus rigorously, and perhaps enviously, on the income his pupils delivered. This view must be balanced by the pictorial and written evidence of Rembrandt's approach to teaching, which reveals a master committed to the transmission of his artistic and technical innovations. It is a mark of Rembrandt's success as a teacher that so many of his students later struck out independently to become successful artists in their own right.

The number of pupils in Rembrandt's studio was high: during a career spanning four decades, three dozen painters can be definitely associated with his workshop, and there were probably others too. His studio's known output is on a par with that of the largest studios in the Republic, including the great ateliers of Abraham Bloemaert and Gerard van Honthorst (see 18 and 59). But what was 'prominent' – in

137
Man Standing in a Doorway, 1639,
Oil on canvas;
200 × 124·2 cm,
78³⁄₄ × 48⁷⁄₈ in.
Staatliche Museen, Kassel

138
Pupil of
Rembrandt,
*Rembrandt's
Studio with
the Master
and Students
Drawing after
a Nude Model*,
1650s.
Pen and brown
ink, brown
wash, black
chalk, white
body-colour;
18 × 26·6 cm,
7⅛ × 10½ in.
Hessisches
Landesmuseum,
Darmstadt

Sandrart's term – about his pupils? One possibility is that the
students were young men of distinguished families who studied
with Rembrandt as amateur draughtsmen; another is that they were
professionally trained assistants who were particularly successful.
The generally high quality of the workshop production suggests that,
by 'prominent', Sandrart meant 'excellent' or 'advanced', although
several drawings verify that amateurs and older artists did come to
Rembrandt for instruction. A drawing by an unidentified pupil repre-
sents the master and five students sketching a reclining female nude
(138). While an older man next to Rembrandt gazes at the model, a
young pupil peers over the master's shoulder.

139
Constantijn
Daniel van
Renesse with
corrections by
Rembrandt,
*The
Annunciation*,
c.1650–2.
Pen and brown
ink, red chalk,
brown and grey
wash, white
body-colour;
17·3 × 23·1 cm,
6¾ × 9⅛ in.
Staatliche
Museen
Preussischer
Kulturbesitz,
Gemäldegalerie,
Berlin

The elderly draughtsman and a well-dressed observer behind him may
represent the sorts of art lovers who came to Rembrandt to cultivate
their avocation. Constantijn Daniel van Renesse (1626–80) was one
such pupil. Having studied literature and mathematics in Leiden,
he asked Rembrandt for artistic advice. On one of his drawings Van
Renesse wrote: 'the first drawing shown to Rembrandt in the year 1649
October 1st, it was the second time that I went to Rembrandt'. A few of

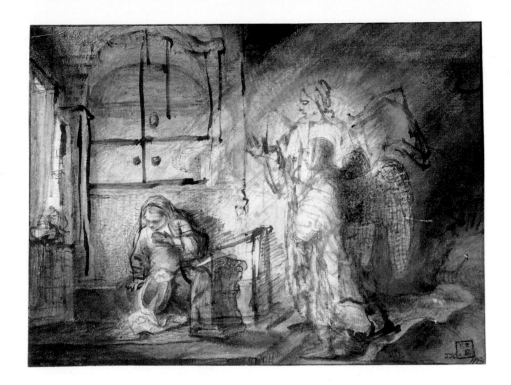

his drawings are based on Rembrandt's models, and two bear the master's corrections (139). Rembrandt strengthened Van Renesse's rendering of the Annunciation by turning the timid archangel into a taller, regal presence, whose message is borne on brushed rays of light. Rembrandt's bold strokes of the reed pen specified the structure of the cabinet behind Mary and enlarged her desk to clarify its position. Although Van Renesse made several paintings and prints, he never became a professional artist.

The drawing of Rembrandt and his pupils observing a model documents a common practice in his studio in the 1640s and 1650s, attested in a fascinating group of drawings of male and female nudes. In sixteenth-century Italy, drawing from live models, particularly male ones, had become closely associated with the recovery of classical nude statues that constituted ideal models for emulation. The study of human anatomy was part of the programme of the academy of art in Florence, founded in 1565, which sought to confer greater intellectual and social prestige on the visual arts. Following the established practice of Italian Renaissance painters, academicians advocated

beautifying the human model by giving it the idealized proportions of classical statues. Such practices slowly reached northern Europe; around 1600 in Haarlem, Karel van Mander, Hendrick Goltzius and Cornelis Cornelisz van Haarlem (1562–1638) applied the term 'academy' to their informal gatherings, probably because they were the first artists in the Republic to draw regularly from nude models (140).

When Bernhardt Keil, who knew Rembrandt in the 1640s, referred to Uylenburgh's stable of artists as a 'famous academy', he may have alluded to the drawing practices of Rembrandt's studio. For

Rembrandt, drawing after the nude appears to have had intellectual significance beyond the practical need to study the human physique. Throughout his career, his nudes articulate the character of his art, whether defiantly grotesque, naturalistically sensuous or intimately observant (see 38, 75 and 112). His interpretation of traditional academic drawing departs from its aim of reconfiguring real bodies according to classical norms. Rembrandt's *Seated Nude* is the modern antithesis of a classical goddess, and his print of *An Artist Drawing from the Model* similarly neglects the academic standard (141). In

this unfinished etching of about 1639, a painter faintly resembling Rembrandt draws a nude woman, seen from behind. She stands in the pose of an antique Venus, but her palm branch and the sheet she holds suggest other identities. Traditionally, a nude woman holding a palm spray personified Fame, but a woman being disrobed could also represent Truth being revealed. Rembrandt did not force the viewer to choose between these identifications. Indeed, if artistic 'truth' means veracity of observation, the print may well argue that truth is the basis of artistic fame, as, indeed, it became for Rembrandt. His nude model asserts the honesty of his drawing: unlike a classical Venus, she has sagging buttocks and irregularly bulging breasts, hips and thighs. She does not appear in a timeless, ideal setting but in a cluttered contemporary studio. If the print advocates the primacy of drawing, it does so on Rembrandt's unconventional terms. In the 1640s, he taught his students to see the nude this way.

Van Hoogstraeten, who warmed rapidly to the classical ideal after studying in Rembrandt's workshop, lamented that his 'old *Academie* drawings' were dedicated to 'unpleasant and disgusting' physiques. These studies resembled the workshop drawings that show a male or female model drawn from different angles by Rembrandt and his pupils during particular sessions. Their execution demonstrates that Rembrandt encouraged his students to render the actual appearance of the human body in plain poses, at the expense of anatomical details or virtuoso contortions. On three occasions in 1646, Rembrandt etched a male model while his pupils drew the figure. Three student drawings, including one attributed to Van Hoogstraeten, show a semi-nude figure standing at ease in the same pose (142). The draughtsmen made no effort to mask the model's awkward physique and coarse facial features. Scratchy pen marks suggest the outlines of the body, and broad washes clarify its modelling and spatial disposition. These drawings depart from the academic tradition of beautifully finished chalk studies of muscular youths produced by Raphael and Michelangelo and emulated by Dutch artists such as Cornelis Cornelisz (see 140).

In Rembrandt's etching nicknamed *The Walker* (see 135), the standing model is positioned between a seated male nude (perhaps the same

140
Cornelis Cornelisz van Haarlem, *Study of a Man Undressing, Seen from the Back*, c.1597. Red chalk; 29·6 × 15 cm, 11⅝ × 5⅞ in. Hessisches Landesmuseum, Darmstadt

141
An Artist Drawing from the Model, c.1639. Etching, drypoint and engraving, second state; 23·2 × 18·4 cm, 9⅛ × 7¼ in

youth in a different pose), and a lightly sketched background scene of a woman encouraging a baby to walk in a frame on wheels. The standing youth appears in reverse because the printing process reverses any design, but Rembrandt evidently made that part of the etching while his pupils drew the model. Where the pupils used differently diluted brown washes to indicate degrees of shadow, Rembrandt applied various densities of hatching and cross-hatching. Making such prints directly from live models allowed Rembrandt to pass his teaching time in the productive preparation of an etching – a marketable commodity

that could also function as model sheet for his students. According to an eighteenth-century critic, Rembrandt compiled a booklet on drawing comprising ten or twelve sheets. No such album survives, but the writer may have known a bound volume of Rembrandt's etchings of nudes and faces, or surmised that he used these prints in teaching. By including a woman teaching a child, Rembrandt turned *The Walker* into a statement on the significance of life drawing. Vondel and other writers used the image of a child learning to walk as metaphor for the exercises required for the young painter to become proficient.

In 1718 Arnold Houbraken, an advocate of 'proper' academic drawing, published a story that suggests both the regular practice and the non-academic character of life drawing in Rembrandt's workshop. To give his pupils private cubicles for drawing nude models, Rembrandt partitioned a rented warehouse. One hot day, a student drawing a female model decided to strip off and interrupt his work for some extracurricular activity, spied on by excited fellow pupils. On his usual round to inspect his students' work, Rembrandt

overheard them say: *Certainly now 'tis as if we were Adam and Eve in Paradise, because we are both naked.* Upon which he knocked on the door with his maulstick, and, to their surprise, addressed them in a loud voice: *Because you are naked, you must leave Paradise*, forcing his pupil with threats to open the door.

He promptly drove the offending couple out of their makeshift garden, allowing them hardly enough time to gather their clothes. Houbraken's anecdote plays up Rembrandt's robust humour, but it also paints an accurate picture of his studio space. When Rembrandt was forced to sell his house in 1658, he was allowed to buy back 'two tile stoves and several partitions in the attic placed there for his apprentices'.

Houbraken identified another drawing practice that Rembrandt must have taught his students:

When it came to art he was rich in ideas, which is why one often sees a lot of different sketches by him of the same subject, also full of changes, in the facial expressions and postures as well as the arrangement of the clothes … Yes, he excelled above all others in this practice: and I don't know anyone who made so many different sketches of one and the same subject.

Houbraken credited this ability to Rembrandt's attentiveness to the varied emotions involved in a scene, as expressed in faces, poses and movements. He specifically cited numerous drawings and prints by Rembrandt of *The Supper at Emmaus*, which he admired for their compelling handling of the stunned disciples. A sheet with three confident sketches of an old man in different attitudes of surprise (143) may be a study for one of Christ's disciples who recognized him when he broke the bread (Luke 24:30–1). As in so many paintings of the story,

142
Samuel van Hoogstraeten, *Standing Male Model*, c.1646. Pen and brown ink, brown wash, white body-colour; 24·7 × 15·5 cm, 9³₄ × 6¹₈ in. Musée du Louvre, Paris

Rembrandt's model appears to lean his hands on the table as he pushes himself back, wide-eyed and tense. The neatly laid-out sequence of drawings indicates that the sheet may have been used as a model for pupils, who could have studied the slightly different figures as exercises in expressing surprise. Completely different gestures of shock and wonder animate Rembrandt's later etching of the theme, made in 1654, in which agitated disciples flank a quietly commanding Christ (144).

Rembrandt's full compositional sketches also justify Houbraken's praise of his constant striving to find alternative solutions to problems of narrative exposition. In an oil sketch, an etching and several drawings, Rembrandt explored the psychological drama of Joseph, favourite son of Jacob, telling his dreams to his father and eleven brothers (Genesis 37:5–11). To the astonishment of his father and the anger of his brothers, Joseph's dreams prophesied that they would bow before him – a prediction that came true when Joseph became viceroy of Egypt. In a small but dense print of 1638 (145), Joseph recounts his dreams to his ageing father, his mother in the bed and his sceptical, stupefied and angry brothers. His sister listens attentively from a stool in the right foreground. The etching was prepared in individual figure drawings and in a grisaille oil sketch of the whole composition, painted a few years before.

143
Three Studies of an Old Man in Attitudes of Surprise, c.1633–4. Pen and brown ink; 17·4 × 16 cm, 6⅞ × 6¼ in. Fondation Custodia, Institut Néerlandais, Paris

144
The Supper at Emmaus, 1654. Etching, drypoint and engraving; 21·1 × 16 cm, 8¼ × 6¼ in

145
Joseph Telling his Dreams, 1638. Etching and drypoint, third state; 11 × 8·3 cm, 4⅜ × 3¼ in

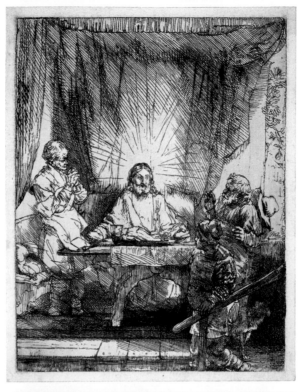

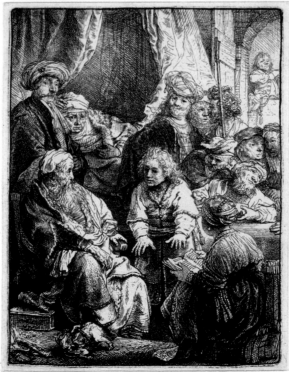

Several years after completing the etching, Rembrandt recast the theme in a drawing that bears no relationship to any finished painting or print (146). Here the breach between Joseph and his family is visualized dramatically, as he is placed opposite his kin. He addresses them in front of a hearth at the end of the room, his right hand placed on his heart to profess the truth of his account. An anxious Jacob clutches his chair; Joseph's older brothers lean inwards with mounting concern. Only Benjamin, the youngest son cradled between Jacob's knees, ignores the speech as he plays with a bauble. By sketching the interior and the dog in broad strokes and reserving delicate penwork for the family, Rembrandt elicited the emotional richness of this tale of sibling rivalry. Numerous such narrative drawings from his workshop confirm that they were made to develop compositional skills, as exercises that doubled as objects for collectors, rather than as preliminary drawings for other works.

146
Joseph Telling his Dreams, c.1640–3. Pen and brown ink with brown wash; 17·5 × 22·5 cm, 6⅞ × 8⅞ in. Private collection

Rembrandt's inventory of 1656 demonstrates that he kept many albums of his own drawings. These sheets were a capital asset, providing models for his own use, teaching material and items for sale. They also formed part of his larger collection of works of art, natural objects and curiosities. The contents of the collection are known from the inventory, which itemized Rembrandt's possessions room by room, listing over 350 lots, many containing multiple objects. While paintings are listed throughout the house, most of the collection was kept on the second floor in the smaller 'painting room' (studio) and in the *Kunst Caemer* or 'art room' – a term that had recently come to designate spaces dedicated to collections.

Rembrandt's collection was organized according to principles established by pioneer collectors of the sixteenth century in Italy and central Europe and maintained by their seventeenth-century successors. These collectors sought out objects for their beauty, rarity and scientific interest, and they placed them in rooms known by the German words *Kunstkammer* and *Wunderkammer* – 'Art chamber' and 'Cabinet of wonders'. Like most such collections, Rembrandt's aspired to 'universality' – to encompassing all sorts of curiosities that together would represent culture and nature. These collections could be studied

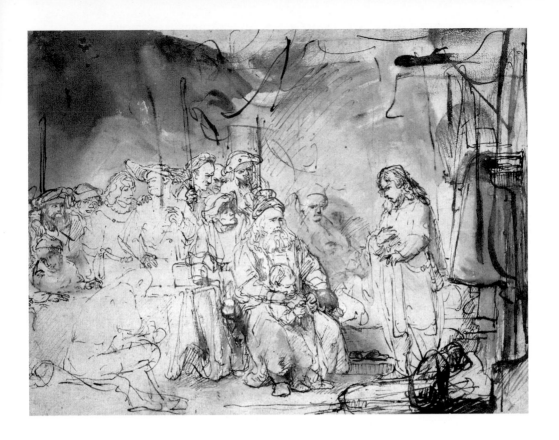

and displayed to friends as concise versions of the entire world and its history, as microcosms that stood for the totality of the macrocosm. Many universal collections could be divided approximately into three categories: *artificialia* or works of human artifice, *naturalia* or specimens of nature, and *antiquitates* or objects of historical (chiefly Roman) origin.

Seventeenth-century artists in Antwerp painted imaginary versions of such encyclopedic collections (147). A painting by Frans Francken the Younger (1581–1642) shows a fine accumulation of paintings, Renaissance coins and medals, a book of drawings, an inlaid coffer and natural wonders such as shells and rare flowers; many such paintings also display casts of antique sculpture. Rembrandt's inventory offers a similar feast, if more heavily weighted towards works on paper. In 1681 the literary critic Andries Pels wrote that Rembrandt scoured the streets and markets for 'suits of armour, helmets, Japanese daggers, furs and frayed collars, which he considered fit for painting'. Two

terrestrial globes in the *Kunst Caemer*, favoured props of seventeenth-century armchair travellers, signalled the universality of Rembrandt's collection. Among the *artificialia* were dozens of paintings by Rembrandt and his Netherlandish predecessors and colleagues, including Lucas van Leyden, Rubens, Lastman, Lievens and Adriaen Brouwer, and several attributed to Italian artists from Raphael and Michelangelo to the Venetians Giorgione and Palma Vecchio. Even more impressive is the list of albums of works on paper by the canonical graphic artists: Mantegna, Michelangelo, Raphael, Dürer, Holbein, Lucas van Leyden,

Bruegel, Goltzius, Rubens, Van Dyck – indeed 'the most significant masters of the whole world', as one entry claimed. *Naturalia* ranged from countless shells and corals to sixty-nine land and sea animals, including a pair of calabashes and male and female lion skins. Antiquities were represented by statues and plaster casts of Roman emperors and Greek philosophers, as well as a cabinet of medals and a death mask of Prince Maurits. Many of the other curiosities could be classified as works of art or antiquities. Overseas exotica included an

'East Indian bowl' bearing a Chinese figure, porcelain cassowaries and a pair of Indian costumes; arms and armour of Japanese, Indian and Croatian origin; and even 'a Moor's head cast from life'. String and wind instruments formed a musical category of their own.

In many collections certain *artificialia* played a double role. Representations of antiquities or natural wonders could substitute for elusive originals such as tropical fishes, large predators and inaccessible archaeological remains. Rembrandt owned prints of Jerusalem and of Turkish buildings and customs, 'drawings of all Roman buildings', prints of statues and figures of 'a lion and a bull modelled from life'. He made his own drawings and prints of natural wonders – lions, elephants (151) and birds of paradise (149), the last probably after the specimen in his inventory. Rembrandt's print of a conical shell (150), etched in 1650, is a record of intense, admiring examination. He placed the *Conus marmoreus* of Southeast Asian origin in half-light, in a shallow space that suggests a drawer or ledge in a shell cabinet. Tropical molluscs were treasured objects, not least because they showed nature itself as supreme artist, sculpting uncannily precise spirals and cones and decorating them with wondrous patterns. Yet Rembrandt's evocation of the shell's soft lustre overturns nature's precedence: as the signature certifies, nature's loveliness is now the artist's creation. The print's exquisite phrasing of art's rivalry with nature undoubtedly won it a place in many cabinets.

By 1600 the ownership of a collection had become a mark of the gentleman-virtuoso, the connoisseur and scholar of the world's marvels. Rembrandt may well have seen his collection as appropriate to his prominent status in the 1640s and 1650s. He had begun to collect in earnest after 1635, when his professional success allowed him to make substantial purchases. Rembrandt features in auction records as a buyer of paintings, works on paper and miscellaneous artefacts. The rapid expansion of his collection coincided with his acquisition of the house in the Sint Antonisbreestraat, his genteel self-portrait of 1640 (see 98) and the commission for *The Nightwatch*. It may have strengthened Rembrandt's place in the middling ranks of the citizen élite, and it probably brought about contact with eminent connoisseurs such as Jan Six.

147
Frans Francken
the Younger,
A Kunstkammer,
1618.
Oil on panel;
56 × 85 cm,
22 × 33½ in.
Koninklijk
Museum voor
Schone
Kunsten,
Antwerp

148
*The Mughal
Emperor
Jahangir,*
*c.*1655.
Pen and brown
ink, brown,
pink and grey
wash on
Japanese
paper;
18·2 × 12 cm,
7⅛ × 4¾ in.
Rijksprenten-
kabinet,
Amsterdam

149
*Two Studies
of a Bird of
Paradise,*
*c.*1638–40.
Pen and brown
ink, brown
wash, white
body-colour;
18·1 × 15·1 cm,
7⅛ × 6 in.
Musée du
Louvre, Paris

150
*Conus
Marmoreus,*
1650.
Etching,
drypoint and
engraving,
second state;
9·7 × 13·2 cm,
3⅞ × 5¼ in.

151
Elephant,
*c.*1637.
Black chalk
and charcoal;
17·9 × 25·6 cm,
7 × 10 in.
British
Museum,
London

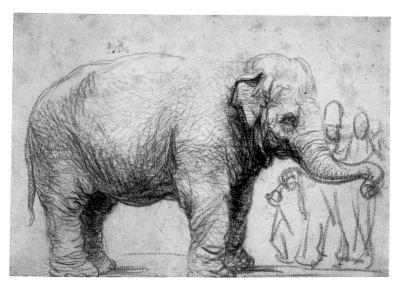

But social prestige and scientific interest may have been only secondary justifications for Rembrandt's collecting habit. While the finest scholarly collections were complemented by distinguished libraries, in 1656 Rembrandt owned no more than two dozen books, including an old Bible and Josephus' *Antiquities of the Jews*. Unlike scholarly collectors, he apparently acquired his books for practical purposes: for reference in the process of painting and for their illustrations.

Rembrandt's collection also provided business advantages. Works of art could be investments, occasionally sold to supplement income. Like many seventeenth-century artists, Rembrandt dealt in art and curiosities when the market was favourable or when he had to raise cash. In 1644 he sold a history painting by Rubens that he had bought seven years earlier for 530 guilders, making a profit of 105 guilders. He attempted to avert bankruptcy in 1655 by selling parts of his collection, and when he reorganized his business in 1660, he made himself an employee of a partnership that dealt in art and curiosities.

Most crucially, however, Rembrandt's collection served his artistic interests. The habit of close observation, fostered in all encyclopedic collections, was always central to his work, and especially in the 1640s when the collection was gaining in strength. The objects were excellent visual sources, too. Even Pels, who took a dim view of Rembrandt's penchant for collecting, perceived that the painter 'took to his advantage all that ever came from the world's four parts'. The prints and drawings represented an important visual library to him and his students; so did a series of contemporary Indian miniatures, which Rembrandt copied in pen and wash during the 1650s. An album 'full of curious miniature drawings' in his inventory probably contained Indian portraits of the Mughal emperors Jahangir (r.1605–28), Shah Jahan (r.1628–58) and their courtiers. The delicate technique of Rembrandt's twenty-four copies on smooth Japanese paper does not imitate the style of the brightly coloured, boldly outlined originals, but his fine lines and soft washes reflect their elegance. In his rendering of the emperor Jahangir (148) Rembrandt carefully drew his tunic and pajamas, slippers, shawl, turban and fine grooming. He may well have been interested primarily in the exotic attire of these figures, for the

'curious miniature drawings' were gathered with 'various woodblock and copper prints of all manner of costumes'.

Rembrandt repeatedly adopted the formal appearance of Indian notables for Old Testament characters. In *Joseph Accused by Potiphar's Wife* (152), the Egyptian Potiphar sports the turban, tunic, trousers, slippers and sword worn by many of the 'small East Indian figures', as Rembrandt referred to them. His short beard, sharp features and stiffly inclined stance also reveal their source. Such borrowings reflect contemporary thought about the proper ways to depict the historic figures of the ancient Middle East. Lacking reliable knowledge of dress and ceremony in biblical times, artists mingled designs taken from various sources about Asian and Arabic customs; theatre records suggest that stage designers took a similar approach. This parallel is relevant, for *Joseph Accused by Potiphar's Wife* may well represent Vondel's interpretation of the biblical episode in his *Joseph in Egypt*.

Vondel's popular play of 1640 was revived at the Amsterdam Theatre in 1655, the year in which Rembrandt painted his work and an assistant made a highly accomplished version of it. According to Genesis 39:7–20, after Joseph had been sold into slavery he was taken to Egypt, where he was bought by Potiphar, one of Pharaoh's men. As God's care for Joseph brought benefits to Potiphar's family, the Egyptian put him in charge of the household. Potiphar's wife fell in love with Joseph and tried unsuccessfully to seduce him. She managed to pull off his cloak as he fled the house, however, and in her pique accused Joseph of attempted rape, pointing to the coat in proof. While in the Bible story Joseph was not present during the denunciation, Vondel heightened the scene's tension by bringing the three characters together on stage. Rembrandt's painting condenses the same dramatic episode with supreme economy: partially disrobed, with dishevelled hair, the plaintiff is seated on the bed; she gestures towards Joseph as she turns away from him to address her husband. Her left foot steps on the damning cloak, while Joseph raises his hand in innocent despair. Although the painting is not a direct record of Vondel's protracted scene, it distills the poet's dramatic confrontation between the wife's evil and Joseph's innocence, between Potiphar's love of his wife and trust in his deputy.

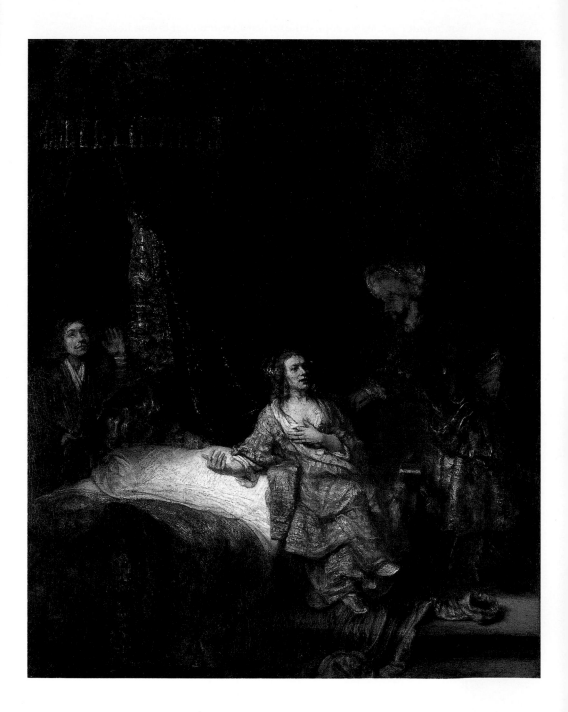

The print albums in Rembrandt's inventory demonstrate his keen interest in the print medium and its greatest practitioners. He made etchings throughout his career, working up several hundred copper plates that cover all the subjects he explored in paintings and drawings: there are historical themes, portraits, scenes of domestic and street life, landscapes, studio exercises and quick sketches. Prints were a profitable extension of the painter's trade, and early in his career

152
Joseph Accused by Potiphar's Wife,
1655.
Oil on canvas;
113·5 × 90 cm
44³⁄₄ × 35¹⁄₂ in.
Staatliche Museen Preussischer Kulturbesitz, Gemäldegalerie, Berlin

153
Nebuchadnezzar's Dream,
1655.
Etching, drypoint and engraving;
9·6 × 7·6 cm,
3³⁄₄ × 3 in

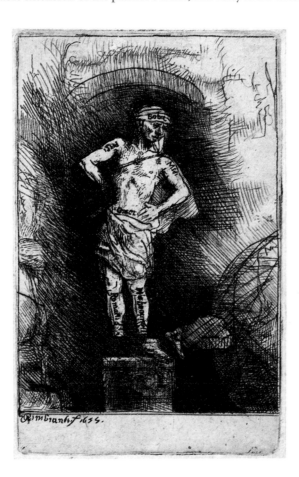

Rembrandt occasionally collaborated with professional printmakers to market his inventions to a wider public (see 29 and 68). After 1635, however, he took sole charge of the process. His book illustrations from this period were favours for friends rather than potboilers. Six's *Medea* (see 127) was hardly intended to be a bestseller, and Menasseh ben Israel's *Piedra Gloriosa* ('Glorious Stone'), for which Rembrandt made four etchings in 1655, was a decidedly esoteric expression of

Jewish hopes for the coming of God's kingdom on earth, using the story of Nebuchadnezzar's dream (Daniel 2:31–5). Nebuchadnezzar dreamt that a stone, symbol of the Messiah, destroyed the feet of an idolatrous statue and then grew to encompass the earth. Rembrandt condensed this mystical narrative in emblematic fashion (153). A humble stone crowds the feet of a statue, posed confidently in the manner of Rembrandt's studio models (see 135, 142), and its future rule of the earth is implied by the globe seen at the right. In the published version of the print the statue bears the names of the empires that would be superseded by the Messianic kingdom: Babylon, Persia, Macedonia, Greece, Rome and the empire of Muhammad. The inventive imagery and technical density of this work are characteristic of Rembrandt's prints; his later print production is so experimental that it warrants separate discussion in Chapter 8.

7

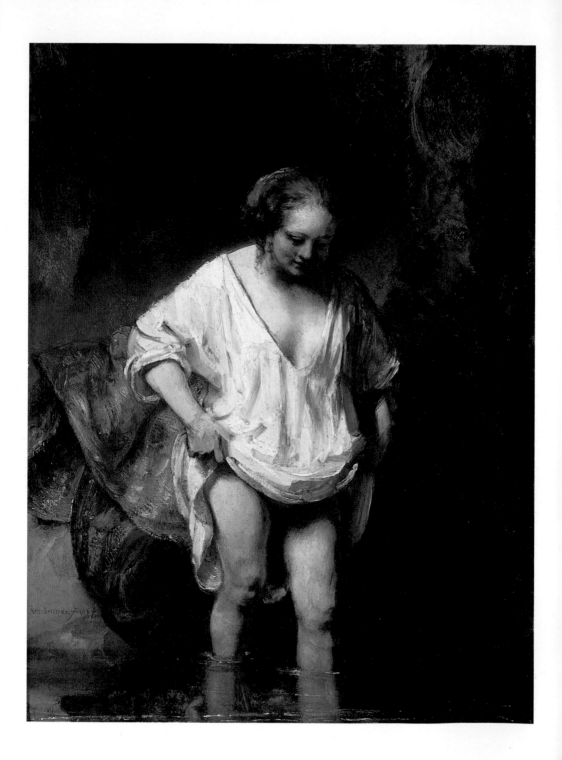

In the early 1650s Rembrandt's business began to run into trouble. The events that led to his insolvency and the sale of his property in 1656 are complex, but their reconstruction affords a rare glimpse into the business dealings of a seventeenth-century artist. Rembrandt's art took on an increasingly innovative character in these years, and although it is hard to be precise about the reciprocity between his art, his business failure and his non-marital relationship with Hendrickje, several paintings of this period appear to reflect on his situation. His financial problems of the 1650s may also have deepened his already well-developed artistic independence.

154
*Woman
Bathing,*
1654.
Oil on panel;
61·8 × 47 cm,
24³⁄₈ × 18¹⁄₂ in.
National
Gallery,
London

Rembrandt's heaviest financial liability was the debt on his house, which should have been paid off by 1646. Between 1639 and 1649 Rembrandt delivered only 6,000 guilders of the purchase price, and in 1653 the seller at last forced him to pay the balance of 7,000 guilders plus interest and taxes, the whole debt amounting to almost 8,500 guilders. To meet this demand, Rembrandt took out three loans for a total of 9,380 guilders. His lenders included Jan Six and the eminent burgomaster Cornelis Witsen. Rembrandt may have used the cash to settle other debts, for the seller of the house did not receive his principal and tax expenses until the end of 1654, when Rembrandt mortgaged the outstanding interest.

The new loans were never paid off, and they did not solve Rembrandt's financial problems. In 1653 he twice appointed representatives to collect debts due to him, and in 1654 he put legal pressure on a man who owed him money. His trouble reclaiming his loans may have been due in part to the economic depression caused by the Anglo-Dutch war of 1652–4, and Rembrandt resorted to other ways of raising funds. In 1655 he apparently planned to move into a cheaper house. He offered 7,000 guilders for the house, 3,000 guilders to be paid in paintings and etchings and the remainder with a mortgage. The sale was cancelled,

possibly because Rembrandt by now had an unimpressive credit status. Around this time he organized several auctions of his personal belongings. The sales did not generate enough money, perhaps because they did not offer enough important works from his collection. Had they included such objects he might have been in the clear, for two experts later valued his collection of paintings at 6,400 guilders and that of his prints, drawings and other curiosities at 11,000 guilders.

Unable to satisfy his creditors, Rembrandt applied in June 1656 for a *cessio bonorum*, a 'surrender of goods' that would give control of his assets to the Chamber of Insolvent Estates. He had tried to save his house by assigning it to Titus, but this move of dubious legality was futile, and in 1658 the Chamber commanded that the house be sold. By that time, the estate managers had already drawn up the famous inventory of July 1656 and auctioned its contents. The sales of the house and its most valuable possessions still did not raise all the money required, for in the end the furniture and household utensils were also sold to a pawn-broker. Even then, not all Rembrandt's debts could be honoured.

To prevent claims against future revenues, Rembrandt restructured his business in 1660. In a scaled-down version of Uylenburgh's operation, Hendrickje and Titus became directors of a dealership in art that paid Rembrandt a salary for producing paintings. The firm's assets were thus inaccessible to Rembrandt's personal creditors. He further secured his reduced situation by moving to a modest rented house in the Jordaan, a quarter in western Amsterdam that was popular with painters and dealers. There he made a reasonable though not especially comfortable living for the last decade of his life.

Apart from Rembrandt's deposition about trade losses and the documents detailing his mortgage problems, there is no direct evidence of the causes of his insolvency. Any analysis must take into account the structure of his investments, economic circumstances beyond his control, the possibly negative impact of his personal conduct and the changing tastes of Dutch collectors. Rembrandt's unwillingness to pay off his mortgage in the 1640s, when he was in a position to do so, is indicative of his tendency not to invest in real estate, which was favoured by his contemporaries as a relatively secure investment.

In 1640 he sold the garden property outside Leiden that he had acquired in 1631, and in the same year he sold a mortgage he had received from his mother's estate, preferring the instant cash over annual interest. The considerable value of his collection demonstrates that he preferred to acquire smaller commodities, which were riskier investments since any economic downturn affected the market in luxury goods first. And since Rembrandt was in the business of producing this kind of object, in present-day parlance his investment portfolio was too unbalanced to weather cataclysmic events such as the First Anglo-Dutch War, which affected many businesses.

Although Rembrandt managed to take out three loans in 1654, he was unable to arrange a mortgage for a smaller house or to avoid a *cessio bonorum*. In addition to his poor record on his first mortgage, by the mid-1650s his personal life may have been a factor in discouraging potential lenders, particularly the men of Mennonite persuasion who had financed Uylenburgh's business. Rembrandt's resolution of his problems with Geertge Dircks could have compromised his social standing, as did his relationship with Hendrickje, whom he never married. In June 1654 their common law marriage became public, when the Reformed Church Council accused Hendrickje of 'having committed whoredom with Rembrandt the painter'. It took a month and three summonses for Hendrickje to appear before the Council, which admonished her to penitence and banned her from the Lord's Supper for an unspecified period, a serious disciplinary action that placed a worshipper in both moral and social limbo. Since Rembrandt was not required to appear himself, it is clear that, unlike Hendrickje, he was not an official member of the Reformed Church. Hendrickje's extramarital relationship with Rembrandt probably came to the Council's notice because she was pregnant at the time. Their daughter Cornelia, named after Rembrandt's mother, was born a few months later. The girl's illegitimacy was no impediment to her baptism in the Reformed Church, and there are no further records of disapproval of Rembrandt's domestic arrangements.

While Rembrandt's personal affairs can hardly be held responsible for his financial woes, changing tastes may have affected the profitability

of his business. During the 1650s younger history and portrait painters flourished with a style based on carefully blended brushstrokes, bright colours and classically proportioned forms. Some, such as Govaert Flinck and Ferdinand Bol, had studied with Rembrandt but changed their styles after they left his studio; others, like Bartholomeus van der Helst, had become significant rivals in the 1640s. The fashion for smoother handling, elegant poses and a full spectrum of hues, developed most splendidly by Van der Helst (155), surely encroached on Rembrandt's patronage, but its most damaging effects are evident only after his financial crisis.

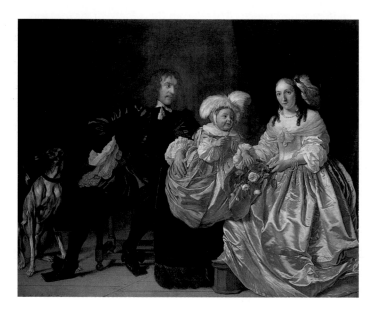

155
Bartholomeus van der Helst,
Portrait of a Couple with their Child,
1652.
Oil on canvas;
187·5 × 226·5 cm,
73⅞ × 89⅛ in.
The Hermitage,
St Petersburg

In the 1650s Rembrandt's production suffered no dramatic decline, and several commissions yielded unforgettable paintings. The portrait of Six, painted in 1654, is his most compelling presentation of a thoughtful regent (see 130). In these years Rembrandt even regained his position as a sought-after portraitist of Amsterdam's élite, painting such sitters as Floris Soop, who had lived next to the Six family since 1631 (156). The large portrait of Soop, painted in 1654, shares the dashing quality of Six's likeness. Represented in his role of standard-bearer to the civic guard, Soop strikes a pose of strength in front of a stone gateway. The black costume and brass buttons have lost some of their lustre due to abrasion, but Soop's boldly modelled face asserts

individuality and civic responsibility. The contrast between the meticulously rendered wood-grain on the pole in the foreground and the broadly indicated fabric of the banner behind Soop creates convincing space for his imposing body. The painting must have been an impressive centrepiece to Soop's collection of 140 paintings.

On the strength of such portraits Rembrandt was offered the commission for *The Anatomy Lesson of Doctor Joan Deyman* (157), his first public work since *The Nightwatch*. The dissection took place at the

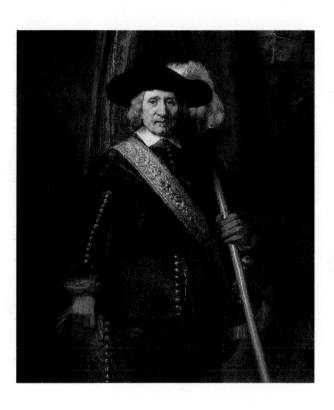

156
*The Standard
Bearer Floris
Soop*,
1654.
Oil on canvas;
140·3 × 114·9 cm,
55¼ × 45¼ in.
Metropolitan
Museum of
Art, New York

beginning of 1656, before Rembrandt's insolvency. In 1653 Joan Deyman had succeeded Nicolaes Tulp as lecturer in anatomy. A quarter of a century after Rembrandt had painted Tulp's lesson (see 52), the surgeons' guild returned to him despite the appeal of younger portraitists. In 1723, a fire destroyed much of the painting, but its full composition can be surmised from Rembrandt's drawing for its frame, presumably sketched after the portrait's completion (158). In the surviving fragment, Gysbrecht Calcoen assists Dr Deyman in the dissection of Joris Fonteijn van Diest, who had been hanged for armed

robbery. According to the drawing, the doctor and the corpse were placed just to the left of centre in front of a rounded balustrade. Behind this partition officers of the guild look on, clustered to either side of an ornamented pillar.

If the symmetrical disposition and even lighting of the sitters made the painting in some respects more conventional than Rembrandt's earlier group portraits, the surviving fragment emphasizes its radically

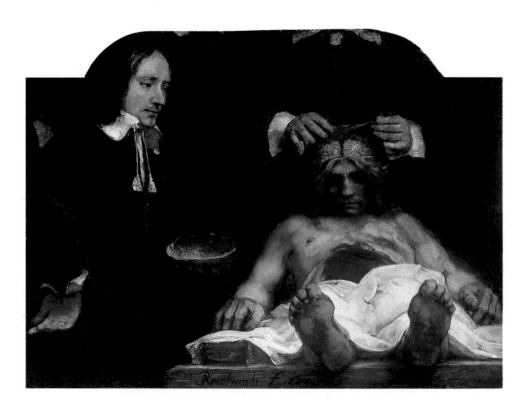

innovative aspects. The extreme foreshortening of the cadaver provides a close view of its protruding foot soles, grey with *rigor mortis*, and an unsettling look into its bloody abdominal cavity. The dramatic frontally supine position of the corpse was unprecedented in paintings of anatomy lessons. Rembrandt borrowed it from a favoured formula for representing the dead Christ, applied by European artists from Mantegna to Rubens. The dead man's face stares out beneath his opened brain, as Calcoen stands by with the removed cranium. Unlike *The Anatomy Lesson of Doctor Nicolaes Tulp*, Rembrandt thus followed the actual order of a dissection. The painting was executed in the broad,

suggestive style of the portraits of Six and Soop, and the surgeons appear to have been well pleased with it, for they hung it in the guild room to the left side of the fireplace, opposite Tulp's anatomy lesson.

While Rembrandt enjoyed steady patronage in Amsterdam in the early 1650s, his fortunes abroad even improved. About 1652, he received an order for a painting from Don Antonio Ruffo, a Sicilian nobleman. A patron of the Bolognese painter Guercino (1591–1666), Ruffo had amassed a collection of some 400 paintings, most by Italian contemporaries and Renaissance artists, with a few by northern

157
The Anatomy Lesson of Doctor Joan Deyman, 1656.
Oil on canvas; 100 × 134 cm, 39⅜ × 52¾ in. Amsterdams Historisch Museum

158
The Anatomy Lesson of Doctor Joan Deyman in Its Proposed Frame, c.1656.
Pen and brown ink, brown wash, red chalk; 10·9 × 13·1 cm, 4¼ × 5⅛ in. Amsterdams Historisch Museum

European painters, including Lucas van Leyden and Van Dyck. Rembrandt was apparently given latitude in the subject. When his *Aristotle* (159) was received in Messina in 1654 it was inventoried as a 'half-length figure of a philosopher ... it appears to be Aristotle or Albertus Magnus', and in 1657 a note still referred to the picture as 'Albertus Magnus'. Ruffo was evidently more interested in acquiring a half-length painting by Rembrandt than in the specific identity of the philosopher. Stimulated by the acquisition, he later ordered matching half-length philosophers from Guercino and three other Italian painters, and two more such pictures from Rembrandt (see Chapter 9).

159
Aristotle,
1653.
Oil on canvas;
143·5 × 136·5 cm,
56$^1_2$ × 53$^3_4$ in.
Metropolitan
Museum of
Art, New York

160
**Albrecht
Dürer,**
Melencolia I,
1514.
Engraving;
24·1 × 19·2 cm,
9$^1_2$ × 7$^1_2$ in

The visual power of Rembrandt's *Aristotle* is barely diminished by
the darkening and abrasion of the paint or by its loss of about 60 cm
(23$^5_8$ in) from the bottom of the canvas. As Julius Held demonstrated
in a classic study, Rembrandt painted Aristotle contemplating the spir-
itual legacy of Homer, who is represented by a bust, touched gently by
Aristotle's right hand. Homer's status as founding author of Greek
epic made him an exemplar of intellectual and ethical strength, yet
Aristotle's sallow face and weary eyes express deep sadness. His atti-
tude is appropriate because Aristotle attached special significance to
melancholy as the privileged condition of the greatest intellects, of
those who ponder the unknowable. Following Aristotle and other
classical accounts of human physiology, Renaissance philosophers
described melancholic depression as a temperament caused by a
preponderance of black bile. The condition was brought about by the
maleficent influence of the planet Saturn, which also bestowed the
kinder gift of mathematical and philosophical brilliance. Whether or
not Rembrandt subscribed to this lore, he was certainly aware of the
celebrated qualities of the Saturnine temperament and quite possibly of
the source of these beliefs in Aristotle. Dürer's engraving *Melencolia I*
of 1514 (160) had given famous visual expression to the condition,

and by the seventeenth century melancholy was so fashionable that courtiers, writers and artists alike flaunted it in art and life, as many of Van Dyck's portraits attest. In England, Robert Burton published the best-selling *Anatomy of Melancholy* (1621), a prodigious, frequently humorous treatise on the pathogenesis and social manifestations of the affliction. It has been suggested that Rembrandt's self-portraits with deeply shaded, brooding eyes probe or even court this pensive disorder (see 2, 11 and 12). Precipitated by excessive artistic contemplation, as Dürer claimed in his writings, melancholy enabled Rembrandt to visualize in contemporary terms the sort of introspection that appears to have motivated much of his art.

Rembrandt implied specific causes for Aristotle's melancholy. The painting hints that Aristotle is torn by the competing demands of spiritual matters, embodied in the bust of Homer, and secular ones, signified by the medal with the portrait of Alexander the Great, which dangles from the gold chain. Rembrandt meant his viewers to understand that Aristotle, who had been Alexander's tutor, received this chain from his lord as a sign of valued service as well as subservience. The tension between worldly and spiritual values was as current an ethical issue in the seventeenth century as it had been in Aristotle's time. Aristotle was a poignant exemplar of this conflict, for the ruler and his former tutor had become estranged when Alexander summarily executed another pupil, perhaps a nephew of Aristotle, for suspected treason. The philosopher's age confirms Rembrandt's allusion to the strained relationship between the ruler and his intellectual master. In 1653 this theme may have had personal relevance for Rembrandt, as the demands of the 'world' and of his art became increasingly at odds with each other.

Ruffo may have valued the painting for its complex emotional narrative but probably more for its virtuoso technique, which must have pleased a connoisseur of Venetian Renaissance art. Rembrandt's picture is a homage to the Venetian tradition of painting, particularly to Titian's late style, which favoured broad, layered strokes and a restricted palette of yellows, reds, whites and blacks (see 76). When seen from a proper distance, as Vasari and Van Mander noted, this

161
Titian,
Flora,
c.1515–16.
Oil on canvas;
79 × 63 cm,
$31\frac{1}{8} \times 24\frac{3}{4}$ in.
Galleria degli
Uffizi,
Florence

162
(Hendrickje
Stoffels as?)
Flora,
c.1654–5.
Oil on canvas;
100 × 91·8 cm,
$39\frac{3}{8} \times 36\frac{1}{8}$ in.
Metropolitan
Museum of
Art, New York

brushwork coheres into glowing forms. Aristotle's richly flowing sleeves and scintillating chain were painted in this bold yet precise fashion. Slightly further back in space, his face has a smoother surface, painted in variegated colours that animate his features. From a distance, Aristotle has commanding presence; seen close up, he dissolves into paint. This is the *rouw* or rough manner of painting at its most expressive, and Rembrandt's evocation of Titian, the founding father of this style, was surely intentional. His self-portraits of 1639 and 1640 had already acknowledged the compositional finesse and understated elegance of Titian's early *Portrait of a Man* (see 95), but

the *Aristotle* explicitly emulates Titian's technique. The white fabric appears indebted to Titian's *Flora* (161), which had been in the Lopez collection around 1640.

Titian's *Flora* structured Rembrandt's own painting of the theme made soon after the *Aristotle* (162). How unselfconscious she is, compared to her previous incarnation resembling Saskia (see 57). Her sweeping, frontal form fills out the large canvas to give her a presence rivalling Aristotle's. Whereas the Greek philosopher averts his gaze in thought, she looks away to offer a handful of flowers to an invisible suitor. Rembrandt borrowed this device from Titian, but he made it more intimate, less

overtly seductive, as Flora's face is turned in profile and her white shirt keeps her covered. Titian's *Flora* is a peculiarly Venetian type of courtesan, the well-bred call girl, conversation partner and selective purveyor of sexual favours. Rembrandt created his flesh-and-blood goddess by grafting the facial features and large hands of a live model, perhaps Hendrickje, on to Titian's timeless ideal. No pictures of Hendrickje can be identified with certainty, but Flora's long nose, large eyes and sculpted double chin recur frequently in Rembrandt's works from the 1650s.

If Rembrandt deliberately cast Hendrickje as Flora, the reference was apt. In her dual capacity as Rembrandt's mistress and mother of his child, she unintentionally played the role of Flora, life-giver and courtesan, and Rembrandt's muse. Here he eschewed the precise descriptive technique of *Saskia as Flora*, which specifies how the flowers and fabrics may have felt to the touch, for a freer handling of paint that mimics the broad optical appearance of skin, cloth and flowers. A brush loaded with dry paint created the rhythmic undulations of the sleeves, so similar to those of *Aristotle*. The finest touches for the bright material near the viewer are set off against broad strokes that delineate folds further back or in shadow. With thick dabs of red and greenish paint Rembrandt denoted flowers without remaking them in paint.

163
Bathsheba,
1654.
Oil on canvas;
142 × 142 cm,
55⅞ × 55⅞ in.
Musée du
Louvre, Paris

The presence of Venetian art in Amsterdam does not by itself explain Rembrandt's engagement with it or his preference, in his late works, for Titian's rough rather than his earlier, smoother manner. Late Titian was not especially current in an artistic culture that favoured the elegant, clear styles of Van der Helst and Flinck, but it suited Rembrandt's emotionally charged yet succinct narratives. In his late years Titian, too, painted difficult works: dark commentaries on moral quandaries and brooding contemplations of life, concentrated on few figures. Moreover, Titian was unrivalled in painting female flesh, in building up and smoothing out oil paint to make skin quiver (see 76). Rubens had emulated Titian's women with effervescent brilliance, but Rembrandt drew on a lower, deeper register of Titian's art. Static and essentially alone, Rembrandt's rare nudes invite a contemplation that is foreign to Rubens' celebratory gusto. Among these women, none is more beguiling than *Bathsheba* (163).

Bathsheba's story, told in 2 Samuel 11, was familiar. Walking on the roof of his palace, David saw a woman bathing and found her beautiful. Told that she was the wife of Uriah, one of his warriors, 'he sent his messengers to fetch her, and when she came to him, he lay with her … She conceived, and sent word to David that she was pregnant.' To avoid scandal, David tried to bring Uriah back from his campaign to get him to sleep with his wife. In his devotion to the Israelite army, Uriah refused. Then David wrote to his commander: 'Put Uriah opposite the enemy where the fighting is fiercest and then fall back, and leave him to meet his death.' When Bathsheba was informed of Uriah's death 'she mourned for him; and when the period of mourning was over, David sent for her and brought her into his house. She became his wife and bore him a son. But what David had done was wrong in the eyes of the Lord.' Rembrandt painted Bathsheba life-size on a square canvas, almost half of which is given over to her mature body. The curvature of her right leg and arm bisects the painting along the diagonal: to its right Bathsheba sits at the edge of a pool, on a mound covered with linens and gold brocade. She gazes down towards the left, where an elderly woman tends to her feet. A warm light sets aglow Bathsheba's creamy skin and rumpled garments; all around her is darkness, except for a few highlights that pick out the neck and hands of her attendant. Here as in his *Flora* Rembrandt rendered his subject ambiguous by placing her torso frontally while turning her head in profile. Her body, near and at rest, is offered up for delectation, its allure heightened by the calculated profile of her breast. But her averted face limits the viewer's access. X-rays show that her face was initially turned upwards and out, in the coy manner of Titian's *Flora* or Rembrandt's own *Danaë* (see 75). Rembrandt's decision to change the position of her head altered his Bathsheba from an attractive nude, willing to meet the eyes of a viewer, to a woman lost in thought.

What is Bathsheba pondering? The biblical mention of her sorrow over Uriah's death might have prompted Rembrandt's decision to paint her in still sadness, but her nudity, the setting and the red-sealed letter suggest that Rembrandt conflated her bath with her reception of David's initial command. Although the Bible does not say how Bathsheba was summoned, painters frequently used a letter to

represent David's invitation. Philips Angel, in his short treatise on painting of 1642, had wondered just how painters were to imagine the delivery of David's message, and concluded that, since Bathsheba was essentially asked to prostitute herself, a procuress must have transmitted a letter to her. The maidservant in Rembrandt's painting partly fits this role, but her serious concentration is rare in depictions of procuresses, and appropriate to Bathsheba's marked gravity. The Bible says nothing about Bathsheba's response, noting only that she went to the king. Rembrandt gave her a moment of reflection, soul-searching, doubt or hesitation – it is impossible to know which – before their adulterous meeting.

Before Rembrandt, no one had painted Bathsheba with such ambiguity, even though the biblical account invites it. Theologians and artists traditionally saw her as the seductress of an all-too-human king. She did not resist David's advances – she went even though she had not been purified from her period – and expressed no reluctance to marry the king after her time of mourning. The child born of her adultery was struck dead by disease, but God loved her second son, Solomon, who succeeded David. By Old Testament standards Bathsheba did well. Rembrandt retained elements of this glamorous Bathsheba of pictorial tradition: the bejewelled band around her arm recalls Italian paintings of courtesans, most famously *La Fornarina*, Raphael's portrait of his presumed mistress (164). Yet the Bible also makes clear that Bathsheba had little choice in the affair and felt grief, and that God was displeased with David. The thoughtfulness of Rembrandt's Bathsheba makes her an involuntary actor in a moral drama. As such she invites the viewer to revisit the sad narrative and experience the limits of her options.

Rembrandt's Bathsheba impresses us as an individual, capable of thought beyond the few emotions ascribed to the biblical figure. The painting has even been seen as a narrative portrait of Hendrickje, painted by Rembrandt in response to the disapproval of their relationship. His apparent quotation of *La Fornarina*'s armband may support this hypothesis. Like Bathsheba, Hendrickje was engaged in an illegitimate affair; and while Bathsheba was doubly taboo to David, because of her marriage and her recent menstruation, so Rembrandt's access to

Hendrickje was doubly complicated in 1654. The Church denunciation may have strained their relationship, and her pregnancy and childbed limited her sexual availability. Rembrandt's response to their situation may have shaped the tension between Bathsheba's open body, described with loving attention, and the withdrawal of her face. Whatever the case, a connoisseur would still have recognized the painting as an unusually thoughtful representation of a woman who had seldom been credited with moral judgment.

164
Raphael,
La Fornarina,
c.1518.
Oil on panel;
85 × 60 cm,
$33\frac{1}{2} \times 23\frac{5}{8}$ in.
Galleria
Nazionale,
Rome

The profoundly personal air of Rembrandt's *Bathsheba* is surpassed only by the direct *Woman Bathing*, painted in the same year (see 154). To modern perceptions trained on the bathers of Edgar Degas (1834–1917), Rembrandt's finest exercise in Titian's late manner looks familiar, but in the seventeenth century an oil painting of a woman revealing herself, without an ostensible historical theme to justify it,

was an oddity. With her plain physique, lovely in an ordinary way, and simple shift, she resembles the freely drawn studies of studio models produced in Rembrandt's workshop. Her informal appearance also recalls brilliantly brushed drawings of a woman usually identified as Hendrickje, the finest of which shows her sleeping in a simple wrap (165).

Although the casual theme and open brushwork of *Woman Bathing* might suggest that it is a mere studio exercise, Rembrandt's signature and date declare that he considered it a finished painting. Moreover, technical research has demonstrated that he achieved the picture's free appearance by a meticulous choice of materials and techniques, which produced the scintillating reflections and ripples in the water as well as the textural contrasts between skin, shift and brocade. This careful handling has prompted attempts to identify this woman as a historical figure, from Bathsheba watched by David or Susannah spied on by the elders (Apocryphal Story of Susannah, 8) to the chaste goddess Diana or her pregnant nymph Callisto (see 71). She has also been seen as Hendrickje caught unawares. All these suggestions have something to recommend them: the water and the discarded, fancy robe are appropriate to the biblical and classical stories, and the single-figure format and familiar facial features support the theory that she is Hendrickje. The erotic innuendo of the lifted shift fits all these possibilities. While strikingly natural, the gesture was probably derived from an engraving after an antique statue of a woman revealing her pudenda, which Rembrandt apparently knew. Yet none of the proposed identifications accounts fully for this woman, and one feels sympathy for the stumped author of an eighteenth-century sale catalogue, who described her as 'A Woman going into the Water holding her Coats pretty high, and laughing at what she sees reflected.' The phrase captures the scene's intimacy, and the sense that this woman is blissfully ignorant of the viewer's presence.

If Rembrandt had a specific narrative in mind when he painted *Woman Bathing*, he left viewers wide latitude for interpreting the work. With its unfinished look, ambiguous story and unconventional semi-nude, the painting is a novelty, a delectable product for the sophisticated art lovers Rembrandt had been cultivating since the

1640s. Houbraken must have had this kind of apparent spontaneity in mind when he remarked that Rembrandt 'in his early period had more patience than he did later for elaborating his works of art'. According to Houbraken, Rembrandt stubbornly refused to finish his later paintings to a high standard, 'maintaining that a piece is completed when the master has reached his intention in it'. The signature and date on Rembrandt's *Woman Bathing* support Houbraken's report.

Looking at all aspects of Rembrandt's life in the 1650s, it is difficult to ascertain the impact of his personal problems and artistic style on his business. Conversely, his insolvency certainly had significant effects on his life and art. His move sometime in 1658 to a modest house in the Jordaan distanced him from Amsterdam's economic and cultural heart. Moreover, as S A C Dudok van Heel has written, his handling of

his business failure would have displeased dedicated Protestants, among them the prominent citizens who had given him commissions. The Reformed Church distinguished bankruptcy, which it considered a moral offence tainted with fraud, from insolvency, which it imputed to causes beyond a person's control, as long as insolvents attempted to honour their debts. The Church looked harshly on attempts to avoid full financial responsibility. By first moving to assign his house to Titus and then restructuring his business to avoid paying off his last debts with future income, Rembrandt violated this code of honour. His conduct may have alienated upstanding citizens such as Six, who apparently terminated contact with Rembrandt.

Rembrandt's paintings of the early 1650s – *Aristotle, Bathsheba, Woman Bathing* – are more boldly unconventional than his earlier works, with the exception of *The Nightwatch*. His insolvency and its aftermath may have reinforced his tendency to go his own artistic way, to push further his thoughtful narrative approach and rough brushwork. This style found new admirers; if their circle was smaller, it was also more vocal. In this period several contemporary poets paid homage to Rembrandt, most notably in *De Hollandtsche Parnas* ('The Dutch Parnassus'), an anthology published in 1660. Rembrandt was usually lauded in standard terms: he makes dead paint come alive, his artistic fame confers glory on his city. A few poets wrote more specifically about the distinctive characteristics of his art. Jeremias de Decker, whom Rembrandt portrayed, evoked the rich shadows in the rocky hillside of *Christ Appearing to Mary Magdalen* (see 110); Jan Vos, a popular writer of historical plays, admired Rembrandt's suspenseful narrative in a lost painting of *The Banquet of Esther and Ahasuerus*. None, however, wrote about the intimate quiet, golden light and virtuoso brushwork so admired today in *Aristotle, Bathsheba* or *Woman Bathing*. Seventeenth-century poems about paintings were concerned primarily with a picture's subject and the fame of its author, and they rarely addressed pictorial qualities. Nonetheless, the unusually numerous literary references to Rembrandt establish that, at this stage in his career, he enjoyed the preeminent status among Dutch artists that he retains today.

Some of Rembrandt's new patrons are known from portrait etchings. Their identities demonstrate how inextricably entangled were Rembrandt's art, life and business. Pieter Haringh had auctioned Rembrandt's property before the *cessio bonorum*. His uncle Thomas Haringh, the subject of another print, directed all of the auctions from 1656 to 1658. Jan Lutma was a prominent goldsmith (166), famous for his works in the prestigious auricular style, a luscious decorative idiom that Rembrandt had used to fashion the golden chamber of *Danaë* (see 75) and to suggest the extravagance of *Belshazzar's Feast* (see 77). His portrait records Lutma's expertise, exemplified in the elegant dish on the table. Lutma quietly regards the candlestick he holds in his right hand – for now he has set aside hammer, punches and gravers: tools shared by the goldsmith and the printmaker, both of whom work their trade in metal.

166
Jan Lutma the Elder, Goldsmith, 1656. Etching and drypoint on Chinese paper, second state; 19·6 × 15 cm, 7¾ × 5⅞ in

8

167
*Ecce Homo
(Christ
Presented to
the People)*
(detail of 184)

Before the advent of photography, prints were the source of Rembrandt's fame. Outside Amsterdam and beyond the Netherlands, he was known through his hundreds of etchings. Reproducible, small and much cheaper than paintings, prints travelled lightly. Since the fifteenth century they had been subject to a vigorous international trade conducted by itinerant artists and dealers, by correspondence and at fairs. Like Dürer before him, Rembrandt participated avidly in this trade, building up an extensive collection of prints by the finest printmakers.

Evidence abounds of Rembrandt's early reputation as a printmaker. In the 1630s the French print publisher François Langlois (1588–1647) produced engraved copies of heads etched by Jan Gillisz van Vliet after Rembrandt's designs (see 29). Langlois' prints had a long circulation, reappearing in other series later in the century. Rembrandt's picturesque heads were equally well known in Italy, where by 1645 they influenced the graphic works of Giovanni Benedetto Castiglione (*c.*1610–63/65). The stock of the Flemish artist and dealer Cornelis de Wael (1579–1667), inventoried in Rome in 1667, included 134 etchings by Rembrandt. Don Antonio Ruffo, one of the rare collectors of Rembrandt's paintings outside the Netherlands, may have learned about him through his etchings. In a letter of 1660, Guercino enthusiastically agreed to paint a companion picture to Ruffo's *Aristotle* because he greatly admired Rembrandt's prints:

As for the half-length figure by Rembrandt that has come into your hands, it cannot be other than complete perfection, because I have seen various works of his in prints that have come to our region. They are very beautifully executed, engraved with good taste and done in a fine manner, so that one can assume that his work in colour is likewise of complete exquisiteness and perfection, and I sincerely esteem him as a virtuoso.

In 1669, even after a disagreement with Rembrandt about a painting he commissioned to accompany the *Aristotle,* Ruffo bought 189 of Rembrandt's prints.

Guercino's remarks highlight the publicizing function of Rembrandt's etchings in places where his paintings were not readily available. In his early career, his self-portrait etchings must have introduced the still little-known artist to a wide public, but it is equally clear that these self-portraits served ends beyond self-promotion. Through them, Rembrandt trained himself as an etcher on a small, inexpensive scale, studied nuances of light and shade, and perfected his expression of the human passions. These prints were his first successful efforts in portraiture and in engaging *tronies*, and as personal documents of his appearance around 1630 they became autobiographical mementos. In their varied functions, quirky handling and personal subject matter, and in the sense that they are variations on a theme, they preface Rembrandt's entire print production.

The print medium allowed artists to experiment. Because prints were rarely made on commission and could be produced in hundreds at modest cost, printmakers could afford to try out new ideas on a market that was wider and more anonymous than that for paintings. Yet Rembrandt's prints were even more radically novel than those of most artist–printmakers. His trial-and-error technique matched the innovative character of his storytelling, and the independence of prints within his artistic production was unusual. To understand the innovations of particular etchings, it is illuminating first to compare his general approach to prints with the practices and techniques of his contemporaries.

Unlike many painters, Rembrandt rarely engaged a professional printmaker or publisher to produce or market his prints. His etchings almost never reproduce his paintings or drawings, although such copying of inventions in other media, by the artists themselves or by hired hands, was standard practice in the workshops of such painters as Rubens and Abraham Bloemaert. It had been bread-and-butter business for large print publishers from Hieronymus Cock (1507/10–70), the publisher of Bruegel's first inventions, through Hendrick Goltzius, who ran a sophisticated print workshop in Haarlem around 1600, to Hendrick Hondius (1573–1650), a prolific print publisher in The Hague. However skilled reproductive printmakers might be, their primary

task was the accurate conveyance of the original design. For this reason reproductive printmakers favoured the technique of engraving, which produces clean lines that have a neutral look, as if the engraver had transcribed the artist's design without adding personal frills.

The engraver digs the design out of a copper plate with a burin, a sharply pointed steel bar. Ink is worked into the engraved lines, the smooth areas of the plate are wiped clean, a slightly moist piece of paper is placed on top of the plate, and the package is rolled through a press. In the printing, the paper is pressed onto the plate and the ink is transferred out of the engraved grooves onto the paper. In the resulting 'impression', the engraved design is necessarily reversed. The technique requires taut control of the burin as well as meticulous inking and wiping. At its best, it yields scintillatingly clear lines that swell and taper elegantly (see 9, 66, 129 and 160). Since engraving does not yield quick, fluid lines, however, it is less suitable for the reproduction of especially painterly works.

It was customary for each agent's role in the production and marketing of a print to be acknowledged in inscriptions. The designer or 'inventor' might be identified with the abbreviation *in.* or *inv.*, for the Latin *invenit*: he invented. Langlois scrupulously added Rembrandt's name with this designation to his prints after the artist's *tronies*. The actual engraver might be distinguished by *sc.* or *sculpsit*: he carved the design out of the plate. The publisher's role could be specified with *excudit*: 'he forged it', that is, produced it. The publisher had the plate printed, marketed and sold, and might even finance the entire work. Early in his career, Rembrandt occasionally had paintings reproduced in whole or in part. For *The Descent from the Cross* Uylenburgh acted as publisher (see 68), but his marketing of the print is an exception in Rembrandt's career. Rembrandt printed and sold most prints himself, and he kept most of his etched plates, reworking them later or pulling more impressions from a finished plate. Around 1500, when printmaking was still a young industry, the ease with which images could be copied had already forced artists and publishers to seek legal protection. Such litigation eventually led to the development of modern copyright legislation, but for Rembrandt and his peers it was

still necessary to make individual arrangements for each plate. While in 1633 he sought a 'privilege' for *The Descent from the Cross*, four years later he sold the plate for his *Abraham Dismissing Hagar and Ishmael* (168) to Samuel d'Orta, a Portuguese painter residing in Amsterdam. Worried about unauthorized sales of earlier impressions of the plate, D'Orta made Rembrandt testify that he would use the copies still in his possession only for his own 'curiosity', a contemporary expression for 'artistic interest'. Rembrandt kept most of his plates, although he eventually sold them to Clement de Jonghe (see 126), whose inventory of 1679 lists dozens. Rembrandt may have transferred the prints before his insolvency sales, for they do not appear in his 1656 inventory.

Rembrandt knew De Jonghe personally and may have sold his plates to the dealer so that he could retain access to them. Rembrandt approached printmaking as an art form in its own right. He must have dedicated almost as much time to it as he did to painting, frequently reworking his plates in various techniques, printing and reprinting them on different papers, and changing the application of the ink. Significantly, the early prints after Rembrandt's paintings are etchings, which have a quirkier, more spontaneous look than the regularized engravings of the Rubens workshop. It is as if Rembrandt wanted the printed lines to transmit the textures of his paint surfaces, the wrinkled ugliness of Christ's dead body or of Judas' contorted face.

Although etching was the most suitable technique for this purpose, until well into the seventeenth century it was seen as a mere labour-saving substitute for engraving, because it is acid, rather than the hand-held burin, that bites the design into the copper. The etcher first coats the plate with a layer of acid-resistant resin, then uses a needle to draw a design through the resin. The coated plate is immersed in an acid that bites away the copper where it has been exposed by the needle; the resin-covered areas are not corroded. Once the design has been bitten deeply enough, the plate is removed from the acid bath and the resin taken off. The plate is then inked in the same manner as an engraving, and pulled through the press to transfer the design onto paper. The relative ease of the etching process was at first considered a disadvantage, since it loses some of the lucid elegance of engraving.

Etched lines look more uniformly thick, and they are less sharp because the acid corrosion gives them slightly ragged edges. Reproductive printmakers strove to mitigate the uneven look of etching by developing less pliable resins that required a stronger grip on the needle, and an etching tool that mimicked the burin's swell and taper. In a treatise published in 1645, the French etcher Abraham Bosse

168
Abraham Dismissing Hagar and Ishmael, 1637. Etching and drypoint, single state; 12·5 × 9·5 cm, 4⅞ × 3¾ in

(1602–76) argued that 'the etcher's main purpose is to counterfeit engraving'. His prints successfully imitate the regular line of engraving, and one of them shows the clear benefit of etching (169). Entitled *Engravers with the Burin and with Acid*, it contrasts the strenuous labour of the engraver with the comfort of the etcher, who manipulates his needle as if it were a quill pen.

Rembrandt's prints range from the deceptively simple to the intensely worked, but they never masquerade as engravings. From the beginning of his career, Rembrandt exploited the unruly potential of the etched line. At their freest, his etchings resemble printed drawings (see 131 and 170), and some were generated in studio drawing sessions (see 135). The 'spontaneity' of these sheets is highly contrived: the needle may be more flexible than the burin, but it does not move through the resinous ground with the ease of a pen. Rembrandt facilitated handling of the needle by developing softer grounds, but even so the confident lightness of *Six's Bridge* must have required meticulous care. Rembrandt may have aimed his freely drawn etchings at the

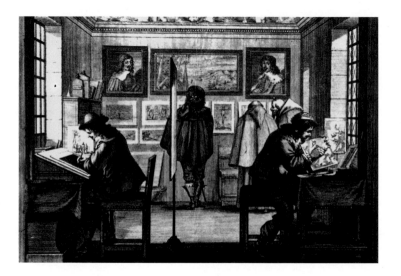

burgeoning market for drawings that reveal artistic process and personality. This market was driven by connoisseurs such as Van de Cappelle, who collected Rembrandt's informal drawings of women and children, or Nicolaes Flinck, who acquired a set of his landscape studies. To such collectors, less was more: Keil claimed that 'one of his drawings, in which little, or nothing, was seen ... was sold at auction for thirty *scudi*', a price equal to that paid for finely finished paintings.

In the 1630s Rembrandt etched several prints of such apparently incon-sequential subjects (170). Each combines studies of his favourite motifs – beggars, Saskia in bed, self-portraits, picturesque heads – and each resembles a random studio drawing (see 13 and 143). The individual

vignettes are finished to different degrees, and they are arranged in seemingly casual fashion, as Rembrandt turned the plate this way or that to begin a new sketch. Like his drawings of street and home life, these prints are intensely personal in subject and technique. They seem to claim that Rembrandt could turn the unassuming aspects of his life into art for a wide, anonymous audience eager for his latest work. They suggest, moreover, that Rembrandt's personal experiences were a direct source of his art. Rembrandt did not invent this notion – it is present in Dürer, Michelangelo, Titian and others – and he did not

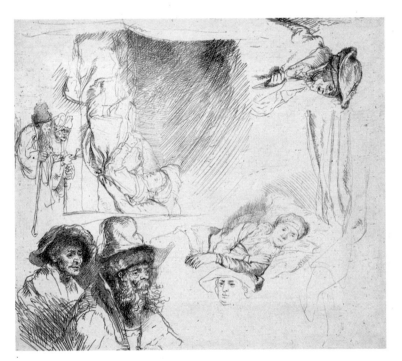

169
Abraham Bosse,
Engravers with the Burin and with Acid,
1645.
Etching

170
Sheet of Studies with A Woman Lying Ill in Bed, Beggars and Picturesque Heads,
c.1639.
Etching,
single state;
15.1 × 13.6 cm,
6 × 5⅜ in

articulate it as fully as Van Gogh or Toulouse-Lautrec were to do two centuries later. In most of his works, the theme in hand overrode his personal concerns, but these carefree, impromptu prints announce his pictorial insistence on the artist's presence in his works.

Rembrandt's most elaborate prints rival his innovations in paint. Admirers of prints had long argued the artistic parity of painting and printmaking. Writing of Dürer in 1528, the humanist scholar Erasmus claimed that the artist surpassed in black lines what Apelles had achieved in colours. Rembrandt's ambitions for his prints were

nourished by this tradition, but more specifically by the prints of
Hercules Segers (1589/90–1633/8), a highly original landscape etcher.
Segers etched fifty-four plates, and no two impressions taken from
them are identical. He edited his plates incessantly, printing each major
stage to yield different 'states' of the print (a state is a distinct phase of
the plate recorded in one or more impressions). Having printed a state,
Segers often changed the print into radically different states. He made
different impressions of one state by printing them on various papers
and cloth, by colouring the paper or by varying the colours of the ink.
Occasionally he used more than one colour in the printing – a device

that seems logical to modern eyes accustomed to full-colour litho-
graphs and photography, but that is difficult to control in etchings.

By these diverse processes, in which chance played a meaningful role,
Segers individualized etchings that were already unprecedented in
their technique. His mossy rocks, eroded valleys and fertile trees evoke
landscapes of the mind. Bubbly and stringy textures suggest the selec-
tive application of resin ground and the direct use of acid on the
unprotected plate. In his *Rocky Landscape* (171), an apparent biting
mistake in the sky was left visible to create a rich atmospheric effect.

The granular appearance of this passage was probably the result of acid biting through an unexpectedly porous ground. Segers also used conventional techniques in novel ways. The squiggles that mimic the texture of stone in *Rocky Landscape* suggest that he drew loosely through a soft ground. He used stopping-out varnish to cover areas that had already been etched, and then returned the plate to the acid. The selective re-biting thickened lines and deepened shadows. Lastly, he softened etched lines with the drypoint technique, in which the previously etched plate is gone over with a needle. Drypoint produces an even scratchier line than etching, and it is prized for the irregular copper edge or 'burr' it leaves raised on one or both sides of the line. When inked and printed carefully, this burr prints as 'bleeding' areas of tone along the lines. Of all printmaking techniques in copper, it gives the softest, most painterly effect. Before Segers, printmakers tended to scrape off the burr to produce cleaner lines, but he recognized the technique's pictorial potential, which Rembrandt eventually exploited to the full.

According to his inventory, Rembrandt owned eight paintings by Segers. Van Hoogstraeten wrote that Segers was 'sure in his Design of landscapes and grounds, nice in attractive mountains and grottoes, and virtually pregnant with entire Provinces, which he delivered with immeasurable space, and showed wondrously in his Paintings and Prints'. He claimed that poverty drove Segers to print on his shirts and bed linen, so that 'he even printed Paintings'. Segers' prints (some of which are indeed on linen) undeniably have the individuality of paintings, rather than serving the function for which they had been invented: the cheap production of multiple, identical copies of a design.

Rembrandt did not quite share that aim (although he realized it in some cases), and did not emulate Segers' colouristic experiments, but the imaginative character of his prints was directly indebted to Segers. Rembrandt apparently owned the plate of Segers' *Landscape with Tobias and the Archangel Raphael* (172), which showed Tobit's son travelling through a wild, dark landscape in search of a wife and a cure for his father's blindness. Perhaps discerning parallels between the journeys of Tobias and the Holy Family, Rembrandt reworked the plate

171
Hercules
Segers,
*Rocky
Landscape with
Church Tower
in the Distance*,
c.1620–38.
Etching,
first state,
in greyish
blue-green on
white paper;
12·0 × 19·2 cm,
4³⁄₄ × 7¹⁄₂ in

into a *Landscape with the Flight into Egypt* (173). He radically altered the right side of the image, replacing Tobias and the Archangel with smaller figures of the Holy Family and a donkey. Ghosts of the archangel's feathers enrich the foliage in the upper right corner. By leaving an ink residue known as surface tone on the plate in some print-ings, Rembrandt blended the Holy Family into the trees behind them.

Replicating Segers' variations of state, colour and texture, Rembrandt made six new states of the plate and printed impressions on vellum and Japanese paper. He varied his printing papers throughout his career, and these different supports can make impressions of a print look strikingly diverse. While bright white paper yields sharp lines and dramatic chiaroscuro, the shiny, off-white Japanese paper, which the Dutch imported through their trading post at Deshima, gives prints a warmer look. Its higher absorbency softens impressions because it lets lines 'bleed' slightly. The effect is even more pronounced in the vellum and light brown oatmeal papers that Rembrandt occasionally used.

The vigorous scraping and bold drypoint in the *Landscape with the Flight into Egypt* suggest that Rembrandt revised Segers' plate in the 1650s, when he developed similarly rough effects in his paintings and drawings (see 128 and 154). In the previous decade, he had begun to experiment more intensely with the themes and techniques of his prints, as *Six's Bridge* (see 131), *The Walker* (see 135) and *Conus Marmoreus* (see 150) show. Most memorable for its intimacy is *The Bed* (174), etched in 1646, which shows a young couple making love. The print has been seen as an expression of Rembrandt's longing for intimacy after Saskia's death, a desire answered temporarily by Geertge. The feathered beret on the near bedpost supports this idea, for Rembrandt sported such headgear in his self-portraits. Yet the illusion of direct observation was the result of much effort, and Rembrandt never fully resolved the composition. The nuanced shading that gives the room its privacy combines fine engraving and freer etch-ing. Rembrandt softened facial features, hair and fabric with drypoint, and in entangling the couple's limbs he gave the woman three arms, never bothering to correct himself. Although the genre of the erotic print is almost as old as printmaking itself, and Rembrandt made

172
Hercules Segers,
Landscape with Tobias and the Archangel Raphael,
1620s.
Etching, drypoint and engraving, first and only state by Segers;
21·1 × 28·3 cm,
8$\frac{1}{4}$ × 11$\frac{1}{8}$ in

173
Rembrandt altered from Hercules Segers,
Landscape with the Flight into Egypt,
c.1650–2.
Etching, drypoint and engraving, fourth state;
21·1 × 28·3 cm,
8$\frac{1}{4}$ × 11$\frac{1}{8}$ in

several late etchings that can be described as such, *The Bed* does not belong to this category. There is no nudity, no lingering on the female body, no promise of extravagant pleasure, no scandal in the setting. In *The Bed*, the viewer is very much at home. While many Dutch artists offered glimpses of home life, Rembrandt was probably the first to depict domestic lovemaking.

In the 1650s drypoint became increasingly responsible for the direct, spontaneous look of Rembrandt's prints. Early in the decade, he began to make prints in pure drypoint. The technique is well suited to describing wooded landscape, with deep shadows and dense foliage that is rarely perfectly still. The two states of *A Clump of Trees with a*

174
The Bed,
1646.
Etching,
drypoint and
engraving,
third state;
12·5 × 22·4 cm,
4⁷⁄₈ × 8⁷⁄₈ in

175
*A Clump of
Trees with
a Vista*,
1652.
Drypoint,
first state, with
surface tone;
15·6 × 21·1 cm,
6¹⁄₈ × 8¹⁄₄ in

176
*A Clump of
Trees with
a Vista*,
1652.
Drypoint,
second state;
12·4 × 21·1 cm,
4⁷⁄₈ × 8¹⁄₄ in

Vista (175, 176) show how he worked up the drypoint from the slightest indications of a hut, fence and phantom tree to a densely foliated grove that dwarfs the human structures. Although the print's first state looks like a preliminary sketch, Rembrandt printed multiple impressions, presumably for sale. Its sketchiness may indicate that he made this state out of doors, in an echo of Gersaint's claim that he took etching plates on his walks. The idea is supported by the print's freshness and the simple drypoint technique. Delicate surface tone gives the impression of a moist, unstable atmosphere. In the second state, the velvet darkness to the left of the farm is pierced by a bright clearing. The irregular outlines of the trees, so different from the 'Venetian' foliage in Rembrandt's drawings, stand out brilliantly against the sky, especially in this impression on white paper without surface tone.

The virtuosity with which Rembrandt's domestic and landscape etchings turn mundane life into riveting art must have appealed to collectors. His biblical prints hold similar pleasures, and their technical accomplishment is matched by the sophistication of their interpretations. *The Hundred Guilder Print* is the most fascinating of these (177). Its traditional title, already current by the beginning of the eighteenth century, is a mark of the esteem in which it has always been held (in Rembrandt's time a hundred guilders could buy a

distinguished small painting). The print's intricate storytelling and unparalleled tonal range rank it with Rembrandt's most ambitious paintings. The undulating composition, selective lighting and copious variety of figures recall the impressive crowd control of *The Nightwatch* (see 103), and Rembrandt probably began the print while painting that commission. His extensive use of engraving and drypoint, however, suggests that he did not finish the second and last state for several years.

The Hundred Guilder Print conflates several episodes from Chapter 19 of St Matthew's Gospel. To the right Rembrandt presented Christ's healing of the sick in 'great crowds', and to the left he pictured Christ's injunction to 'suffer the Children to come unto me'. Christ beckons mothers and children with his right hand and raises his left in a gesture of blessing as well as preaching. The urgency of the sick is conveyed by the praying man, whose hands cast a shadow on Christ's tunic – a motif recalling the commanding shadow of Captain Frans Banning Cocq's hand (see 103). The sick emerge from the shade of a huge city gate, embodying his promise that 'many who are first will be last, and the last first'. The sceptics and the uncomprehending are fully exposed in the light. The Pharisees question Christ's words with the energy of the disciples in Leonardo's *Last Supper*. Closer to Christ, his disciples listen with concern as he tells them to let the children approach because 'theirs is the kingdom of heaven'. Just below the disciples, a young man in fine costume ponders Christ's words. He is the melancholy rich man of Christ's parable, for whom it is more difficult to enter the kingdom of Heaven than it is for a camel to pass through the eye of a needle. His predicament is figured by a camel that has just come through the gate.

In *The Hundred Guilder Print* Rembrandt reinvented a tradition of representing a sequential religious narrative in one picture. Instead of grouping different episodes around a central scene, however, as early Netherlandish painters did, he fused the vignettes in a plausible tableau that evokes the hope, anger, reflection and confusion that Christ's ministry must have caused. Each part of the story is so powerfully characterized that, a century and a half later, the print-maker Captain William Baillie (1723–1810) saw fit to cut the plate into different pieces for reprinting. With their everyday faces, Rembrandt's agitated, trusting, sad and sullen people stand for the whole spectrum of responses to Christ, not only in his lifetime but also in the seventeenth century. The metaphysical poet H F Waterloos, who owned Rembrandt's *Christ Appearing to Mary Magdalen* (see 110), understood the print's contemporary relevance in these terms:

177
The Hundred Guilder Print, c.1642–9. Etching, drypoint and engraving, first state, on Japanese paper; 27·8 × 38·8 cm, 11 × 15¼ in

Thus Rembrandt's needle draws God's Son from life

and places him amidst the sick, in droves:

So that the World, sixteen centuries on,

would see the miracles he wrought for all.

Here the sick are cured by Jesus' hand. And here the children

(True Divinity!) are blessed; admonished those who hold them back.

But woe! The Young Man mourns. The Pharisees sneer at

the Faith of holy men, the rays of Christ's divinity.

The poem tracks its author's experience of viewing the print and discovering the different stories that make up Christ's ministry on earth. Waterloos, a member of a Calvinist meditational group, demonstrates that his knowledge of the biblical source matches that of the artist: steeped in the Bible and in Protestant sensibility, he is the sort of viewer for whom this exegetical print was most rewarding.

The Hundred Guilder Print **is a consummate example of Rembrandt's printmaking. It displays his command of three different techniques, and it flaunts the colouristic potential of the black-and-white print. By leaving the scene on the left barely defined while working up the sick to finely nuanced levels of black, Rembrandt demonstrated his own order of printmaking. He laid out the composition in etching, strengthened the shadows with the burin and then used the drypoint to develop atmosphere and texture. Houbraken was so startled by the range of finish in** *The Hundred Guilder Print* **that he cited it as an example of Rembrandt's unwillingness to finish his works properly, even though the print also showed that he was capable of doing so:**

But it is to be lamented that, being fickle and easily driven to changes or other things, he finished many things only halfway, in his paintings and even more so in his etched prints, in which the completed parts give us an idea of all the beauty that we would have had from his hand, if he had finished everything to the same degree of the beginning, as can be seen particularly in the so-called hundred guilder print …

Many collectors, however, have admired this print precisely for this sense of a work in progress. An early inscription on one impression claims that Rembrandt never sold the print but distributed it only to

178
Lucas van
Leyden,
*Ecce Homo
(Christ
Presented to
the People)*,
1510.
Engraving;
28·6 × 45·2 cm,
11¼ × 17¾ in

friends. His decision not to sign this ambitious print may reflect his intention to circulate it among connoisseur friends, as a masterpiece whose unmistakable style was its signature. Early examples of such grand collector's items include master engravings of similar size and format by Martin Schongauer (*c.*1450–91) and Lucas van Leyden. Like *The Hundred Guilder Print*, Schongauer's *Christ Carrying the Cross* and Lucas' *Ecce Homo* (178) narrate scenes from the life of Christ through dozens of figures. These virtuoso prints, well known to the collector Rembrandt, may have prompted him to make a masterpiece in their mould.

The profuse humanity and technical display of *The Hundred Guilder Print* also make it an exception among Rembrandt's late religious prints. In many of these, he condensed the narrative to a quiet interaction among few figures, in whose experiences the viewer is asked to participate. His technique is less demonstrative than in *The Hundred Guilder Print*, but it brilliantly serves his narrative inventions. In 1645 Rembrandt revisited Abraham's sacrifice by having the patriarch explain to Isaac the purpose of their journey (179). Father and son are seen in near profile, focused on each other, and their interaction fills most of the print. Young and trusting, Isaac has asked why there is no young animal for the sacrifice. Abraham presses his right hand to his heart and leans in insistently to state that 'God will provide himself with a young beast for the sacrifice.' Isaac's gently submissive attitude

as he steadies the wood for his pyre replicates his father's uncondi-
tional obedience to God, which Rembrandt signified by the upward
gesture of Abraham's left hand. Like the sitters of Rembrandt's portrait
etchings of the mid-1640s, Abraham and Isaac appear as thoughtful
individuals. Isaac's face is softly clouded, Abraham's sharply drawn.
Isaac's commanding presence contrasts tellingly to his spectacular but
ultimately conventional facelessness in the earlier painting (see 78).

Abraham and Isaac prompts the viewer to feel compassion for
the father, torn between obedience to his God and love of his son.

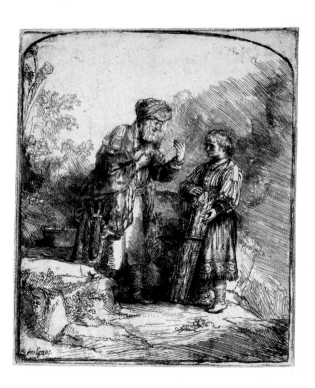

179
*Abraham
and Isaac,*
1645.
Etching and
engraving,
single state;
15.7 × 13 cm,
6$\frac{1}{8}$ × 5$\frac{1}{8}$ in

180
*Christ
Returning from
the Temple
with his
Parents,*
1654.
Etching and
drypoint,
single state;
9.5 × 14.4 cm,
3$\frac{3}{4}$ × 5$\frac{5}{8}$ in

Rembrandt's late prints of New Testament episodes similarly appeal
to emotions rather than to intellectual understanding, in ways that
are curiously reminiscent of traditional devotional paintings. While
Catholic religious art presented the Christian mystery in an emotion-
ally evocative fashion, Protestantism favoured storytelling and
explanation over a direct appeal to sentiment. Compared with his
earlier biblical etchings, most of Rembrandt's late biblical prints
narrate little and explain less, but they are nonetheless compatible with
a Protestant understanding of salvation. By exploring the personal

nature of the viewer's relationship to Christ, Rembrandt created
new possibilities for devotional art in a predominantly Protestant
culture. Christ figures with new prominence in Rembrandt's prints
from the 1650s: there are touching, intimate images of the Adoration
of the Shepherds (both in radiant light and in impenetrable darkness),
the Circumcision in the Stable, the Holy Family travelling into Egypt,
Jesus disputing with the doctors or preaching to an attentive crowd.
And there is the great sequence of prints on the Passion of Christ and
its aftermath, from Christ's lonely Agony in the Garden through his
Crucifixion to his posthumous appearances to his followers.

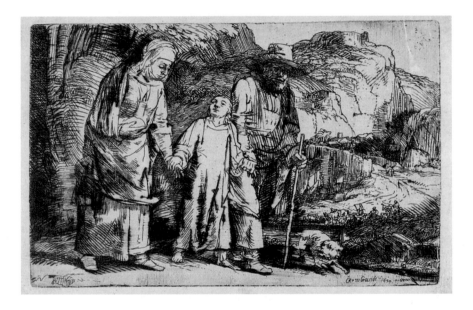

In a print from 1654 on a rare theme (180), the twelve-year-old Jesus is
seen returning to Nazareth after his precocious debate with the scribes
in Jerusalem (Luke 2:41–51). After looking for him for three days, his
parents had found him in the Temple. To Mary's wounded rebuke Jesus
replied 'What made you search? Did you not know that I was bound to be
in the house of my Father?' Rembrandt transformed this early revelation
of Christ's divinity into a silent moment following the exchange between
two worried parents and their adolescent son. The solemn, worn atti-
tudes of Joseph and Mary register the uneasy blend of relief and concern.
In the impressions on Japanese paper, the mellow paper and the rich
drypoint burr enhance the tenderness of the small family drama.

Unlike most of Rembrandt's late prints, *Christ Returning from the Temple* appears in a single state. The four different states and the hugely varied impressions of *The Entombment* encourage the viewer to enter the Christian mystery on increasingly personal terms. The first state (181) gives a close view of the men lowering Christ into the tomb. To the left we make out a sorrowing Mary, a solemn Joseph of Arimathea and four other mourners. The bright light illuminating Christ's shrouded body emphasizes the physical work of the entombment; its source is a lantern obscured by the man seen from behind. The open, parallel line work, a loose version of the classic engraved

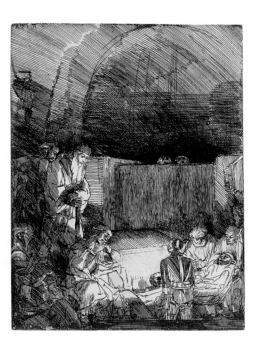

181
The
Entombment,
c.1654.
Etching,
first state,
on Japanese
paper;
21·1 × 16·1 cm,
8¼ × 6⅜ in

182
The
Entombment,
c.1654.
Etching,
drypoint and
engraving,
second state,
with surface
tone;
21·1 × 16·1 cm,
8¼ × 6⅜ in

line, gives this print the sense of a lucid witness account. Over the next three states, Rembrandt radically darkened it (182). In these states the white areas, including the spaces between the etched lines, were muted with the burin, and lightly etched areas were darkened with drypoint. As a result, the print draws the viewer into the cave to participate in mourning. The individual impressions of these states are highly dissimilar. The second and third states are printed on Japanese paper and on vellum, and the fourth exists only on white paper. Each impression has a distinctive pattern of inking and wiping. In some, a dense

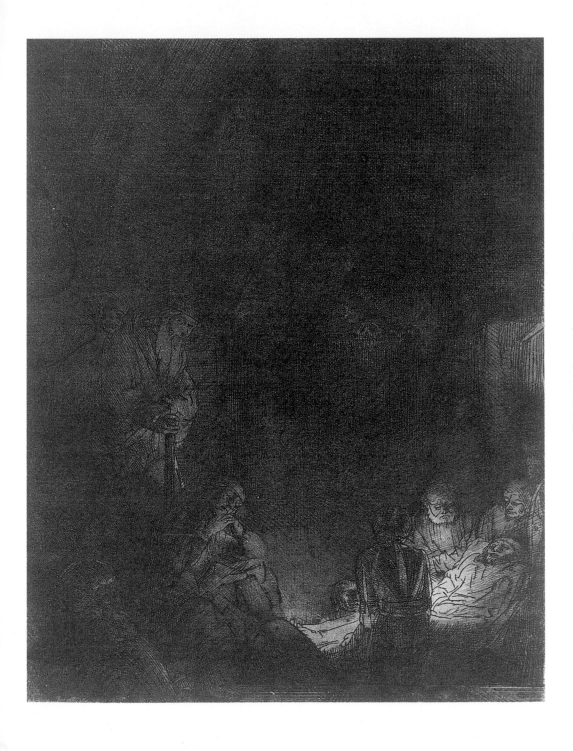

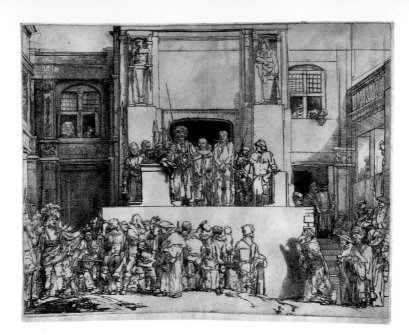

183
Ecce Homo (Christ Presented to the People), 1655. Drypoint, fifth state; 35.8 × 45.5 cm, 14⅛ × 17⅞ in

layer of surface tone spells pervasive doom; in others, tone has been wiped selectively to emphasize the body and face of Christ or the expressions of the mourners. The illumination of Christ's face ranges from deathly pallor to peaceful radiance. Although each impression of *The Entombment* sets a different tone, all fathom the event as approachable Christian mystery.

In his *Ecce Homo (Christ Presented to the People)* of 1655, Rembrandt fully developed the progressive narrative through different states, in the manner pioneered in *The Entombment*. The human variety in the early states of this drypoint (183) rivals that of *The Hundred Guilder Print*, and it is explicitly indebted to Lucas van Leyden's engraving of the theme (see 178). Rembrandt adopted Lucas' town setting and wild crowd, but by increasing the scale of the figures in relation to the architecture and by limiting the number of buildings he brought the scene of Pilate presenting Christ closer, implying the viewer's own complicity in Christ's death.

In a bright Mediterranean light, the Roman governor points out the man who will not defend himself. In response to the mob's 'Crucify! Crucify!', Pilate pleads on Christ's behalf, in words that will absolve him of responsibility: '*Ecce homo* [Behold the man] … Take him and crucify

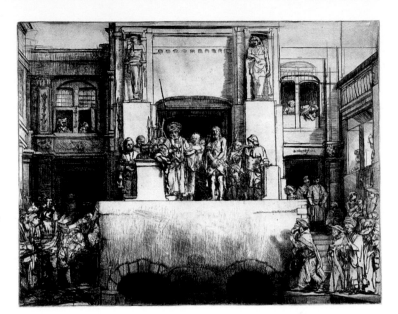

184
*Ecce Homo
(Christ
Presented to
the People)*,
1655.
Drypoint,
eighth state,
on Japanese
paper;
35·8 × 45·5 cm,
14⅛ × 17⅞ in

him yourselves; for my part I find no case against him' (John 19:5–6).
The print subtly announces Pilate's eventual abdication of legal princi-
ple in the interest of crowd management. The shimmering drypoint
evokes the scene's confusing flux: a worn, resigned Christ is surrounded
by serious court officials, dutiful guards and a scowling Barabbas, soon
to be released. Bystanders press in towards the tribunal or lean out of
windows; mothers have dragged young children along to the spectacle.
In Rembrandt's time executions were public events that demonstrated
collective justice and also served as popular entertainment, and he cast
Christ's tribunal in contemporary terms, basing the architecture on the
building where criminals of Amsterdam were pilloried.

In the eighth state (184) Rembrandt burnished away most of the crowd,
leaving only the group to the left of the stage and the people approach-
ing from the right, still led by the man who casts a shadow onto the
wall. The ghostly outlines of the throng in front of the stage remain
visible above two gaping holes, dark ciphers of dread. A sculpted figure
of an old man guards these entrances, resting his head on his hand in
a gesture of melancholy (see 160) as though at the gateway to a subter-
ranean realm. The removal of the distracting mob and the darkening
of the stage force new concentration on Pilate's quandary, now shared
by the viewer.

Several of Rembrandt's late Passion prints went through this development from detailed narrative to concentrated focus on the meaning of the event. Often, as in *The Entombment*, the involvement of Christ's followers becomes exemplary for the viewer's faith. It has been persuasively argued that the progression of states in the *Ecce Homo* from an outward witnessing to an inward understanding resembles the structure of Protestant metaphysical poetry, as written by John Donne in England and by Constantijn Huygens in the Netherlands. Rembrandt apparently knew this strand of religious writing, for his *Raising of the Cross* evokes its strategies (see 65), as does *The Entombment*. An amateur writer of such meditations was Heiman Dullaert (1636–84), who studied painting with Rembrandt in the 1650s. His sonnet 'Christ Dying' gradually moves from a powerful imagination of Christ's suffering, through a plea to his readers for compassion, to the significance of Christ's death:

The comforter of all, expiring, wan,
The world's support, condemned to death and anguish;
A fatal darkness dims those eyes which languish
Like faint roses, deprived of dew and sun.

Oh world, heir of this abundant prize,
Angels, starry powers in your spheres,
Inhabitants of earth, have you no tears
While Jesus sinks his head, while your king dies?

Since he departs from life, I long for death:
But even as I wish an end to breath
A brimming stream of life o'erflows my soul.

Oh highest wonder! How can it be said
That strength can come from weakness' toll,
That life can die to save from death the dead?

The difference between the first and second states of Rembrandt's *Entombment* echoes Dullaert's movement from visceral empathy with Christ's torments to comprehension of their meaning. The comparison suggests that Rembrandt visualized a Protestant meditational process through which to grasp Christ's role. Imagining the physical suffering

sustained by Christ could be part of such meditation, but its ultimate goal was a reasoned, direct faith in the redemptive grace of his death. In this emphasis Protestant devotion continued to differ from Catholic religion, which encouraged the worshipper to re-experience God's sacrifice in a more physical sense, mediated through communion and its iconic representation in altarpieces. Unlike the great altarpieces of Rubens, which present the body of Christ as the original Eucharist, Rembrandt's late Passion prints do not put Christ's body at centre stage. They ask us to regard his face, and to scrutinize the responses of those who loved him. These are real people, whose recognizably human pain is transmuted into quiet faith, rather than exalted denizens of heaven.

However well Rembrandt's print technique served his themes, it was admired for its own sake too. His tireless reworking of his plates and variation of techniques individualized his prints well beyond the contemporary norm. The different impressions of *The Entombment* virtually qualify as monoprints – unique, irreproducible products. These singular impressions were prototypes for modern artists such as Degas, who made the monoprint a specialized artistic genre. In 1686 Baldinucci, author of the first history of etching and engraving, acknowledged the idiosyncrasy of Rembrandt's prints. He included Rembrandt's biography as one of eighteen lives of the greatest graphic artists – an honour accorded to no Dutch contemporary. Curiously, even though Baldinucci believed that Rembrandt's true excellence lay in etching, he wrote primarily about his painting. His comments on Rembrandt's printmaking accurately describe its idiosyncrasy:

That in which this artist truly proved his worth was a most bizarre manner of etching, which he invented and was his and his alone, never used by others nor seen again, that is, with certain scrawls and scribbles, and irregular lines, and without outline, yet as a whole resulting in a deep chiaroscuro of great force, and a pictorial taste that was refined to the last line; he coloured the plate entirely black in some places, while in others leaving the white of the paper, and in keeping with the tone he wanted to give to the costumes of his figures, or to the foreground or the distance, he sometimes used very little shadow, and sometimes just a plain outline, without anything else.

Baldinucci claimed that Rembrandt was irrationally covetous of his own etchings and compensated for his low portrait prices by selling his prints. Their success presumably led him to consider his etchings underpriced, and to improve their value he bought up his prints from all over Europe at extravagant prices, once acquiring an impression of the *Raising of Lazarus* even though he still owned the plate. Although unverifiable, Baldinucci's account evokes Rembrandt's personal and artistic investment in prints.

Rembrandt's reported effort to collect his own etchings also suggests the desirability of their individual states and impressions for collectors. By the end of the seventeenth century, print connoisseurs had apparently started to collect 'the Complete Work of Rembrandt'. Several collectors each owned more than four hundred of his prints, perhaps as a result of seeking to acquire impressions of all states. Houbraken laughed at this practice, but he recognized that Rembrandt encouraged it to reap economic benefit:

This habit brought him great fame and no less financial advantage: especially the trick of minor change, or small and slight additions, which he brought into his prints, whereby he could sell them once again. Truly the desire at that time was so great, that people would not be considered true connoisseurs if they did not have the little Juno with and without the crown, the small Joseph with the white face and the brown face and other such things. Yes, the Woman by the Stove, though one of his least prints, each had to have with and without the white cap, and with and without the stove key.

Baldinucci and Houbraken implied that Rembrandt steered the collecting craze for his graphic *oeuvre*. Whatever Rembrandt's involvement in the run on his prints may have been, it is clear that he nourished his contacts with dedicated print collectors such as Six, who retained the plate for his portrait etching, and De Jonghe, whose own portrait etching exists in six different states.

Another dedicated collector, the pharmacist Abraham Francen, is the subject of one of Rembrandt's last portrait etchings, made around 1657 (185). Francen was friendly with Rembrandt, serving in legal capacities

185
*Abraham
Francen,*
*c.*1657.
Etching,
drypoint and
engraving,
fourth state,
with surface
tone, on
Japanese
paper;
15·2 × 20·8 cm,
6 × 8$\frac{1}{8}$ in

for him and for his family, and the portrait may well have been a gift. Revised through ten states, it represents the man in his private role as a connoisseur. Rembrandt adapted the effective composition of the Six portrait to an oblong format, placing Francen near a window that allows daylight to facilitate his study of a drawing. Like Six, he is defined by the breadth of his interests, signified by several paintings, a book, a skull (perhaps a reference to his medical trade) and a Chinese figurine. Although Francen is ostensibly near us, his facial features remain indistinct, suggesting rapt concentration. In the muted light and still atmosphere, enhanced in this impression by Japanese paper, Francen looks the part of the serious connoisseur for whom Rembrandt apparently intended his later prints.

Guercino recognized the ambition of Rembrandt's prints as collector's items when he praised them as the works of a *virtuoso*, a telling term. When Rubens described his reproductive printmaking operation, he stipulated that he wanted his engraver to imitate his designs perfectly and that he preferred 'to have the prints made in my presence by a well-intentioned youth rather than by some great *virtuosi*, who work according to their own caprice'. It was such virtuoso quirkiness that appealed to Guercino, Ruffo, Baldinucci and countless Dutch collectors of Rembrandt's prints.

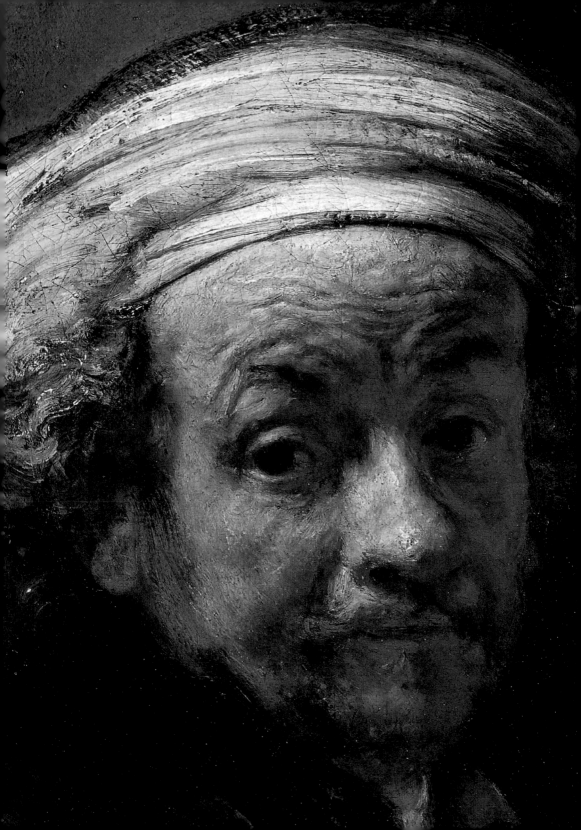

Writing in the age of Gauguin and Van Gogh, the first modern biogra-
phers of Rembrandt interpreted his last decade as a period of personal
loneliness and splendid artistic isolation. Although this view was exag-
gerated by Romantic visions of the artist as spiritual rebel, it has roots
in the earliest accounts of Rembrandt's art and in the facts of his later
years. By his relocation to the Jordaan, Rembrandt removed himself
from the cultural centre of Amsterdam. His financial situation
remained precarious: in 1662 he had to sell Saskia's grave, and he later
paid rent from the savings of Cornelia, his daughter with Hendrickje.
In the plague years 1663 and 1668 he lost Hendrickje and the newly
married Titus, his business managers and closest companions. After
Rembrandt died on 4 October 1669 he was buried in a rental plot, and
his meagre estate was a faint shadow of the rich document of 1656.

186
*Self-Portrait
as the
Apostle Paul*
(detail of 199)

A tally of Rembrandt's surviving works shows that he was less produc-
tive in the 1660s than in any other period of his life. The decline might
be ascribed to physical weakening – etching is especially demanding on
the eyes and hands, and Rembrandt made only two prints in the 1660s
– but it may have been aggravated by loss of market share.

Towards the end of his life Rembrandt's critical fortunes apparently
dwindled, although he continued to work within a smaller circle of
patrons and followers. Matthias Scheits (1625/30–c.1700), a German
painter who worked in Holland, was unequivocal about Rembrandt's
reduced standing, recording in 1679 that 'Rembrandt had become
esteemed and eminently respectable because of his art, but that this
diminished somewhat in the end.' Four years earlier Sandrart had
complained that Rembrandt diminished his art by associating with
humble folk. Houbraken in 1718 saw this tendency as a particular
preference of the artist's last years, substantiated in his diet of 'a pick-
led herring, a hunk of cheese and a roll'. Anticipating Rembrandt's
modern biographers, Houbraken linked these plain habits to the
independence of his art:

'In the Autumn of his life he mostly kept company with common people, and those who practised art. Perhaps he knew the laws of living properly, described by Gratian, who said: It is good to associate with excellent People, to become like them, but once one has accomplished that, one should keep company with the mediocre. And he [Rembrandt] gave this reason for it: When I want to restore my spirit, it is not honour that I seek, but freedom.

187
Aert de Gelder,
Self-Portrait with the Hundred Guilder Print,
*c.*1700.
Oil on canvas;
79·5 × 64·5 cm,
31¼ × 25⅜ in.
The Hermitage, St Petersburg

Rembrandt continued to associate with artists. Although his only known pupil in the 1660s was Aert de Gelder, the large number of paintings in Rembrandt's late manner indicates that his workshop was not empty. While De Gelder made a long career producing history paintings and self-portraits in Rembrandt's rugged style, most of the pupils of the last years were occupied with portraits, single-figure pictures of apostles and possibly contributions to the master's works. De Gelder was unusually dedicated in his attachment to Rembrandt's art: in a self-portrait of *c.*1700 (187) he strikes the elegant pose of Rembrandt in his Renaissance mode of 1640 (see 98). His role is that of connoisseur and proud owner of *The Hundred Guilder Print*.

Rembrandt's late works fostered the image of the artist as a lone, brilliant and free spirit. He reduced his historical narratives to a few figures quietly interacting or trapped in moral quandaries. Portrait sitters avert their eyes in thought or look out without gestures or signs of speech. The late self-portraits eschew the theatrical display or refined poses of earlier self-representations. The style of these paintings is singular and wilful, out of line with the 'smooth' mode championed by such painters as Flinck and Van der Helst. The early sources link Rembrandt's rough style to anecdotes about his rudeness. Following a Renaissance tradition of biography, which held that 'every painter paints himself', Rembrandt's biographers told tales about his personal affairs to substantiate their assessment of his art. Generally devoid of illustrations, books about artists needed such riveting biographical details to give readers a sense of their works.

The early biographies of Rembrandt thus reveal contemporary opinions about his late work, however biased they are towards the smooth style of painting. Baldinucci knew two paintings by Rembrandt and lots of rumours about *The Nightwatch*, and on this basis he concluded that 'professors of art esteemed Rembrandt more for his particular mode of etching than for his painting'. His description of Rembrandt's style makes it clear that the *professori* specifically objected to the rough, densely stratified paint layers Rembrandt had developed in the 1650s (see 154, 159 and 162). Despite his distaste for this laborious manner, Baldinucci was struck by Rembrandt's dedication to it. He interpreted Rembrandt's obsessive, 'most extravagant mode of painting' as one reason for his rough behaviour – headstrong and temperamental, Rembrandt refused to lose time meeting the great and the good.

A powerful example of Rembrandt's late historic mode is *Peter Denying Christ* (188). As in *Ecce Homo* (see 183, 184), Rembrandt compressed an emotionally charged narrative into a single challenging image. Peter's threefold denial is wrenching because Christ foretold it against Peter's avowals of loyalty. Although all the Gospels recount the episode, Rembrandt chose Luke's detailed version (22:54–61). After

the temple police had brought Christ to the house of the High Priest, Peter joined them around a fire. First a maid identified Peter as a follower of Christ, and then another called him 'one of them'. Both times Peter denied knowing the prisoner, and when, an hour later, another questioned him more strongly,

Peter said, 'Man, I do not know what you are talking about.' At that moment, while he was still speaking, a cock crew; and the Lord turned and looked at Peter. And Peter remembered the Lord's words, 'Tonight, before the cock crows you will disown me three times.'

At the core of Rembrandt's painting, Peter warily rebuts the maidservant. The 'firelight' that caused her to notice him, mentioned by Luke, has been transformed into the candle she shields. Nearby, two soldiers listen with puzzled concern. In the distance to the right the prophecy is fulfilled, as Christ looks back to his disciple. Temporally and spatially, the painting is as unclear as the conflicting and overlapping Gospel accounts. How are Peter, the maid, the soldiers placed in the pictorial space? How near is Christ? Which moment is represented? Yet in the painting as in the biblical accounts, the moral weight of the story is immediately evident because of its focus on Peter's denial and his instant remorse.

188
Peter Denying Christ, 1660.
Oil on canvas; 154 × 169 cm, $60\frac{5}{8} × 66\frac{1}{2}$ in.
Rijksmuseum, Amsterdam

Peter Denying Christ may well have been the kind of picture Baldinucci had in mind when he described Rembrandt's style as lacking good outlines and forging a strong, transparent chiaroscuro from random brushstrokes. The lucid chiaroscuro in *Peter Denying Christ* has forceful narrative drive, and the rugged, insistent brushwork that defines figures and faces can indeed look quite arbitrary. Baldinucci's assessment captures the distinct lack of polish and dramatic lighting characteristic of *Peter Denying Christ*, and his judgment echoes that of Sandrart, who had praised Rembrandt's glowing colour while insinuating that he used deep shadows to hide weak outlines. The murky profile of the soldier on the left or the phantom image of Christ may be examples of what Sandrart considered to be fudging.

Baldinucci blamed Rembrandt's thick paint layers for his intolerably slow pace. 'The reason for such inertia', he explained, 'was that, once

the first work on a painting had dried, he would return to place new strokes and dabs on it, until the paint in a given place would rise to almost half a finger's thickness.' The account admirably suggests the craggy, gravelly quality of Rembrandt's late surfaces. In *Peter Denying Christ*, shiny armour, crumpled fabrics and lined faces stand out by virtue of their heavy impasto. Real light reflects irregularly off these small mounds of paint, redoubling the glow that resulted from Rembrandt's meticulous distribution of light in the painting. Baldinucci ostensibly regretted this time-consuming impasto only because it cramped Rembrandt's productivity, but three decades later Houbraken considered it evidence of Rembrandt's refusal to finish works smoothly. He saw Rembrandt's heavy manner as the product of careless speed, occasioned by his numerous commissions:

For many years he was so busy painting that people had to wait long for their pieces, even though he worked along quickly, especially in his last period, when his work, seen from near by, would look as if it was smeared on with a trowel. Which is why, when people came to his studio and wished to see his work from close by, he would pull them back saying 'the smell of the paint would bother you.' It is also said that he once painted a portrait so thickly, that one could lift the painting from the ground by the nose. Thus one sees also gems and pearls on jewels and turbans that are painted in such raised fashion as if they have been modelled, by which manner of handling his pieces look strong even from afar.

Besides evoking the effects of Rembrandt's late style, Houbraken here echoed Baldinucci's observation that Rembrandt could be irreverent towards customers, a notion supported somewhat by documentary evidence. In the 1630s Rembrandt let Frederik Hendrik wait several years for the completion of his Passion series, and in 1654 the Portuguese merchant Diego d'Andrada demanded that Rembrandt change a portrait of a girl because it showed 'no resemblance what-soever' to the sitter. This was a standard complaint, and Rembrandt answered gruffly but reasonably that he would not touch the picture until the client guaranteed payment and agreed to let the painters' guild judge the resemblance of the revised portrait.

The case of Antonio Ruffo was different. In 1661 Ruffo received from Rembrandt two paintings he had ordered to accompany the *Aristotle* (see 159): *Alexander the Great* and *Homer*. A year later Ruffo complained that *Alexander* was painted on a makeshift canvas, with disfiguring seams where Rembrandt had presumably enlarged an existing painting. He also asked that Rembrandt finish *Homer*, which had arrived incomplete. Rembrandt eventually returned the altered *Homer* in 1664, but a transcript of his letter to Ruffo shows that he was defensive about *Alexander*, which he considered perfectly well painted. Proper lighting should make the seams invisible, and if Ruffo insisted on having a new painting he would have to return the first one at his own risk and pay 600 guilders (100 more than for the rejected painting) for the new one. Ruffo's ultimate response is not known – *Alexander* does not survive – but it did not stop him buying 169 of Rembrandt's etchings in the last year of the artist's life. Other patrons were similarly forgiving. In 1655 the brothers Dirk and Otto van Cattenburch attempted to sell Rembrandt a less expensive house, apparently to relieve his financial problems. They agreed to accept in partial payment the promise of an etched portrait of Otto 'equal in quality to the portrait of Lord Jan Six' (see 109), and they valued it at an extravagant 400 guilders. The print was never made, although some believe that the portrait of Abraham Francen (see 185) began as Otto's portrait. Undaunted, the brothers provided Rembrandt with copper plates to make a series of etchings of the Passion, but none of these was completed. Still supportive, Dirk ordered a painting of *Simeon in the Temple*, which, a contemporary noted, remained unfinished on Rembrandt's easel at his death.

Each of these cases suggests that Rembrandt was never short of work. Baldinucci thought that he was popular as a portraitist because of his famous colouring, and Houbraken reported that there was a long waiting list for his pictures. In the 1660s Rembrandt's public patrons included two prestigious civic institutions that would have been well aware of the roughness of his style. The Town Hall officials asked him to paint the largest history painting he would ever complete, and the Drapers' Guild commissioned his last official group portrait.

189
Ferdinand
Bol,
*The Consul
Fabritius
Resisting the
Intimidation
of Pyrrhus,*
1655.
Oil on canvas;
485 × 350 cm,
191 × 137¾ in.
Royal Palace,
Amsterdam

In 1661 Rembrandt became involved in the decoration of the new Town
Hall of Amsterdam, the largest artistic project in the city since the refur-
bishment of the Kloveniersdoelen. The grand building, now the Royal
Palace on Dam Square, had been built between 1648 and 1655 on a classi-
cist design by Jacob van Campen (1595–1657), the favourite architect of
Frederik Hendrik and Constantijn Huygens. Rembrandt's participation
in its decoration came late, for in 1655 the initial set of commissions had
gone to such artists as Flinck and Bol, who worked in the fashionable,
courtly style. For the burgomasters' chamber Bol had painted a splen-
did, colourful painting of the story of the Roman consul Fabritius, who
resisted the bribes and intimidation of Rome's enemy (189). The consul's
sang-froid was meant to mirror the steadfastness of the burgomasters,
and all the paintings and sculptures in the building implied similarly
edifying parallels. In 1659 Flinck had been commissioned to decorate
the lofty public corridor running along all sides of the building with
twelve giant, arch-shaped paintings of scenes from political and military
history. Four of his canvases were to depict biblical and Roman heroes,
and eight were to chronicle the revolt of the Batavians, the ancient
inhabitants of the Netherlands, against their corrupt Roman governors.

The choice of themes was inspired, since the revolt of the Batavians, recounted by the Roman historian Tacitus, was widely seen as prefiguring the Dutch revolt against Spain. Writers reasoned that the insurrection of Claudius Civilis, the Batavian leader, was aimed not against the Roman Empire but against its corrupt delegates in the Netherlands. The modern Dutch revolt had brought Amsterdam the economic growth that occasioned the building of the largest town hall in northern Europe, and this would have been reason enough to display the Batavian precedent. But the city government may also have wished to flatter the House of Orange, which liked to portray William I of Orange, the cautious founder of the Dutch Republic, as a Claudius Civilis reborn. Despite its political independence, Amsterdam sought to maintain good relations with Orange loyalists. Even when the Republic temporarily abolished the position of *stadhouder*, as it did in 1653, the House of Orange remained alert to opportunities for military leadership and enjoyed widespread popular support. It was in preparation of a visit from Amalia van Solms, Frederik Hendrik's widow, that the town government began to plan the decoration of the gallery.

Flinck's mastery of an exuberant but elegant international style would have yielded a striking, unified decorative programme. But Flinck died suddenly in February 1660, leaving only sketches for some paintings and one full-size canvas with a watercolour sketch of the first theme: *The Conspiracy of the Batavians under Claudius Civilis*. Eager to avoid further delays, the Town Hall decided to recommission the paintings from various artists, instead of giving the whole project to one painter. Although Jan Lievens, Jacob Jordaens and Jurriaen Ovens (1623–78) eventually delivered works for the gallery, Flinck's original programme was never completed. Rembrandt was asked to paint his own version of *The Conspiracy of the Batavians under Claudius Civilis* (190), a nocturnal theme that may have been considered appropriate because of his reputation for strong chiaroscuro. According to Tacitus, the Batavians gathered in a grotto under the pretext of a banquet, and worked themselves up to the plot with wine and fierce rhetoric. Upon Civilis' urgings they swore an oath of revolt 'in a barbarian rite'.

Rembrandt painted the solemn rebels gathered round the banqueting table, pledging an oath to their towering leader, their swords gleaming in the glow of hidden lamps. One man raises his drinking bowl, another clutches his glass – reminders that their resolve was hardened by drink. A more dramatic rendering of the hushed conspiracy is scarcely imaginable, and yet the painting hung in the Town Hall for less than a year, after which it was returned to Rembrandt in 1662 for repainting. It is not recorded how and for what reason Rembrandt was to alter the painting, and he was apparently inclined to make some changes, but he never reached an agreement with the Town Hall. He

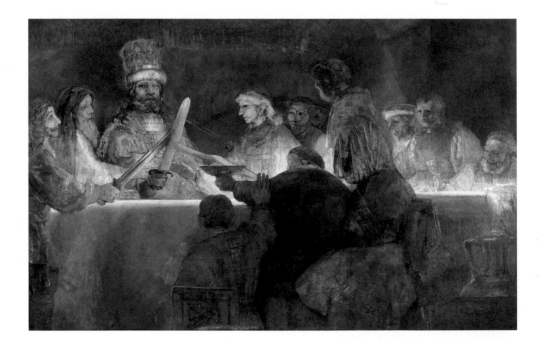

retained the canvas and cut it down from 6 × 5·5 m (20 × 18 ft) to its still impressive size of about 2 × 3 m (7 × 10 ft), presumably to make it saleable. By 1663 the empty space in the gallery was filled with Flinck's original watercolour sketch, finished in oil paint by Ovens.

Rembrandt's sketch of the composition as it would have appeared *in situ* (191) suggests what the building lost. The cavernous grotto had lofty arches mirroring the architecture of the Town Hall gallery. A few trees indicate the wooded setting, but Rembrandt focused attention on the brightly lit group of Batavians. In the painting, the figures to either

side of Civilis were simplified, and the leader was placed more squarely behind the table, with the result that he looms more impressively over his soldiers. In cutting down the painting, Rembrandt limited the action to the oath and excluded its larger context. Seen from below and at a distance, the oath-taking must have glowed against its dark setting. It is difficult to reconstruct how Rembrandt manipulated the paint to mould the Batavians in a crusty, clay-like relief. While some of the paint marks simulate the gleam of metal or the weight of a gold chain, others bear little direct relationship to what they represent. The

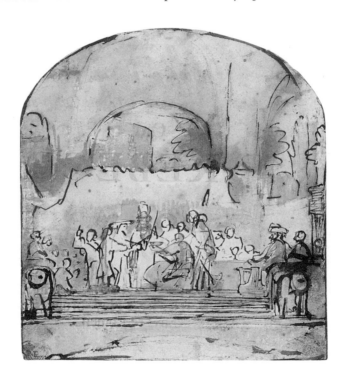

190
The Conspiracy of the Batavians under Claudius Civilis,
c.1661–2.
Oil on canvas;
196 × 309 cm,
77$\frac{1}{8}$ × 121$\frac{5}{8}$ in.
Nationalmuseum, Stockholm

191
The Conspiracy of the Batavians under Claudius Civilis,
c.1661–2.
Pen and brown ink, brown and white wash;
19·6 × 18 cm,
7$\frac{3}{4}$ × 7$\frac{1}{8}$ in.
Staatliche Graphische Sammlung, Munich

repeated short, vertical strokes on the wall behind the table vaguely indicate a fringed cloth of honour. The table cover is a glow of bright yellow paint, rather than a piece of well-lit cloth. Besides a variety of stiff brushes, Rembrandt must have used a palette knife and other tools, including his fingers. The roughness of the marks evokes the raw honour of the heroic Dutch ancestors, and, having seen the sketch and the work in progress, the Town Hall officials could have anticipated this result. Why, then, was Rembrandt asked to alter the painting after it was hung, and why did it not return to the gallery?

Many reasons have been proposed for the painting's rejection (if that is what it was). In one view, Rembrandt did not accept the price; in another, the Town Hall officials decided that Rembrandt's painting was too flattering to the Orange leadership. The most plausible is that Rembrandt's rough style and unpolished conception of the Batavians and their 'barbaric ritual' conflicted with the contemporary heroization of Civilis and his companions. Perhaps the smeared, daubed, licked and scratched paint was not the central issue, since from a distance it shows figures forcefully, as Rembrandt knew and even Houbraken admitted. But the individual conspirators and their sword oath evoked the crude barbarians described by Tacitus, heated by alcohol and violent rhetoric, rather than the legitimate challengers of corruption celebrated by Dutch historians. Artists had traditionally dressed the Batavians in elegant attire more appropriate to a picnic than a nocturnal drinking session. In such illustrations the Batavian elders politely shake hands with a youthful Civilis, as if concluding a gentlemen's agreement. No artist before Rembrandt had interpreted the oath as a medieval meeting of swords, however well the rite evokes Tacitus' words.

As so often, Rembrandt strove to paint both the letter and spirit of the text. He was the first painter to follow Tacitus in representing Civilis with one eye – a decision that flouted seventeenth-century rules of decorum in the representation of heroes. In 1707 the classicist painter Gerard de Lairesse (1641–1711), who knew Rembrandt personally, advised artists to mask physical disfigurement by depicting people from the most advantageous point of view. For one-eyed men, he advocated profile positions. Rembrandt's violation of this requirement may have disconcerted the Town Hall officials; as the art historian H van de Waal wrote, contemporaries must have been 'bewildered by the sight of Rembrandt's conspiratorial bargees and peat-cutters'.

The unhappy outcome of the Town Hall commission appears symptomatic of the increasing independence of Rembrandt's art in these years. This sense of autonomy is evident even in his exceptionally fine group portrait of the sampling officials or 'syndics' of the cloth trade, which he painted to the apparent satisfaction of the sitters (192). The five men

wearing hats were appointed to maintain standards of quality for dyed cloth production; behind them stands the steward of the building where they met. While the paint application is characteristic of Rembrandt's late style, the composition, colour scheme and lighting are more conventional. The painting was one of several such group portraits in the meeting room, going back a century, all of which depicted the syndics seated and the servant standing. Rembrandt placed the group around and behind a table, and he varied the traditional format by having one of the men rise from his chair. The warm red table carpet softens the stark effect of the black and white costumes and gives a mellow tone to the light, which is unusually bright for a portrait by Rembrandt. For once it is unmistakably daylight, entering the room through a window in the upper left wall and yielding strong facial shadows.

The painting is unique among Rembrandt's group portraits, and rare in the seventeenth-century tradition of the genre, because all the sitters regard the viewer from their slightly elevated position. The striking collective effect of the board's outward gaze has given rise to intriguing differences in interpretation. Noting that one of the men is standing, marking his place in a book, critics once surmised that Rembrandt represented a public board meeting, at which a member of the audience, perhaps the viewer, was questioning the board, and they saw the board members as reacting with solicitous responsibility or impatient irritation. It is now known that the syndics did not meet with shareholders, and their elevated level was designed to fit the painting's position on the wall of a large boardroom. More fundamentally, the idea that Rembrandt painted one specific moment defies conventions of seventeenth-century portraiture, which aimed at a lasting representation of the sitters, specified in age and physique but not pinned down to one incident. Three surviving preparatory drawings and x-ray photographs of the painting demonstrate that Rembrandt indeed changed the positions and attitudes of the sitters several times, clearly not aiming to record an actual moment.

And yet, these meticulous alterations suggest how hard Rembrandt worked to produce the impression of a group unified in one momentary

192 Overleaf
The Syndics of the Drapers' Guild of Amsterdam, 1662.
Oil on canvas; 191·5 × 279 cm, 75³⁄₈ × 109⁷⁄₈ in. Rijksmuseum, Amsterdam

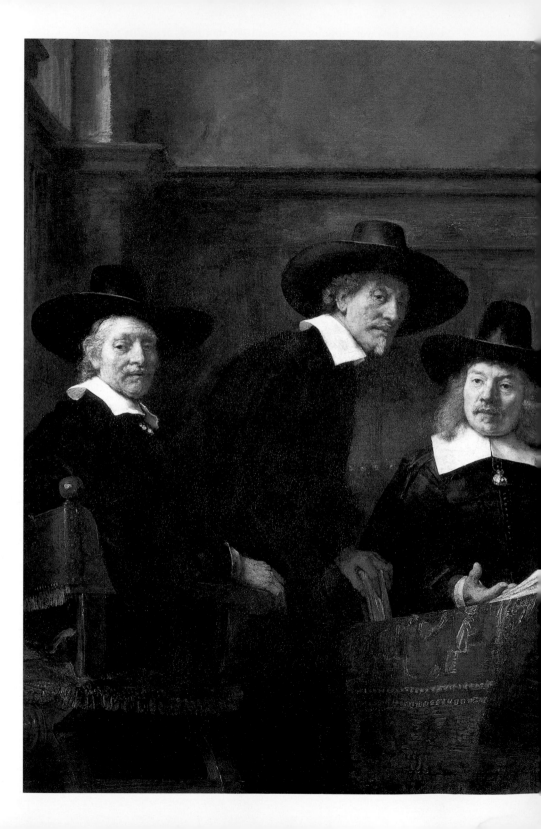

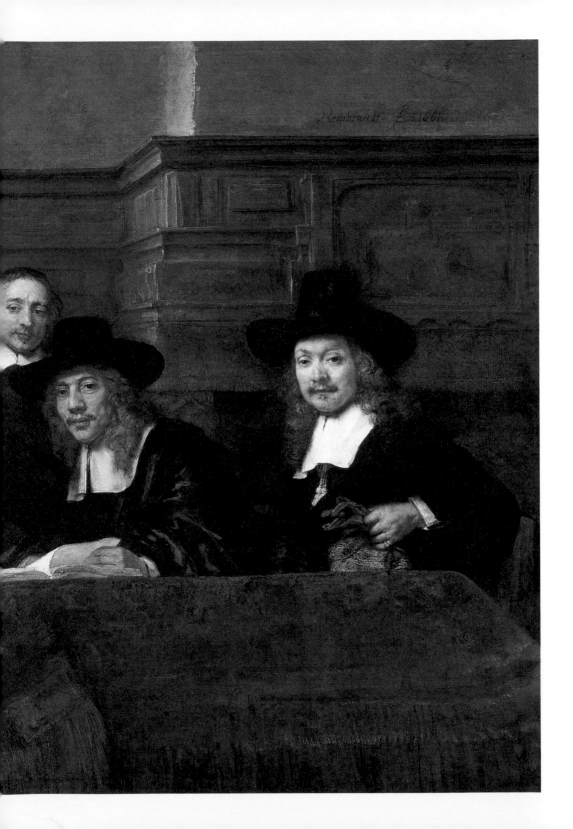

action and to create the feeling of direct interaction between viewer and sitters. The deliberate motion with which the rising man turns to look out is especially effective: it appears as if he has been interrupted in mid-thought. The preparatory drawings show that Rembrandt repeatedly revised this standing figure to arrive at his pronounced forward bend and outward gaze. Together, the men look out with such rapt attention that it seems as if they are reacting to the viewer's presence. But their action is surely more general: the painting evokes their collective responsibility and asserts their fitness for it. The two centrally seated men lean in slightly over what is probably an account book, while the most prominent, presumably the chairman, under-scores a point with his right hand. Rembrandt portrayed the officials as worthy of their task as guardians of the dyed cloth trade, and he alluded to their function with the faint painting of beacons burning in a watchtower at the right.

The Syndics is the most celebrated example of Rembrandt's grave late portrait manner, which appears to have been very successful, judging from the large number of painted portraits surviving from this decade. Over a dozen can be confidently attributed to Rembrandt, and many more were produced by assistants or close followers. Few of the sitters are identifiable, but Rembrandt's distinctive mode of portrayal imparts to them their fabled humanity. *The Jewish Bride* demonstrates how, in his late portraits, he created the impression of distinct individuals in deep reverie (193). More strikingly than before, he concentrated light on the sitters' faces and upper bodies, and occasionally (as here) on their hands. The overhead light source creates deep shadows in the couple's eyes and necks, and their dark eyes are extraordinary pools of red, brown, grey and black paint, enlivened with tiny white reflections off the upper irises. Gleaming highlights on the noses and foreheads give the faces pronounced three-dimensionality. The couple's indeterminate facial features, without defined outlines or solid modelling, contribute to their powerful humanity. Rembrandt's complex technique of building up faces in overlapping paint layers and feathered brushstrokes achieves a shimmering effect that implies the rich possibilities of human expression.

193
Portrait of a Couple in the Guises of Isaac and Rebecca (The Jewish Bride), c.1663–5.
Oil on canvas; 121·5 × 166·5 cm, 47⅞ × 65½ in.
Rijksmuseum, Amsterdam

Although these people are not known by name, they strike us as familiar figures, joined in what has become a paradigmatic image of loving marriage. Their individuality is startling because in one sense they are mere actors: Rembrandt based their portrait on a little-known composition by Raphael depicting the biblical lovers Isaac and Rebecca, thus turning the woman into an actual Jewish bride. The image of the union of two specific individuals is the result of imaginative artistic decisions. By having both sitters avert their gaze and posing them in seemingly immovable positions, Rembrandt made them look lost in

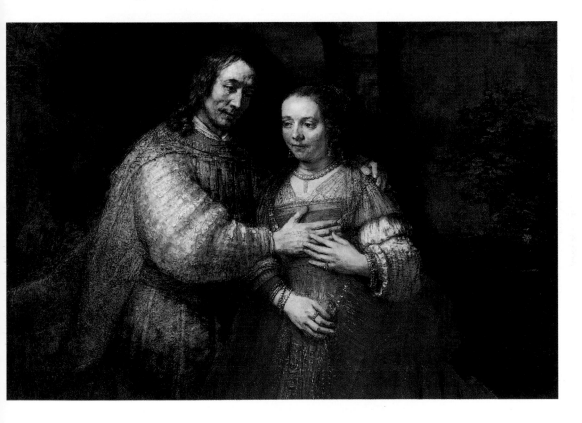

profound thought. The communication between them is unspoken and essentially physical: they incline gently to each other as the man's left hand cradles the woman's shoulder and his other hand lies flat on her chest. It is a gesture of keeping rather than a caress, and she reciprocates with the slightly spread fingers of her left hand. Rembrandt expertly distinguished these hands: the flesh tones are almost identical, but the woman's are slightly warmer; the white highlight on the back of the man's hand is dabbed on with a coarse brush to mimic his

rougher, drier skin. And although these hands appear blended, the visible direction of the brushstrokes along the fingers accentuates the angle at which her hand touches his.

If the profound humanity of Rembrandt's late portraits was the result of masterly contrivance, it is all the more impressive for its seeming naturalness. His late drawings claim a similar honesty, revisiting familiar themes in a sparser manner that suggests direct observation. In a sheet of apparently random studies, he placed a woman supporting a urinating boy next to the head of a horse (194). Both studies display

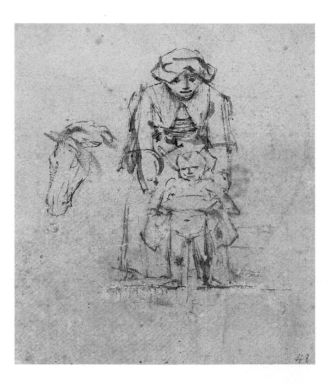

194
Studies of a Woman with Urinating Child and a Horse's Head, c.1659–61.
Reed pen and brown ink; 13·5 × 11·8 cm, 5¼ × 4⅝ in.
Rijksprenten-kabinet, Amsterdam

the distinctive split line of the reed pen, which has indented the paper by its force. Like drypoint, the irregular nib of the reed pen yields soft atmospheric effects, while its angular lines allow the construction of boldly skeletal drawings. The lines of varying width and the redrawn, partly unfinished contours align this drawing with the evocative, non-descriptive quality of Rembrandt's late paintings. And yet everything is there for the viewer to grasp the action: eyes and nose are drawn with one or two short lines, and carefully observed details such as the boy's navel and his shaded left shin anchor the figures in space.

Rembrandt's late biblical drawings resemble these impressions of daily life. It can be difficult to identify their themes, which are condensed to a few human figures, without indication of their setting. Highly unusual is the representation of *Christ Healing Peter's Mother-in-Law* (195), which Rembrandt drew in the late 1650s, at a time when he was preoccupied with the figure of Peter. He was probably drawn to the story because of the turning point it represented in Christ's earthly life: the healing of Peter's feverish mother-in-law was Christ's first miraculous cure (Mark 1:29–31). News of it brought crowds of diseased

195
Christ Healing Peter's Mother-in-Law, c.1658–60. Reed pen and brown ink, brown wash, corrections in white body-colour; 17·1 × 18·9 cm, 6¾ × 7½ in. Institut Néerlandais, Fondation Custodia, Paris

people to Christ, all of whom he healed. The miracle thus precipitated Christ's fame, and already foreshadowed the mob danger that was to bring about his death. The drawing focuses squarely on the act of healing, performed physically by Christ's hands, which pull the woman from her bed (the Gospel mentions just one hand!), and spiritually by his eyes. Her raised face appears to receive his gaze without any sign of doubt. Christ's bent attitude and the perceptible effort of his legs signal the physical toll his healings took on him, however dependent they may have been on faith. This interpretation is true to the letter of

the Gospel, which emphasized the earthly aspects of Christ's ministry. The style of the drawing is physical, too, with its varied marks of the reed pen, corrections in white body-colour and patches of wash smudged with the finger.

Unrelated to paintings or prints and not made to please by precise description, these late drawings evoke the image of an artist engaged in his own concerns. Rembrandt's last history paintings are too large to have been generated solely by such personal inclination, yet there is no evidence that they were commissioned; he probably made them independently with the ultimate intention of finding buyers. These works are particularly personal interpretations of ancient moral narrative, the most poignant of which may be *The Return of the Prodigal Son*, a painting of Rembrandt's very last years (196).

Lit by the overhead light source Rembrandt favoured for his late portraits, the father places his two hands firmly on the shoulders of his rogue son. The shared colour of the father's hands and the son's shirt intimates the intensity of their reunion. Rembrandt carefully differentiated the paint strokes that depict the fingers from those of the shirt, and thus let the fingers indent the son's back. The father's weary expression and closed mouth indicate silent forgiveness. On his knees and displaying one of his sore foot soles, the destitute son buries his head in his father's chest. This eloquent gesture of penitence deviates from the pictorial tradition, which emphasized the son's facial expression. Rembrandt may have remembered the tale of the Greek painter Timanthes, who was famous for his varied representation of the emotions. Karel van Mander recounted with approbation Timanthes' cleverest solution: to represent the unspeakable sadness of Agamemnon at the sacrifice of his daughter Iphigenia, Timanthes covered his face because his grief could not be captured by standard expressions. Similarly, the Prodigal Son's deep gratitude and relief may well be impossible to capture in facial features. Although the bystanders are defined vaguely and painted in a thinner, less sculptural manner, their solemnity befits the moment of forgiveness and reconciliation. In most representations of the parable, the Prodigal Son is greeted by an agitated group of family members and servants.

196
The Return of the Prodigal Son, c.1666–8.
Oil on canvas; 262 × 206 cm, 103⅛ × 81⅛ in.
The Hermitage, St Petersburg

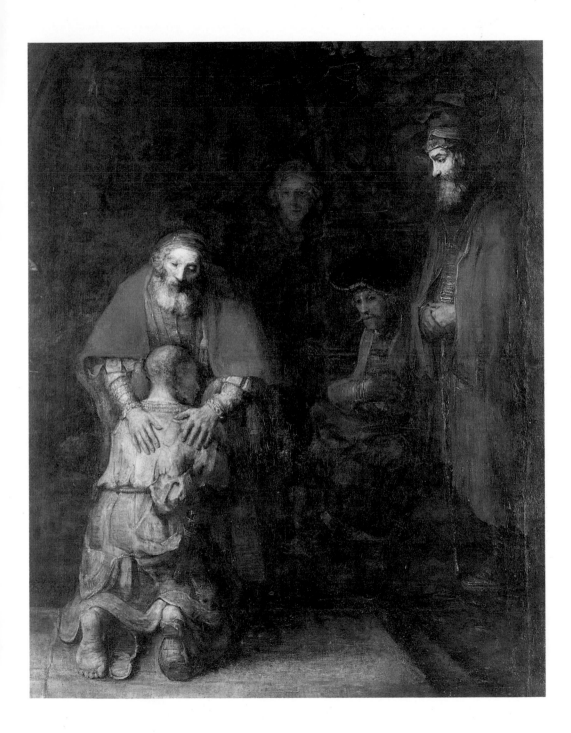

The Return of the Prodigal Son offers a moment of human interaction so still that it prompts the viewer to contemplation. The same narrative principle structures most of Rembrandt's late history paintings. *Aristotle* and *Bathsheba* (see 159 and 163) are model viewers as well as exemplary subjects for these works: capable of weighing the grand human quandaries, responsible for their own morality. In several late paintings, Rembrandt isolated figures of moral courage or wisdom, from both antiquity and the Bible. Even the violent *Suicide of Lucretia* (197), a pivotal event in the history of Rome told by Livy (*Histories* I, 57–8), became an elegiac display of ethics. Lucretia was raped by Sextus Tarquin, the son of the last, cruel king of Rome. Against the pleas of her husband and father, she committed suicide because she did not want future women of Rome to invoke her in justification of adultery. Before she plunged the dagger into her heart she exhorted the men to avenge her virtue, and her self-sacrifice thus precipitated a popular insurrection that ended the reign of the Tarquins and brought about the Roman Republic. Rembrandt filled out his canvas of 1666 with a frontal, life-size view of the dying Lucretia. She has already removed the dagger from her left side, where bright red blood has begun to soak through the white shift. Her loosened hair and dishevelled garments suggest the assault that has brought about her desperate act. Her eyes turn away, in weakness or in a last plea to the men who will avenge her; in the spirit of Livy's narrative, she does not appeal to the viewer for pity.

197
The Suicide of Lucretia, 1666.
Oil on canvas; 105·1 × 92·3 cm, 41³⁄₈ × 36³⁄₈ in.
Minneapolis Institute of Arts

Rembrandt painted this theme at least two times, yet subjects from Roman history are otherwise rare in his production. The political content of the story has suggested to some people that the painting was commissioned by an outspoken Dutch Republican. All that is known about the original owners of these paintings, however, is that in 1658 the bankrupt couple Abraham Wijs and Sara de Potter owned a large painting of Lucretia by Rembrandt, which cannot be identified. Whatever the case for the *Lucretia* of 1666, it would be difficult to interpret it as a piece of political propaganda in a modern sense, since it makes no direct reference to the depraved royalists who precipitated the suicide or to the heroic Republicans who drove them out.

Moreover, for Rembrandt the challenge seems to have been artistic and ethical rather than political. The story of Lucretia had been interpreted by Italian Renaissance artists from Raphael to Titian, and Rembrandt may have taken the opportunity to measure himself against them once more. An engraving by Marcantonio Raimondi after Raphael displays the statuesque heroine in a loggia, next to a pedestal inscribed in praise of her virtue. Rembrandt may have derived the idea of isolating her from this print, but the painting's pervasive melancholy and richly worked paint are closer to Titian's late works, including several dark paintings of the rape of Lucretia. Rembrandt's radical reduction of the story asks the viewer to contemplate her guiltless death. The colour scheme is restricted and the rawness of the paint – pasted on thickly where there is substance, dragged across bare ground in shadow – registers Lucretia's pain.

The heavy, expressively worked paint of Rembrandt's late moral narratives is calibrated to the themes it conjures. His last self-portraits owe much of their gravity to the dense and crusty character of this paint, which moulds an image of introspection. Collectively, Rembrandt's presentations of himself in old age – their number alone is striking – are largely responsible for his reputation as a lone and defiant artist, with wisdom born of adversity, and these paintings depend on their rough surfaces for their full effect. In all of them his pyramidal body, seen at half or three-quarter length, fills much of the picture surface and serves as a powerful yet unobtrusive base for his brightly lit head. Rembrandt's densely modelled face is framed by unruly grey curls and plain caps. Although directed at the viewer, the gaze of his deep-set eyes appears inward.

In his last two decades, Rembrandt portrayed himself frequently as a working artist. Where he had earlier limited his self-portraits at work to prints and drawings (see 134), he now painted large portraits of himself as painter, wearing stained smocks and painter's turbans, sitting at an easel or holding painter's tools. The novelty of these self-portraits cannot be overstated. Painters since Jan van Eyck had portrayed themselves with artistic turbans or tools of their art, but they had avoided referring to its physical strenuousness and messy

character. Instead they depicted themselves in spotless, fashionable dress, elegantly displaying a neatly arranged palette or a spray of brushes. These conventions projected a desirable image of the artist as a well-remunerated intellectual. Rubens was living proof that the ideal could be attained: an eyewitness report from 1621 has him painting, entertaining visitors, dictating a letter and listening to a reading of Tacitus all in one sitting. Throughout the sixteenth and seventeenth centuries, writers on painting felt compelled to demonstrate the nobility of the art by emphasizing its gentility, its high remuneration by royalty, its artistic equality to poetry and, not least, its intellectual superiority to the manual art of sculpture. In his self-portrait, now at Kenwood House in London, Rembrandt defied such propriety (198).

The painter stands broadly, with arms akimbo, holding a palette, a maulstick and several brushes in his nearly indistinguishable left hand. His expression is weary, with furrowed brow, mouth closed, sagging but decisive jowl. The impasto on the nose, forehead and painter's turban is so pronounced and fresh that it looks as if Rembrandt has just finished the work. The brashness of the paint accords with the painter's frontal stance, which echoes the royal pose of Holbein's Henry VIII. But if Rembrandt is king, he rules a realm of art, even if the setting is not unequivocally the studio. On the right, a long vertical mark may represent the edge of a canvas. Behind Rembrandt are two approximate half-circles. The fields they outline are so similar in colour to the background that he is unlikely to have intended them as representations of actual objects in his studio. Instead, he encouraged the viewer to read them as symbolic shapes.

The two half circles evoke images of an old map of the world or of a pair of celestial and terrestrial globes. Both cartographic products were made in massive quantities in Amsterdam; in contemporary paintings they function as decoration and as symbols of the world, and in collections, including Rembrandt's, they were reference tools as well as shorthand statements of the collection's microcosmic ambitions. Universality may well have been on Rembrandt's mind when he painted the half-circles, for in art theory from Van Mander to Van Hoogstraeten this quality was the prerogative of the most perfect

painters. As an expert in three media and all the known genres of painting, Rembrandt could lay rightful claim to universality.

In a painting that emphasizes the work of the painter's hand, however, the shapes take on more specific meaning. Drawn with a vigorous, bristly brush, the curved lines look very much as if Rembrandt has just painted them. It has been argued that he intended this effect to refer to the Italian painter Giotto (*c.*1267–1337), who once demonstrated his virtuosity by drawing a perfect circle freehand. The story was well known in the Netherlands, having been taken from Vasari by Van Mander. Vasari had used it to substantiate his claim that Giotto was the father of what he termed the 'rebirth' of Italian painting in the manner of antiquity, and the tale was itself a recycling of a classical legend about Greek painters who were recognized by the perfection of their freehand lines. In this sense, the motif suited Rembrandt's demonstration of his own dexterity and his unconventional emphasis on the manual labour involved in making art. While Giotto's perfect circle and its ancient models were studies in precise draughtsmanship, Rembrandt's unevenly but boldly painted circles display his own brand of virtuosity. This kind of painting is ultimately indebted to the Venetian heritage of Titian rather than the tradition of Giotto, and the deep red of Rembrandt's smock may acknowledge his source.

198
Self-Portrait,
*c.*1663–5.
Oil on canvas;
114·3 × 94 cm,
45 × 37 in.
Kenwood
House,
London

What is notable about these shapes, and about the vaguer straight markings to the painter's right, is their relative imperfection as lines. The circles are of different sizes, and the straight lines evoke the image of a mathematician working out a geometry problem on scrap paper. While these lines anchor the painter within a stable surface geometry, it would be anachronistic to suggest that Rembrandt added abstract markings purely to make a satisfying design. Rather, he may have inserted them to imply that he is, as his serious mien suggests, an artist of melancholy temperament. In 1644 the Dutch translation of Cesare Ripa's *Iconologia*, a standard reference work on allegorical representation, described Melancholy as an old woman who has drawn geometric figures behind her in the sand. Rembrandt's knowledge of melancholy's special status in the Renaissance theory of humours must have been informed by Dürer's engraving *Melencolia I* (see 160), a condensed,

intellectual statement that has rightly been seen as Dürer's spiritual self-portrait. Rembrandt's serious expressions in his self-portraits as artist suggest that he, too, saw the malady as a creative aspect of his identity. If Rembrandt painted this picture after Hendrickje's death, his melancholy may have been acute; claimed by a proudly manual artist, the lofty melancholy guise also lends the self-portrait a tone of defiance.

In his *Self-Portrait as the Apostle Paul* (199), painted in 1661, Rembrandt cast himself in a humbler attitude of melancholy – even if his identification with Paul strikes a bold note. The book he holds and the sword he has tucked away in his coat establish his role as Paul, but these attributes are subordinate to Rembrandt's face. Its active, quizzical yet resigned look is among the most engaging of his facial expressions, and it is remarkably true to the spirit of Paul's Epistles. Of all New Testament writers, Paul showed the most sustained engagement with the explication of the Word of God, and as such he became a compelling model for Protestant theologians. His exemplary status to Protestants was enhanced by his conversion from persecutor of Christ's followers to most ardent promoter of early Christianity. To Calvin and his followers, Paul offered first proof that God's grace will save a penitent sinner of true faith. His relentless advocacy of faith and his melancholy investigation of his own weaknesses must have made him a figure of powerful fascination for Rembrandt, who had repeatedly painted Paul in his role of interpreter and defender of God's Word (see 33). The sword, legendary instrument of Paul's martyrdom, here signifies his evangelical mission: held close to the heart, it is 'the sword of the Spirit, which is the Word of God' (Ephesians 6:17). Rembrandt's questioning gaze and air of resigned acceptance suggest both Paul's thoughtful legacy and an understanding of the limitations that come with old age.

Rembrandt's late self-portraits suggest a remarkable confidence about his place as an artist and about art's capacity for capturing, even shaping, a complex human life. The brooding *Self-Portrait at the Age of Fifty-two* (see 3) presents Rembrandt as lord of the pictorial world he invented, full of rich, fanciful costumes and appealingly human figures. In the last self-portraits the facial folds are puffier, the eyes less

199
Self-Portrait as the Apostle Paul,
1661.
Oil on canvas;
91 × 77 cm,
35⅞ × 30¼ in.
Rijksmuseum, Amsterdam

fiery, but the steady gaze from deep sockets still gives the impression that Rembrandt filtered his observations through an acute mind.

The painting Rembrandt left incomplete on his easel when he died confirms the image of a painter stubbornly dedicated to picturing the miraculous insight of which the human soul is capable. In *Simeon Holding the Christ Child* (200), begun for Otto van Cattenburch, Rembrandt returned to a theme that had occupied him since the 1630s. According to Luke (3:25–35), the Holy Spirit had told the aged Simeon that he would not die until he had seen the Son of God. On the day Mary and Joseph presented their son in the Temple, the Spirit moved Simeon to hold the child. As he took the baby into his arms he praised God and said 'Now Lord, let your servant go in peace, after your word.' Simeon's eyes are shrouded in apparent blindness, but his inner vision is unimpaired.

200
Simeon Holding the Christ Child, c.1668–9. Oil on canvas; 98 × 79 cm, 38⅝ × 31⅛ in. National-museum, Stockholm

'He loved but his liberty, painting and money.' In this succinct state-
ment of 1753, the French art critic Jean-Baptiste Descamps summed
up prevailing opinions of Rembrandt since his death, and prefaced the
next two and a half centuries of Rembrandt criticism. Current views of
Rembrandt, including the one put forward in this book, define them-
selves in relation to the vast body of previous writing on him – and
implicitly to Descamps' character sketch. A survey of Rembrandt's
critical fortunes over three centuries reveals that the image of the histor-
ical Rembrandt shifted according to the time and place in which it was
formulated. Certain constants in this image may clarify how Rembrandt
saw his own art, and they suggest why he continues to fascinate today.

201
Charles
Laughton in
Alexander
Korda's film
Rembrandt,
1936

In Descamps' list of Rembrandt's affections, painting is central: the
sheer volume of his production, variety of his themes, diversity of his
interpretations and boldness of his technical experiments establish
his commitment to being, in Van Mander's terms, a universal painter.
Descamps' 'liberty' has a likely source in Houbraken's claim that
Rembrandt refreshed his spirit by associating with people of low
station and with those who practised art. Rembrandt contrasted this
social freedom with 'honour', or the hierarchies of polite society; in
terms of his art, this liberty with convention is one of Rembrandt's
defining characteristics. 'Money', Descamps' third term, is puzzling.
Rembrandt was a poor financial manager, but Descamps probably
made his assessment on the authority of Houbraken, who mentioned
that Rembrandt's pupils teased their master by painting coins on the
floor, which he would greedily try to pick up.

To Houbraken, Descamps and their eighteenth-century peers, Rembrandt's
unconventional behaviour, his supposed meanness and his penchant
for 'common' people were qualities mirrored in his art, but they were
undesirable in an artist who, like them, could have been a powerful
spokesman for the honour of painting. Soon after Rembrandt's death,

Sandrart, Pels, Van Hoogstraeten and Baldinucci had already struggled to assess this ambitious artist, celebrated by contemporaries as 'the miracle of our age' and 'the Apelles of our time', without condoning the wayward qualities of his pictorial idiom. Rembrandt's grotesque females, fanciful costumes and rough handling of paint were at odds with the new preference for a classically based painting, and it is for these qualities that the early critics had their sternest words. In 1681 the theatre critic Andries Pels, inspired by the *Seated Nude* (see 38), articulated this opinion for young poets:

You will fail miserably if you lose the well-worn path,
if you choose, despairingly, a more dangerous one,
and if, satisfied with fleeting praise, you opt to do
as Rembrandt did, who didn't get it from Titian or Van Dyck,
from Michelangelo or Raphael,
and who preferred rather to err grandly,
to be the first heretic in painting,
and to lure many a novice to his line;
than to sharpen himself by following the experts
and by subjecting his famous brush to the rules;
who, even though he did not yield to any of these masters
in chiaroscuro or in force of colouring
when he would paint a naked woman, as sometimes happened,
chose no Greek Venus for his model,
but a laundress or peat treader from a barn,
calling his error the following of nature,
all else vain ornament. Weak breasts,
disfigured hands, yes marks of corset laces
on the stomach, of garters on the legs,
all must be rendered for nature to have her due –
at least *his* nature, which suffered neither rules
nor reason of proportion in the human limbs.

Calling Rembrandt 'the first heretic in painting', Pels managed to praise him while disavowing his extravagant early realism. In a temporal sense, 'first' implies Rembrandt's originality; but since he was not the first artist to revel in wrinkled skin and non-classical limbs, 'first' could also

be taken as 'pre-eminent' or 'leading'. Pels' reference to the young painters attracted by his art suggests that he indeed considered Rembrandt the originator of an unorthodox, misguided style. In 1707 Gerard de Lairesse, the painter and theorist who recommended that artists gloss over physical deformities, admitted that in his youth he 'had a special preference for Rembrandt's manner', which he had been forced to 'recant' once he had learnt 'the infallible rules of art'. To Pels and Lairesse, Rembrandt's art was heretical in its rejection of the decorum of classical antiquity and the Renaissance, and in its false claim that nature was its model.

The classical 'rules' that structured the earliest Rembrandt criticism governed eighteenth-century academic discussions of art, especially in France, where classicism and rationality rapidly became reciprocal standards of philosophy, poetry and art. As rule-breaker Rembrandt existed on the borders of this academic discourse, but collectors and artists showed little concern, avidly collecting his prints. In 1751 all etchings then attributed to Rembrandt were catalogued, in their various states, by the dealer–connoisseur Gersaint. His publication was the first *catalogue raisonné* of the production of any Western artist. A true Enlightenment product, such 'reasoned catalogues' were to become the basic tools of modern art history and the art trade. Meanwhile, artists were engaged in a cottage industry of reprinting Rembrandt's plates, copying his prints and varying his designs. The spectacular naturalism of one of Rembrandt's most popular landscape etchings, *The Three Trees* (202), exerted formative influence on the development of the sublime landscape in France and England. William Baillie, the printmaker and dealer who reworked, reprinted and finally cut up *The Hundred Guilder Print*, called his copy of *The Three Trees* an 'improvement' on Rembrandt's design (203). In keeping with the dramatic late eighteenth-century conception of nature as fickle, grandiose agent, Baillie dramatized Rembrandt's ominous clouds into a full-blown thunderstorm, with lightning bolts to distract from his ponderous rendition of Rembrandt's exquisite human details and driving rain.

The eighteenth-century preference for Rembrandt's dark landscapes, tormented biblical figures, brooding *tronies* and self-portraits is a reminder that the Enlightenment was by no means a monolithic movement towards a supremely rational philosophy, society and art.

202
*The Three
Trees*,
1643.
Etching,
engraving and
drypoint with
sulphur tint,
single state;
21·3 × 27·9 cm,
8$\frac{3}{8}$ × 11 in

203
William
Baillie after
Rembrandt,
The Three
Trees,
1770s.
In reverse,
etching and
mezzotint;
20·9 × 28·1 cm,
8¼ × 11 in

In much eighteenth-century cultural expression there is a sense of reason's precariousness, an awareness that it can barely keep the demons of the irrational at bay. No artist articulated this insight more insistently than Francisco Goya (1746–1828), and his keen knowledge of Rembrandt was a lifelong fount of inspiration. Goya copied Rembrandt's prints early in his career, and his print production emulated

204
Francisco
Goya,
*Self-Portrait
with Doctor
Arrieta*,
1820.
Oil on canvas;
115·6 × 79·1 cm,
45$\frac{1}{2}$ × 31$\frac{1}{8}$ in.
Minneapolis
Institute of
Arts

Rembrandt's in its volume, apparent spontaneity of line and technical experimentation. His self-portraits evoke Rembrandt's in their regis-tration of the artist's physical blemishes and inner preoccupations. The late *Self-Portrait with Doctor Arrieta* (204) is one of Goya's finest works in Rembrandt's late manner, with its highly selective lighting and its calibrated differentiation of states of finish. Goya's linen shirt

and rough coat, his glowing red blanket and sagging face recreate the mode Rembrandt favoured for his most searching paintings.

By 1820, when Goya painted his self-portrait, Rembrandt was no longer seen universally as an uncouth upstart. His painterly roughness and earthy realism were still considered the mirror of his life, but early nineteenth-century writers interpreted his social and artistic unconventionality in positive terms. In a forceful reaction against the rule-bound rationality of much Enlightenment culture, musicians, writers and artists were valued increasingly for their individuality, the mark of the 'genius', the inspired and impetuous creator whose anti-social exterior is a measure of his originality. Thus Eugène Delacroix (1798–1863), a model Romantic genius beguiled by Rembrandt's glowing colour and expressive brushwork, could predict that 'people will discover one day that Rembrandt was as great a painter as Raphael'. The comment was a barb at the Neoclassical painter Jean-Auguste-Dominique Ingres (1780–1867) who had derided the 'blasphemous' habit of comparing Rembrandt to Raphael. The exchange between Delacroix and Ingres foreshadows the conflict later in the century between the officially condoned art of the Salons and the challenges to it from Realist and Impressionist painters. Rembrandt gave impetus to the ordinary heroes of Gustave Courbet (1819–77), the spirited brushwork of Édouard Manet (1832–83), the incisive self-portraits of Degas, the airy landscape etchings of James McNeill Whistler (1834–1903).

In the Netherlands, Rembrandt's international revaluation allowed him to become a culture hero in the nineteenth-century pantheon of Dutch nationalism, a movement that gained special force after 1830, when the country was reeling from Belgium's declaration of independence from the Dutch monarchy. To become an exemplar of national virtue on a par with the admirable Vondel or the naval commanders of the Golden Age, Rembrandt's unsavoury image needed tidying up. Dutch intellectuals reconstructed Rembrandt as a rational, observant, eminently successful artist. In the process, they recovered the ambition and international acclaim of the historical Rembrandt, but reduced the novelty of his approach, the deliberate waywardness of his style.

So effective was the Dutch rehabilitation of the wholesome Rembrandt that he became the respectable guardian spirit of his country, rather than a rebel genius, as he was in French culture. This mainstreaming of Rembrandt was embodied in the statue Amsterdam erected in his memory in 1852, twelve years after Belgium had produced its grander monument to Rubens. A pedestrian cast iron affair, it presented the artist as a serious but eminently respectable citizen (205). In 1882 the cultural historian Conrad Busken Huet could call his broad cultural history of Holland *The Land of Rembrandt*, in counterpoint to his similar survey of *The Land of Rubens*. Dutch art historians were extremely protective of Rembrandt's new standing. When Abraham Bredius, director of the finest Dutch collection of paintings, the Mauritshuis, found documents in 1899 that established Rembrandt's extramarital troubles with Geertge Dircks, he withheld publication, afraid of what the revelations might do to the master's hard-won reputation as soulful family man. That image was shored up in Bredius' grand catalogue of Rembrandt's paintings, published in 1935, which turned numerous *tronies* and unidentified portraits into images of his mother, father, sister, brother, wives and son – many of them, it is now clear, anonymous figures painted by Rembrandt's followers.

Nationalist interest in Rembrandt was not confined within Dutch borders. In 1890 the German philosopher Julius Langbehn published a protracted German lament called *Rembrandt als Erzieher* ('Rembrandt as Educator'), in which he bewailed the materialist spirit of the German *Reich* and claimed Rembrandt (now an honorary German) as the model embodiment of the true, obscured essence of the German people. Langbehn's tract was reprinted for decades and exerted influence on German art history in the Nazi period. In a study of Rembrandt's self-portraits published in 1943, Wilhelm Pinder marvelled that the German popular spirit had found its most perfect expression in Rembrandt.

More constructively, the revaluation of Rembrandt spawned intricately detailed archival, technical, stylistic and iconographic researches. In the last four decades, much of this scholarly work has attempted to modify the extravagantly singular status Rembrandt assumed by 1906, the tercentenary of his birth, which occasioned one of the first

205
Wreaths laid at
Rembrandt's
statue,
16 July 1906,
Amsterdam

year-long, blockbuster celebrations of an Old Master. Meticulous stud-
ies of Rembrandt's paintings virtually halved Bredius' catalogue of
over six hundred surviving paintings; investigations of his pictorial
sources demonstrated that, for almost every thematic invention,
Rembrandt might have seen a sixteenth-century precedent in print;
documentary research fleshed out the people Rembrandt knew.
Although all of these studies have placed Rembrandt more squarely in
his culture, it remains difficult to reduce him to the sum of his sources,
techniques and social circumstances. His expert knowledge of art past
and present, his intimacy with the great and the good, his understanding
of the economic system of art do not, singly or combined, account for
the tremendous appeal he holds today. Despite the historical specificity
of his art, it is its accessibility, its directness that captivates modern view-
ers. This apparent openness of the work, along with its complex variety,
is what allows different generations to interpret Rembrandt's love of
'liberty, painting and money' in such astoundingly different terms.

The personal quality of Rembrandt's art has ensured its continued interest for modern and contemporary artists. The finest fictional account of Rembrandt in any medium remains Alexander Korda's film *Rembrandt* (1936), with Charles Laughton (see 201) starring as a seamless amalgam of the seventeenth-century Rembrandt and his Romantic incarnation as a genius despite himself, 'born a peasant' and irreconcilably at odds with the regent class of Banning Cocq. In the very first scene, Rembrandt refuses to paint the militiamen: 'I don't like their faces; I am busy painting Saskia.' Bereft of her, Rembrandt becomes ever more absorbed in his wilfully wayward art, to the detriment of his fortunes but to the benefit of his love life and spirit. Much in Korda's vision reconfigures Rembrandt's art rather than his life. Tired of materialist Amsterdam, embodied in a nagging Geertge Dircks, Rembrandt returns to his family in the mill to read the evening scripture, in a scene that casts him as Prodigal Son and Christ at Emmaus at once. Throughout the film Rembrandt is a mesmerizing narrator, beguiling family members, a beggar, drunken youths and an entire company of jaded guardsmen. Korda brilliantly interpreted Rembrandt's light effects and compositional techniques. With dramatic *repoussoirs*, radically asymmetrical shots and sharp shadows on bright walls he recalled Rembrandt's effects without succumbing to the temptation to cast every scene in spot-lit darkness. The film's black-and-white clarity indeed evokes Rembrandt's etchings, which preface distinct episodes. Korda's Rembrandtesque cinematography powerfully influenced other Rembrandt biopics, including Hans Steinhoff's *Ewiger Rembrandt* ('Eternal Rembrandt') of 1942, a more dramatically lit film by a Nazi propagandist, but its lighting effects eventually affected Hollywood movies from Hitchcock's *Notorious* (1946) to Disney's *Cinderella* (1950).

One of Rembrandt's last self-portraits is the sort of work that conditioned Korda's vision of the eccentric genius and the rigid focus of his early critics on his violation of the rules. Rembrandt painted it when he had long relinquished the defiant realism of his early career (206). It is probably his final self-portrait as painter, and it is the last in which he plays a historical part. The thick, yellowed varnish on this painting cannot obscure its heavy build-up of the painter's cloak, its encrusted moulding of the artist's aged face. This is a portrait that one could 'lift

by the nose', in Houbraken's sense. Rembrandt manipulated the paint around his mouth into a toothless smile, a grimace that for years was thought to mark the painter's defiance of the critical tide, or perhaps of death itself. When Albert Blankert showed, in 1973, that Rembrandt painted himself laughing as the Greek painter Zeuxis, it became apparent that these speculative readings had intuited the meanings of the self-portrait's persona. Aert de Gelder's smiling self-portrait provided the key to Rembrandt's role, for it is a more elaborate version of his master's

206
*Self-Portrait
as Zeuxis*,
c.1665–7.
Oil on canvas;
82.5 × 65 cm,
32½ × 25⅝ in.
Wallraf-
Richartz-
Museum,
Cologne

painting (see 55). The old woman De Gelder depicted seems to have been based on the now dim model in Rembrandt's painting. In the seventeenth century, a laughing painter portraying an elderly female could only be Zeuxis. Writing of the proper expression of the passions, Van Hoogstraeten noted that Zeuxis, 'when he was painting a comical old hag from life, burst out in such uproarious laughter that he choked and died'.

If Rembrandt at age sixty had reason to paint himself as an artist near death, what motivated him to play Zeuxis for a final role? Zeuxis, the master of deceptive, illusionistic painting, had probably meant much

to him in the 1640s, when he painted pictures that rival the legendary masterpieces of classical painters (see 115, 116). Here, however, he drew on Zeuxis' fame as a scrupulous imitator of life and as a supreme painter of the passions, no matter how banal. Van Hoogstraeten might have been writing about Rembrandt when he noted that 'Zeuxis always sought some spiritual embellishment, representing either some urges and passions ... or eventually, in his old woman, his own curious nature, because he laughed himself to pieces.' Mimicking shrivelled old skin in paint, portraying faces from life, capturing the passions of the human soul and painting his own curious nature had been lifetime preoccupations for Rembrandt. Invoking Zeuxis as his spiritual model, he issued an implied challenge to those contemporaries who championed the Zeuxis who tricked birds with lifelike, smoothly painted grapes.

Rembrandt's late self-portraits affirm that art had an introspective purpose for him. By their thoughtfulness these works prompt contemplation in the viewer too. In 1893, Émile Michel, a sensitive French biographer of Rembrandt, made much of this quality:

there is no artist who, with similar abandon, put into his works the secret of his thoughts, his joys, his loves and his troubles, no artist who exposed himself more openly, with the sad contrast between his genius, so powerful, and his childlike nature incapable of behaving, having no will but to work, maintaining to the very end, across the cruellest and often most deserved trials, that ardent love for his art, before which all should cede and which dominated his entire existence.

While this splendidly crafted description of a quintessentially Romantic *artiste* does not fit the evidence available today, it can still be said that much of Rembrandt's work lent itself to such characterization. Eventually, it thereby helped shape modern ideals of the artist as an autonomous individual who has privileged insight into the human condition. If Rembrandt's personal exploration of human identity is different in expression rather than in kind from the probing of his Protestant contemporaries, it speaks more directly to us by its immediate appeal to our sight and touch. This aspect of Rembrandt is not universally transparent or significant to all people: clearly it was neither to his earliest critics. Introspective art has a history, and Rembrandt can anchor us in it.

&

Glossary

Academy Sixteenth-century term for an organization of artistic training, often run informally from artists' studios, but in the cases of Florence and Paris full educational institutes rivalling the **Guild of St Luke**. The early modern academies were usually dedicated to the study of live models and of classical and Italian Renaissance art.

Aemulatio Latin for 'emulation', this concept of classical rhetoric designated the highly desirable ability to produce new inventions that could rival the great classical and modern models of literature.

Antiquitates Term for objects collected for their historical as well as their artistic value, including works from classical and more recent history.

Artificialia Those objects in an early modern collection that were products of the human hand valued for their artistic accomplishment, rather than their documentary, scientific or historical interest.

Auricular Also known as 'lobate', a prestigious style of ornament in European metalwork of the late sixteenth and seventeenth centuries, named for its capricious loops and folds that resemble somewhat the structure of the human ear. The style was particularly popular in the Prague of Emperor Rudolf II and developed in myriad ways in the Dutch Republic.

Calvinism Form of Protestantism adherent to the thinking of the Swiss theologian Jean Calvin; generally associated with strict adherence to the biblical text and sober worship devoid of all but the most elementary visual or musical ornamentation.

Cessio bonorum Latin term for 'ceding of goods', a seventeenth-century legal construction that allowed people in insurmountable debts to transfer their assets to a legal administrator without incurring the moral stigma attached to bankruptcy.

Chiaroscuro Literally 'light–dark', the Italian word refers to the painter's modelling of three-dimensional form by means of judicious contrasts of light and dark, and also to the painter's distribution of areas of light and shade across the picture surface in order to structure their composition; in this sense the term is often used to describe the dramatic light–dark contrasts of Caravaggio (1571–1610) and Rembrandt.

Deadcolouring Preliminary stage of oil painting, usually on canvas, in which the painter lays in the composition in black, grey and white tones that indicate the outlines of the forms and patterns of light and dark to be worked up in colour.

Ground Smooth paste covering a wood panel or canvas to create a surface suitable for the reception of oil paint.

Guild of St Luke Early modern professional association of visual artists in any given town, serving as a trade organization governing the education and business interests of local painters and possibly printmakers, sculptors and other makers of images; dedicated to St Luke because the evangelist had produced a legendary portrait of the Virgin Mary.

Iconoclasm Destruction of religious images intended to remove visual supports for worship; during the Reformation, this age-old Christian phenomenon, occasioned by the second commandment against the making of graven images, was particularly severe in German and Swiss cities (1525) and in the Netherlands (1566).

Impression An individual print, usually on paper, made by the transfer of ink from a design engraved in copper, cut in wood or made on any other material.

Kunst caemer Literally 'art room', this seventeenth-century Dutch term referred to rooms in which collectors kept the majority of their works of art and curiosities. By extension, the term in later centuries came to stand for an entire collection, regardless of its storage or display facilities. Most collections, including Rembrandt's, encompassed a wide variety of *naturalia*, *artificialia* and *antiquitates*.

Maulstick Also known as 'mahlstick', this long stick was held or propped up by the painter to support the hand holding the brush; the padded end of the stick rested against the frame or painting support.

Melancholy In early modern physiology this mental condition, similar to clinical depression, was considered to be caused by the astrological influence of the planet Saturn, which precipitated an excess of black bile in the precarious balance of the four basic human fluids known as the 'humours' (the others being blood, yellow bile and phlegm). Aristotle and his Renaissance admirers saw melancholy as the mark of especially gifted thinkers, writers and artists.

Mennonite Follower of Menno Simons (1496–1561), who founded an Anabaptist sect

that rejected the concept of original sin, advocated a sober and pacifist life and forbade involvement in any social function that required the taking of an oath, including government.

Naer het leven Literally 'from the life', this Dutch seventeenth-century expression refers to art made by direct copying from life, *ie* from nature, although occasionally the term was applied to art that had its basis in nature but was clearly refined by drawing or painting **uyt den gheest**.

Naturalia Objects of natural origin collected for their beauty and/or scientific interest, often with a view to demonstrating the miraculous nature of God's creation.

Peripeteia Term from Greek dramatic theory denoting the sudden, complete reversal of fortune experienced by the hero of a tragedy, which may lead to his or her increased insight into specific relationships or into the human condition.

Primuersel Still incompletely understood, this Dutch term resembling 'priming' usually referred to the **ground** of a painting or even to a layer of sizing preparing the canvas for reception of the ground.

Protestant see **Reformation**

Reformation Religious upheaval instigated in 1517 by Martin Luther as a plea for ecclesiastic reform, but eventually leading to the schism of the church into Roman Catholic and Protestant; the Protestant denominations took the name from their official protestation in 1529 against the decree of Emperor Charles V preventing freedom of worship.

Regent Member of a deeply connected Dutch citizen élite, an aristocracy of birth, accomplishment or both, involved in the government of cities, provinces and the Dutch Republic.

Remonstrant Faction of the Dutch Reformed church advocating peace with Spain and religious tolerance within a generally Reformed Republic; named after the *Remonstrantie* ('critical protest', 1610) written by **Wtenbogaert** against the harder line espoused by the more strictly Calvinist faction of the Reformed church.

Repoussoir French term derived from the word *repousser* ('to push back'), denoting a prominent, often dark form placed in the foreground of a picture. This space-creating device creates a sharp distinction between fore- and middle ground and draws the eye to the centre of the picture.

Schilderachtig Until the seventeenth century this Dutch word had merely meant 'painter-like' or 'of' or 'belonging to painting', but in Rembrandt's time its use became controversial. Some artists applied it to lowly themes 'worth painting' while critics such as **Jan de Bisschop** and Gerard de Lairesse tried to

reclaim it for classical themes and forms which they considered worthier of representation. Despite their efforts, in later centuries the term came to mean something close to 'picturesque'.

Stadhouder 'City holder', title of the highest military and political official appointed by the legislative bodies of the Dutch provinces and, by extension, usually by the **States General** of the Republic. In the seventeenth century the title was invariably accorded to a member of the Orange family, except during periods in which the States General sought to exercise power independently of that dynasty.

State A distinct stage of a print's development that is recorded in one or more **impressions** by the artist.

States General Legislative and policy-making body of political representatives, most of **regent** stock, from all of the provinces of the Dutch Republic, based in The Hague.

Tronie Dutch word for 'face' that in the seventeenth century came to mean a genre of painting dedicated to bust-length or close-up facial paintings of single figures distinguished by striking features and expressions, picturesque skin and/or fanciful costumes. *Tronie* models were occasionally identified by name, but most appear anonymously.

United East Indies Company Known by its Dutch acronym VOC, this trading company, chartered in 1607, was given the sole Dutch privilege for trade in the East Indies, which for all practical purposes extended from Cape the Good Hope to Japan. In the course of the seventeenth century the VOC built up a huge Asian trading empire centered on the colony of Batavia (Jakarta) and engaged equally in intra-Asian and Asian–European trade.

Uyt den gheest Dutch seventeenth-century term for art produced 'from the spirit', implying the mental process of idealization involved when the artist seeks to make a convincing representation of things seen or imagined, carefully selecting from nature that which corresponds to their mental image of the most perfect forms.

Virtuoso Italian term for a truly and often self-consciously accomplished artist, collector and connoisseur, often implying all these qualities in one person.

X-ray photography Because x-rays do not penetrate lead and most early modern oil paints contained lead white as a basic substance, x-ray photography of paintings produces an image of all the layers of paint containing lead white. By comparing the x-ray image of a painting to its extant surface, one can often see changes made in the composition during painting or detect areas of the composition that were held in reserve by the artist for painting figures or other details in the foreground of the painting.

Philips Angel (1617/18–64) A painter from Leiden whose work is virtually unknown, Angel became a spokesperson for the city's artistic community. In 1641 he addressed local artists with a speech *In Praise of the Art of Painting* (*Lof der Schilder-Konst*), a rallying cry for the reinstatement of Leiden's guild of painters, which had been abolished in 1572. The address, published as a small book in 1642, propounded standard notions of Renaissance art theory, occasionally enriched with insightful praise of his Leiden peers such as Rembrandt and **Dou**.

Cornelis Claesz Anslo (1592–1646) The textile merchant Anslo was a renowned preacher of the Amsterdam **Mennonite** community, of which **Uylenburgh** was also a member. A man of pronounced integrity, he took personal responsibility for the debts incurred by his son, who bankrupted his textile business.

Frans Banning Cocq (1605–55) An accomplished lawyer and son of a wealthy apothecary and a regent's daughter, Banning Cocq moved easily up the ranks of Amsterdam government. Having married a successful merchant's daughter in 1630, he held increasingly important civil functions, including that of burgomaster. His career as militia officer of the Kloveniersdoelen kept pace with his government advancement: eventually he became one of the two colonels in charge of all Amsterdam civic guards.

Jan de Bisschop (1628–71) A lawyer, Latinist, amateur draughtsman and art critic, De Bisschop (also known as Episcopius) married Anna van Baerle, the daughter of the humanist Caspar Barlaeus in 1653. In his drawings he copied works by Bartolomeus Breenbergh (1598–1657), whose drawing style he emulated in a gold-brown ink that became known as 'bisschop's ink'. His two books of prints after classical sculptures (1668) and Italian drawings (1671), dedicated to **Huygens** and **Six**, propagated a rigorously classical style of painting; in them, De Bisschop argued for an ideal, classical manner at the expense of the *schilderachtig* interest in lowly themes and details.

Ferdinand Bol (1616–80) The son of a surgeon from Dordrecht, Bol received his artistic training there before seeking a further apprenticeship with Rembrandt in 1637, possibly staying till 1642, when he began to sign his works. In the 1640s and 1650s he received numerous commissions from charitable institutions, the Amsterdam Town Hall and distinguished portrait sitters, perhaps in part through the offices of his well-connected father-in-law. His later history paintings are in the prestigious, elaborate manner associated with the decorative programs for the Oranjezaal for **Amalia van Solms** and the Amsterdam Town Hall. After his second marriage in 1669 to a wealthy widow, Bol apparently stopped painting.

Ephraim Bueno (1599–1665) Born in Portugal to a Jewish family of physicians, Bueno (also known by his Latinized name Bonus) spent most of his life in Amsterdam, where he practiced medicine. He also wrote and translated Spanish poetry and was active in the Sephardic community, supporting the publishing venture of **Menasseh ben Israel** and co-founding a Jewish academy in 1656.

Jan van de Cappelle (1626–79) Van de Cappelle was an agent for his father's prosperous dye-works, which he took over in 1674, but his independent wealth and his father's management of the business allowed him to become a successful marine painter and collector of Dutch art. His limpid marine paintings, suggestive of the moist Dutch atmosphere, demonstrate his direct experience of the water, gained in trips on his pleasure yacht. His collection included about two hundred paintings and over seven thousand drawings, including five hundred by Rembrandt.

Jacob Cats (1577–1660) Well-connected to political circles in The Hague, Cats wrote widely-read conduct books that combined a Calvinist ethic with classical erudition and plain common sense. His bestsellers, illustrated by contemporary printmakers and issued in editions for all pockets, included *Marriage* (*Houwelick*, 1625), which sold over 50,000 copies in the seventeenth century. During the first, brief period without a *stadhouder* Cats served as the highest political functionary in the Republic.

Charles I (1600–1649) The Stuart King of England was one of the greatest art patrons and collectors of the seventeenth century, acquiring a fine group of Old Master paintings by the wholesale acquisition of collections such as that of the Duke of Mantua as well as a choice selection of contemporary works by commissioning the likes of **Rubens**, **Van Dyck** and **Honthorst**. Through his envoy James Kerr he became one of the first heads of state to own youthful works by Rembrandt and **Lievens**.

René Descartes (1596–1650) Philosopher educated in the rigorous analytical methods of the Jesuits. While serving in the Dutch army of Prince Maurits (1617–19) he met the Dutch mathematician Isaac Beeckman, who persuaded him to pursue fundamental

questions of mathematical physics. Ten years later, he moved to the Dutch Republic to work within a Christian philosophical framework, but away from the watchful eye of the Catholic Church. Most influential of his scientific and metaphysical writings was his *Discourse on the Method* (1637), a mere preface to his largest scientific work, *De Mundo*. The *Discourse* first articulated the central tenet 'I think, therefore I am'; its claim for the need of scientific proof of God's existence put Descartes at loggerheads with strict Dutch Calvinists.

Gerard Dou (1613–75) Dou received his initial training as a glass painter and was taught oil painting by the young Rembrandt (1628–31). His meticulous, detailed technique geared to the miniaturist imitation of textures gained him renown as 'the Dutch Parrhasios', a reference to the Greek painter whose paintings fooled all eyes. Dou enjoyed distinguished international and local patronage in Leiden, including a thousand-guilder annual fee from Pieter Spiering, agent for Queen Christina, for the mere right of first refusal on any of his paintings.

Adam Elsheimer (1578–1610) Trained as a painter in Frankfurt and active in Germany for the first decade of his short career, Elsheimer painted his most influential works in Rome, where he arrived in 1600. There he joined a circle of humanists and painters that included **Rubens**, the neo-Stoic philosopher Justus Lipsius and the printmaker Hendrick Goudt (1583–1648), who acted as Elsheimer's patron but also seems to have been his student. Goudt disseminated Elsheimer's magically-lit compositions through prints, but eventually had a falling out with him, perhaps because of Elsheimer's nervous disposition. His small, colourful, highly detailed and smoothly finished history paintings on copper powerfully affected **Lastman**'s style.

Govaert Flinck (1615–60) Trained in Leeuwarden by Lambert Jacobsz (*c.*1598–1636), a fellow **Mennonite**, Flinck moved to Amsterdam in 1633 for three years of additional training with Rembrandt, whose agent **Uylenburgh** was Jacobsz's partner. During the 1630s he painted ambitious history paintings and portraits in the master's manner. In the 1640s Flinck developed a smoother, brighter style based on the elegant works of **Van Dyck**. With this manner he became a highly sought-after painter to the **regent** élite, painting allegories for **Amalia van Solms** and heroic scenes for the Amsterdam Town Hall. His sudden death terminated the work he had barely begun on twelve monumental paintings for the Town Hall Gallery.

Abraham Francen (1613–?) Francen was a pharmacist and an art collector who not only commissioned a portrait print from Rembrandt and collected his etchings, but also supported the artist in his financial difficulties and in various capacities as legal witness. He became the guardian of Cornelia, the daughter of Rembrandt and Hendrickje Stoffels, and he is known to have served her in legal capacities after her father's death.

Aert (also known as Arent) de Gelder (1645–1727) Rembrandt's last pupil (*c.*1661–3) was first trained in his native Dordrecht by **Van Hoogstraeten**. Working in Dordrecht, he was one of the few artists to paint history paintings and portraits in Rembrandt's late mode well into the eighteenth century, when critical tide ran against it. His artistic autonomy may have been facilitated by the financial independence afforded by his family fortune.

Frans Hals (1582/3–1666) The pre-eminent portrait painter of Haarlem gained renown for his group portraits of militia companies and of wardens of charitable institutions and for his innovative genre paintings. In the late 1620s his novel, dashing brushwork was highly sought after by portrait sitters, but after 1640 this style lost favour somewhat to the smoother styles of **Van der Helst** and **Flinck** in Amsterdam. Despite his success, Hals suffered financial difficulties throughout his career.

Bartholomeus van der Helst (*c.*1613–70) Trained in Amsterdam in the late 1630s, perhaps by Nicolaes Eliasz (1590/1–1654/6), Van der Helst soon began to paint portraits in Rembrandt's manner. In 1639 he already received the commission for a militia portrait in the Kloveniersdoelen. On the strength of its successful composition and stylish handling, Van der Helst became the leading portrait painter of the **regent** élite, matching seemingly effortless poses with a fluid, smooth brushwork in a style that updated the courtly portraits of **Van Dyck**. In 1652 he was awarded the commission to paint Mary Stuart, the widow of William II of Orange.

Gerard van Honthorst (1590–1656) After training with Abraham Bloemaert (1566–1651) in Utrecht, Honthorst spent a decade in Rome where his brilliant nocturnal scenes, influenced by Caravaggio and his followers, earned him the nickname Gherardo della Notte ('Gerard of the Night'). Back in Utrecht in 1620 his art became popular with collectors throughout the Republic. He soon attracted the attention of the **stadhouder** Frederik Hendrik; his portraits for the court in The Hague were executed in a newly bright, smooth portrait style that eventually brought him patronage from the English court as well.

Samuel van Hoogstraeten (1627–78) A pupil of his father in Dordrecht and then of Rembrandt in the mid-1640s, Van Hoogstraeten became a highly self-conscious artist and gentleman. He specialized in illusionist still-life and perspective painting, and took this exacting form of art to Vienna (1651), Rome (1652) and London (1662–6), where its geometric and optical exactitude brought him into contact with members of the Royal Society. In 1678 he published his *Introduction to the High School of Painting* (*Inleyding tot de hooge schoole der schilderkonst*), one of the few sustained Dutch art treatises of the seventeenth century.

Arnold Houbraken (1660–1719) Born in Dordrecht and trained there as a painter by **Van**

Hoogstraeten, Houbraken became a versatile but conventional painter in his native city and Amsterdam, where he resided from 1710. He is more famous for his *Great Theatre of Nederlandish Painters* (1718–21), three volumes of biographies of Netherlandish artists that begin where Van Mander's *Schilder-Boeck* left off. While the biographies evince Houbraken's preferences for smooth, classically inspired painting, their full narratives paint a rich picture of the seventeenth-century art world in the Netherlands, often, as in the case of Rembrandt, evoking specific qualities of the artist's work through the content of his or her life.

Constantijn Huygens (1596–1687) Born in The Hague to **Protestant** refugee parents from the Southern Netherlands, Huygens rapidly rose through the administrative ranks of the Dutch Republic, becoming first secretary to the Council of State and then private secretary to the *stadhouder* **Frederik Hendrik**. Highly erudite, Huygens was one of the most distinguished Dutch connoisseurs of art and architecture, as well as a accomplished poet in Latin and Dutch. His youthful memoir, written *c.*1629–31, is a testament to his well-rounded education; evocative of the courtly ideals of Castiglione, it includes a series of essays on the greatest Netherlandish artists of his generation, including **Rubens**, Rembrandt and **Lievens**. In the capacity of culture broker, Huygens exerted significant influence on the building and decoration of fine palaces for Frederik Hendrik and **Amalia van Solms** in the 1630s.

Menasseh ben Israel (1604–57) A native of Lisbon, Menasseh ben Israel spent almost his entire life in Amsterdam, where his Sephardic parents had fled to in 1605. At the age of eighteen he was appointed rabbi in the second Sephardic synagogue of Amsterdam. As a writer, Menasseh sought to reconcile Orthodox Jewish and Christian positions in the Bible.

Clement de Jonghe (1624/5–77) An immigrant from Schleswig-Holstein, De Jonghe became a prominent print and map publisher and dealer. He kept a large stock of plates from which he could reissue prints as needed, including some by **Lievens** and, eventually, seventy-four by Rembrandt. The business did not flourish, and two years after his death his son was forced to liquidate it.

Pieter Lastman (1583–1633) Trained in Amsterdam by accomplished painters in a classical manner, Lastman developed a more dramatic mode of history painting in Rome (*c.*1601–5). There, he was associated with Northern artists (including **Elsheimer**) who favoured bright palettes and detailed storytelling. Back in Amsterdam he stood at the centre of a circle of artists who infused classical and Old Testament narratives with a new urgency, relying on archaeological details and strong rhetorical gestures. Lastman briefly taught Rembrandt as well as **Lievens**.

Jan Lievens (1607–74) Having been Rembrandt's close associate and rival in Leiden from 1625–31, Lievens eventually became a celebrated portraitist in a different style, based on elegant poses and smoothly blended colours in a cosmopolitan manner. He acquired this mode in England (1632–5), where he met **Van Dyck** and probably studied Italian paintings in the best collections. Subsequently in Antwerp (1635–44), he solidified his knowledge of Flemish painting. Upon his definitive move to Amsterdam in 1644 he participated in the most significant decorative works of the day, including the Oranjezaal for **Amalia van Solms** and the Amsterdam Town Hall.

Frederik Hendrik, Prince of Orange (1584–1647) Son of William I of Orange, the legendary leader of the Dutch Revolt, Frederik Hendrik became *stadhouder* after his half-brother Maurits died in 1625. As accomplished Captain-General of the Dutch armies, he secured crucial military victories, particularly that over 's-Hertogenbosch in 1629, that eventually guaranteed the Republic its independence at the Peace of Münster (1648). In religious politics Frederik Hendrik followed a more consensual approach than his predecessor, who had identified aggressively with the Counter-**Remonstrant** faction of the Reformed Church. With **Amalia van Solms**, his sophisticated wife, Frederik Hendrik also set new standards of international courtliness for his entourage, hosting them in fine, newly built or redecorated palaces in and on the outskirts of The Hague. Advised by **Huygens** and other connoisseurs, he patronized Netherlandish artists such as **Honthorst**, Rembrandt and **Van Dyck**. His increasingly grand court was an effective instrument of his dynastic ambitions for the House of Orange, realized most spectacularly in the marriage of his heir William II (1626–50) to Mary Stuart (1631–61), daughter of **Charles I** of England in 1641.

Peter Paul Rubens (1577–1640) Trained as an artist in Antwerp, Rubens came of artistic age in Italy, where he worked from 1600–8, absorbing the lessons of ancient and Renaissance art in Rome and Venice and studying the contemporary works of Caravaggio and several Bolognese artists. Upon his return to Antwerp he became court painter to the archdukes who governed the Southern Netherlands; for them, he eventually worked as diplomat as well as artist. Similar dual appointments followed to **Charles I** of England, who knighted him, and to Philip IV of Spain, along with a grand commission from Marie de' Medici (1622–5). Rubens' prodigious and inventive *oeuvre* was primarily produced in Antwerp, where he oversaw a large workshop adjacent to his gentlemanly home. Many of Rubens' works were reproduced in engravings produced under his supervision.

Petrus Scriverius (1576–1660) The historian Scriverius (also known as Pieter Schrijver) identified strongly with the **Remonstrant** cause, and hence could not hold office after

the Counter-Remonstrants had gained crucial popular and political support at the Synod of Dordrecht in 1618. He was a proponent of the literary and visual arts, commissioning several portraits and a painting parodying the Synod; he also owned two fairly large paintings by Rembrandt.

Hercules Segers (1589/90–1633/8) The son of a **Mennonite** immigrant from Antwerp, Segers was apprenticed to the landscape painter Gillis van Coninxloo (1544–1607) of Amsterdam, who had also left Antwerp for religious reasons. Working in innovative, maverick techniques, he developed a distinctive repertoire of landscape paintings and etchings that were distantly indebted to Van Coninxloo's Flemish tradition. Segers lived in at least three cities, in 1631 he was forced by bankruptcy to move from Amsterdam to Utrecht.

Jan Six (1618–1700) Rembrandt's most significant patron between about 1645 and 1654 was an independently wealthy city official of Huguenot descent, who eventually became a burgomaster (1691). In 1655 he married Margaretha Tulp, the daughter of Nicolaes. He spent much of his time writing poetry and building his art collection, buying extant works as well as commissioning new pictures.

Amalia van Solms, Princess of Orange (1602–75) Daughter of the Count von Solms-Braunfels, a **Protestant**, and educated in an international courtly ambiance, Amalia van Solms was a perfect partner for the *stadhouder* Frederik Hendrik, whom she married in 1625. In the 1630s Amalia strongly encouraged the international and dynastic aspirations of the court in The Hague, hosting lavish receptions and stimulating the building and decoration of palaces and gardens in a classical style. Together with the *stadhouder* she amassed a fine collection of contemporary Netherlandish paintings, tapestries and jewellery, and after his death she oversaw the construction and grand decoration of the Oranjezaal at Huis ten Bosch in his memory (1649–53). In the '*stadhouder*less period' from 1650 to 1672, she worked behind the scenes for the eventual accession of her grandson William III to the position of *stadhouder*.

Baruch Spinoza (1632–77) A philosopher born and raised in the Sephardic community of Amsterdam, Spinoza was a keen student of the ethical fundamentals shared by Judaism and Christianity, and an ardent proponent of religious and political tolerance. His expulsion from the synagogue in 1656 may have been caused by his rationalist approach to religion, insistent on logical interpretation of the Bible. The *Tractatus theologico-politicus* of 1670 is an erudite and polemical record of his views.

Jacob Isaacsz van Swanenburgh (1571–1638) Rembrandt's first teacher was trained in Leiden by his father Isaac, a local dignitary. From c.1591 to 1618 he worked in Venice, Rome and Naples, where he developed his characteristic city views and paintings of

infernal landscapes. He continued to paint such works in Leiden, where he taught Rembrandt from about 1621 to 1624.

Hendrick Uylenburgh (1587–1661) Born into a Frisian **Mennonite** family, Uylenburgh was raised in religious exile in Poland, where he was trained as a painter. By 1628 Uylenburgh had become an art dealer in Amsterdam. He was one of the most prominent figures in the city's art world, selling art, brokering portrait commissions, commissioning copies after master painters, arranging apprenticeships and offering lodging and studio space to young artists. Some of the finest Dutch painters, including several of Rembrandt's pupils, worked with him. Hendrick's son Gerrit took over the versatile, international business, but had to declare insolvency in 1675, when war with France and England had plunged the Dutch economy into recession.

Anthony Van Dyck (1599–1641) **Rubens**' most talented pupil, Van Dyck became the leading European portraitist of the first half of the seventeenth century, painting the political, social and economic élites of Genoa, Antwerp and England. He served as court painter to the Archduchess Isabella of the Southern Netherlands and to **Charles I** of England; he also visited The Hague to paint the *stadhouder* Frederik Hendrik (c.1631). His graceful but energetic poses, innovative compositions, imaginative dress and fluid brushwork set new standards of portraiture, followed by **Lievens**, **Van der Helst** and **Flinck**.

Joost van den Vondel (1587–1679) Born a **Mennonite**, the great Dutch poet of Christian tragedies converted to Catholicism in the early 1640s. In 1637, *Gijsbreght van Aemstel,* his inaugural play for the new Amsterdam Theatre, had been controversial for its performance of a Catholic mass. In his translations, plays and poems, Vondel reclaimed classical dramatic principles for contemporary Dutch literature; he was also an accomplished art critic. Vondel ran a silk business, which was ruined financially by his or his son's risky investments on the Amsterdam Exchange. In recognition of his literary merits Amsterdam gave him the clerkship of the city pawnshop for the remainder of his life.

Johannes Wtenbogaert (1557–1644) Raised a Catholic in Utrecht, Wtenbogaert converted to the Reformed church at a young age. In 1589 he became field chaplain to Prince Maurits of Orange and teacher to **Frederik Hendrik**, but his adherence to the more tolerant faction of the church led to conflict with Maurits. In 1610 Wtenbogaert's *Remonstrantie* set forth the core beliefs of the **Remonstrant** group; eight years later during the Synod of Dordrecht all Remonstrant preachers were fired and Wtenbogaert fled to Antwerp, where he founded the Remonstrant Confraternity. In 1626, soon after the milder Frederik Hendrik had become *stadhouder*, Wtenbogaert returned to The Hague, where he remained active as a theologian and church historian.

Key Dates

Numbers in square brackets refer to illustrations

The Life and Art of Rembrandt van Rijn		A Context of Events
1606	Rembrandt born in Leiden, 15 July	
		1609 Declaration of the Twelve Years Truce between the States General and the Spanish Netherlands; *de facto* recognition of the Dutch Republic
		1609–72 Expansion of Amsterdam on plan of concentric canals
c.1618–20	Attends Latin School, Leiden	1618 Hugo Grotius flees Holland for exile in France
		1618–19 Reformed Synod of Dordrecht sides with strict Calvinist faction of the Church
		1619 Political execution of State Councilor Johan van Oldenbarnevelt. Johannes Wtenbogaert is exiled to Antwerp. Dutch settlement of Batavia on the Indonesian island of Java. Thomas de Keyser, *The Anatomy Lesson of Doctor Sebastiaen Egbertsz de Vrij* [53]
1620	Registered at University of Leiden	
c.1621–24	Pupil of Jacob van Swanenburgh	1621 End of the Twelve Years Truce. Dutch West Indies Company chartered
c.1624	Six-month apprenticeship with Pieter Lastman in Amsterdam	
1625	Independent painter in Leiden. *The Stoning of St Stephen*, first dated work [20]	1625 *Stadhouder* Maurits dies; his half-brother Frederik Hendrik succeeds him. Johannes Wtenbogaert returns from exile to The Hague. Joost van den Vondel, *Palamedes*. Jacob Cats, *Houwelick*, verse treatise on marriage
c.1628–31	Gerard Dou and Isack Jouderville become Rembrandt's first pupils in Leiden	
1629	*The Penitent Judas Returning the Thirty Pieces of Silver* [28] admired by Constantijn Huygens on visit to Rembrandt and Jan Lievens	1629 Frederik Hendrik conquers 's-Hertogenbosch, Catholic frontier city
1630	Harmen van Rijn, Rembrandt's father, dies in April	1630–54 Northeastern Brazil under Dutch governorship
1631	Lends 1,000 guilders to Hendrick Uylenburgh, June. *Nicolaes Ruts*, first known portrait of Amsterdam patron [45]	c.1631 Constantijn Huygens writes memoir of his youth
1632	Lodges with Hendrick Uylenburgh in Amsterdam, June. *The Anatomy Lesson of Doctor Nicolaes Tulp* [52]. Paints portrait of *Amalia van Solms* [60]. Begins Passion series for *stadhouder* Frederik Hendrik [64, 65]	

	The Life and Art of Rembrandt van Rijn	A Context of Events
1633	Paints and etches portraits of *Johannes Wtenbogaert* [48, 49]	
1634	Marries Saskia Uylenburgh in Friesland. Becomes Citizen of Amsterdam and member of Guild of St Luke	
1635	Rents house in Nieuwe Doelenstraat. Son Rombertus born in December. *Self-Portrait with Saskia in the Guise of the Prodigal Son* [62]	
1636	Rombertus dies in February. Corresponds with Huygens about the Passion series. Etches portrait of *Samuel Menasseh ben Israel* [51]	
1637	Moves to rented house on Binnen-Amstel. Ferdinand Bol becomes a pupil	1637 Publication of the *Statenbijbel* (States Bible), commissioned by the States General. Inauguration of Jacob van Campen's Amsterdam Theatre with Vondel's *Gijsbreght van Aemstel*. Descartes, *Discourse on the Method*, published in Leiden
1638	Daughter Cornelia is born and dies after several weeks. Saskia's relatives complain that she is squandering her inheritance	1638 Marie de' Medici visits Amsterdam
1639	Buys house on the Sint Anthonisbreestraat in January; moves to the house in May. Corresponds with Huygens about the Passion series. Draws copy of Raphael's *Portrait of Baldassare Castiglione* [97]	1639–45 The new hall of the *Kloveniersdoelen* is decorated by the leading painters of Amsterdam [103, 104]
1640	Second daughter Cornelia is born and dies after several weeks. Rembrandt's mother dies in September. Samuel van Hoogstraeten becomes a pupil.	1640 Peter Paul Rubens dies. Vondel, *Joseph in Egypt*
1641	Son Titus, Rembrandt's only surviving child with Saskia, is born in September. Philips Angel praises Rembrandt's *The Wedding of Samson* [82] in a lecture to artists in Leiden	1641 Anthony Van Dyck dies. Jan Jansz Orlers, *Description of the City of Leyden* (*Beschrijvinge der Stadt Leyden*)
1642	Saskia dies on 14 June. *The Nightwatch* is completed [103]. Geertge Dircx employed as a nurse for Titus and soon becomes Rembrandt's mistress	1642 Philips Angel, *In Praise of the Art of Painting* (*Lof der Schilder-Konst*)
1643	Etches *The Three Trees* [202]	
1646	Frederik Hendrik pays Rembrandt 2,400 guilders for two paintings of the infancy of Christ. *The Holy Family with a Curtain* [115]	
1647	Rembrandt's estate estimated at 40,750 guilders. Etches portrait of *Jan Six* [109]	1647 Frederik Hendrik dies; his son Willem II succeeds him
c.1647	Hendrickje Stoffels is employed as a live-in servant and soon becomes Rembrandt's new mistress	1647–55 Jacob van Campen builds the new Amsterdam Town Hall
		1648 Peace of Münster: recognition of the Dutch Republic. Jan Six, *Medea* [127]
1649	Geertge sues Rembrandt for breach of marital promise, Rembrandt is ordered to pay her an annual allowance of 200 guilders	1649–50 States General and Amsterdam seek to curtail the power of Willem II

The Life and Art of Rembrandt van Rijn	A Context of Events
1650 Rembrandt pays to have Geertge committed to the women's house of correction in Gouda. Etches *Conus Marmoreus* [150]	1650 Willem II dies after failed attempt to march on Amsterdam. His son, the future *stadhouder* Willem III, is born
	1651 Office of the *stadhouder* abolished in five key provinces
1652 Produces two drawings for the *album amicorum* of Jan Six [128]	1652 Dutch colony founded at Cape of Good Hope, Africa
	1652–54 First Anglo-Dutch war, mostly favourable to English interests
1653 Owner of Rembrandt's house seeks final payment of the mortgage. *Aristotle* [159]	1653 Johan de Witt is appointed Advocate of the Land, chief representative of the Republic
1654 Hendrickje denied communion by the Reformed Church Council for affair with Rembrandt. Third daughter Cornelia is born to Hendrickje and Rembrandt out of wedlock, October. Rembrandt cannot obtain a loan to buy a house in the Handboogstraat. *Bathsheba* [163]. Paints portrait of *Jan Six* [130]	
1655 Etches eight states of *Ecce Homo* [183, 184]	1655 Menasseh ben Israel, *Piedra Gloriosa*
	1655–97 The Amsterdam Town Hall is decorated by leading Flemish and Dutch artists [189]
1656 Rembrandt applies for a *cessio bonorum* from the Chamber of Insolvent Estates, which draws up an inventory of goods to be sold. *The Anatomy Lesson of Doctor Joan Deyman* [157, 158]	
1657–8 Liquidation auctions of Rembrandt's art, household goods and house	
1658 Moves to rented house on the Rozengracht, in the Jordaan section of Amsterdam	
1660 Rembrandt becomes employee of an art dealership directed by Hendrickje and Titus	1660 Death of Govaert Flinck
*c.*1660 Aert de Gelder becomes a pupil	
1661 *Self-Portrait as the Apostle Paul* [199]. Begins *The Conspiracy of the Batavians under Claudius Civilis* [190, 191]	
1662 *The Conspiracy of the Batavians under Claudius Civilis* [190] is returned to Rembrandt from the Amsterdam Town Hall. Rembrandt sells Saskia's grave. *The Syndics of the Drapers' Guild of Amsterdam* [192]	
1663 Hendrickje Stoffels dies in July and is buried in a rented grave in the Westerkerk	
	1665–7 Second Anglo-Dutch war, largely favourable to the Republic
1668 Titus marries Magdalena van Loo, daughter of a silversmith and friend of Rembrandt, in February, and dies seven months later	
1669 Titus' daughter Titia is born, and Rembrandt is godfather at the baptism in March. Rembrandt dies on 4 October and is buried four days later in a rented grave in the Westerkerk. *Simeon Holding the Christ Child* [200] left unfinished on the easel	1669 Jan de Bisschop, *Paradigmata*

Borders and landmasses shown are those at the start of the 21st century

North Sea

Leeuwarden •

NETHERLANDS
(DUTCH REPUBLIC)

Haarlem • • Zwolle
 • Amsterdam
The Hague • • Leiden
 • Utrecht
 Waal
 Meuse *Rhine*

Antwerp •

Brussels • GERMANY

BELGIUM
(SOUTHERN NETHERLANDS)

FRANCE

| 0 | 50 | 100 | 150 miles |
| 0 | 100 | | 200 kilometres |

Further Reading

All Rembrandt research is facilitated immeasurably by fundamental publications about the documented facts of the artist's life, his paintings, drawings and prints, and his reception. The books and exhibition catalogues listed in the general section were consulted for virtually every chapter in the book. More specialized publications are listed under the chapter in which their findings are first discussed. Occasionally, articles listed under a chapter refer back to works in the general section.

General

Otto Benesch, *The Drawings of Rembrandt*, 6 vols (London, 1973)

Holm Bevers, Peter Schatborn and Barbara Welzel, *Rembrandt: The Master and His Workshop, Drawings and Etchings* (exh. cat., Altes Museum, Berlin; Rijksmuseum, Amsterdam and National Gallery, London, 1991)

David Bomford *et al.*, *Art in the Making: Rembrandt* (exh. cat., National Gallery, London, 1988)

A Bredius, rev. edn by H Gerson, *Rembrandt: The Complete Edition of the Paintings* (London, 1969; 1st edn 1935)

B P J Broos, *Index to the Formal Sources of Rembrandt's Art* (Maarssen, 1977)

Christopher Brown *et al.*, *Rembrandt: The Master and His Workshop, Paintings* (exh. cat., Altes Museum, Berlin; Rijksmuseum, Amsterdam and National Gallery, London, 1991)

Josua Bruyn *et al.*, *A Corpus of Rembrandt Paintings*, 3 vols (The Hague etc., 1982–9)

H Perry Chapman, *Rembrandt's Self-Portraits: A Study in Seventeenth-Century Identity* (Princeton, 1990)

Martin Royalton-Kisch, *Drawings by Rembrandt and His Circle in the British Museum* (exh. cat., British Museum, London, 1992)

Seymour Slive, *Rembrandt and His Critics 1630–1730* (The Hague, 1953)

Walter L Strauss and Marjon van der Meulen, *The Rembrandt Documents* (New York, 1979)

Ernst van de Wetering, *Rembrandt: The Painter at Work* (Amsterdam, 1997)

Christopher White, *Rembrandt as an Etcher: A Study of the Artist at Work*, 2 vols (University Park, PA and London, 1969)

Christopher White and Karel Boon, *Rembrandt's Etchings*, 2 vols (Amsterdam, 1969)

Christopher White and Quentin Buvelot, eds, *Rembrandt by Himself* (exh. cat., National Gallery, London and Mauritshuis, The Hague, 1999)

Inspiring general biographies and assessments of the artist, very different in scope and emphasis, include:

Bob Haak, *Rembrandt: His Life, His Work, His Time* (New York, 1969)

Jakob Rosenberg, *Rembrandt: Life and Work* (Cambridge, MA, 1948)

Simon Schama, *Rembrandt's Eyes* (New York, 1999)

Christopher White, *Rembrandt* (London, 1984)

Introduction

David Beck, *Spiegel van mijn leven: Haags dagboek 1624* (Hilversum, 1993)

Stephen Gaukroger, *Descartes: An Intellectual Biography* (Oxford, 1995)

Stephen J Greenblatt, *Renaissance Self-Fashioning* (Chicago, 1980)

Margaret Gullan-Whur, *Within Reason: A Life of Spinoza* (London, 1999)

Joseph Koerner, 'Rembrandt and the Epiphany of the Face', *Res*, 12 (1986), pp.5–32

John Martin, 'Inventing Sincerity, Refashioning Prudence: The Discovery of the Individual in Renaissance Europe', *American Historical Review* (1997), pp.1309–42

Seymour Slive, *Frans Hals*, 3 vols (Oxford, 1970–4)

Charles Taylor, *Sources of the Self: The Making of the Modern Identity* (Cambridge, MA, 1989)

Christopher White, David Alexander, and Ellen D'Oench, *Rembrandt in Eighteenth-Century England* (exh. cat., Yale Center for British Art, New Haven, 1983)

Chapter One

Kurt Bauch, *Der frühe Rembrandt und seine Zeit: Studien zur geschichtlichen Bedeutung seines Frühstils* (Berlin, 1960)

Robert W Baldwin, '"On earth we are beggars, as Christ himself was" The Protestant Background of Rembrandt's Imagery of Poverty, Disability and Begging', *Konsthistorisk Tidskrift*, 54 (1985), pp.122–35

Albert Blankert, *Rembrandt: A Genius and His Impact* (exh. cat., National Gallery of Victoria, Melbourne and National Gallery of Australia, Canberra, 1997)

S A C Dudok van Heel, 'Rembrandt van Rijn

(1606–1669): A Changing Portrait of the Artist', in Brown *et al.*, *Rembrandt: The Master and His Workshop*, pp.50–78

J A Emmens, *Rembrandt en de regels van de kunst/Rembrandt and the Rules of Art* (Utrecht, 1968)

Ernst Kris and Otto Kurz, *Legend, Myth, and Magic in the Image of the Artist: A Historical Experiment* (New Haven and London, 1979; 1st German edn Vienna, 1934)

Mansfield Kirby Talley Jr, 'Connoisseurship and the Methodology of the Rembrandt Research Project', *International Journal of Museum Management and Curatorship*, 8 (1989), pp.175–214

Astrid Tümpel and Peter Schatborn, *Pieter Lastman, The Man Who Taught Rembrandt* (exh. cat., Rembrandthuis, Amsterdam, 1991)

Christian Tümpel, *Rembrandt: All Paintings in Color* (New York, 1993)

Christiaan Vogelaar *et al.*, *Rembrandt and Lievens in Leiden: 'A Pair of Young and Noble Painters'* (exh. cat., Stedelijk Museum De Lakenhal, Leiden, 1991)

Lyckle de Vries, 'Tronies and Other Single Figured Netherlandish Paintings', *Leids Kunsthistorisch Jaarboek*, 8 (1989), pp.185–202

M L Wurfbain *et al.*, *Geschildert tot Leyden anno 1626* (exh. cat., Stedelijk Museum De Lakenhal, Leiden, 1976)

Chapter Two

Josua Bruyn, 'Rembrandt's Workshop – Function and Production', in Brown *et al.*, *Rembrandt: The Master and His Workshop*, pp.68–89

J Bruyn and E van de Wetering, 'Stylistic Features of the 1630s: The Portraits', in Bruyn *et al.*, *A Corpus of Rembrandt Paintings*, vol. 2, pp.3–13

R E O Ekkart and E Ornstein-van Slooten, *Face to Face with the Sitters for Rembrandt's Etched Portraits* (exh. cat., Museum het Rembrandthuis, Amsterdam, 1986)

Wayne Franits, *Paragons of Virtue: Women and Domesticity in Seventeenth-Century Dutch Art* (Cambridge, 1993)

R H Fuchs, *Rembrandt in Amsterdam* (Greenwich, CT, 1969)

W S Heckscher, *Rembrandt's Anatomy of Dr Nicolaas Tulp: An Iconological Study* (New York, 1958)

Paul Huys Janssen and Werner Sumowski, *The Hoogsteder Exhibition of Rembrandt's Academy* (exh. cat., Hoogsteder & Hoogsteder, The Hague, 1992)

Jonathan Israel, *The Dutch Republic: Its Rise, Greatness, and Fall 1477–1806* (Oxford, 1995)

Walter Liedtke *et al.*, *Rembrandt/Not Rembrandt in The Metropolitan Museum of Art: Aspects of Connoisseurship* (exh. cat., vol. 2, Metropolitan Museum of Art, New York, 1995)

J W von Moltke, *Govaert Flinck, 1615–1660* (Amsterdam, 1965)

Peter Schatborn and Eva Ornstein-van Slooten, *Rembrandt as Teacher* (exh. cat., Museum het Rembrandthuis, Amsterdam, 1984)

W Schupbach, *The Paradox of Rembrandt's 'Anatomy of Dr Tulp'* (London, 1982)

Leonard J Slatkes, Review of White, *Rembrandt as an Etcher*, and White/Boon *Rembrandt's Etchings*, *Art Quarterly*, 36 (1973), pp.250–63

David Smith, *Masks of Wedlock: Seventeenth Century Dutch Marriage Portraiture* (Ann Arbor, MI, 1982)

Werner Sumowski, *Gemälde der Rembrandt-Schüler*, 6 vols (Landau, 1983–94)

Ernst van de Wetering, 'Problems of Apprenticeship and Studio Collaboration', in Bruyn *et al.*, *A Corpus of Rembrandt Paintings*, vol. 2, pp.45–90

Chapter Three

Kenneth Clark, *Rembrandt and the Italian Renaissance* (New York, 1966)

Peter van der Coelen *et al.*, *Patriarchs, Angels and Prophets: The Old Testament in Netherlandish Printmaking from Lucas van Leyden to Rembrandt* (exh. cat., Museum het Rembrandthuis, Amsterdam, 1996)

John Gage, 'A Note on Rembrandt's *Meeste Ende die Naetureelste Bweechgelickheijt*', *Burlington Magazine*, 111 (1969), p.381

Horst K Gerson, 'Rembrandt and the Flemish Baroque: His Dialogue with Rubens', *Delta*, 12, no. 2 (Summer 1969), pp.7–23

Lawrence Otto Goedde, *Tempest and Shipwreck in Dutch and Flemish Art: Convention, Rhetoric, and Interpretation* (University Park, PA, 1989), esp. pp.77–83

Henrietta Ten Harmsel, *Jacobus Revius: Dutch Metaphysical Poet* (Detroit, 1968)

R Hausherr, 'Zur Menetekel-Inschrift auf Rembrandts Belsazarbild', *Oud Holland*, 78 (1963), pp.142–9

Joachim Kaak, *Rembrandts Grisaille Johannes der Täufer Predigend: Dekorum-Verstoß oder Ikonographie der Unmoral* (Hildesheim, 1994)

Madlyn Millner Kahr, 'Danaë: Virtuous, Voluptuous, Venal Woman', *Art Bulletin*, 60 (1978), pp.43–55

Volker Manuth, 'Die Augen des Sünders: Überlegungen zu Rembrandts Blendung Simsons von 1636 in Frankfurt', *Artibus et Historiae*, 21 (1990), pp.169–98

J H Meter, *The Literary Theories of Daniel Heinsius* (Assen, 1984)

Erwin Panofsky, 'Der gefesselte Eros (zur Genealogie von Rembrandts Danae)', *Oud Holland*, 50 (1933), pp.193–217

Peter van der Ploeg *et al.*, *Princely Patrons: The Collection of Frederick Henry of Orange and Amalia of Solms* (exh. cat., Mauritshuis, The Hague, 1997)

H-M Rotermund, *Rembrandt's Drawings and*

Etchings for the Bible (Philadelphia, 1969)

Margarita Russell, 'The Iconography of Rembrandt's "Rape of Ganymede"', *Simiolus*, 9 (1977), pp.5–18

Simon Schama, *The Embarrassment of Riches: An Interpretation of Dutch Culture in the Golden Age* (New York, 1987)

Gary Schwartz, *Rembrandt: His Life, His Paintings* (Harmondsworth, 1985)

Maria A Schenkeveld, *Dutch Literature in the Age of Rembrandt: Themes and Ideas* (Amsterdam and Philadelphia, 1991)

Eric Jan Sluijter, *De 'heydensche fabulen' in de Noordnederlandse schilderkunst, circa 1590–1670* (PhD dissertation, University of Leiden, 1986; with English summary)

Irina Sokolova et al., *Danaë: The Fate of Rembrandt's Masterpiece* (St Petersburg, 1997)

Christian Tümpel, *Rembrandt* (Amsterdam, 1986)

—, 'Studien zur Ikonographie der Historien Rembrandts: Deutung und Interpretation der Bildinhalte', *Nederlands Kunsthistorisch Jaarboek*, 20 (1969), pp.107–98

Christian Tümpel et al., *Het Oude Testament in de schilderkunst van de Gouden Eeuw* (exh. cat., Joods Historisch Museum, Amsterdam, 1991)

W A Visser 't Hooft, *Rembrandt and the Gospel* (Philadelphia, 1957)

H van de Waal, 'Rembrandt at Vondel's Tragedy *Gijsbreght van Aemstel*', in H van de Waal, *Steps Towards Rembrandt: Collected Articles 1937–1972*, ed. by R H Fuchs (Amsterdam and London, 1974), pp.73–89

Arthur K Wheelock Jr, *Dutch Paintings of the Seventeenth Century: The Collections of the National Gallery of Art Systematic Catalogue* (Washington, DC, 1995)

Chapter Four

Josua Bruyn, 'On Rembrandt's Use of Studio-Props and Model Drawings during the 1630s', in *Essays in Northern European Art Presented to Egbert Haverkamp-Begemann on His Sixtieth Birthday* (Doornspijk, 1983), pp.52–60

W Busch, 'Zu Rembrandts Anslo-Radierung', *Oud Holland*, 86 (1971), pp.196–9

Baldessare Castiglione, *The Book of the Courtier* (Harmondsworth, 1967)

Stephanie S Dickey, 'Prints, Portraits and Patronage in Rembrandt's Work around 1640' (PhD dissertation, New York University, 1994)

S A C Dudok van Heel et al., *Dossier Rembrandt/ The Rembrandt Papers* (exh. cat., Museum het Rembrandthuis, Amsterdam, 1987)

J A Emmens, 'Ay Rembrandt, maal Cornelis Stem', *Nederlands Kunsthistorisch Jaarboek*, 7 (1956), pp.133–65

Egbert Haverkamp-Begemann, *Rembrandt: The Nightwatch* (Princeton, 1982)

Madlyn Kahr, *The Book of Esther in Seventeenth-Century Dutch Art* (PhD dissertation,

Columbia University, New York, 1966)

W G Hellinga, *Rembrandt fecit 1642: De Nachtwacht/Gysbrecht van Aemstel* (Amsterdam, 1956)

E de Jongh, 'The Spur of Wit: Rembrandt's Response to an Italian Challenge', *Delta*, 12, no.2 (Summer 1969), pp.49–67

Peter Schatborn, *Catalogue of the Dutch and Flemish Drawings in the Rijksprentenkabinet, Rijksmuseum, Amsterdam*, vol. 4: *Drawings by Rembrandt, His Anonymous Pupils and Followers* (The Hague, 1985)

Mieke B Smits-Veldt, *Het Nederlandse renaissance-toneel* (Utrecht, 1991)

Ernst van de Wetering, 'Rembrandt's Manner: Technique in the Service of Illusion', in Brown et al., *Rembrandt: The Master and His Workshop*, pp.12–39

Chapter Five

Svetlana Alpers, *Rembrandt's Enterprise: The Studio and the Market* (Chicago, 1988)

Christopher Brown et al., *Paintings and Their Context IV: Rembrandt van Rijn, Girl at a Window* (exh. cat., Dulwich Picture Gallery, London, 1993)

Nicola Courtright, 'Origins and Meanings of Rembrandt's Late Drawing Style', *Art Bulletin*, 78 (1996), pp.485–510

Wolfgang Kemp, *Rembrandt: La Sainte Famille ou l'art de lever un rideau* (Paris, 1989)

Frits Lugt, *Mit Rembrandt in Amsterdam: Die Darstellungen Rembrandts vom Amsterdamer Stadtbilde und von der unmittelbaren landschaftlichen Umgebung* (Berlin, 1920)

John Michael Montias, 'Works of Art in Seventeenth-Century Amsterdam: An Analysis of Subjects and Attributions', in David Freedberg and Jan de Vries, eds, *Art in History/History in Art: Studies in Seventeenth-Century Dutch Culture* (Santa Monica, 1991), pp.331–72

Cynthia P Schneider, *Rembrandt's Landscapes*, (New Haven and London, 1990)

Cynthia P Schneider et al., *Rembrandt's Landscapes: Drawings and Prints* (exh. cat., National Gallery of Art, Washington, DC, 1990)

K Thomassen, ed., *Alba Amicorum, Vijf eeuwen vriendschap op papier gezet: Het Album Amicorum en het poëziealbum in de Nederlanden* (exh. cat., Rijksmuseum Meermanno-Westreenianum/ Museum van het Boek, The Hague, 1990)

Ernst van de Wetering, 'The Question of Authenticity: An Anachronism? (A Summary)', in *Rembrandt and His Pupils: Papers Given at a Symposium in Nationalmuseum Stockholm* (Nationalmuseum, Stockholm, 1993), pp.9–13

Chapter Six

Albert Blankert, Ben Broos et al., *The Impact of a Genius: Rembrandt, His Pupils and*

Followers in the Seventeenth Century (exh. cat., Waterman Gallery, Amsterdam and Groninger Museum, Groningen, 1983)

Bob van den Boogert, ed., *Rembrandt's Treasury* (exh. cat., Museum het Rembrandthuis, Amsterdam, 1999)

A Th van Deursen, 'Rembrandt and His Age – The Life of an Amsterdam Burgher', in Brown *et al.*, *Rembrandt: The Master and His Workshop*, pp.40–9

E Haverkamp-Begemann, 'Rembrandt as a Teacher', in *Rembrandt after Three Hundred Years* (exh. cat., The Art Institute of Chicago, 1969), pp.21–30

Peter Schatborn, 'Aspects of Rembrandt's Draughtmanship', in Holm Bevers *et al.*, *Rembrandt: The Master and His Workshop*, pp.10–21

R W Scheller, 'Rembrandt en de encyclopedische kunstkamer', *Oud Holland*, 84 (1969), pp.81–147

Leonard Slatkes, *Rembrandt and Persia* (New York, 1983)

Werner Sumowski, *Drawings of the Rembrandt School*, 10 vols (New York, 1979–92)

Chapter Seven

Ann Jensen Adams, ed., *Rembrandt's Bathsheba Reading King David's Letter* (Cambridge, 1998)

Maryan Wynn Ainsworth *et al.*, *Art and Autoradiography: Insights into the Genesis of Paintings by Rembrandt, Van Dyck and Vermeer* (New York, 1982)

H Bramsen, 'The Classicism of Rembrandt's "Bathsheba"', *Burlington Magazine*, 92 (1950), pp.128–31

Amy Golahny, 'Rembrandt's Paintings and the Venetian Tradition' (PhD dissertation, Columbia University, New York, 1984)

Julius S Held, 'Aristotle', in Julius S Held, *Rembrandt Studies*, 2nd edn (Princeton, 1991), pp.17–58 and pp.191–3

Neil MacLaren and Christopher Brown, *National Gallery Catalogues: The Dutch School 1600–1900*, 2 vols (London, 1991)

Chapter Eight

Clifford S Ackley, *Printmaking in the Age of Rembrandt* (exh. cat., Museum of Fine Arts, Boston and Saint Louis Art Museum, 1980)

Anthony Blunt, 'The Drawings of Giovanni Benedetto Castiglione', *Journal of the Warburg and Courtauld Institutes*, 8 (1945)

Margaret Deutsch Carroll, 'Rembrandt as Meditational Printmaker', *Art Bulletin*, 63 (1981), pp.585–610

Egbert Haverkamp-Begemann, *Hercules Segers: His Complete Etchings* (The Hague, 1973)

Nadine Orenstein, *Hendrick Hondius and the Business of Prints in Seventeenth-Century Holland* (Rotterdam, 1996)

Ludwig Münz, *Rembrandt's Etchings*, 2 vols (London, 1952)

Rembrandt, Experimental Etcher (exh. cat., Museum of Fine Arts, Boston and Pierpont Morgan Library, New York, 1969)

Timothy J Standring, 'Giovanni Benedetto Castiglione' (Book Review), *Print Quarterly*, 4 (March 1987), pp.65–73

Frank J Warnke, *European Metaphysical Poetry* (New Haven and London, 1961)

Emanuel Winternitz, 'Rembrandt's "Christ Presented to the People" – A Meditation on Justice and Collective Guilt', *Oud Holland*, 84 (1969), pp.177–90

Chapter Nine

Arent de Gelder (exh. cat., Dordrechts Museum, 1998)

Mària van Berge-Gerbaud, *Rembrandt et son école: Dessins de la Collection Frits Lugt* (exh. cat., Fondation Custodia, Paris, 1997)

B P J Broos, 'The "O" of Rembrandt', *Simiolus*, 4 (1970), pp.150–84

Margaret Deutsch Carroll, 'Civic Ideology and Its Subversion: Rembrandt's *Oath of Claudius Civilis*', *Art History*, 9 (1986), pp.12–35

Katherine Fremantle, *The Baroque Town Hall of Amsterdam* (Utrecht, 1959)

Barbara Haeger, 'The Religious Significance of Rembrandt's *Return of the Prodigal Son*: An Examination of the Picture in the Visual and Iconographic Traditions' (PhD Dissertation, University of Michigan, 1983)

H van de Waal, 'The Iconographical Background to Rembrandt's *Civilis*', 'Holland's Earliest History as Seen by Vondel and His Contemporaries', and '*The Syndics and Their Legend*', in H van de Waal, *Steps towards Rembrandt: Collected Articles 1937–1972* (Amsterdam and London, 1974), pp.28–43, pp.44–72 and pp.247–92

Epilogue

Albert Blankert, 'Rembrandt, Zeuxis and Ideal Beauty', in J Bruyn *et al.*, eds, *Album amicorum J G van Gelder* (The Hague, 1973), pp.32–9

Jeroen Boomgaard and Robert Scheller, 'A Delicate Balance: A Brief Survey of Rembrandt Criticism', in Brown *et al.*, *Rembrandt: The Master and His Workshop*, pp.106–23

Kees Bruin, *De echte Rembrandt: Verering van een genie in de twintigste eeuw* (Amsterdam, 1995)

J A Emmens, 'Rembrandt als genie', in J A Emmens, *Kunsthistorische opstellen*, vol. 1 (Amsterdam, 1981), pp.123–8

Julius S Held, 'Rembrandt-*Dämmerung*', and 'Rembrandt: Truth and Legend', in Julius S Held, *Rembrandt Studies*, 2nd edn (Princeton, 1991), pp.3–16 and pp.144–52

Emile Michel, *Rembrandt, sa vie, son oeuvre et son temps* (Paris, 1893; English edn, 1894)

Index

Numbers in **bold** refer to illustrations

Acknowledgements

Rembrandt invites looking, engenders thought, provokes comment. One delight of writing about him is reading the rich literature he has generated; my bibliography begins to indicate my debts. Even greater pleasures are in the shared looking and committed conversation he stimulates. Unfailingly willing to look, read and talk over the years have been Perry Chapman, Stephanie Dickey, Reindert Falkenburg, Emilie Gordenker, Egbert Haverkamp-Begemann, Walter Liedtke, Irina Sokolova, Marina Warner, Arthur K Wheelock Jr, Joanna Woodall and participants in my Rembrandt seminars at Rutgers University. Family members forgave repeat, rain-drenched pilgrimages to central works and landmark exhibitions (a Rembrandt show always is): my affectionate thanks to Charlie Pardoe, our children Annie, Lucelle, Wim and, of course, Harmon, my sister Anneke and my mother, who introduced me to Rembrandt.

All the talk in the world cannot produce a book. For doing just that in a thoughtful, creative, patient manner I am grateful to Pat Barylski and Cleia Smith, who edited with exquisite care, to Michael Bird, who tuned and trimmed sentence upon sentence, to Giulia Hetherington and Sophie Hartley, who found excellent photographs on scant leads, and to Bruce Nivison, who designed with equal sensitivity to text and image. The book's contents are my responsibility, as the familiar disclaimer goes, but I hope that, in a fashion, they are Rembrandt's too.

M W

Martien and Anneke Westermann-de Boer, my parents
In memoriam

Photographic Credits

Amsterdams Historisch Museum: 53, 157, 158; Art Gallery and Museum, Brighton: 25; Artothek, Peissenberg: 79, 118, photo Joachim Blauel 2, photo Blauel/Gnamm 18, 64, 65, photo Ursula Edelmann 55; Ashmolean Museum, Oxford: 15; BFI Films, Stills, Posters and Designs, London: 201; British Museum, London: 11, 12, 13, 27, 58, 66, 68, 87, 94, 109, 126, 127, 129, 131, 133, 135, 141, 144, 145, 151, 153, 160, 165, 166, 168, 170, 173, 174, 176, 177, 178, 179, 180, 181, 182, 184, 185, 202; Christie's Images, London: 146; by the kind permission of the Master, Fellows and Scholars of Clare College in the University of Cambridge: 106; Collectie Six, Amsterdam: 128, 130; Collection Frits Lugt, Institut Néerlandais, Paris: 143, 195; Devonshire Collection, Chatsworth, by permission of the Duke of Devonshire and the Chatsworth Settlement Trustees: 81, 84, 122; by permission of the Trustees of the Dulwich Picture Gallery, London: 116; English Heritage Photographic Library, London: 198; Fitzwilliam Museum, Cambridge: 183; Frans Halsmuseum, Haarlem: 44; The Frick Collection, New York: 3, 45; Gemeentearchief, Amsterdam: 42; Gemeentearchief, Leiden: 16; Germanisches Nationalmuseum, Nuremberg: 1; J Paul Getty Museum, Los Angeles: 72; Graphische Sammlung Albertina, Vienna: 97; Herzog Anton Ulrich-Museum, Braunschweig: photo Museumsfoto B P Keiser 61, 119; Hessisches Landesmuseum, Darmstadt: 138, 140; The House of Orange-Nassau Historic Collections Trust, The Hague: 59; Institut de France, Musée Jacquemart-André, Paris: 60; Isabella Stewart Gardner Museum, Boston: 69; Jack Kilgore & Co, New York: 85; Koninklijk Museum voor Schone Kunsten, Antwerpen: 147; Musées Royaux des Beaux-Arts de Belgique, Brussels: 99; Los Angeles County Museum of Art: gift of H F Ahmanson and Company in memory of Howard F Ahmanson, © 1998 Museum Associates, Los Angeles County Museum of Art, all rights reserved 26; Mauritshuis, The Hague 32, 37, 52; Metropolitan Museum of Art, New York: purchase, the Annenberg Foundation Gift, 1991 (1991.305), photograph © 1991 The Metropolitan Museum of Art 73, Robert Lehman Collection, 1975 (1975.1.794), photograph © 1978 The Metropolitan Museum of Art 83, Robert Lehman Collection, 1975 (1975.1.799), photograph © 1984 The Metropolitan Museum of Art 132, Jules Bache Collection, 1949 (49.7.35), photo Malcolm Varon © 1996 The Metropolitan Museum of Art 156, purchase, special contributions and funds given or bequeathed by friends of the Museum, 1961 (61.198), photograph © 1993 The Metropolitan Museum of Art 159, gift of Archer M Huntington, in memory of his father, Collis Potter Huntington, 1926 (26.101.10), photo by Malcolm Varon © 1995 The Metropolitan Museum of Art 162; Minneapolis Institute of Arts: the William Hood Dunwoody Fund 197, the Ethel Morrison Van Derlip Fund 204; Mountain High Maps, © 1995 Digital Wisdom Inc.: p.341; Musée des Beaux-Arts de Lyon: photo Studio Basset, Caluire 20; Museo del Prado, Madrid 76; Museum het Rembrandthuis, Amsterdam 89; Museum of Fine Arts, Boston: Zoë Oliver Sherman Collection, given in memory of Lillie Oliver Poor 39, Juliana Cheney Edwards Collection 113; Museum Wasserburg Anholt, Isselburg 71; National Galleries of Scotland, Edinburgh: 112, photo Antonia Reeve Photography 21; National Gallery of Art, Washington, DC: Andrew W Mellon Collection 86; National Gallery of Ireland, Dublin: 117; National Gallery of Victoria, Melbourne: Felton Bequest, 1934, 33; National Gallery, London: 24, 28, 57, 77, 95, 98, 111, 154; National Museum, Stockholm: 190, 200; North Carolina Museum of Art, Raleigh: purchased with funds from the State of North Carolina 23; care of Petrushka Ltd, Moscow: 75, 78, 155, 196; Philadelphia Museum of Art: W P Wilstach Collection 80, John G Johnson Collection 93; Photothèque des Musées de la Ville de Paris: photo Patrick Pierrain 10, photo Philippe Ladet 136; Rheinisches Bildarchiv, Cologne 206; Rijksmuseum, Amsterdam: 5, 7, 9, 14, 19, 29, 36, 38, 48, 49, 51, 91, 92, 102, 103, 104, 105, 108, 120, 124, 125, 134, 148, 150, 171, 172, 175, 188, 192, 193, 194, 199; RMN, Paris: 6, 142, photo J G Berizzi 96, 149, photo Jean Schormans 163; Royal Academy of Arts, London 4; The Royal Collection © 1999 Her Majesty Queen Elizabeth II: photo A C Cooper 8, 100, photo Rodney Todd-White 35, 50, 110; Scala, Florence: 161, 164; Smith College Museum of Art, Northampton, Mass: purchased with the gift of Adeline F Wing, class of 1898, and Caroline R Wing, class of 1896, 1957, photo Stephen Petegorsky 31; Sotheby's, New York 40; Spaarnestad Fotoarchief, Haarlem: 205; Staatliche Graphische Sammlung, Munich 191; Staatliche Kunstsammlungen Dresden: 74, 82, photo Klut, Dresden 62; Staatliche Museen Kassel: 114, photo Brunzel 115, 137; Staatliche Museen zu Berlin, Preussischer Kulturbesitz: Gemäldegalerie, photo Jörg P Anders, 30, 43, 70, 101, 152; Kupferstichkabinett, photo Jörg P Anders: 56, 90, 123, 139; State Hermitage Museum, St Petersburg: 187; Stedelijk Museum De Lakenhal, Leiden: 17, 22; Sterling and Francine Clark Art Institute, Williamstown, Mass: 203; Stichting Koninklijk Paleis te Amsterdam: 189; Tiroler Landesmuseum Ferdinandeum, Innsbruck: 34

351 Acknowledgements

Phaidon Press Limited
Regent's Wharf
All Saints Street
London N1 9PA

First published 2000
© 2000 Phaidon Press Limited

ISBN 0 7148 3857 8

A CIP catalogue record for this book is
available from the British Library.

Text typeset in Minion

Printed in Singapore

Cover illustration Detail from *The Nightwatch*,
1642 (see p.162)